THE STYLE OF MOVEMENT

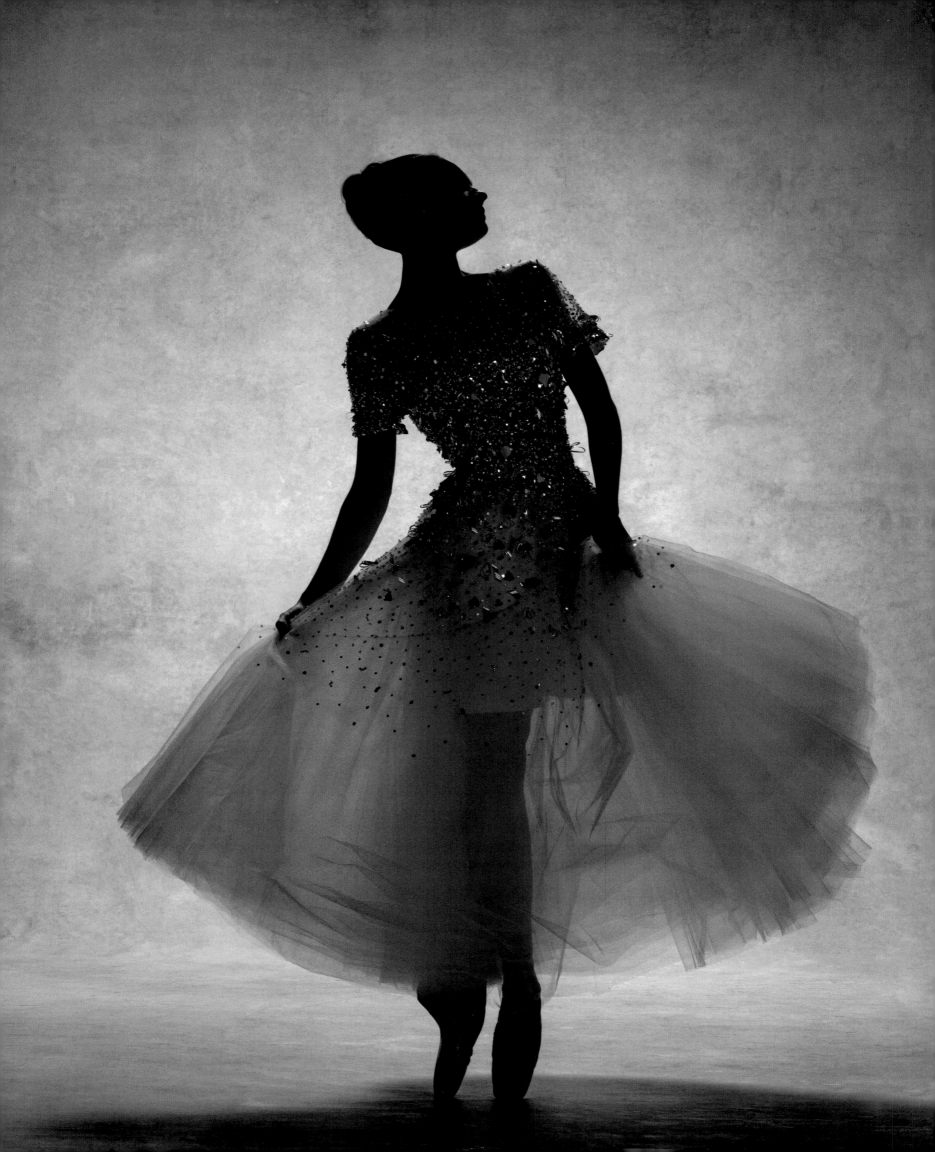

THE STYLE OF MOVEMENT

Ken Browar and Deborah Ory
NYC Dance Project

RIZZOLI
NEW YORK

New York · Paris · London · Milan

Introduction

Dance is the virtuosity of the human body pushed to its limits; the body understood as an instrument of resonance and sharing that sends signals and waves that our enchanted senses capture and record at the speed of light. Dance possesses a charismatic ability to draw the thread of its own journey right before our eyes, like a spider spinning its web, thereby capturing the gaze of an audience, focusing our attention so we transcend the given moment. It is much like how the single click of a camera can freeze the continuous explosion of forms and fix the flow of life in an instant of perpetual movement, creating a timeless bubble that can change the viewer's perspective. With photography, a previously invisible detail becomes distinguishable, the incomparable can be compared, the ephemeral is analyzed, and enchanting, fleeting moments are revealed.

Dance and fashion appear to have been made for each other. They work together beautifully, like a pair of superb, colorful lovebirds, each always ready to show off their joie de vivre, lovingly flirting, giggling, and sparkling together. More than ever, it is time to celebrate their union, their fusional osmosis of flesh and bones that the camera magnifies so beautifully. A photograph's ability to capture the instant allows us to understand something about dance that cannot be told in words, but is instead communicated in another, equally complex register. This more energetic, tactile, and visual system of signs leaps off the page and leaves us free to observe how within this knowing, absolutely beautiful blend lies a breathtaking, creative genius.

How not to notice the clear affinities, the unbreakable bond that unites fashion and dance? While one structures, underlines, and adorns the body with the most beautiful attire, the other reveals the intelligence of muscles under fabric, a supple network of intimate connections working at full stretch to show us how the simplest movement can express the deepest thought. And when they are on the same wavelength, extending our imaginations, supported by a body's well-oiled motor coordination, they reveal a high-wire exercise, a natural and breathtaking tour de force, a glamorous synergy that can feel like holding your breath in space. It is a spectacle captured in delightful photographs by a camera that cannot turn its regard away from this stunning duo.

What we now call classical dance was created during the long reign of Louis XIV, the Great (1638–1715), in the court at Versailles. Ascending to the throne aged five, Louis XIV hardly knew his father, Louis XIII. So it was his mother, Anne of Austria, who ruled as Regent of France, and her principal minister Cardinal Mazarin, who took charge of his education. Intellectual activities, such as literature and mathematics, were of little interest to the young sovereign, but he delighted in physical exercise, and was—as his father had been—passionate about music and dance. Practicing for hours every day, Louis XIV learned to dance with Pierre Beauchamps, an experienced choreographer and composer, who would later become founding ballet master at the Académie Royale de Musique, as well as director of the Académie de la Danse. Beauchamps taught Louis XIV the steps that would form the basis of classical dance: chassé, assemblé, and sissonne; later he created a new system of choreographic notation that, notably, codified the five classical, fundamental positions of the feet and arms. It became the standard work and is still in use today.

As well as actively encouraging the spread of classical dance, Louis XIV is also remembered for laying the functional groundwork for another industry, one with a particularly bright future. "For France, fashion is that which the gold mines of Peru are to Spain," wrote Jean-Baptiste Colbert, celebrated economist, Louis's minister of finance, and the man with total control of French-made fashion. To support this economic prize, and its extravagant financial implications, there was nothing like having a royal ambassador—at home and on duty full-time—to step into the fashion breach.

In 1653, for example, the Sun King arrived on stage in the guise of Apollo, like a traditionally dressed bullfighter entering the arena, proudly wearing his "Costume of Light." Radiant like a thousand fires, its torso-hugging top shone with an embroidered sun. For Louis XIV, this appearance in the Ballet Royal de la Nuit was not simply about getting a stunned reaction from the assembled audience—which it was guaranteed to do—but it was also another step in the careful cultivation of his "brand image." His stage appearances were used to promote the latest French fashion in front of an audience of powerful guests, dazzling them with an excess of spectacle, style, and munificence.

Since the king's early stage appearances, fashion's catwalks have leapt to life. A key moment in this evolution came in Paris in the early 1970s when models were set free, released with a spring in their step to move naturally. It was one of Kenzo's early shows, Jungle Jap, an event of such joyous organized chaos that it exploded the traditional idea of stiff, strait-laced haute couture shows—a new generation of women had hit the catwalk and they were dancing.

Flash-forward to the twentieth and twenty-first centuries: the worlds of dance and fashion are more intertwined than ever before. Coco Chanel crossed national and political divides when she designed for Diaghiliev and the Ballet Russes in 1924, and there have been countless notable designer and choreographer collaborations since: Norma Kamali and Twyla Tharp, Rei Kawakubo and Merce Cunningham, Christian Lacroix and the Paris Opera Ballet. Halston, Calvin Klein, and Donna Karan all created clothes for Martha Graham at some point in their careers. The world of dance and fashion are in constant conversation, so much so that the New York City Ballet now focuses its fall gala on celebrating the evolving relationship between fashion and dance. If dance and fashion are indeed a pair of colorful lovebirds, then their bond is stronger than ever.

—PAMELA GOLBIN

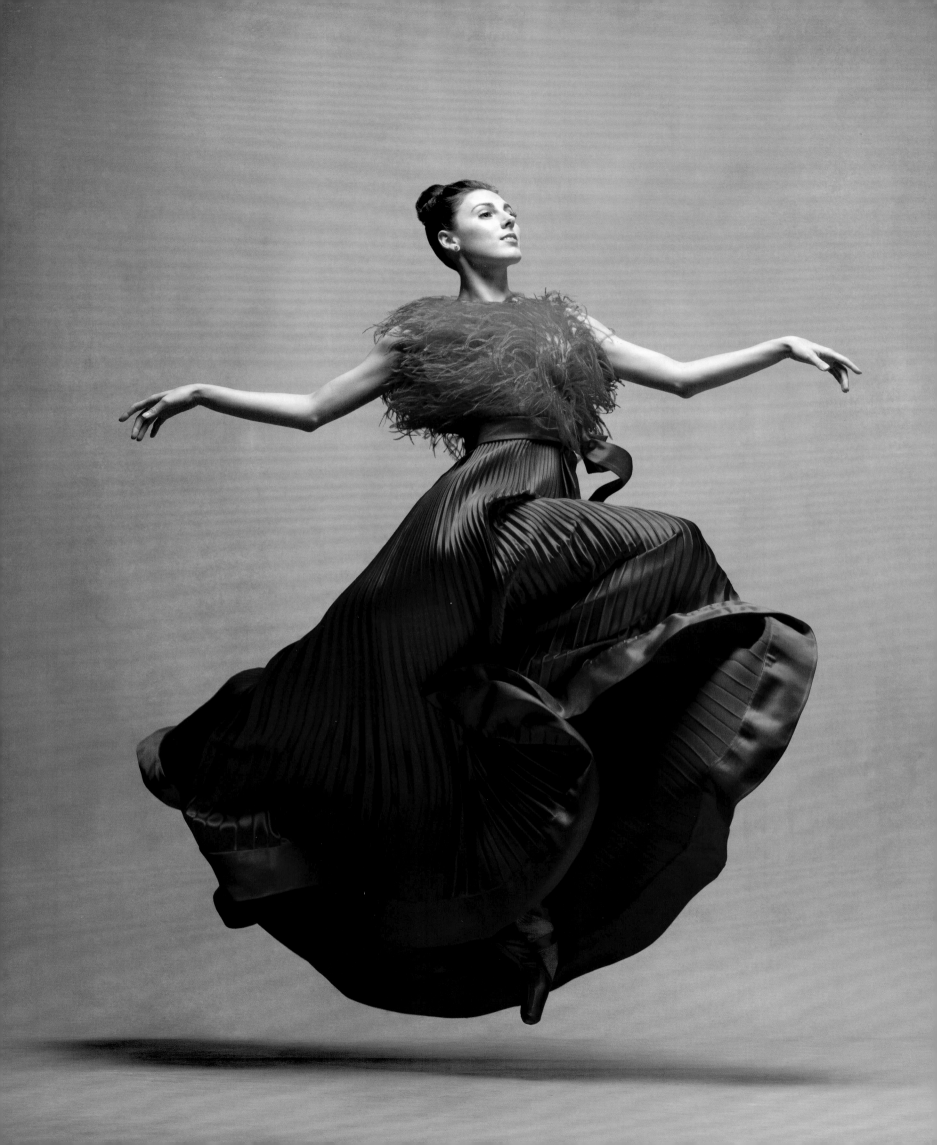

Foreword

I have always designed thinking about the movement of the woman wearing the dress—where would she wear it, how would she move in it, and what it means to her. A dress should never be designed just to be viewed from just one angle; movement *must* be considered in an entire 360-degree point of view. Wearing clothing is about expressing emotion—just the way dance is. Dancers have a remarkable elegance with the way they hold their bodies: they truly carry a dress with the gentlest touch; a way that allows the dress to have freedom to move and be and carry the emotion of the movement. I have loved collaborating with dancers throughout my career because the movement of a dancer brings life to my designs.

Martha Graham: Dressing the Body in Motion

Martha Graham's reverence for the body, combined with her radical ideas for using that instrument on stage, was the undeniable impetus for her revolution in dance. And among her many innovations, her provocative and deeply meaningful use of fabric and costuming—how she adorned and accentuated the human form—was essential to her new approach.

Her new style of dance was driven by the torso. Her famous "contraction" and "release" compacted or expanded the center of the body and powered the extremities. Breaking away from traditional costuming, Graham's garments revealed this articulation of the dancer's torso to be intimate, revelatory, and, in her early days, shocking.

Martha's men are often bare-chested, with low-slung trunks or pants, and her women are in dresses with skirts hung from the hip rather than the waist—exposing the length of the spine and each action or reaction of the body's core, every sigh or shudder.

But Martha's costuming was not only designed to accentuate the body's expressiveness. From her earliest creations, the costume was symbolic, metaphoric, and integral to the emotional theme of the dance.

This is stunningly clear in *Lamentation*, her solo from 1930 in which the dancer writhes within a tube of resistant fabric, looking like a Brancusi sculpture come to life. This solo announced to the world that Graham had brought the modernist movement to dance. And it was unmistakably the design of her costume that sent the message.

From *Lamentation* forward, her costume designs were on the cutting edge. By the time she choreographed *Night Journey*, which is represented with images in these pages, Martha was at the height of her powers. Every item on the stage and worn by the dancers was coordinated to propel the impact of this extraordinary work.

The simplicity of Martha's costumes coupled with their inherent theatricality has intrigued fashion designers for decades. Some of the greats, notably Halston and Calvin Klein, have designed costumes for her dances. In recent years such diverse designers as Zac Posen, Tracy Reese, Atlantique Ascoli, Doo-Ri Chung and Dior have all named Martha as inspiration for their latest collection. In 2016, *Vogue* matched iconic Graham costumes with dresses from several top collections, including Céline, Vionnet, and Valentino.

I believe that Martha's simple, modernist designs continue to inspire because they invariably celebrate the beauty of the body in motion and speak to our own innate understanding of that ideal. Each and every Graham costume was born out of her devotion to the human form and to the dance. As she said, "You will know the wonders of the human body because there is nothing more wonderful. The next time you look in the mirror, just look at the way the ears rest next to the head; look at the way the hairline grows; think of all the little bones in your wrist. It is a miracle. And the dance is a celebration of that miracle."

—JANET EILBER, ARTISTIC DIRECTOR, MARTHA GRAHAM DANCE COMPANY

PeiJu Chien-Pott | Principal, Martha Graham Dance Company | *Costumes by Martha Graham for* Night Journey

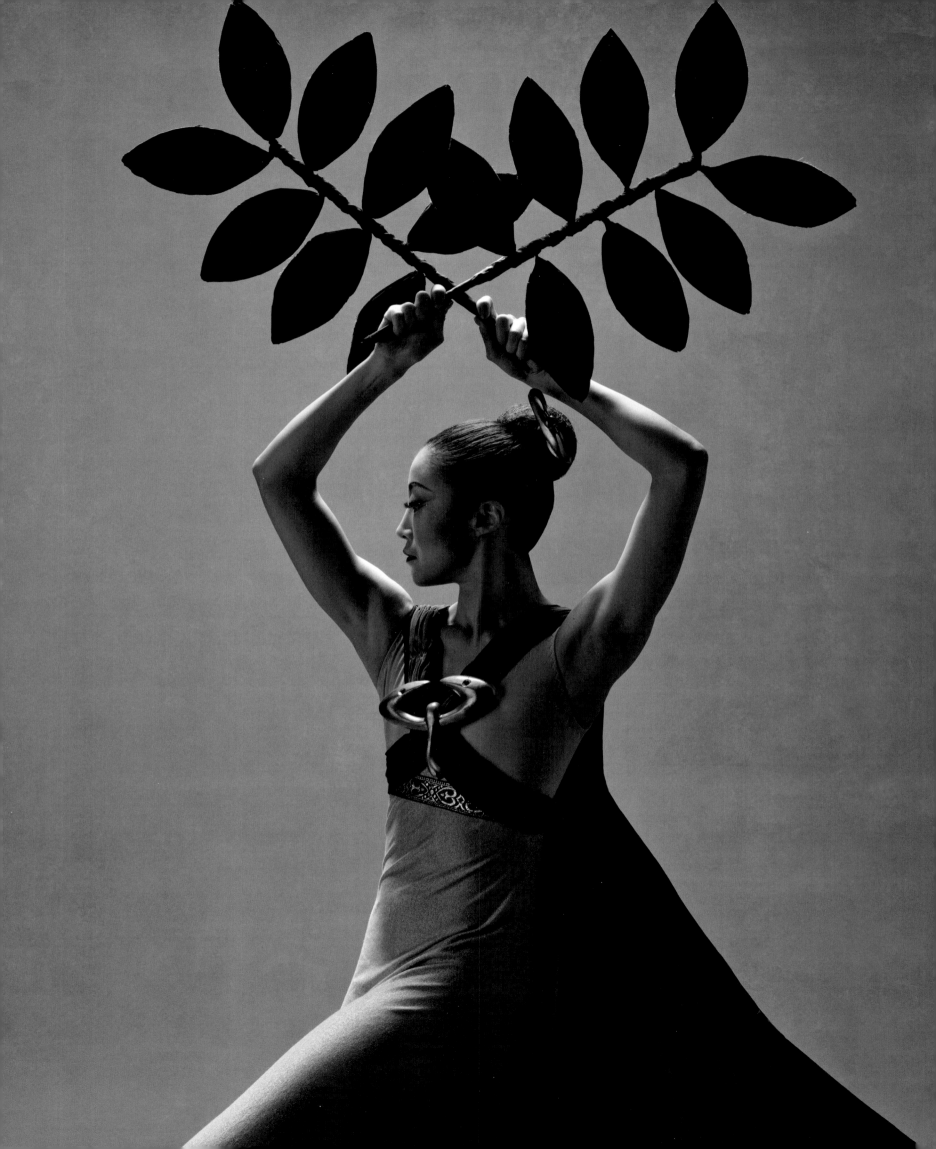

"The instrument through which dance speaks is also the instrument through which life is lived—the human body. It is the instrument by which all the primaries of life are made manifest. It holds in its memory all matters of life and death and love."

—MARTHA GRAHAM

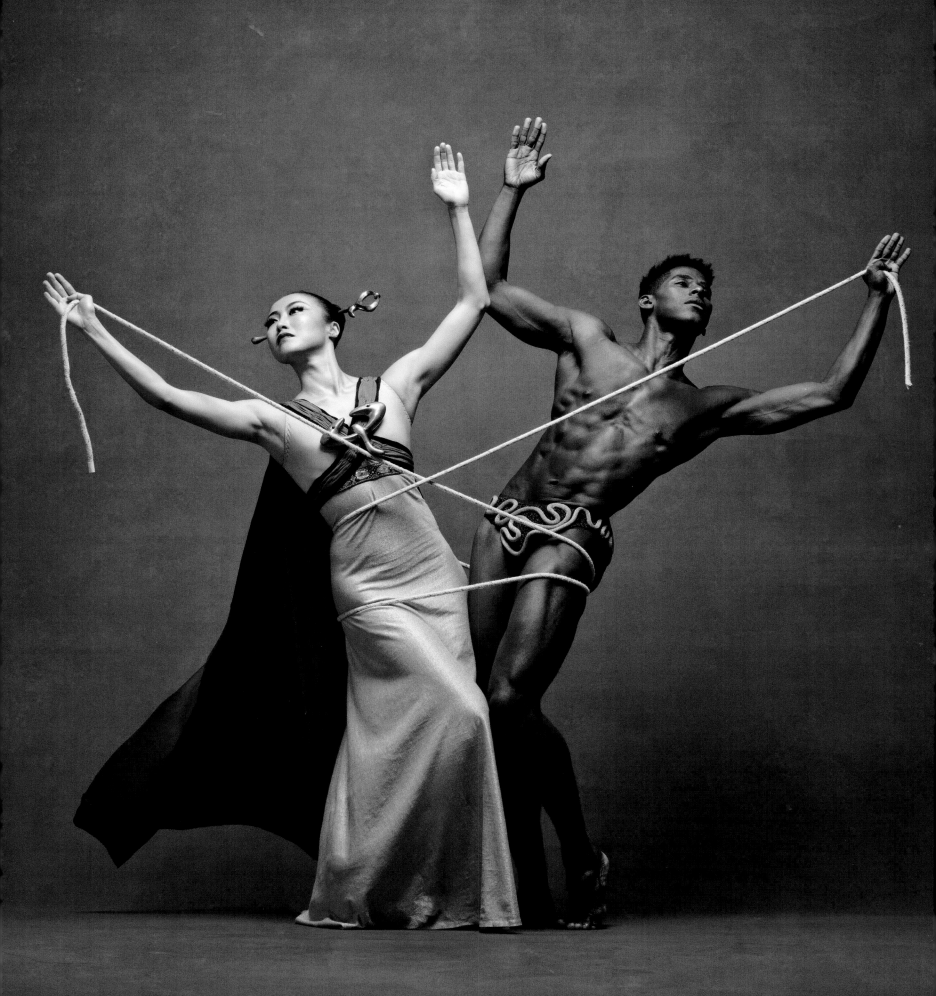

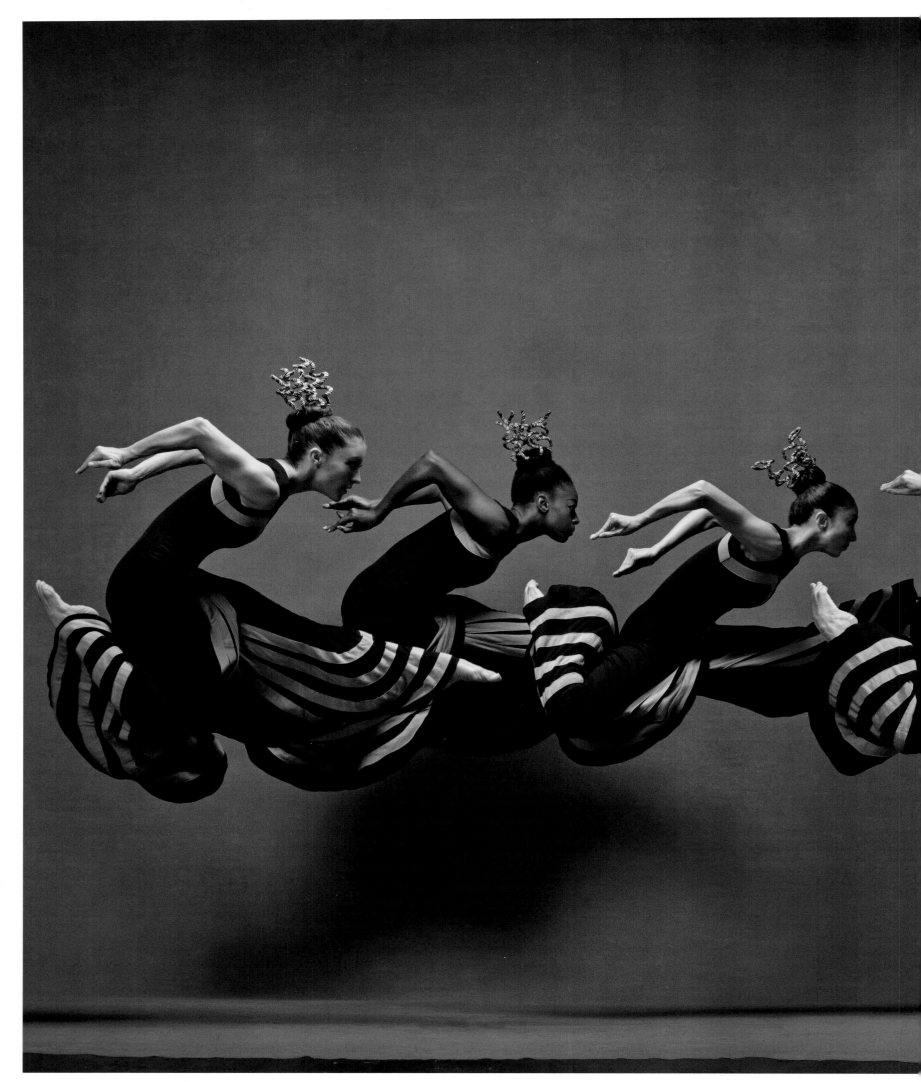

Laurel Dalley Smith, Leslie Williams, So Young An, Anne O'Donnell, Anne Souder, and Charlotte Landreau

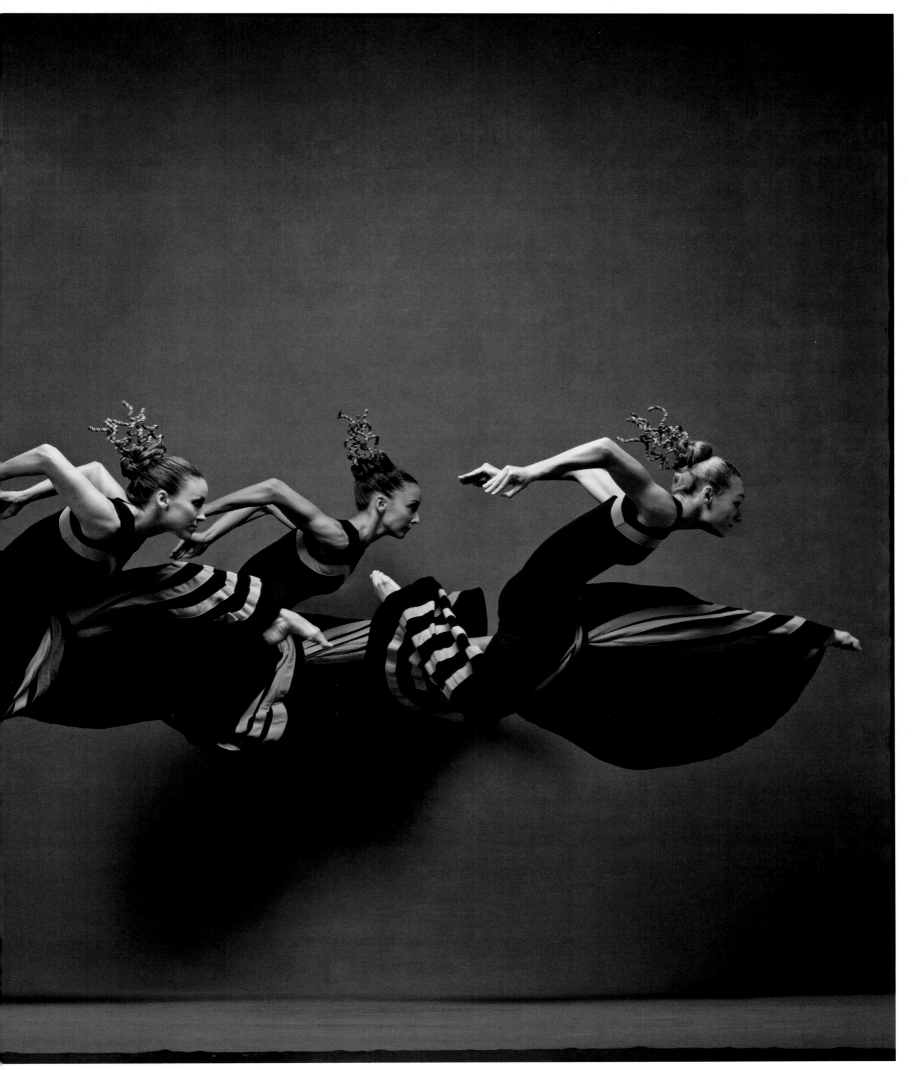

Martha Graham Dance Company | *Costumes by Martha Graham for* Night Journey

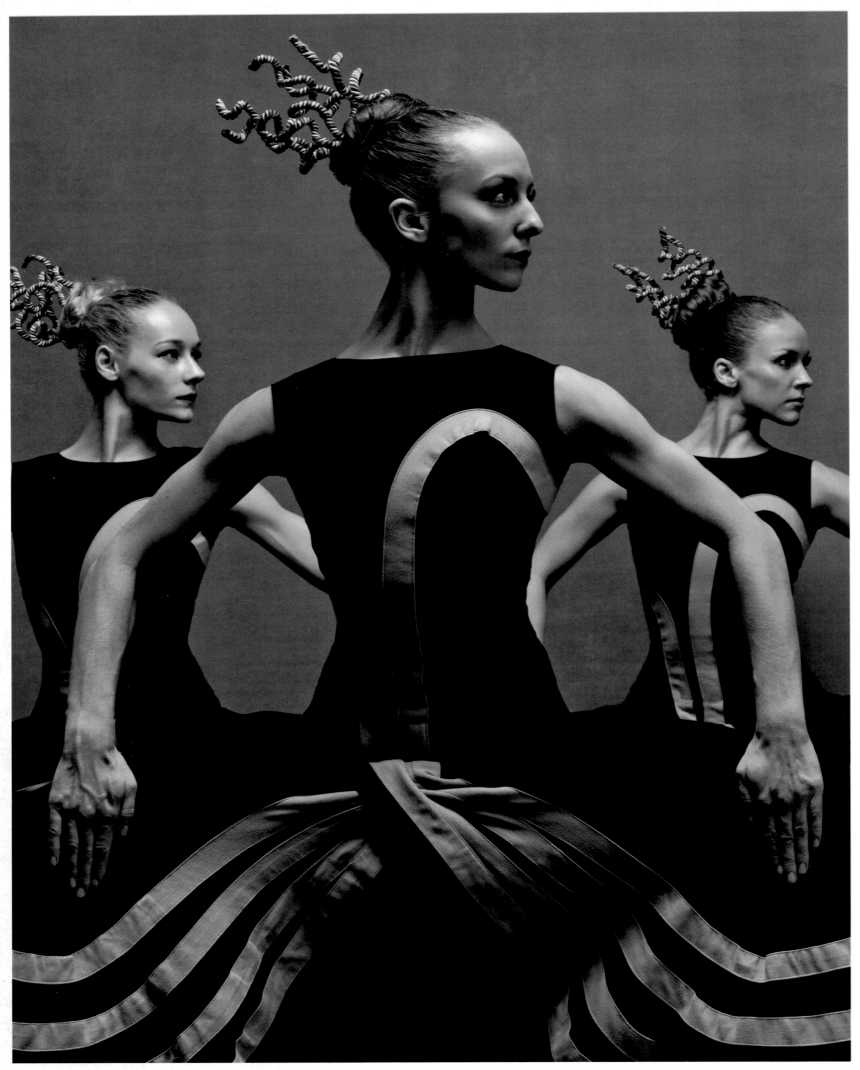

Charlotte Landreau, Anne Souder, Anne O'Donnell, and Leslie Williams | Martha Graham Dance Company

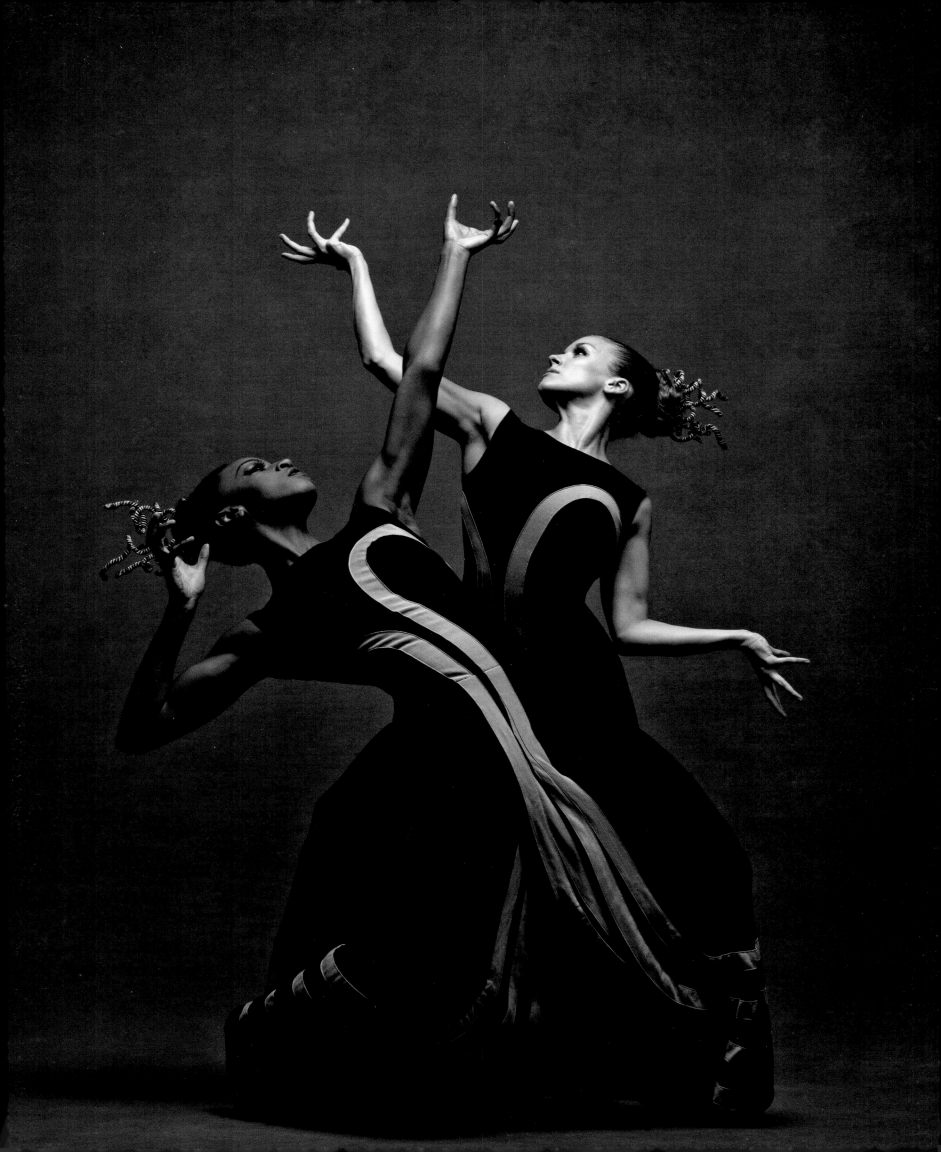

"In all my work, I try to make clear that fashion is an artistic expression; showing and wearing art, and not just a functional tool that's devoid of content. With my work, I intend to show that fashion can be timeless, and that its immediate consumption can be less important than its creation. Wearing clothing creates an exciting and imperative form of self-expression. I find that form complements and changes perception of the body, and thus the inherent emotion. Movement, so essential to and in the body, is just as important in how I approach my work. By bringing form, structure, and materials together, I try to suggest and realize optimal tension and movement."

—IRIS VAN HERPEN

Charlotte Landreau | Soloist, Martha Graham Dance Company | *Clothing by Iris Van Herpen*

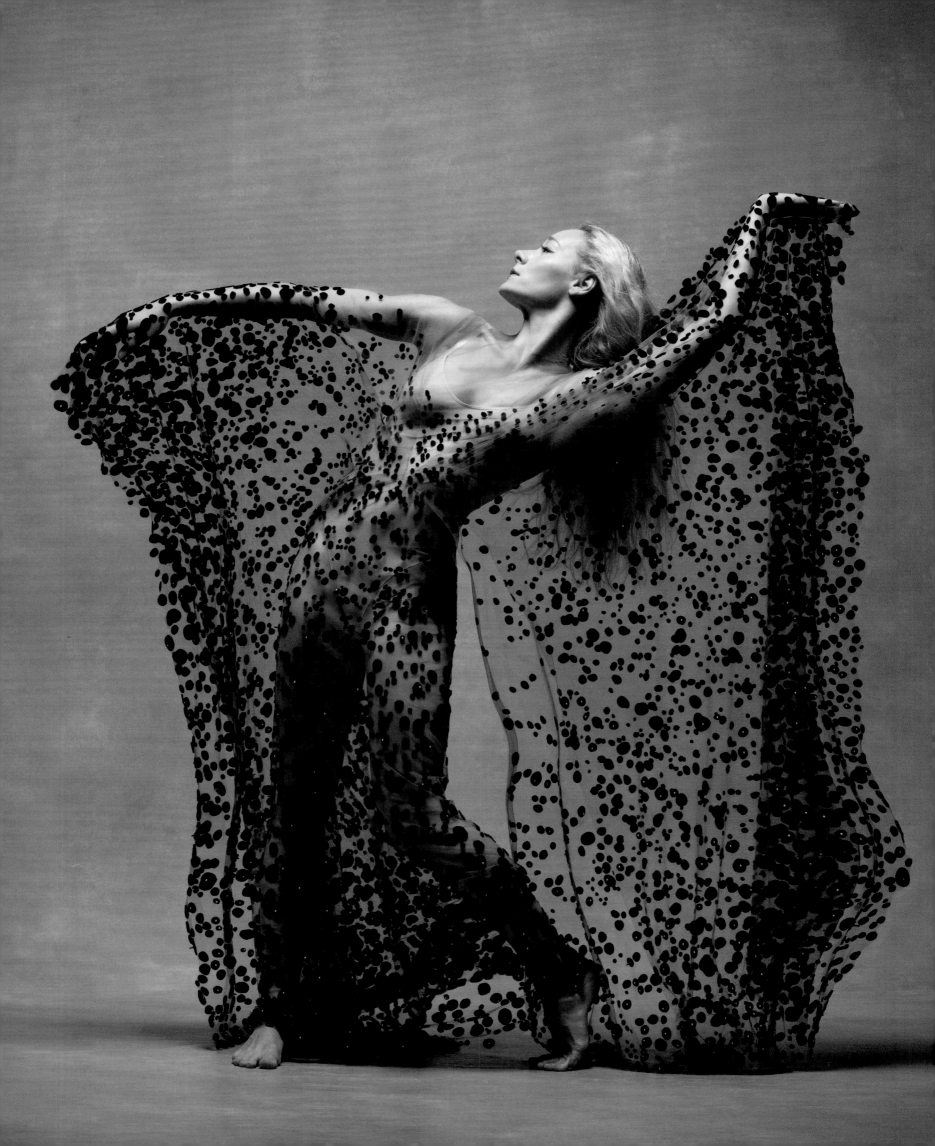

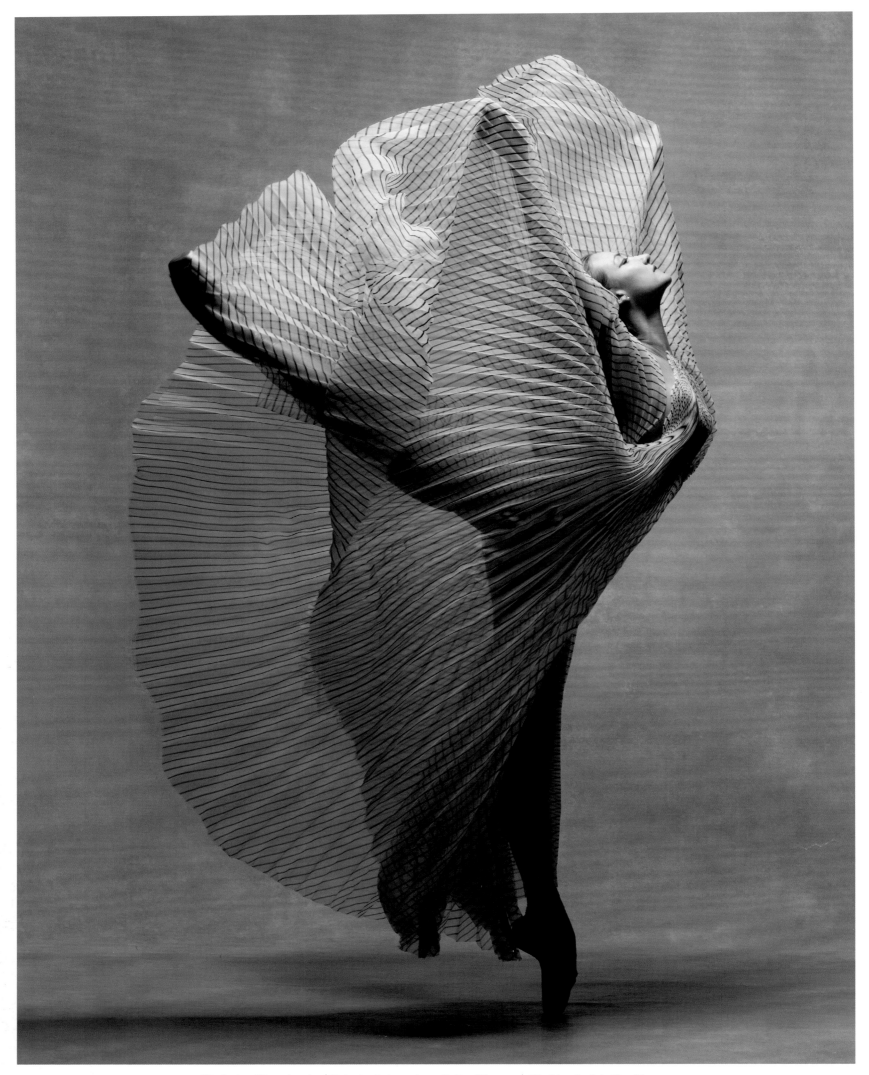

Christine Shevchenko | Principal, American Ballet Theatre | *Clothing by Iris Van Herpen*

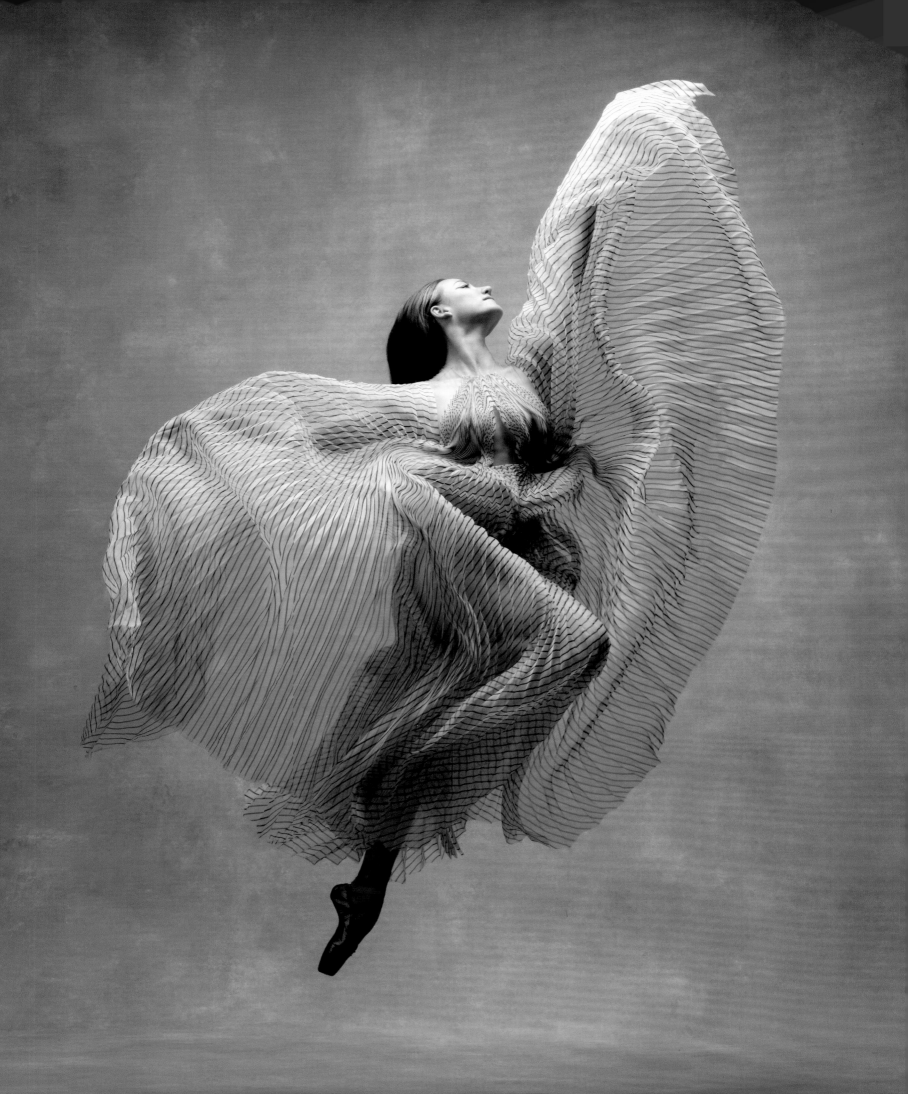

Ben Freemantle | Principal, San Francisco Ballet | *Suit by Moschino, c. 2000, courtesy New York Vintage*

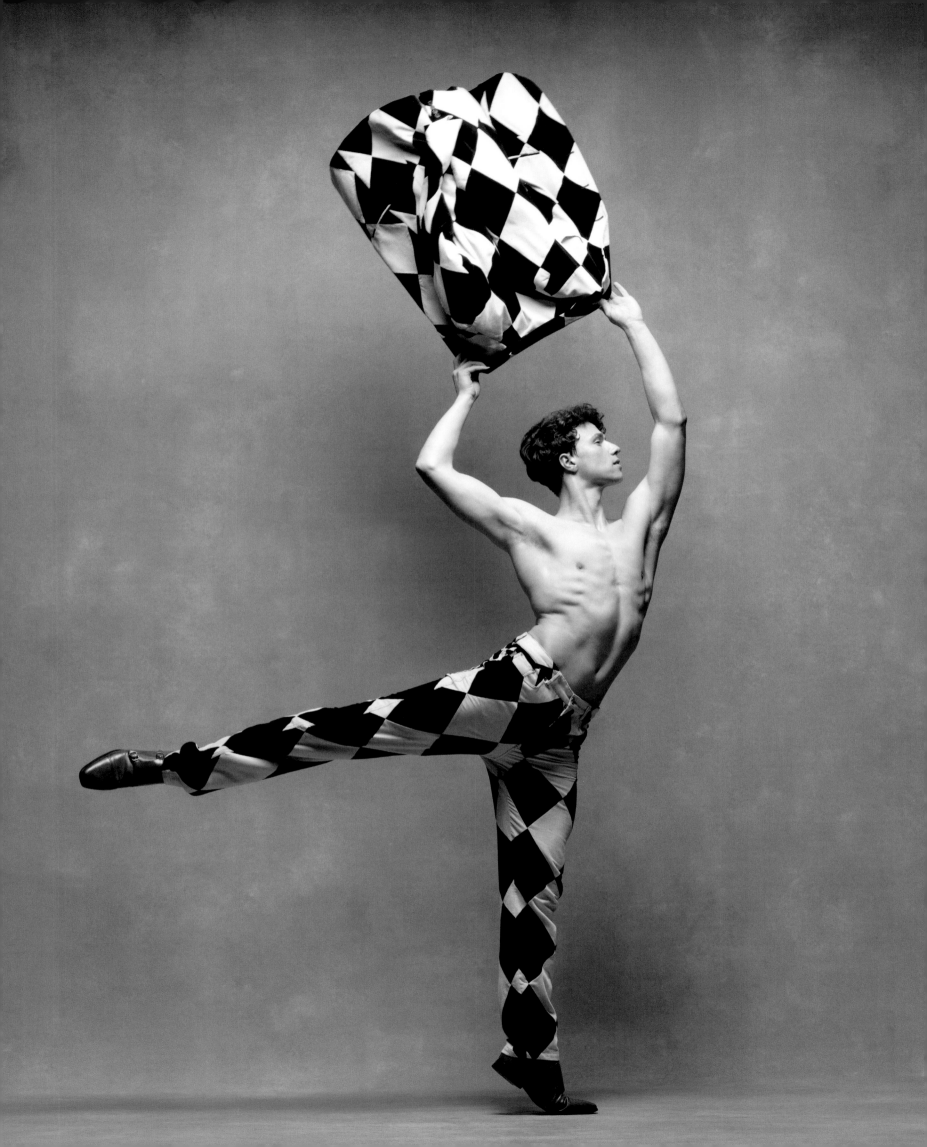

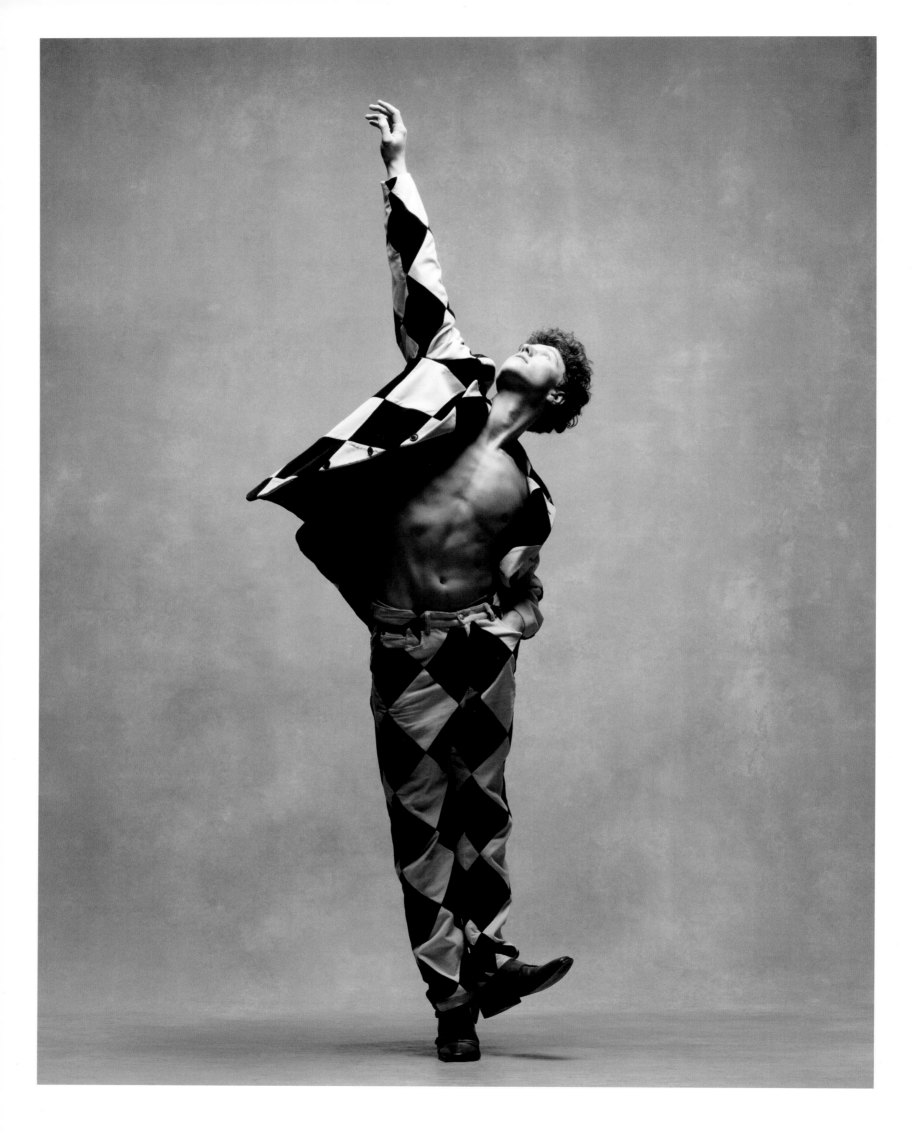

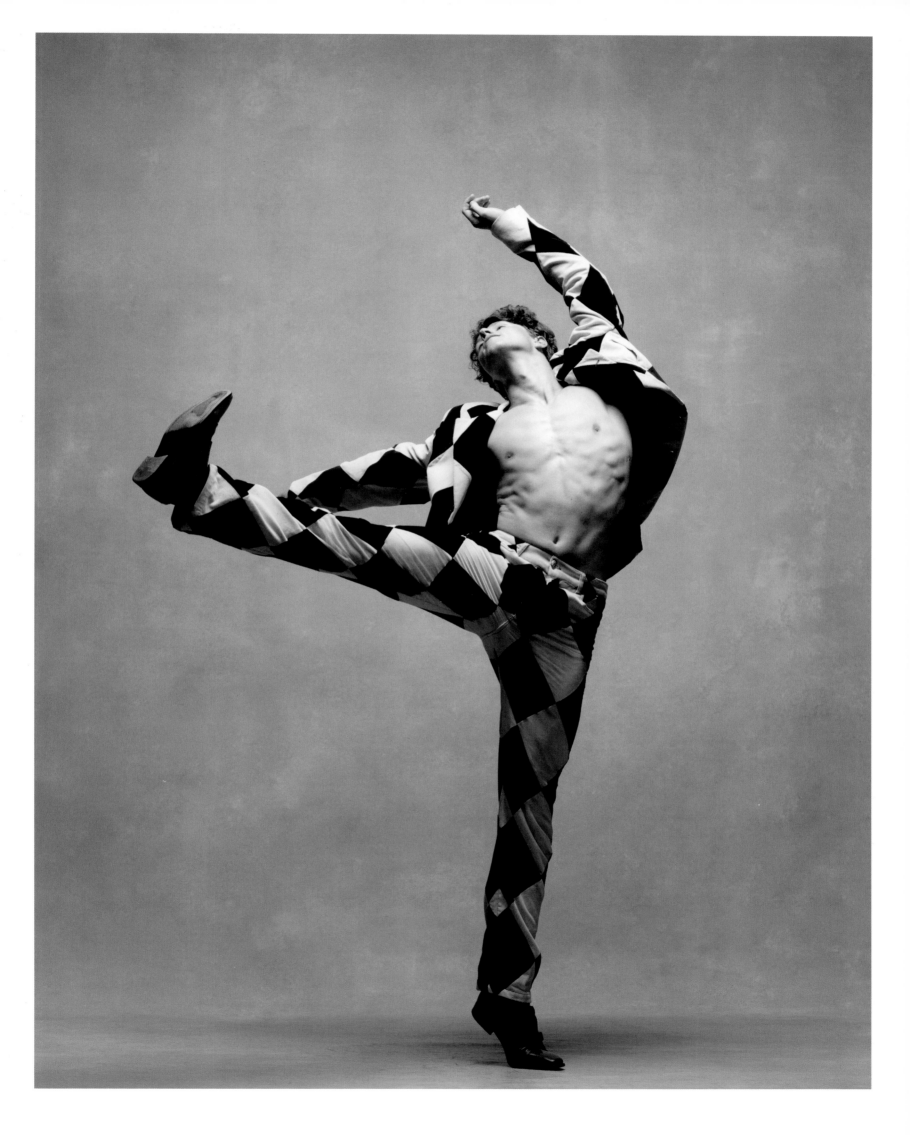

Christine Shevchenko and Devon Teuscher | Principals, American Ballet Theatre | *Clothing by Oscar de la Renta*

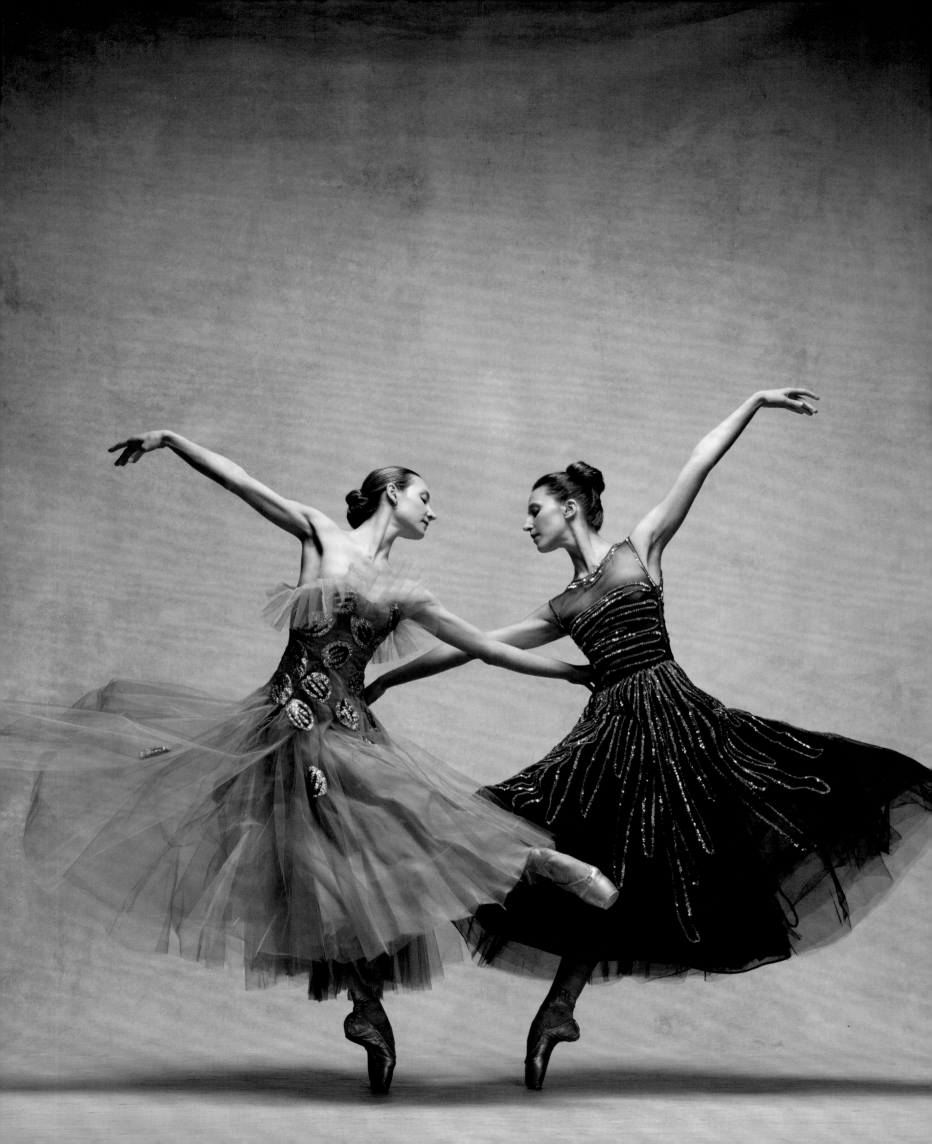

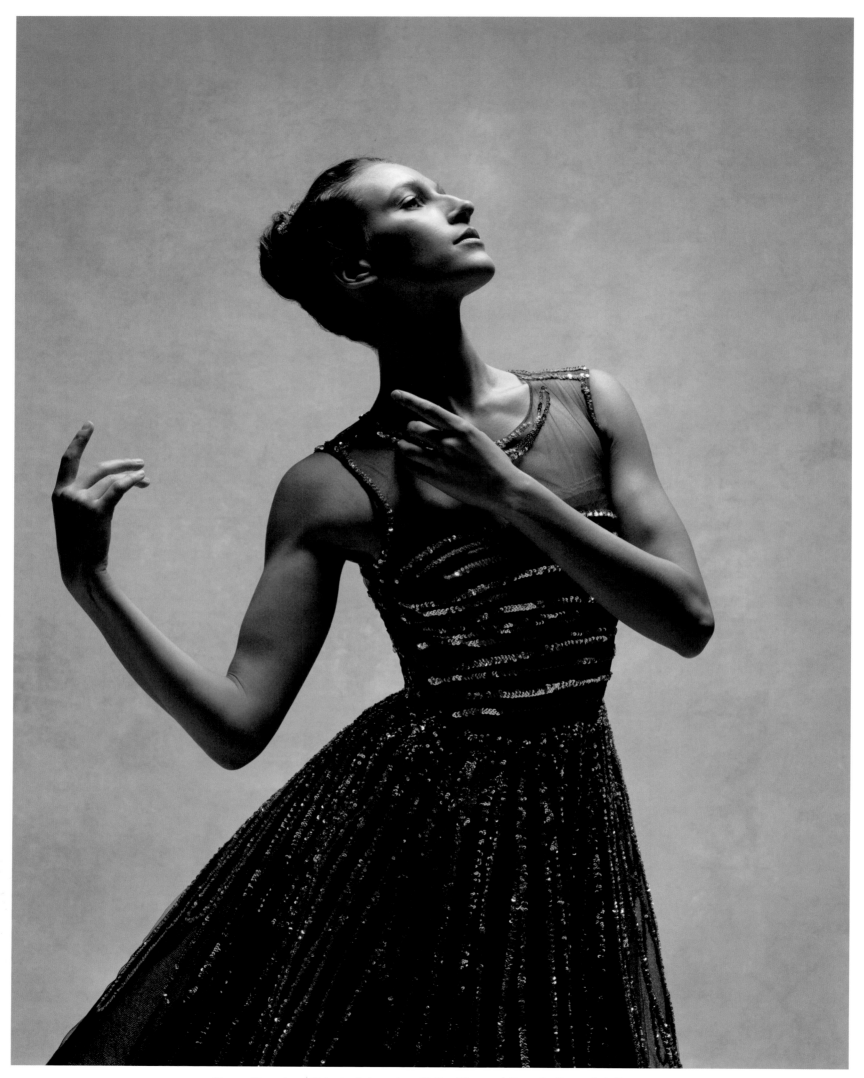

Devon Teuscher | Principal, American Ballet Theatre | *Dress by Oscar de la Renta*

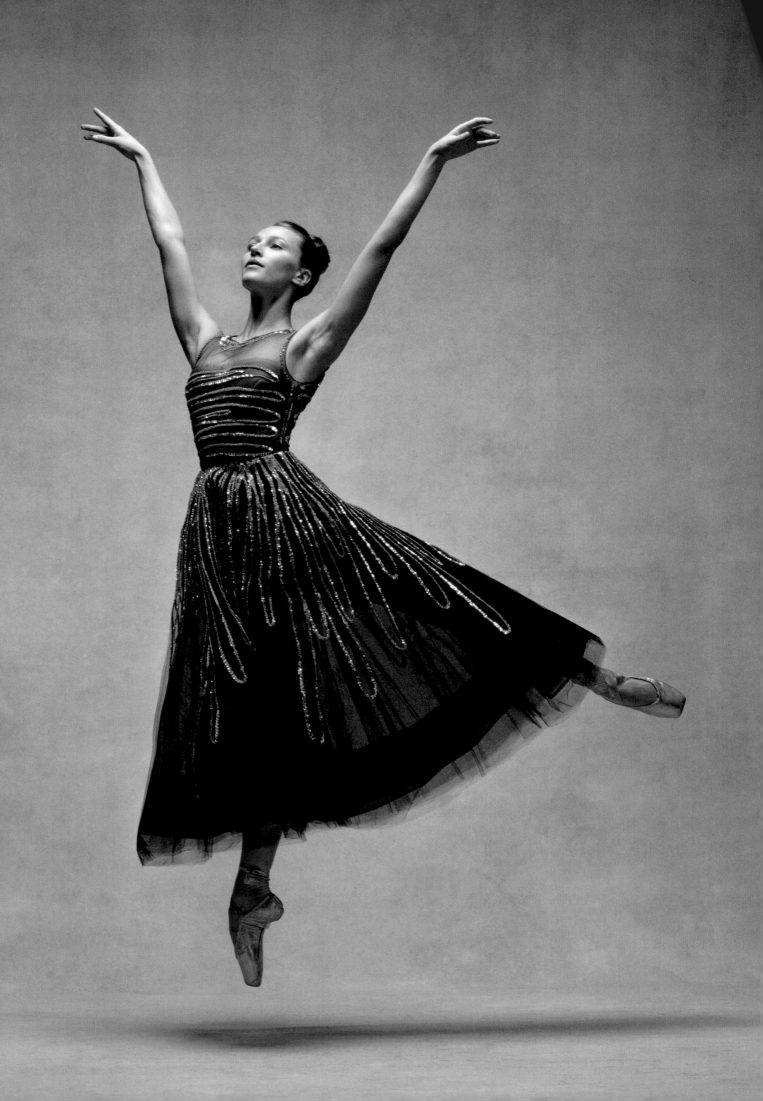

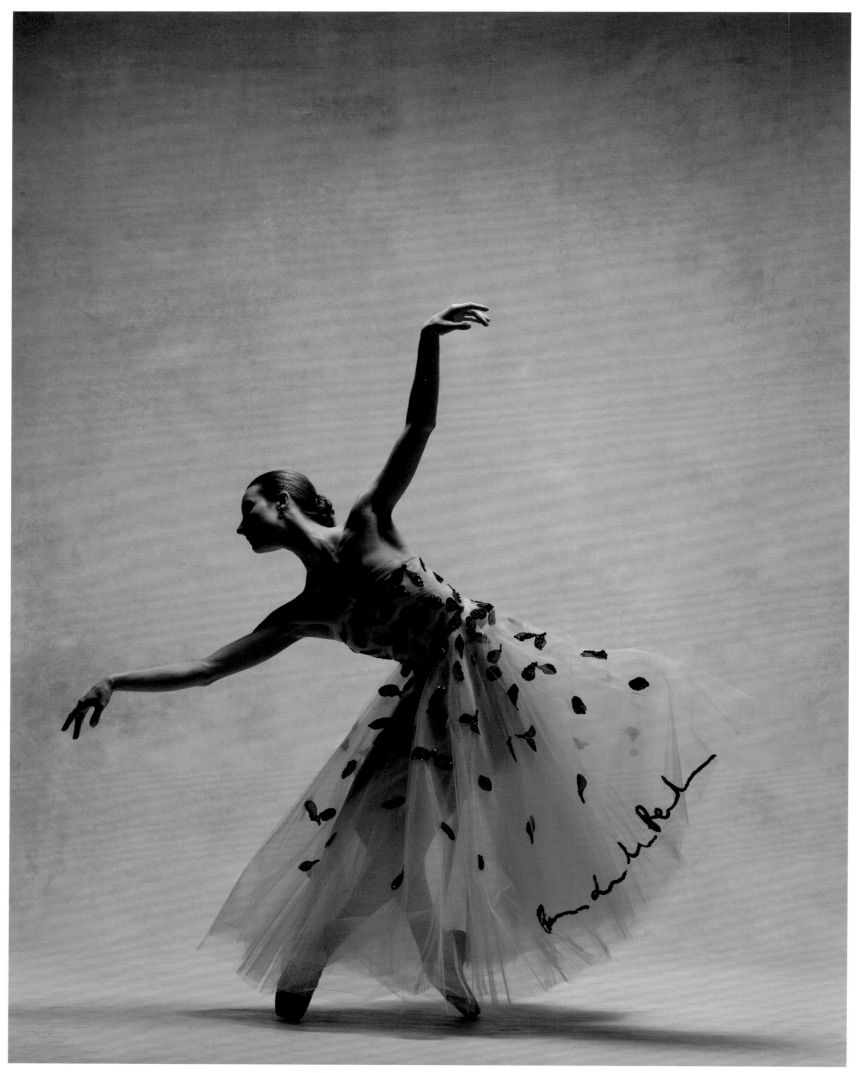

Christine Shevchenko | Principal, American Ballet Theatre | *Dress by Oscar de la Renta*

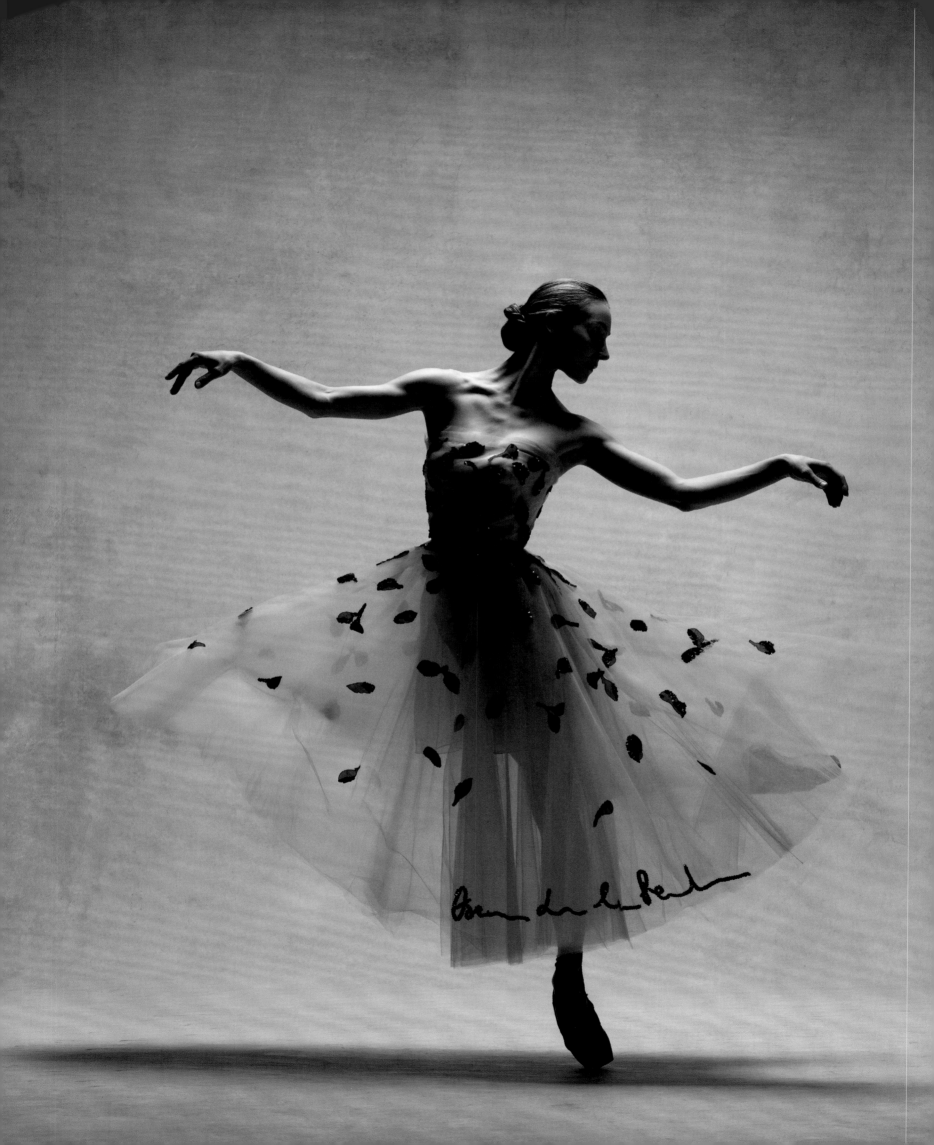

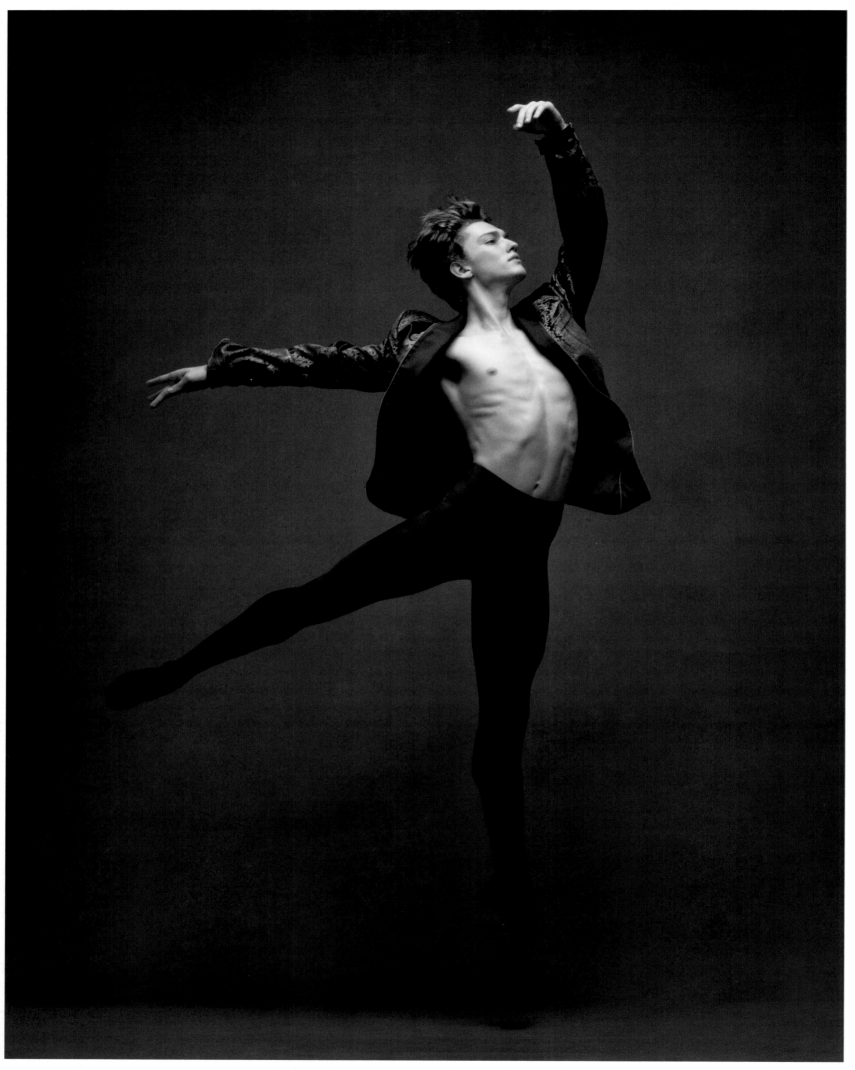

Julian MacKay | First Soloist, Mikhailovsky Theatre | *Clothing by Franco Lacosta*

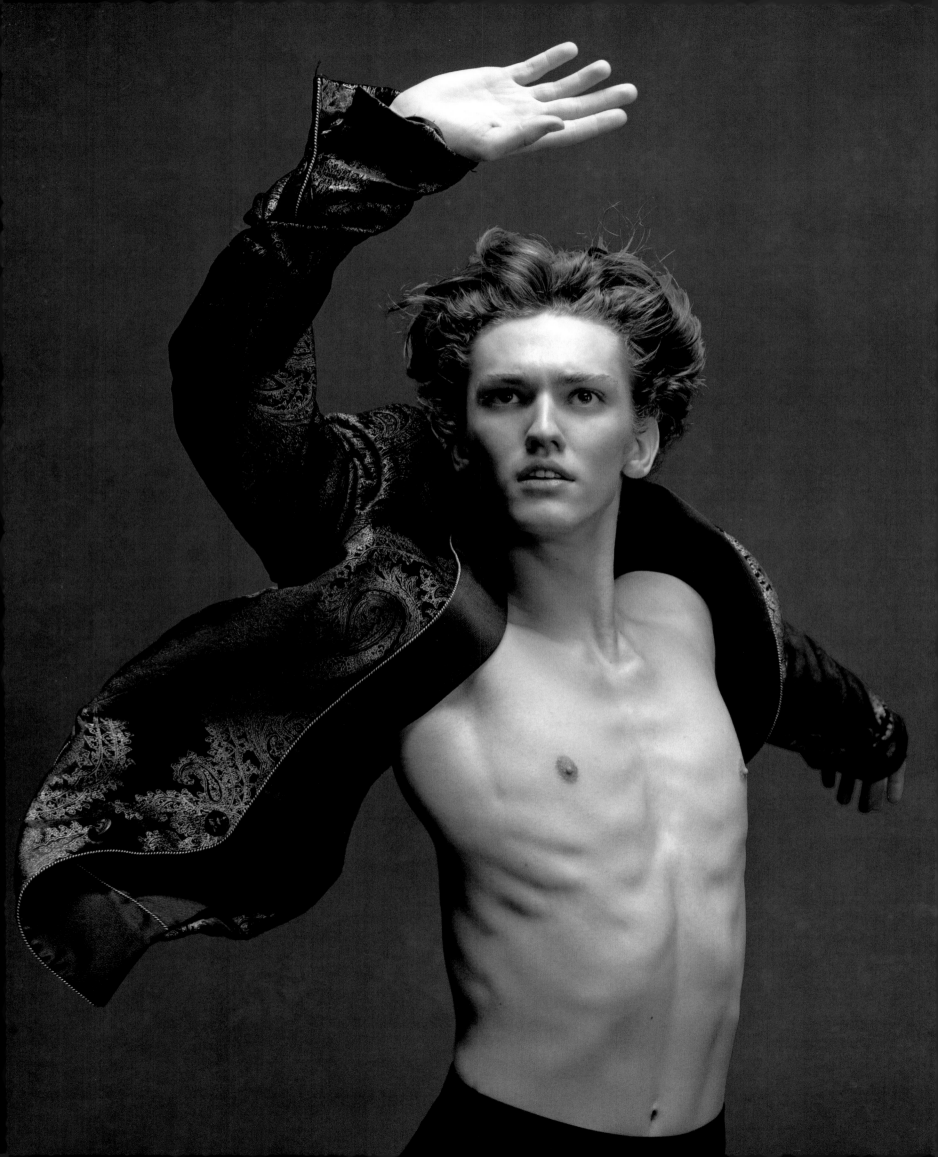

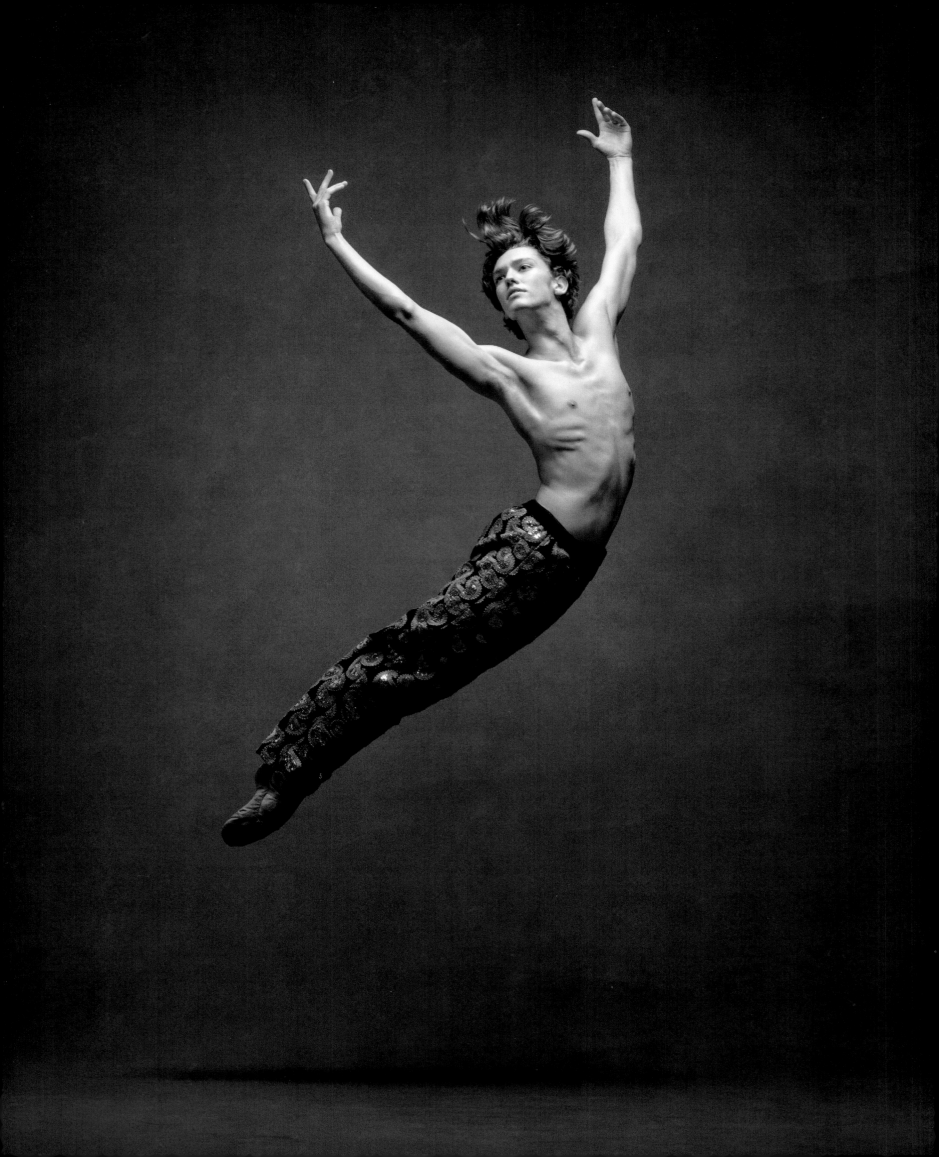

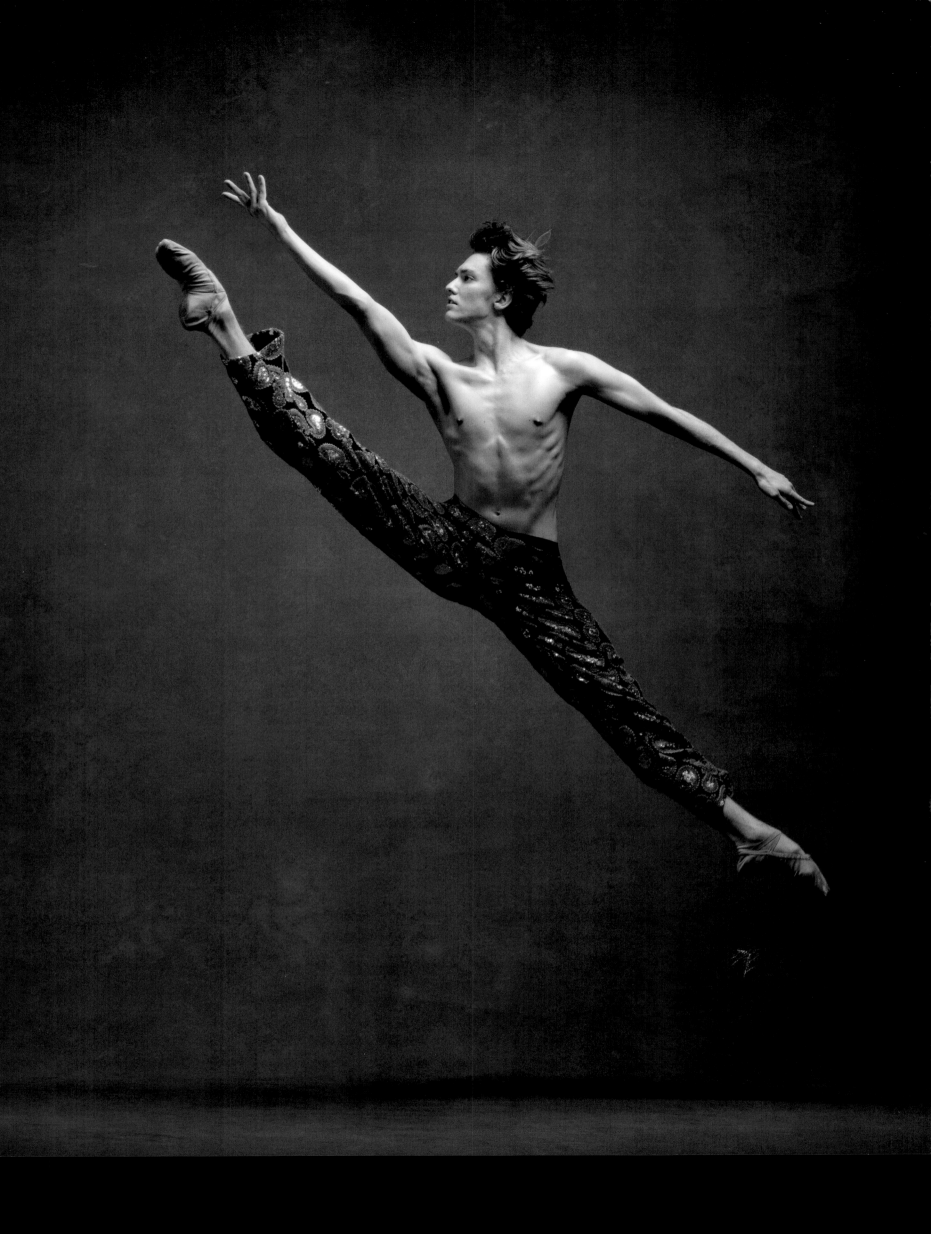

"I feel my best when what I'm wearing becomes
one with my movement."

—LAURA HALZACK

Laura Halzack | Paul Taylor Dance Company | *Clothing by Norma Kamali*

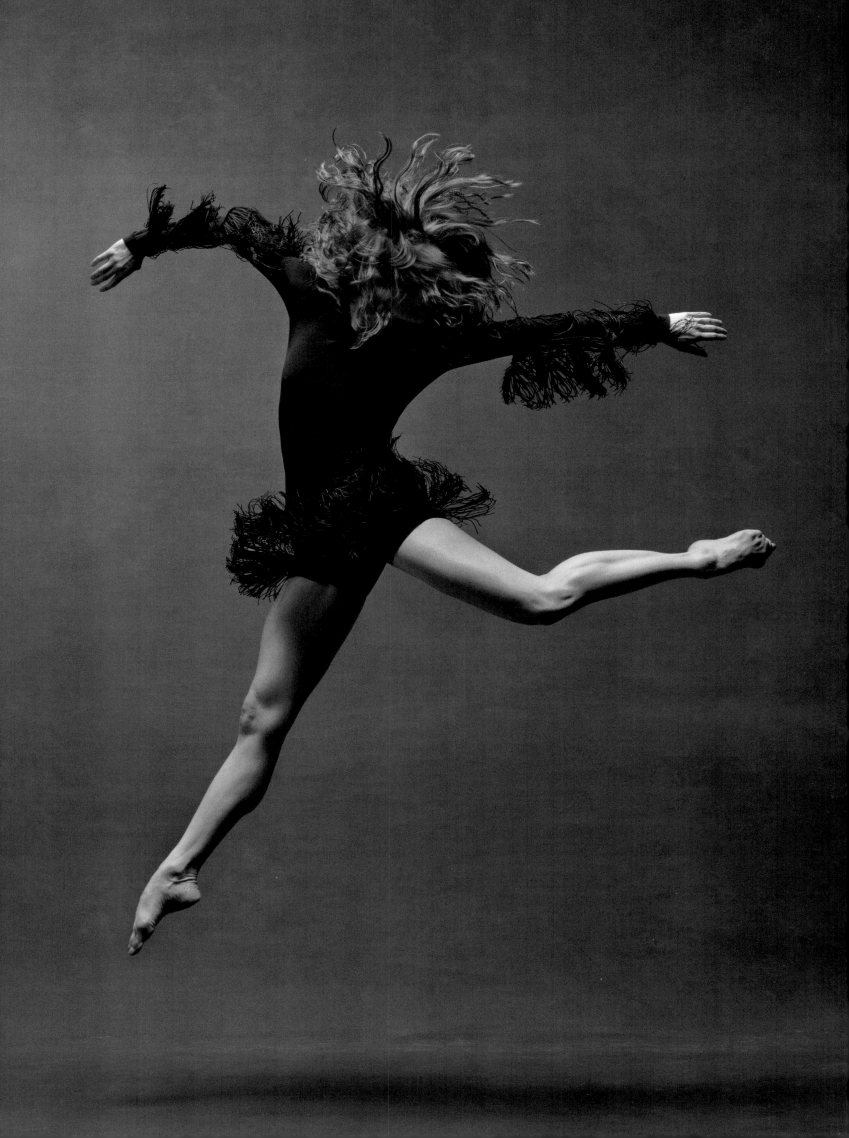

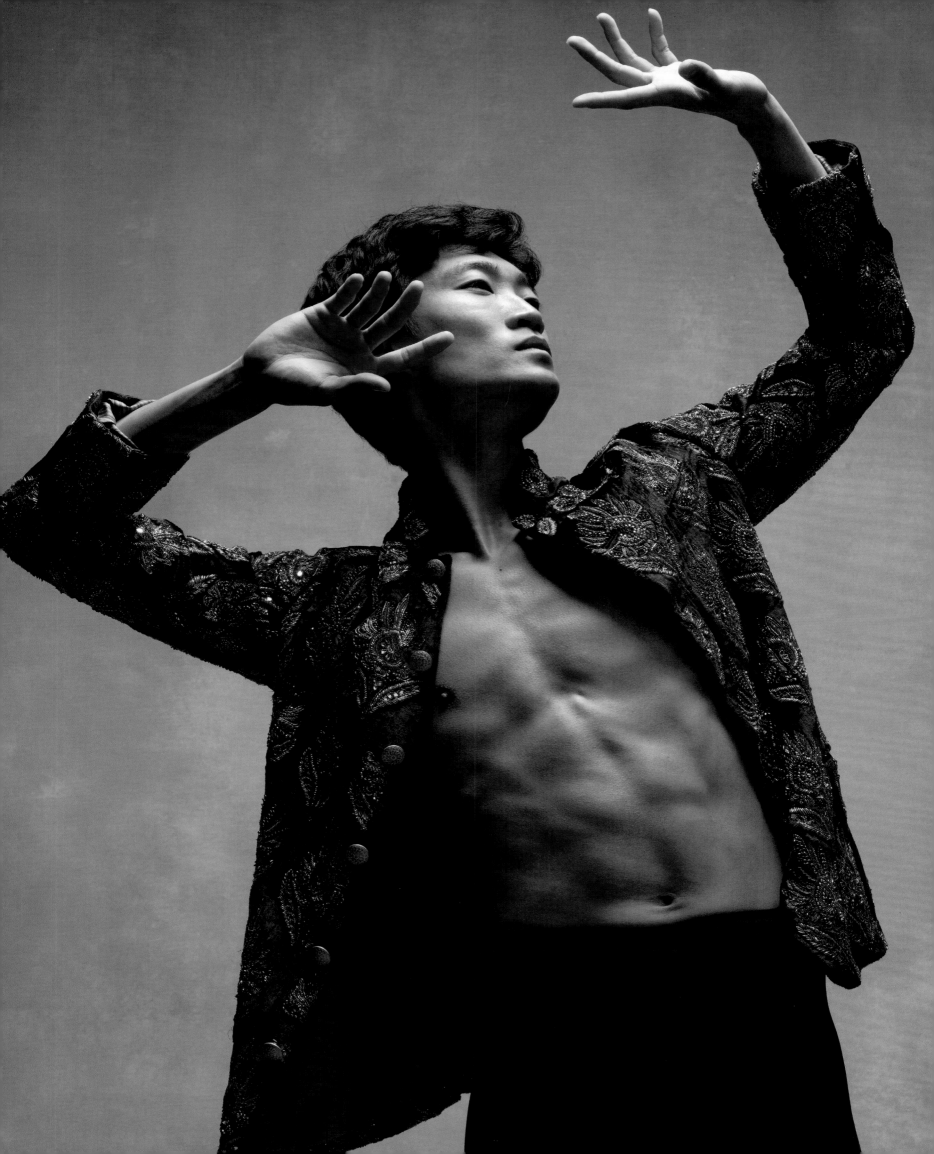

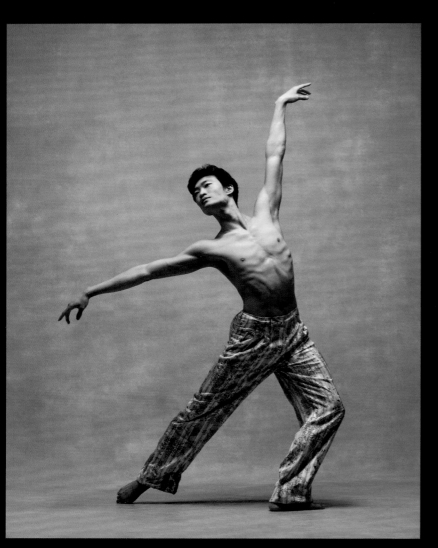
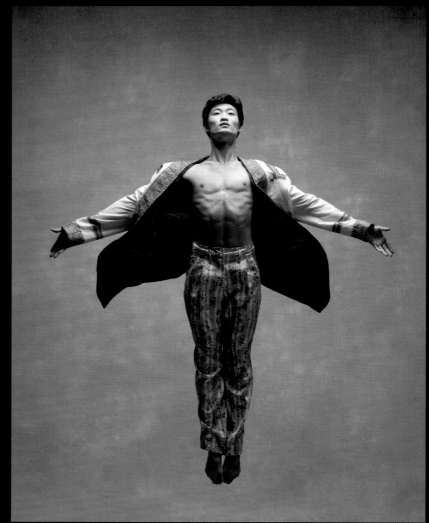

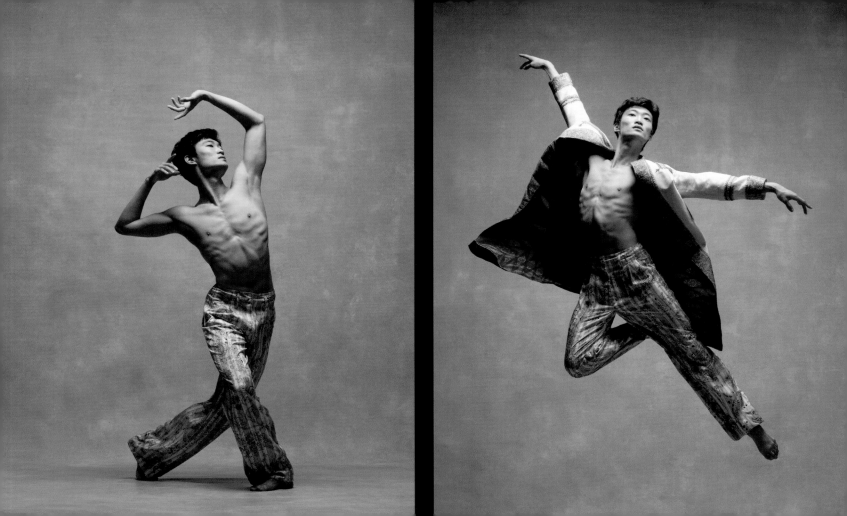

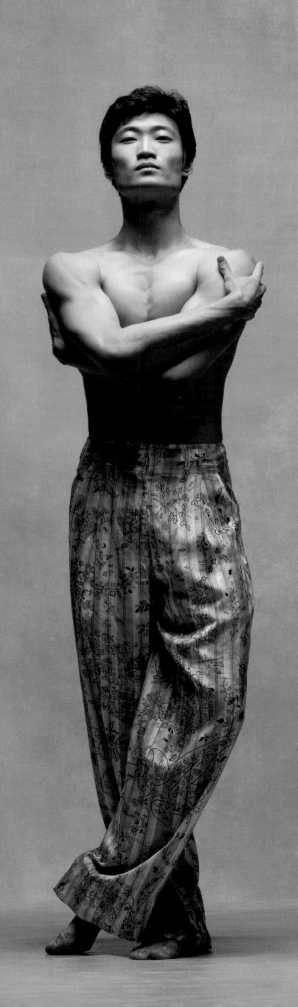

"I love dancing in either very little—like a leotard—so I'm not restricted at all; or in flowing pieces, because I love the feeling of movement that also catches the wind. It can make you feel and look like you're floating or flying."

—JACQUELINE GREEN

Jacqueline Green | Alvin Ailey American Dance Theater | *Clothing by J. Mendel*

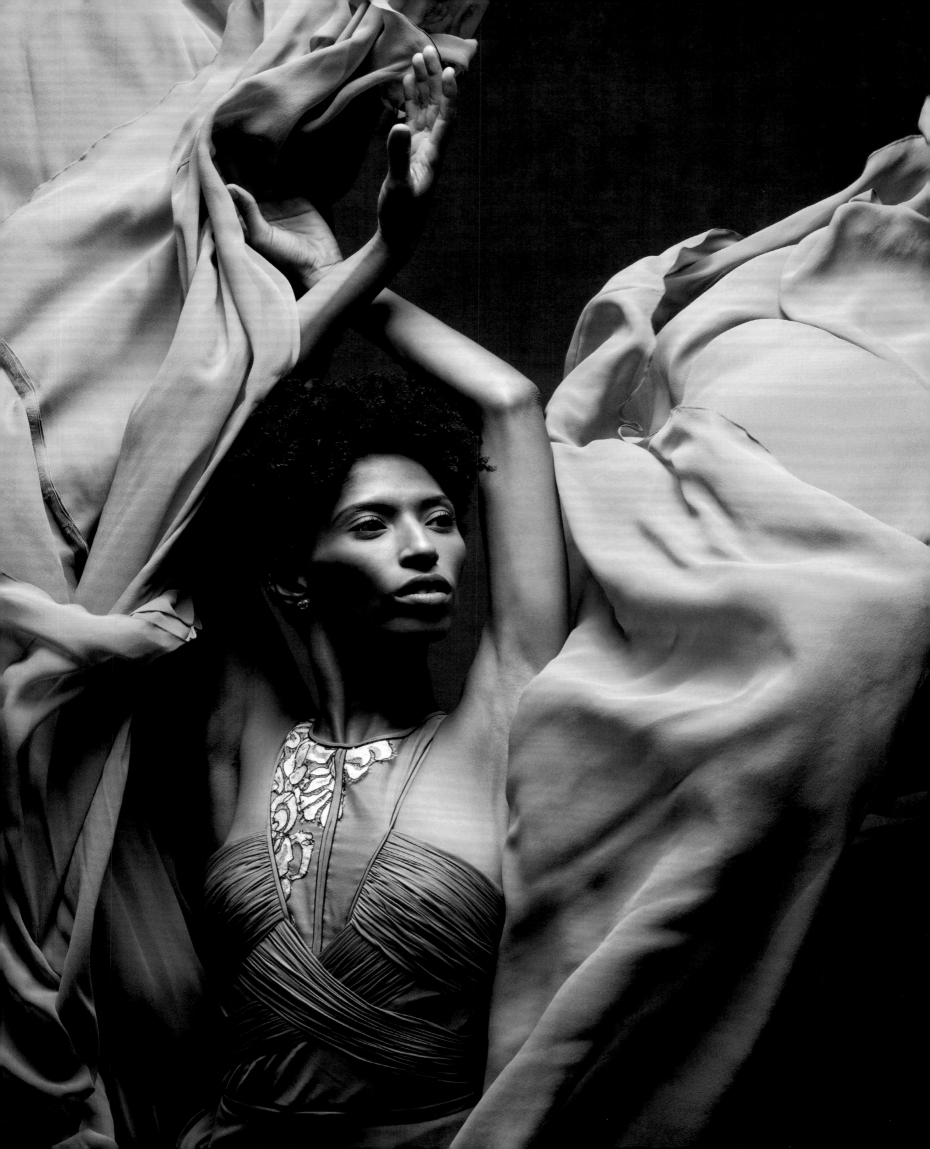

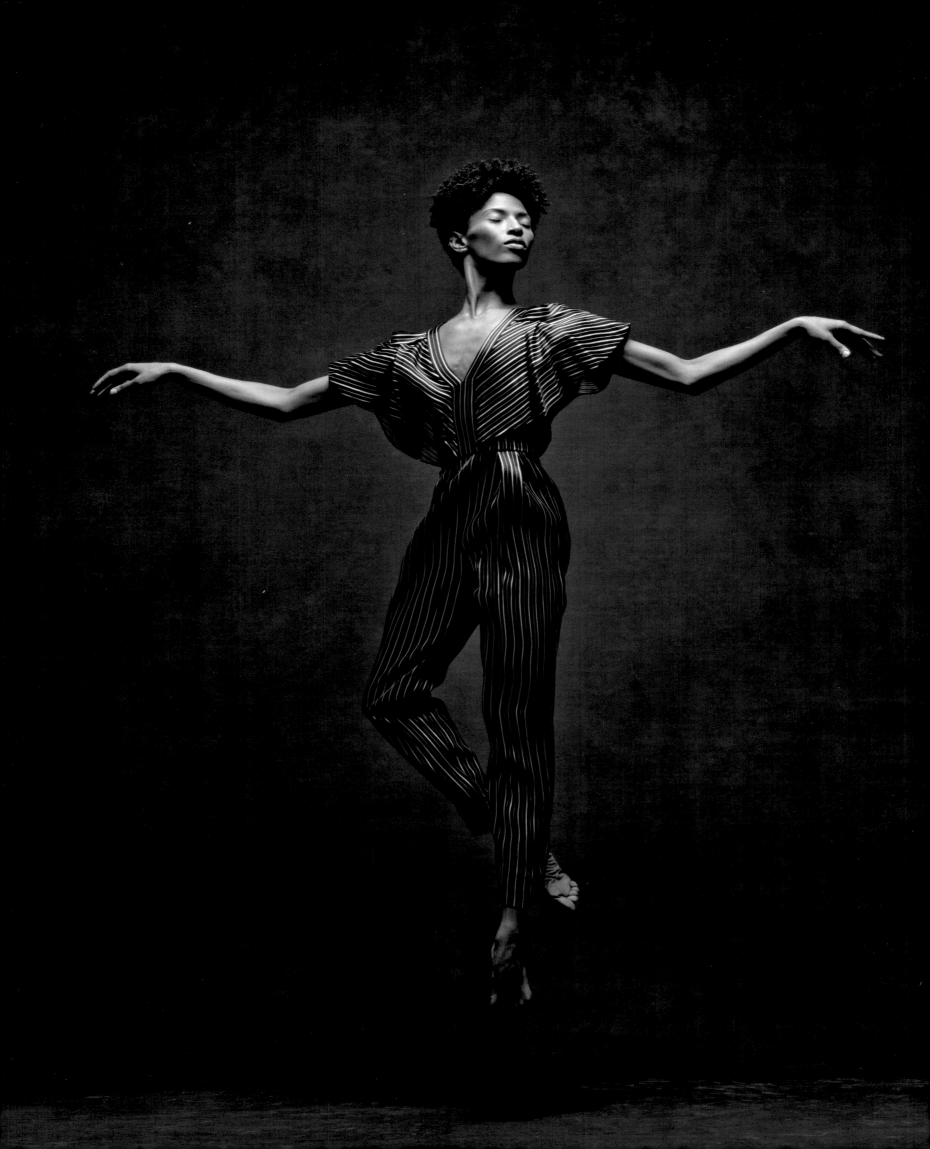

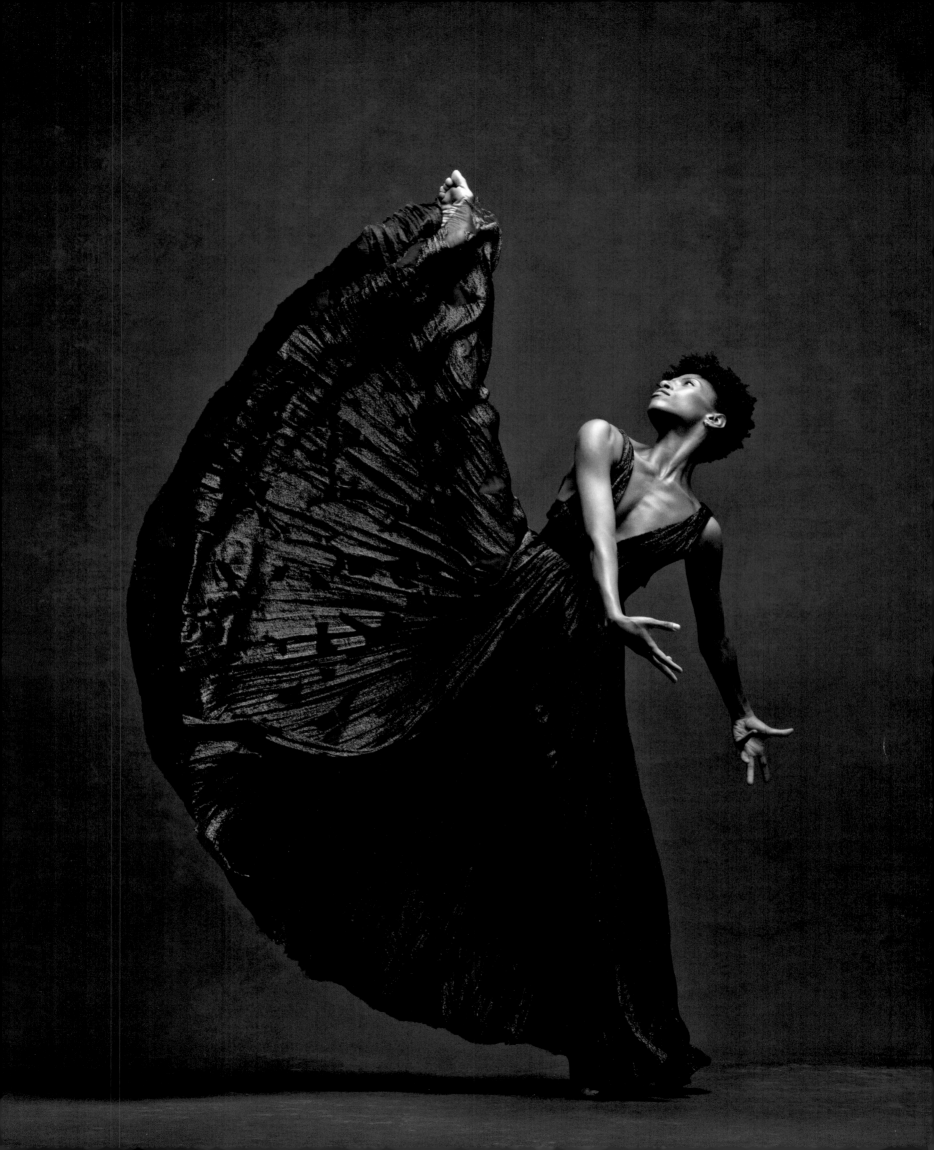

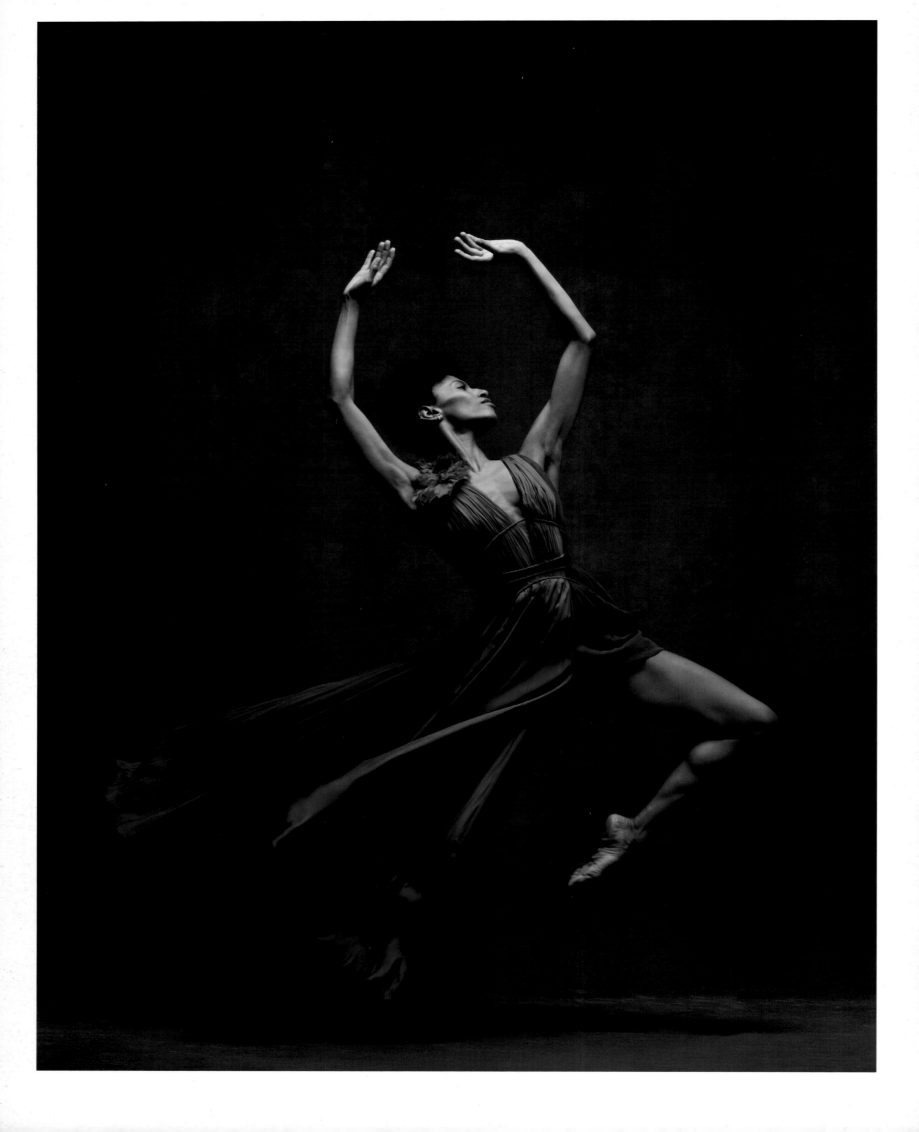

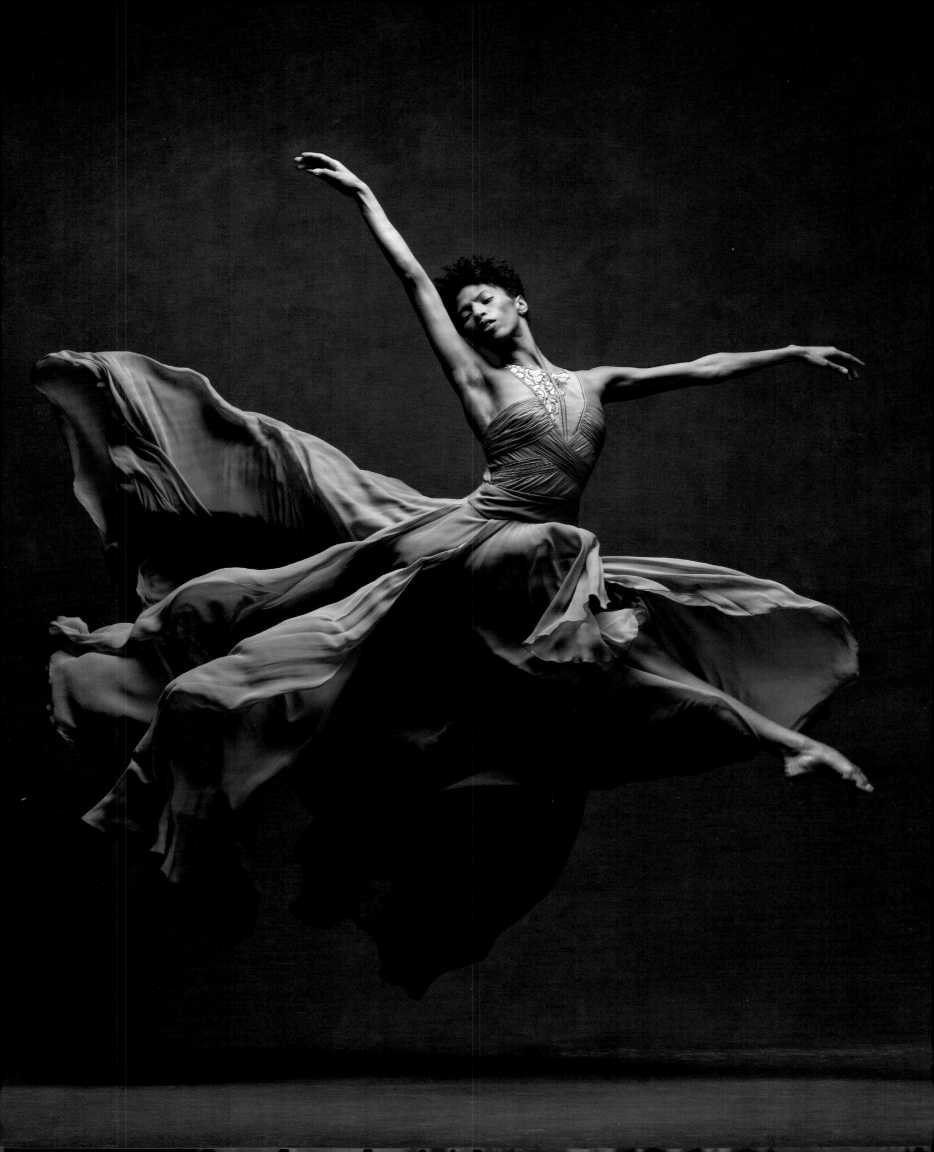

Cassandra Trenary | Soloist, American Ballet Theatre | *Clothing by Irene Luft*

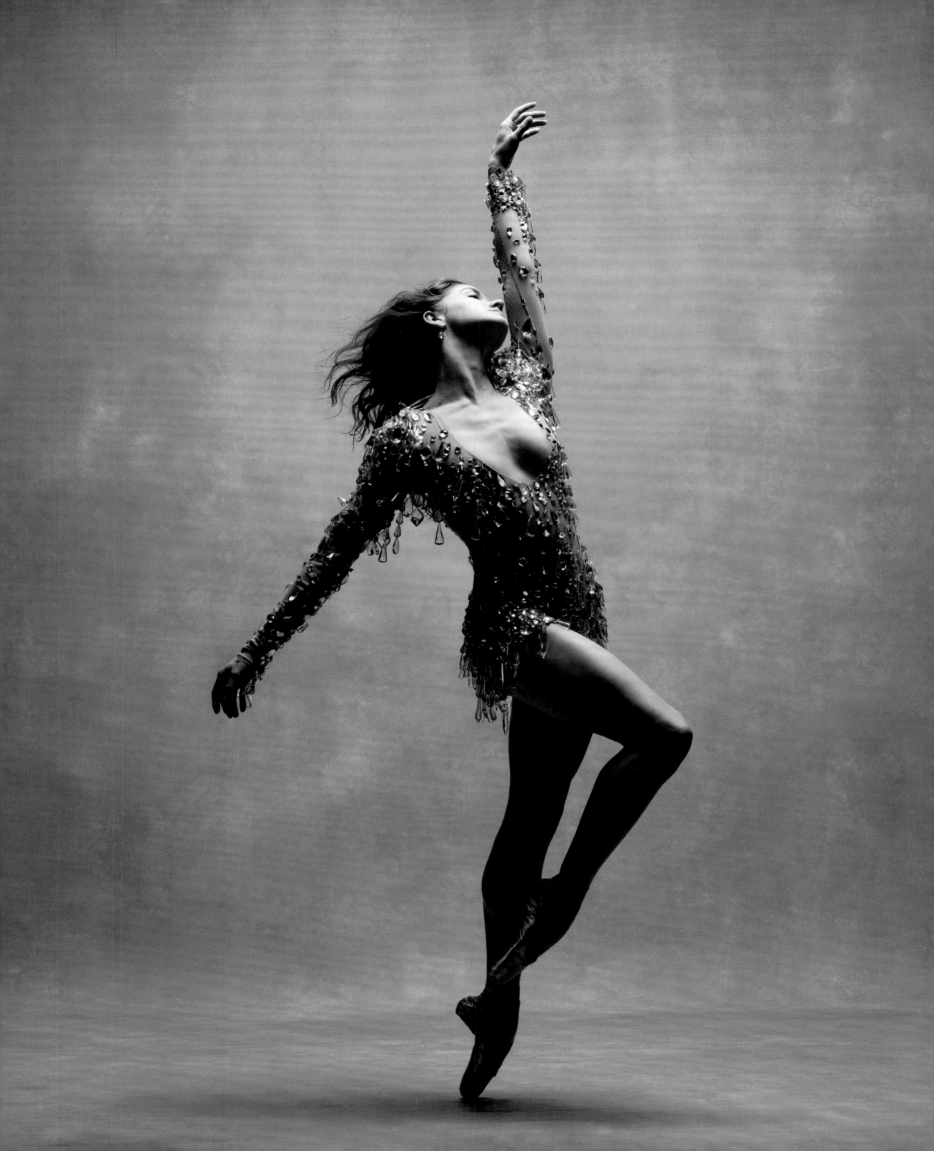

"I think the relationship between dance and fashion is just at its beginning. We can go further, create so much more, inspire each other. Dance and fashion have the same goals: to inspire young generations with elegance and beauty, and to try to change the world gracefully."

—CHARLOTTE LANDREAU

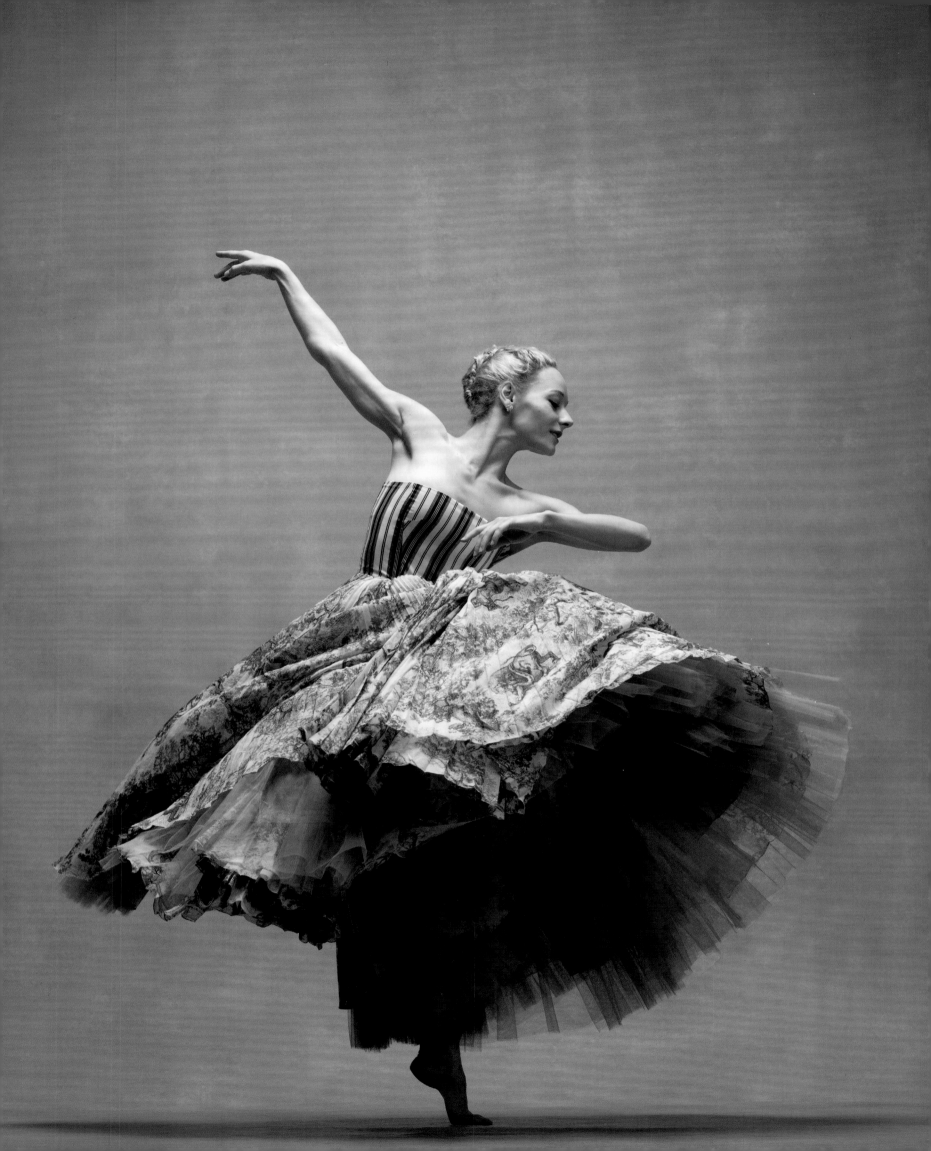

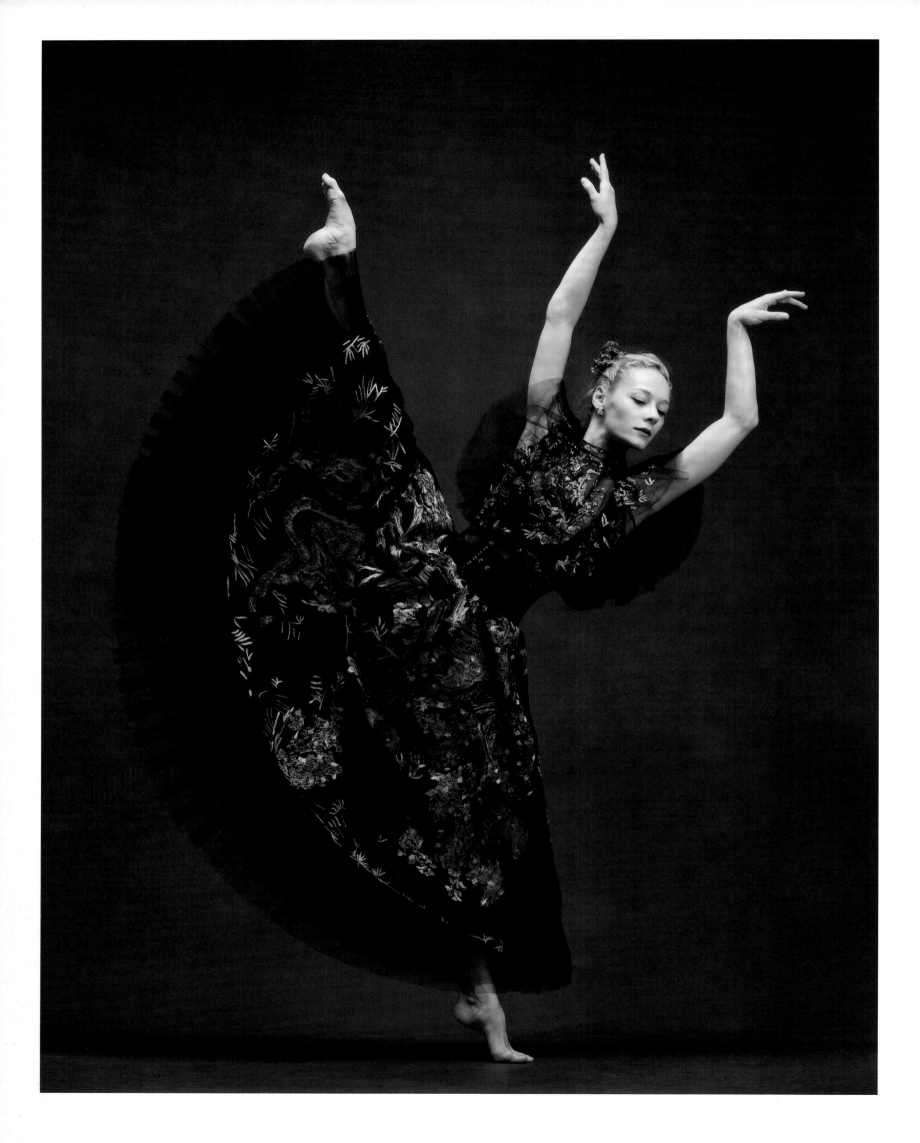

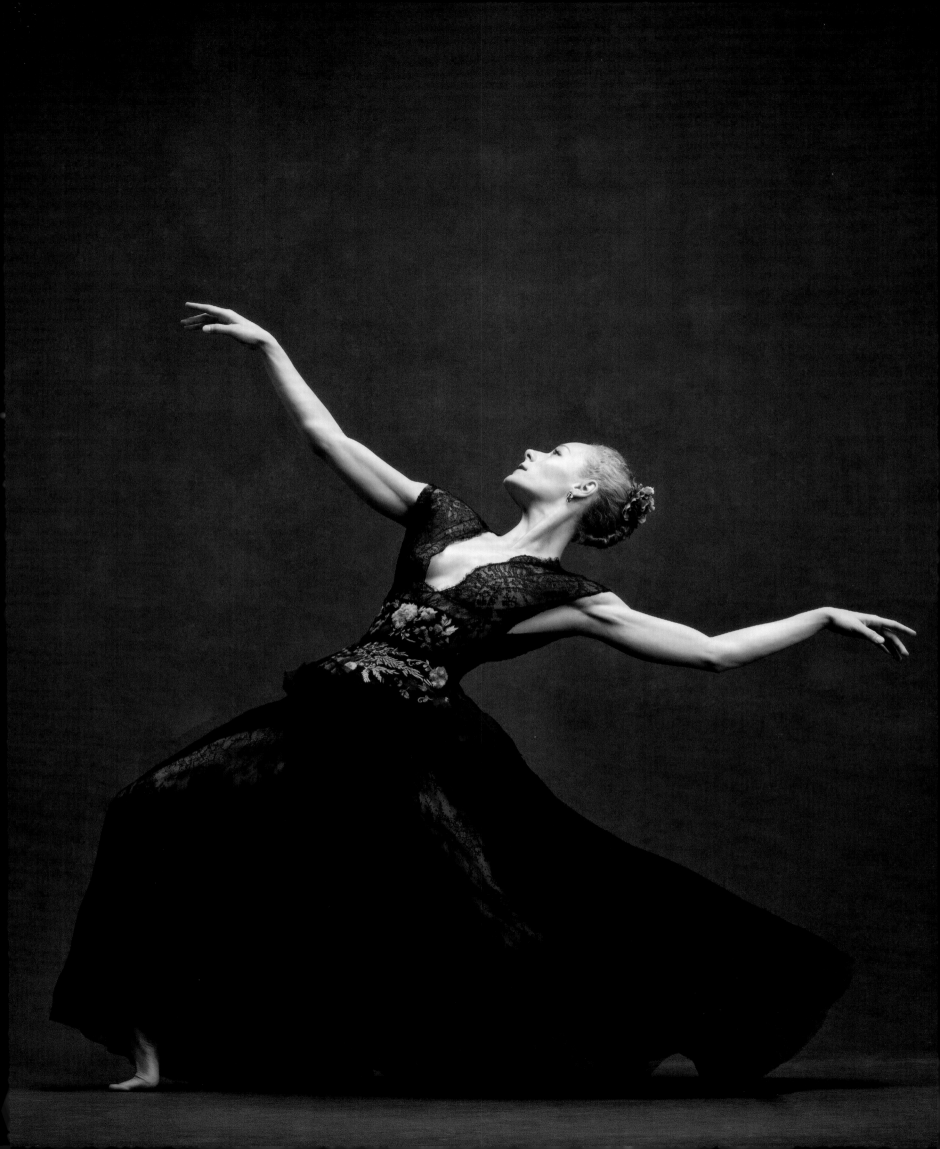

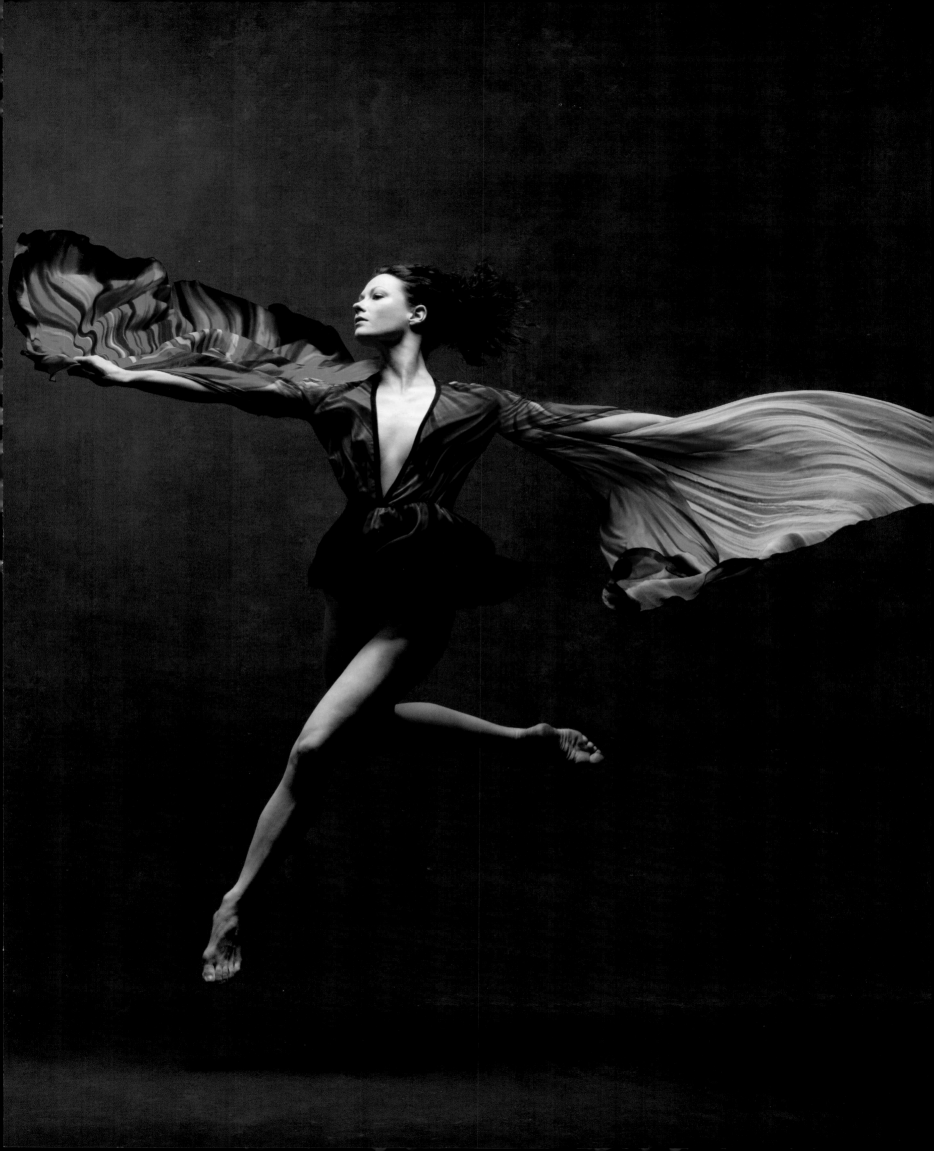

Renan Cerdeiro, Kleber Rebello, and Jovani Furlan | Principals, Miami City Ballet
Costumes by Norma Kamali for Twyla Tharp's In the Upper Room

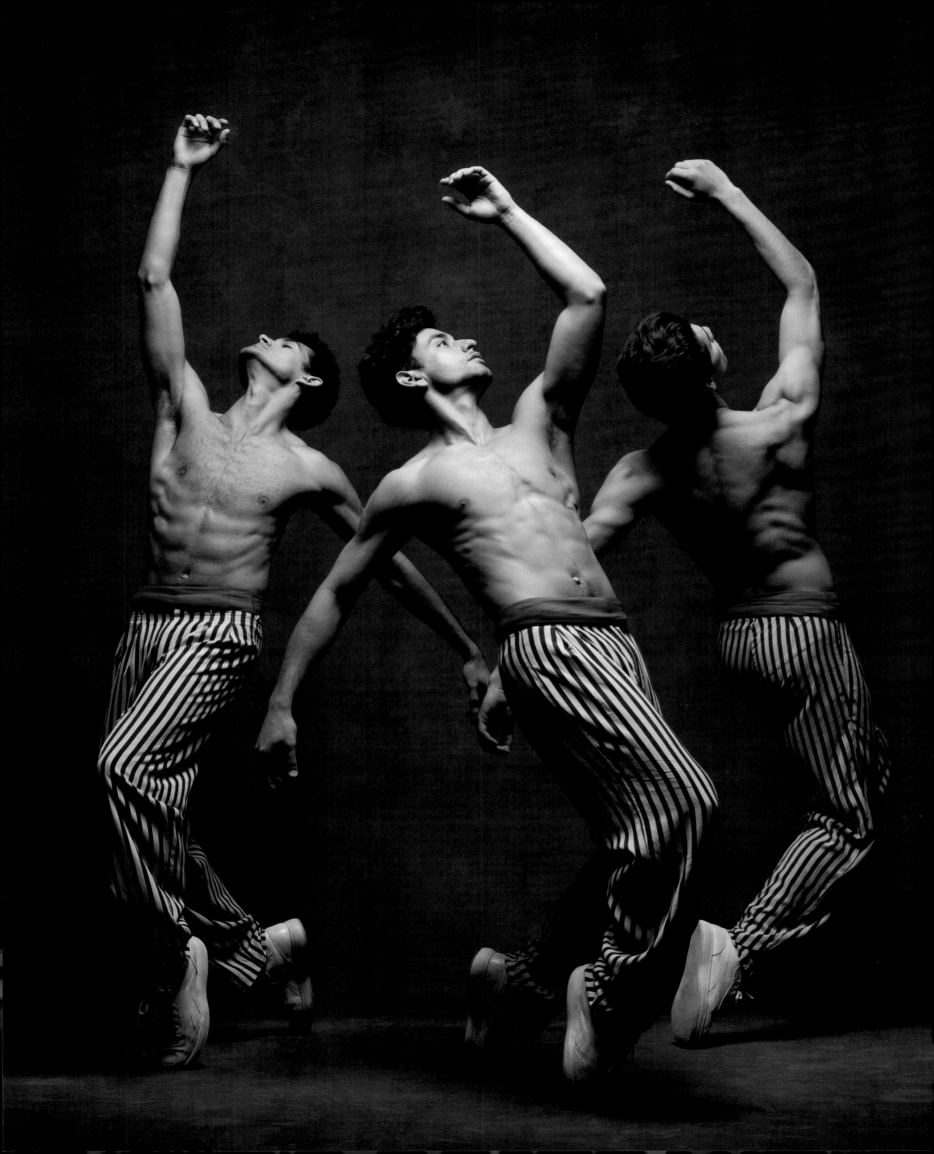

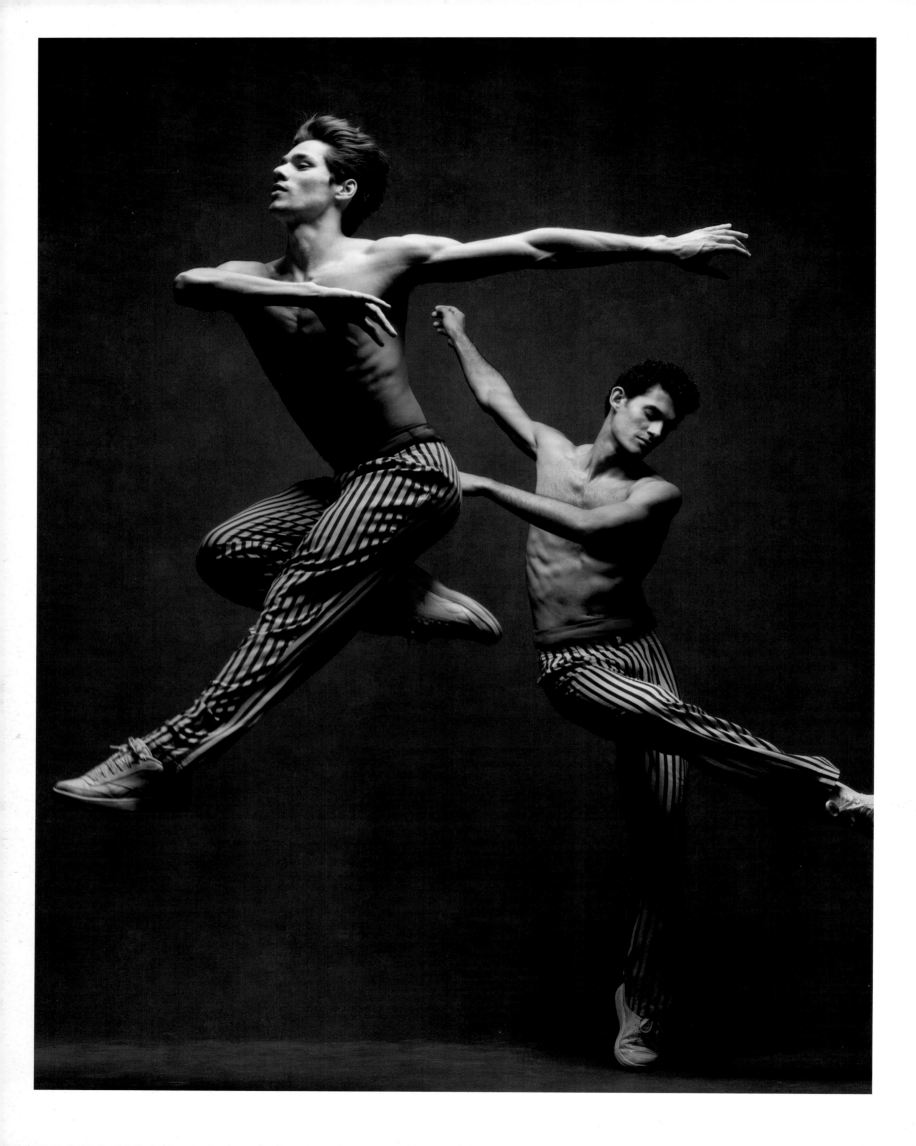

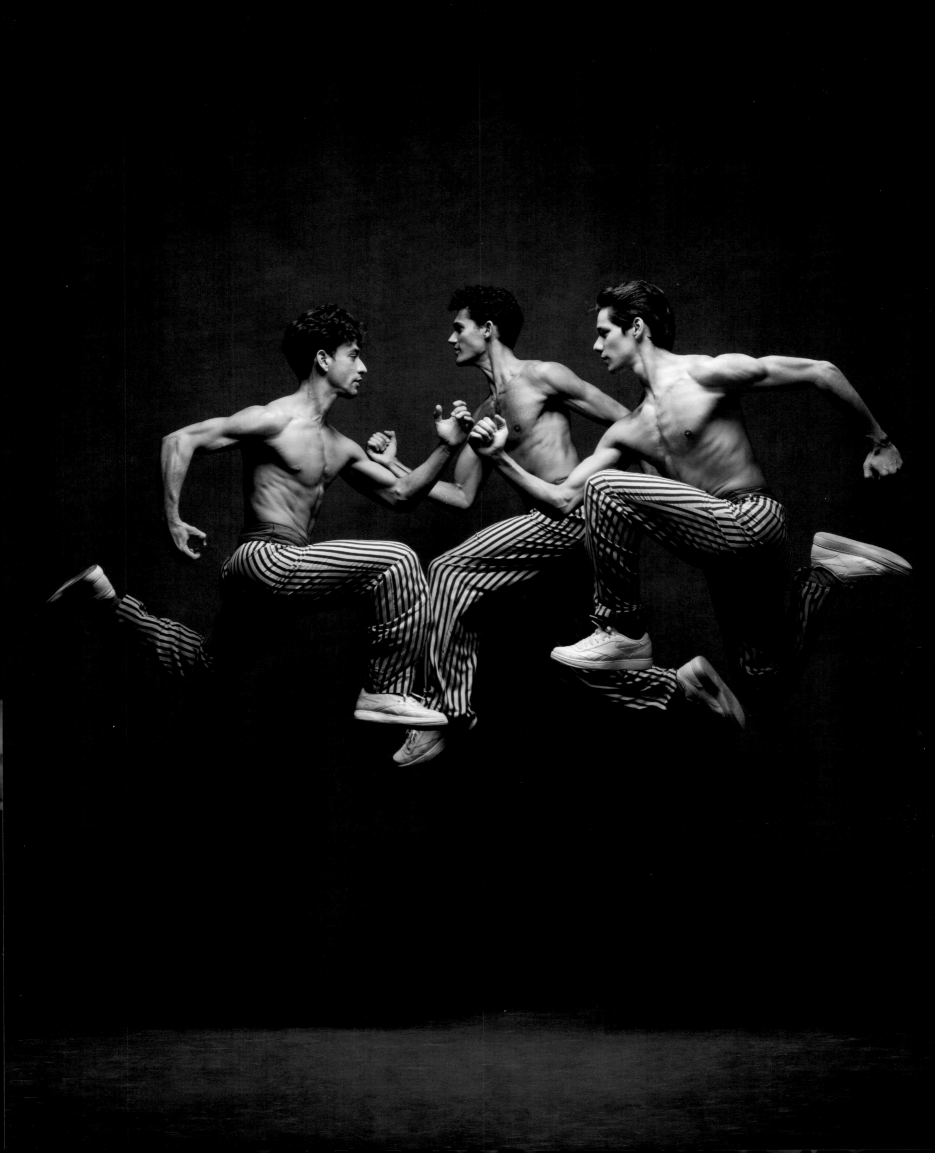

Sasha De Sola and Angelo Greco | Principals, San Francisco Ballet | *Clothing by Marchesa*

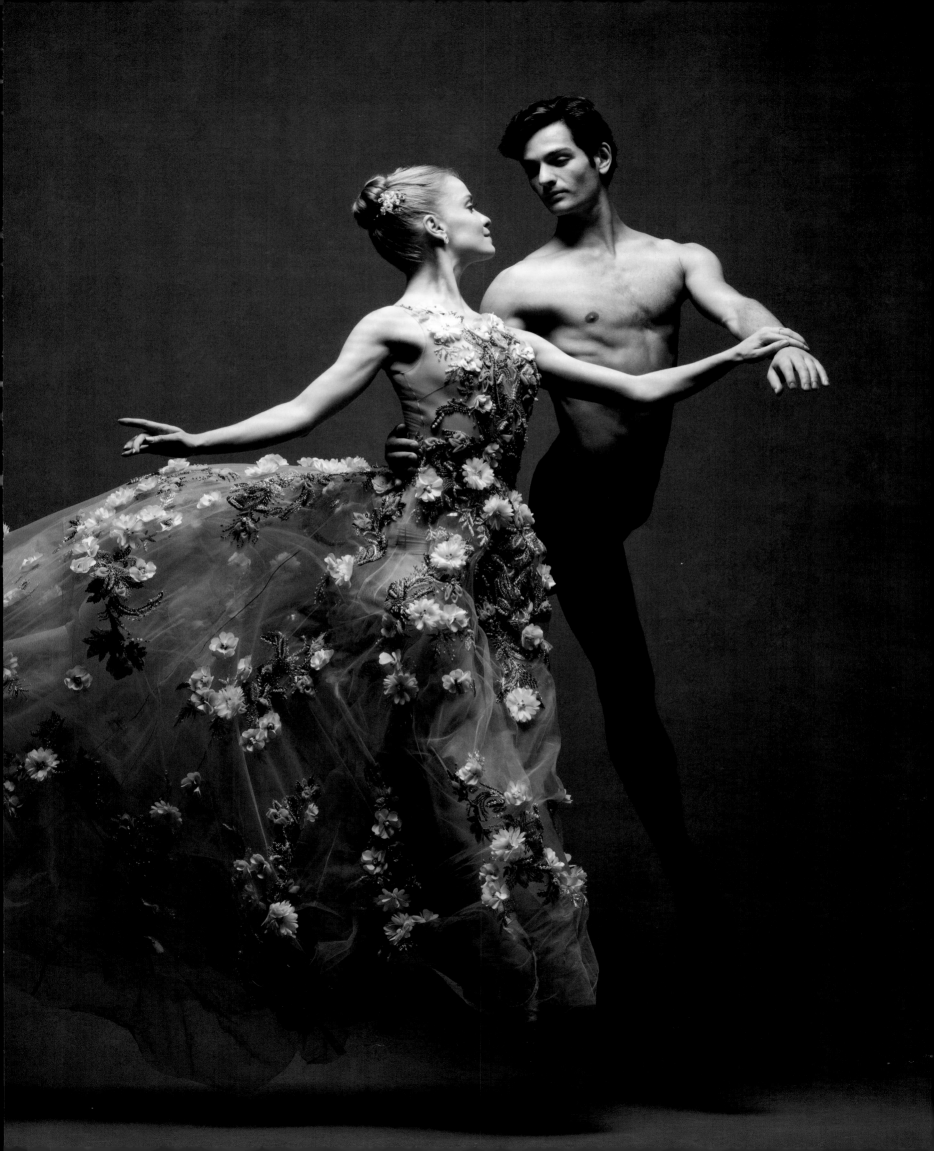

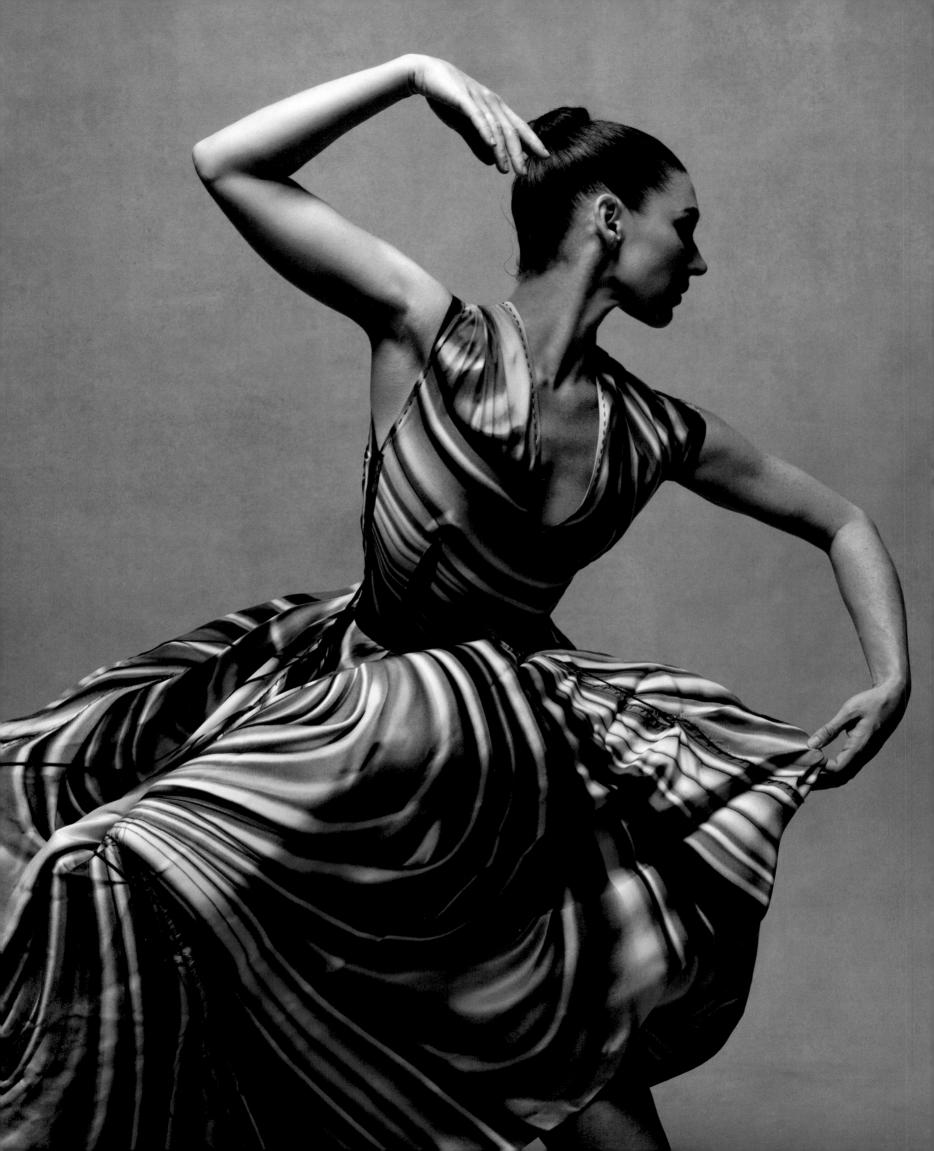

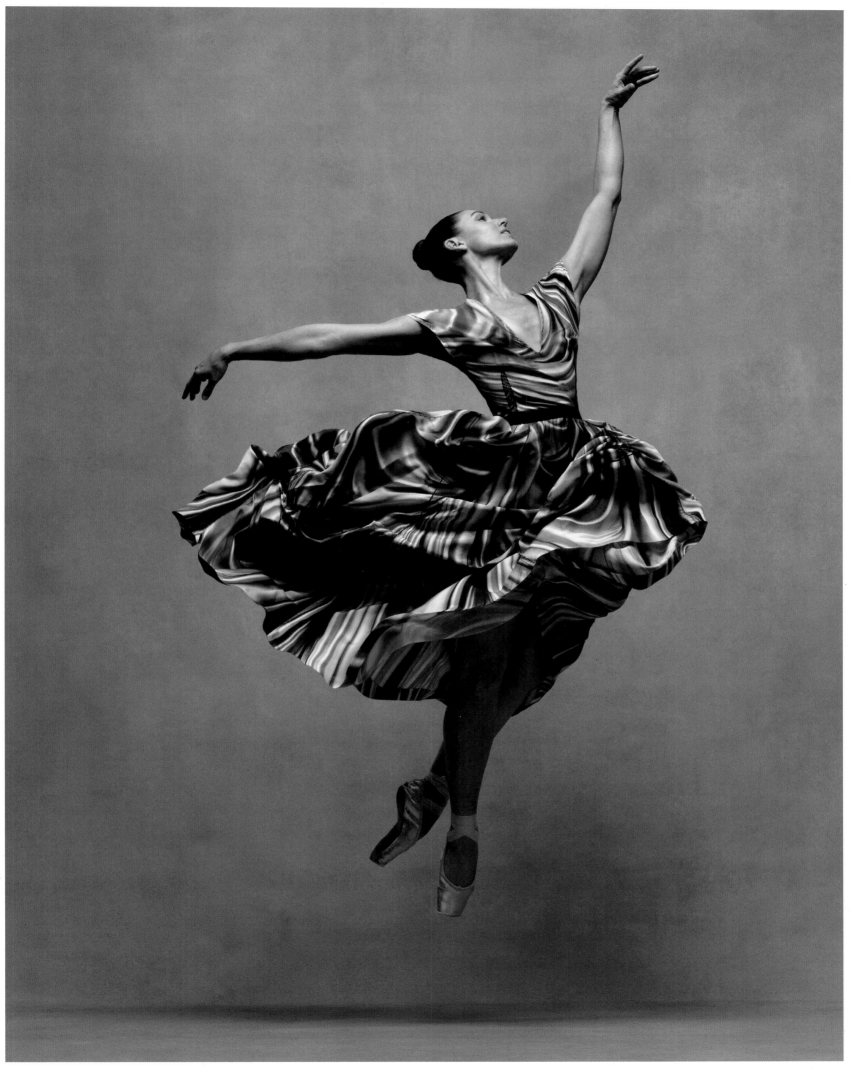

Kathleen Breen Combes | Principal, Boston Ballet | *Vintage dress by Moschino, courtesy New York Vintage*

"Each dress has its own life, and inspires some kind
 of emotion or thought inside of my head.
 When I simply express those emotions and ideas,
 the poses come out so naturally!"

—FANA TESFAGIORGIS

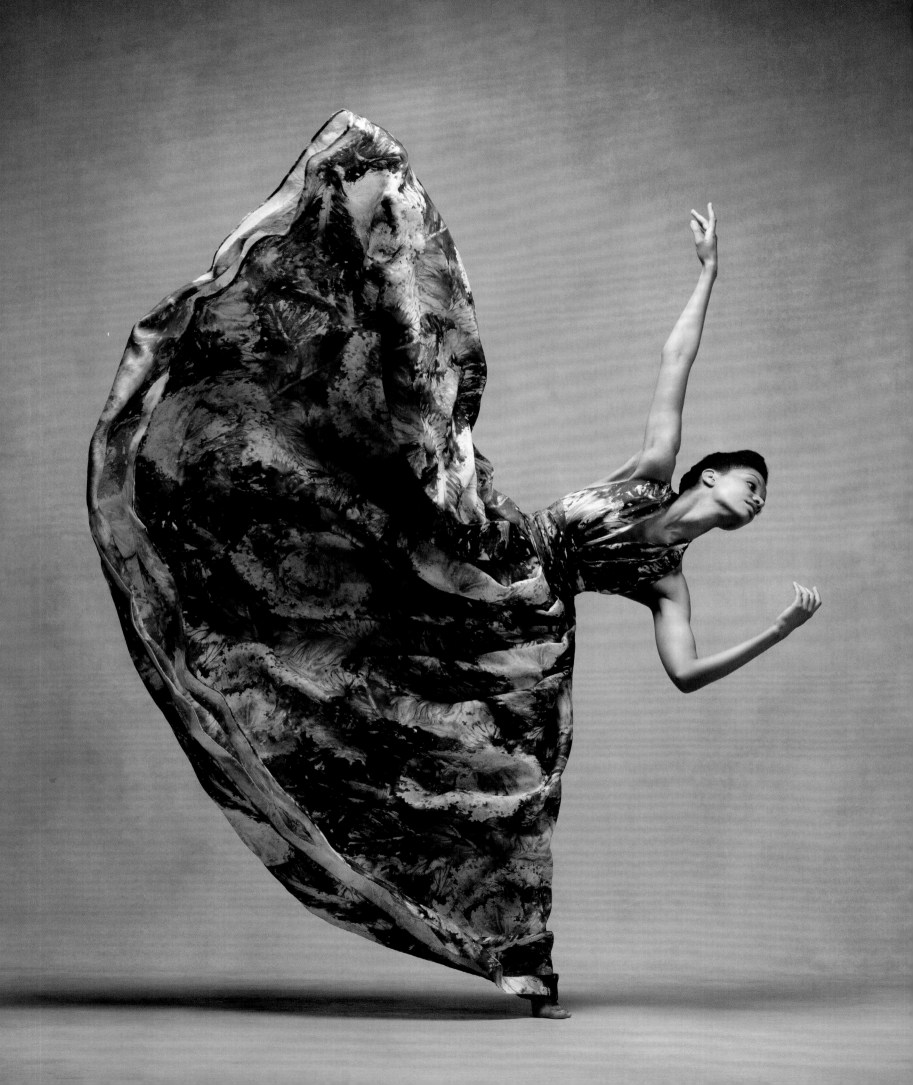

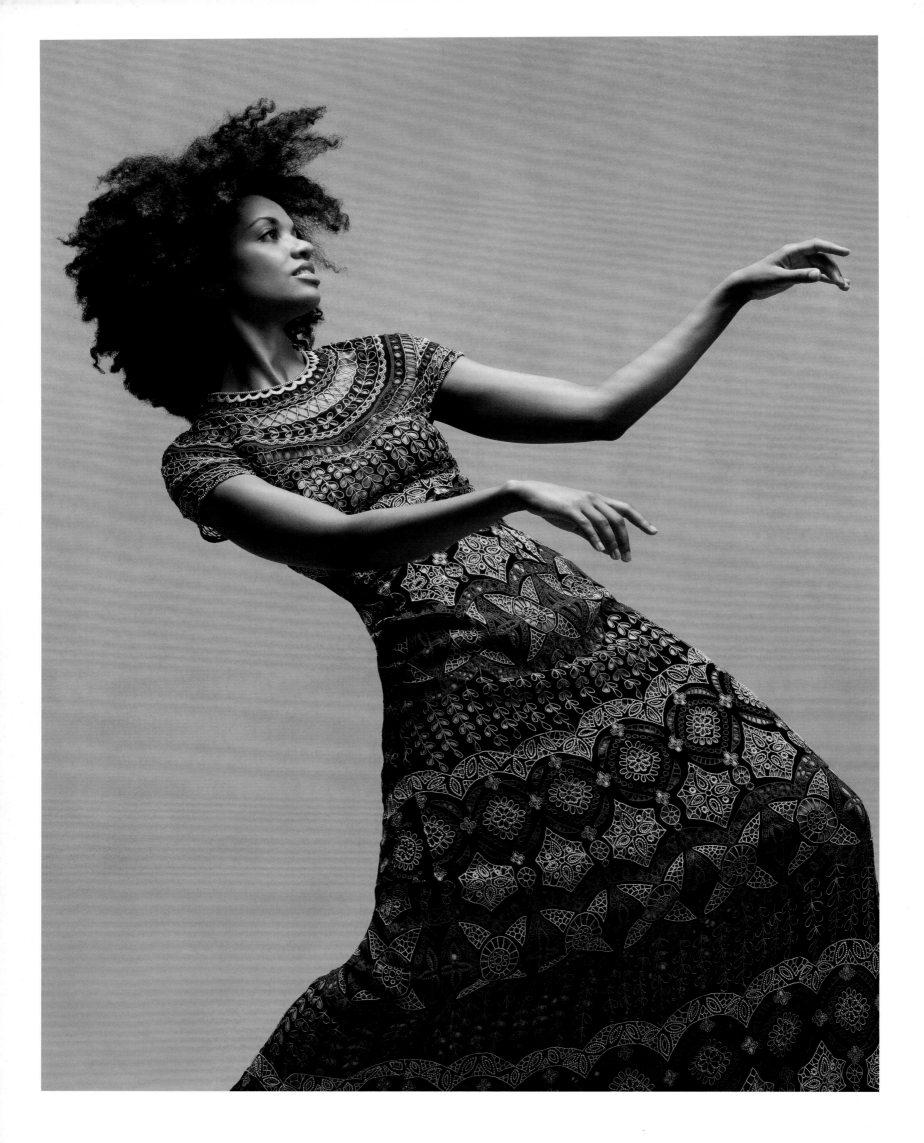

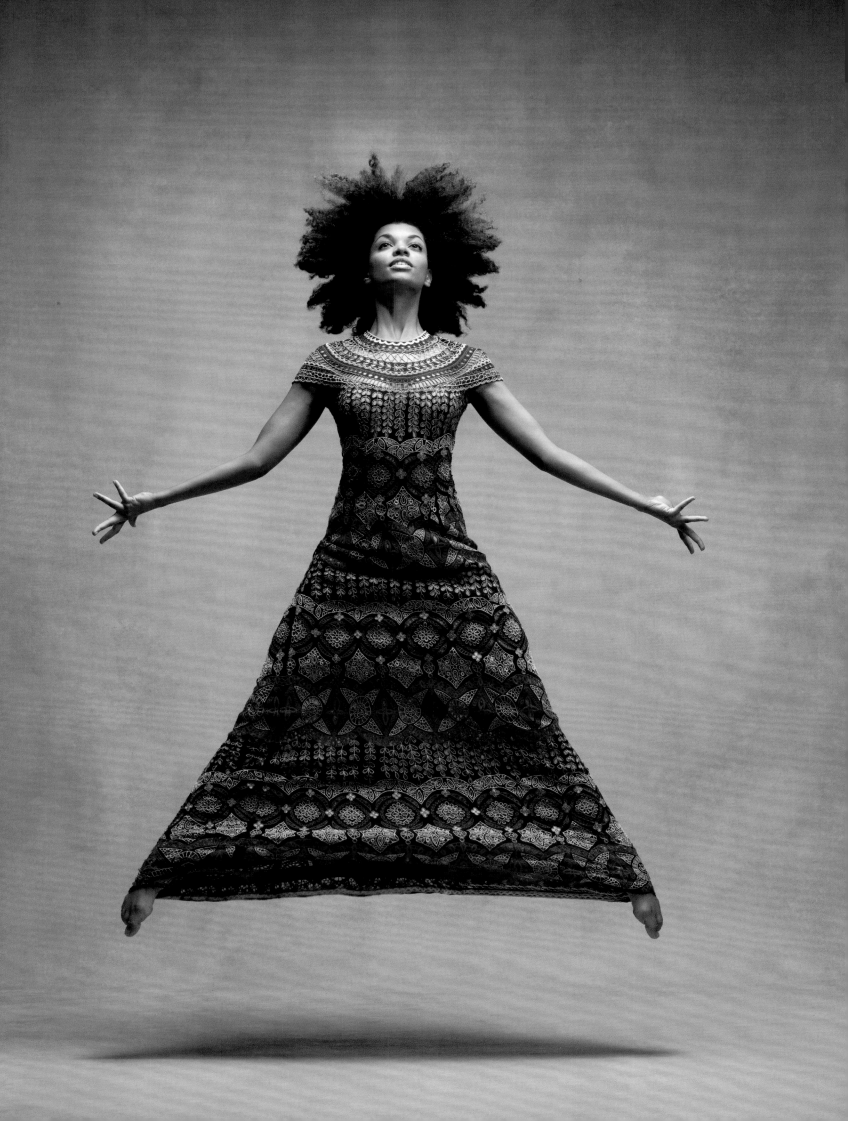

Calvin Royal III | Soloist, American Ballet Theatre | *Vintage cape by Dior, courtesy New York Vintage*

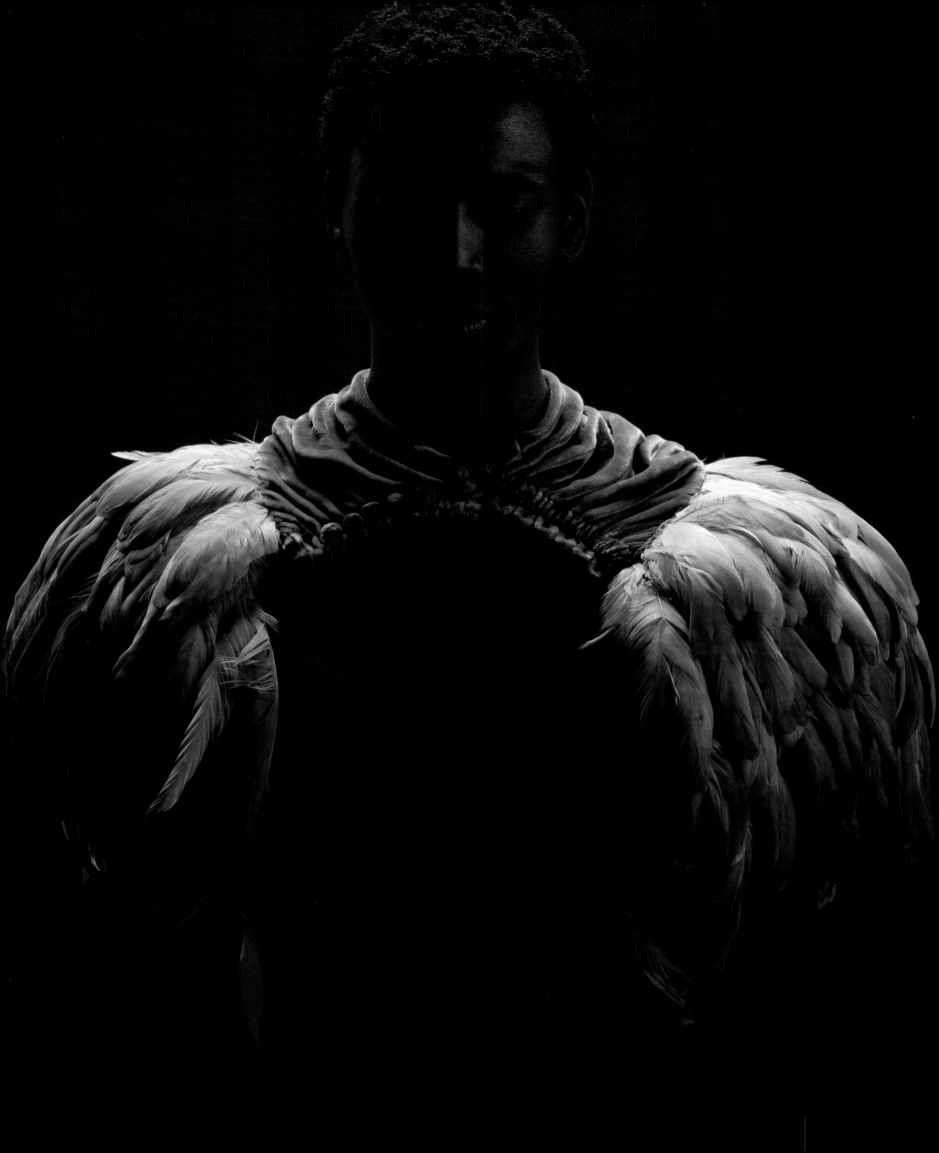

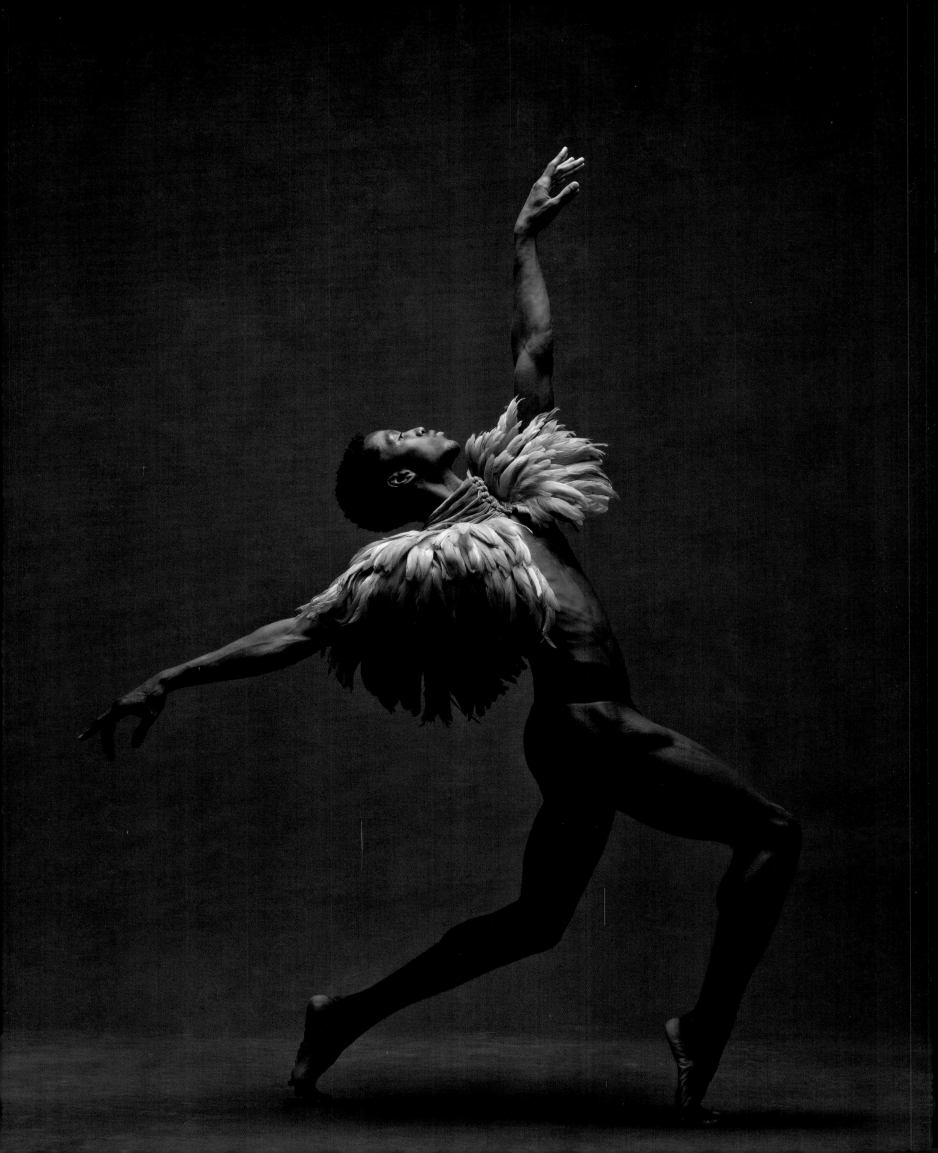

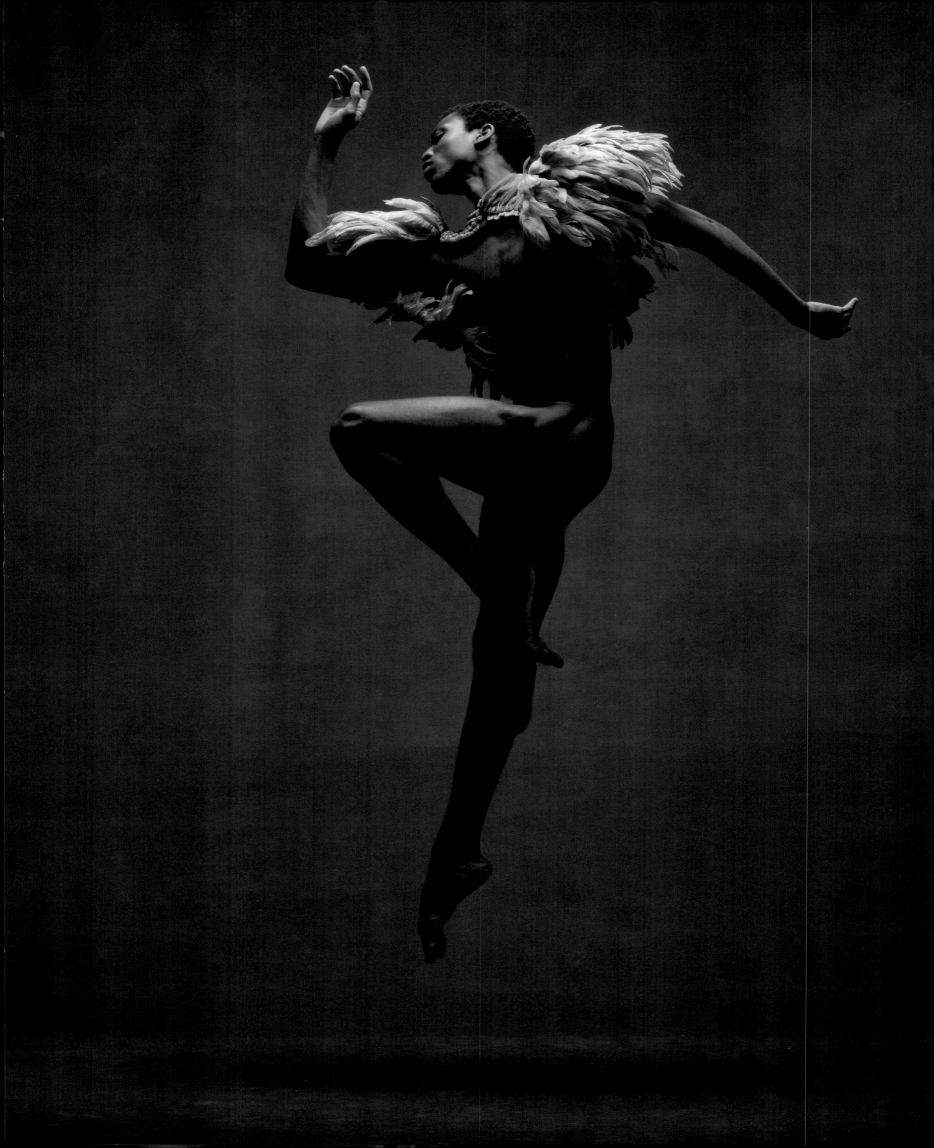

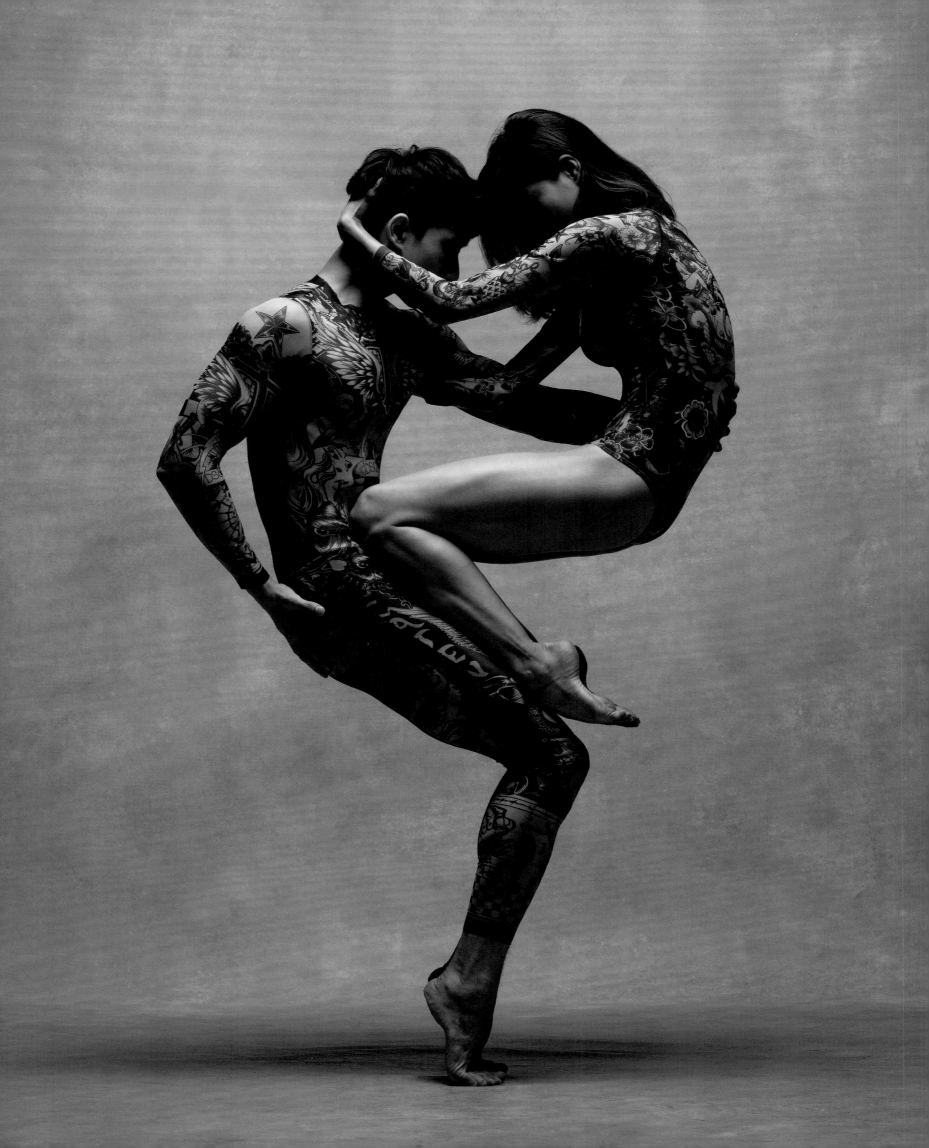

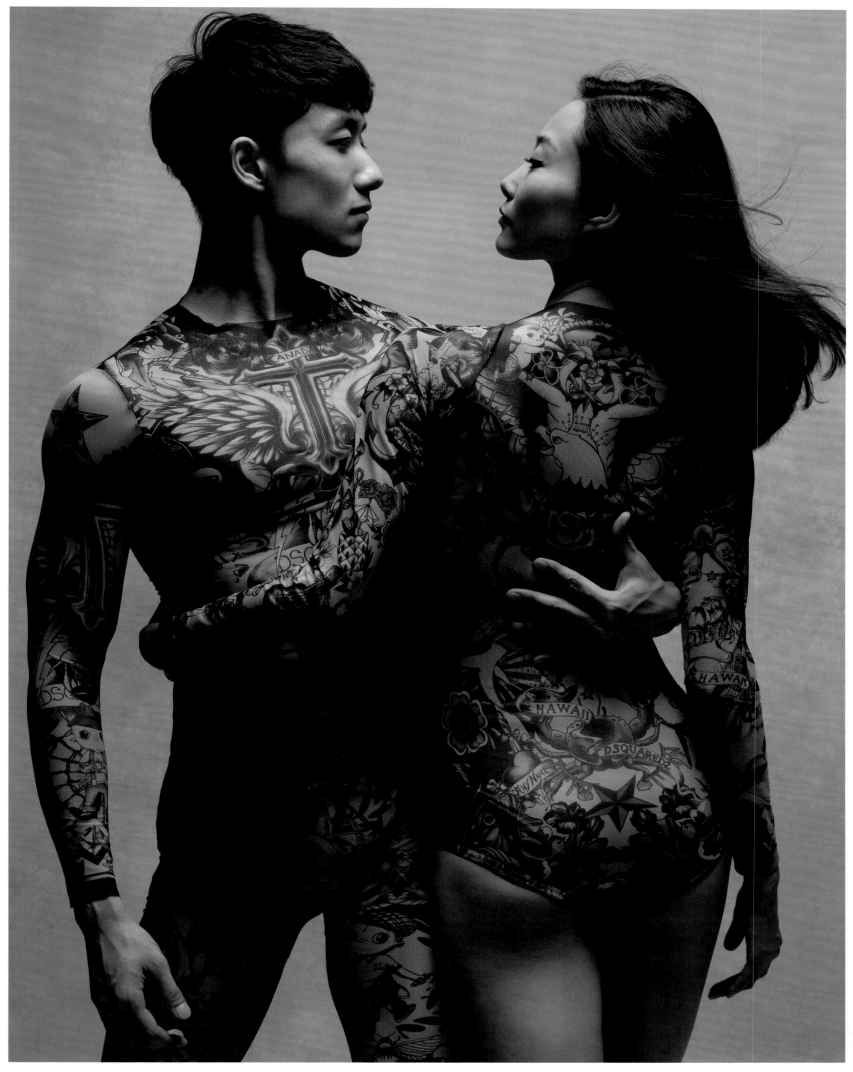

Bruce Zhang | American Ballet Theatre | **WanTing Zhao** | Principal, San Francisco Ballet | *Clothing by DSquared2*

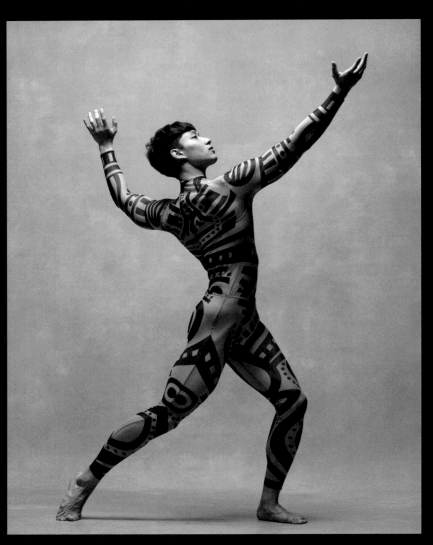
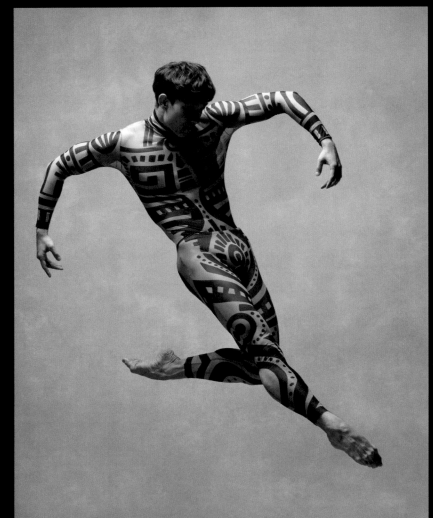

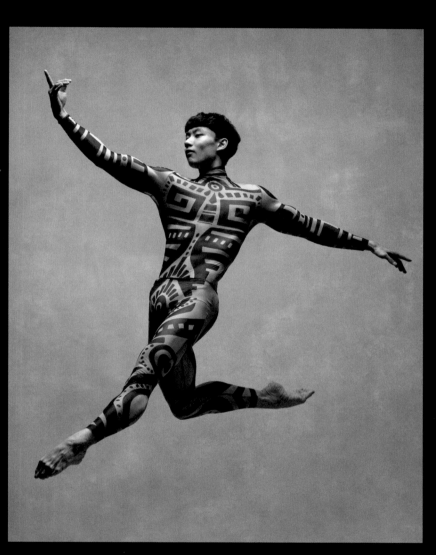
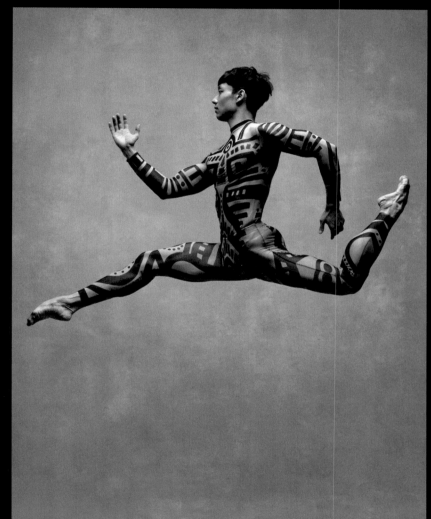

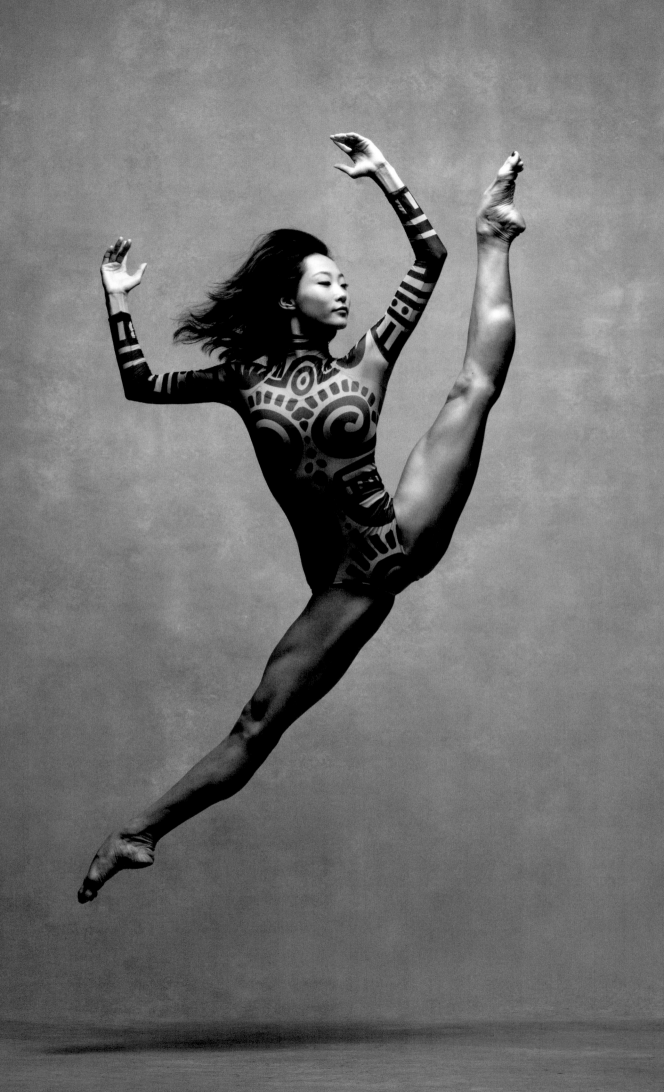

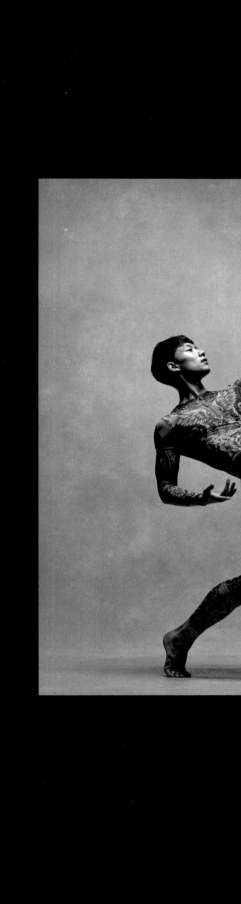

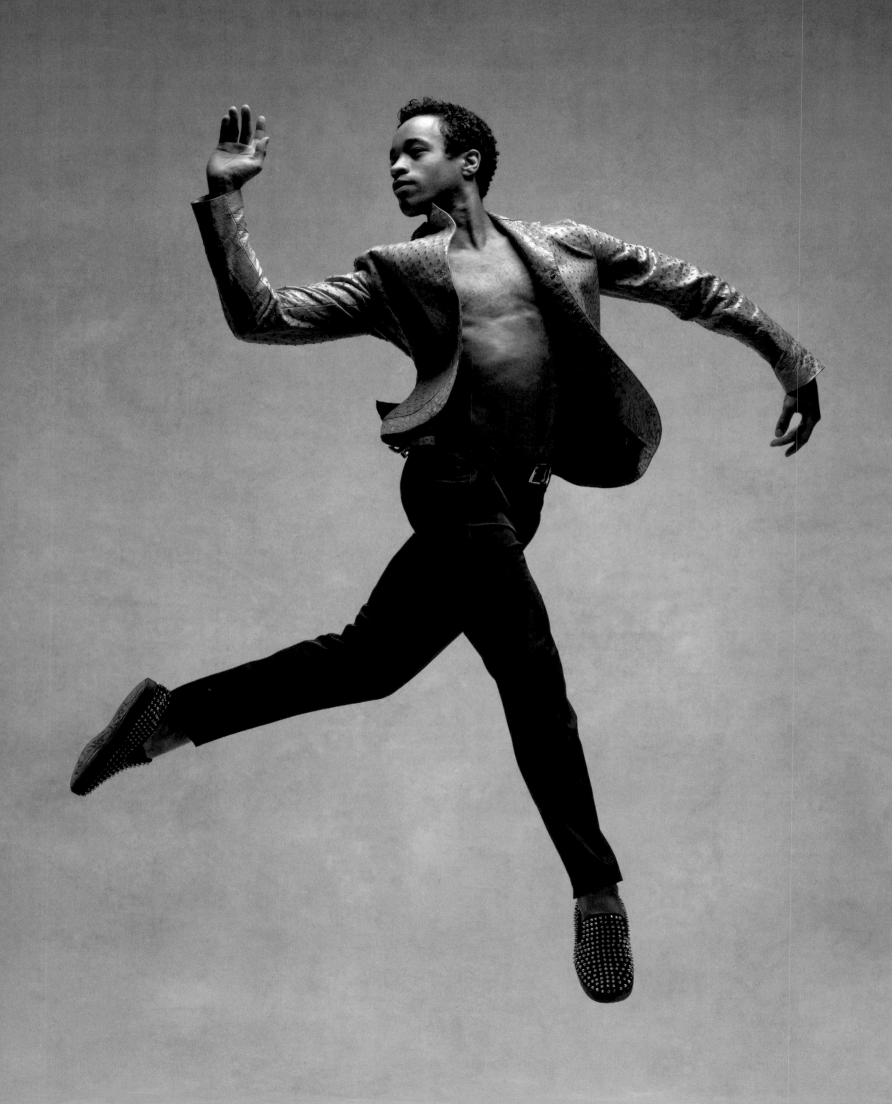

Homage to Alexander McQueen and his dress of flowers.

Meaghan Grace Hinkis | Soloist, The Royal Ballet | *Flower dress by Madeleine Hinkis, floral design by Olga Sahraoui*

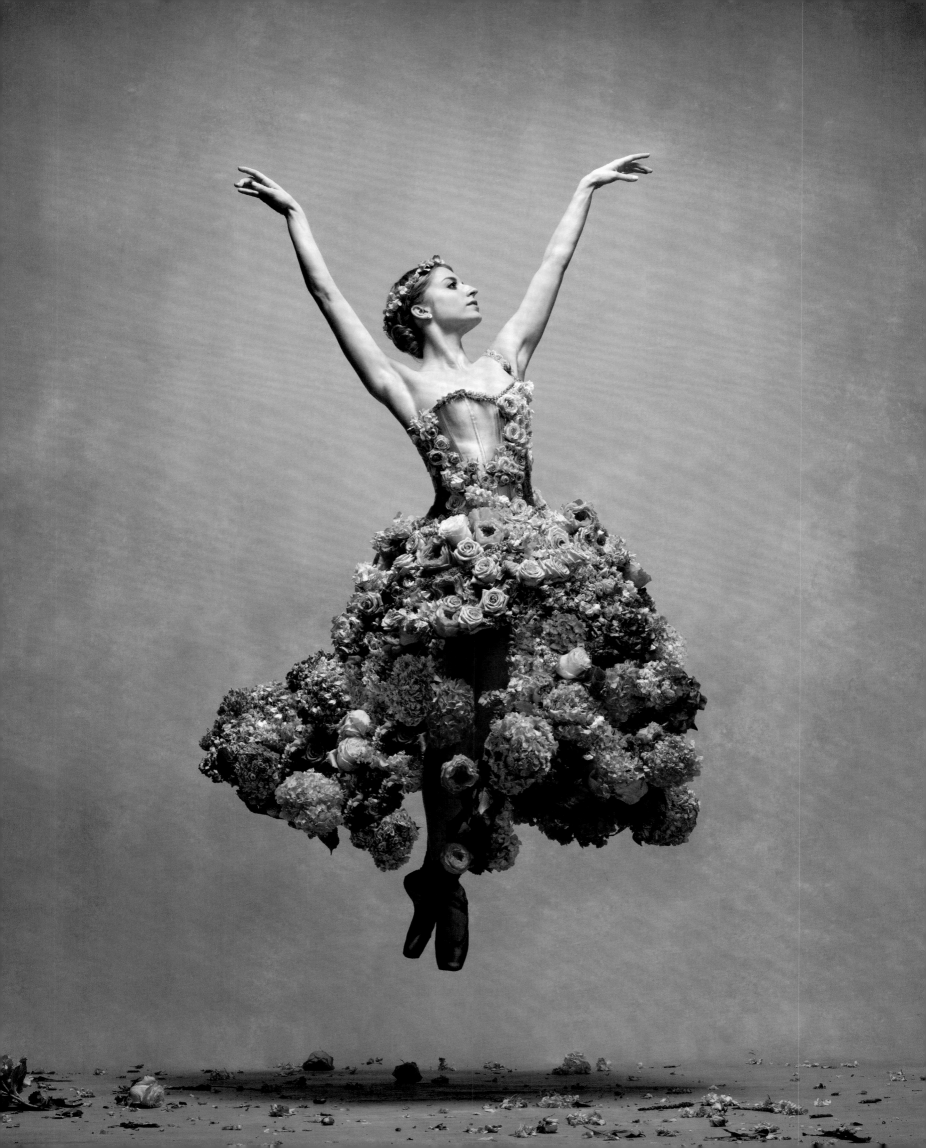

"Enamored by the films of Fred Astaire when I was growing up, I was always envious of his impeccably cut suit, envious of his relaxed style and elegance. As soon as I saw this beautiful, classic black tuxedo with tails I knew I would attempt to capture the essence of this idol of mine, this dance icon. It definitely affected the way I moved throughout the shoot— an air of elegance, turns that would let the jacket and tails float away from my body, jumps that would hover in midair with ease."

—MICHAEL TRUSNOVEC

Michael Trusnovec | Paul Taylor Dance Company | *Vintage tails, c. 1950*

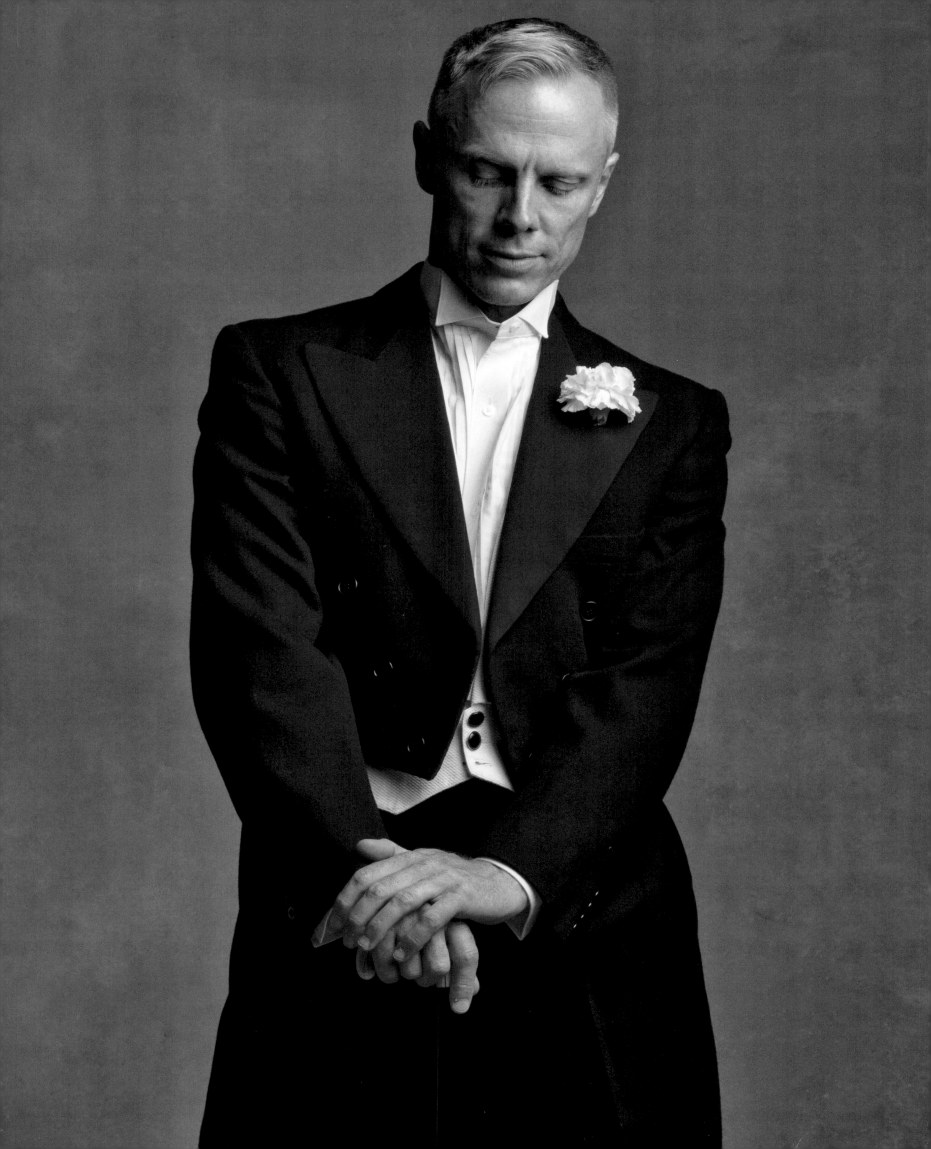

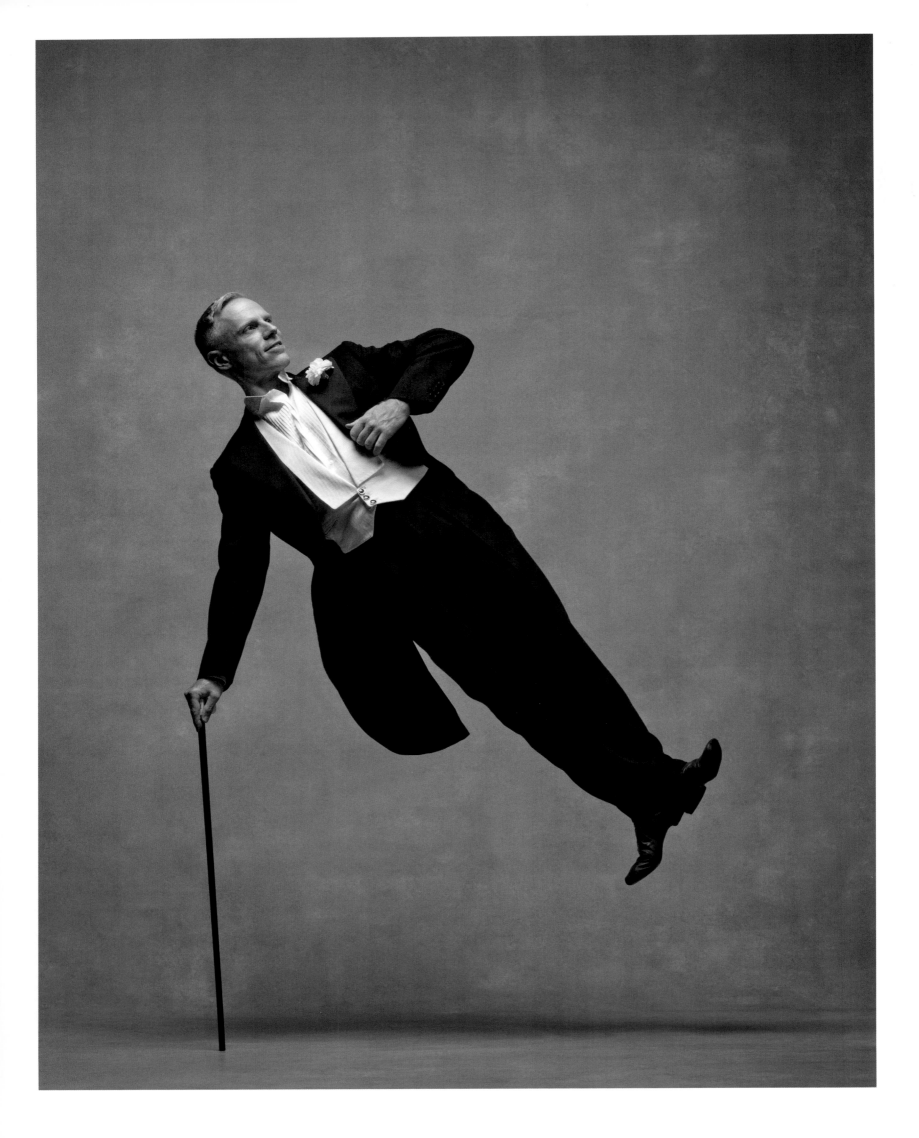

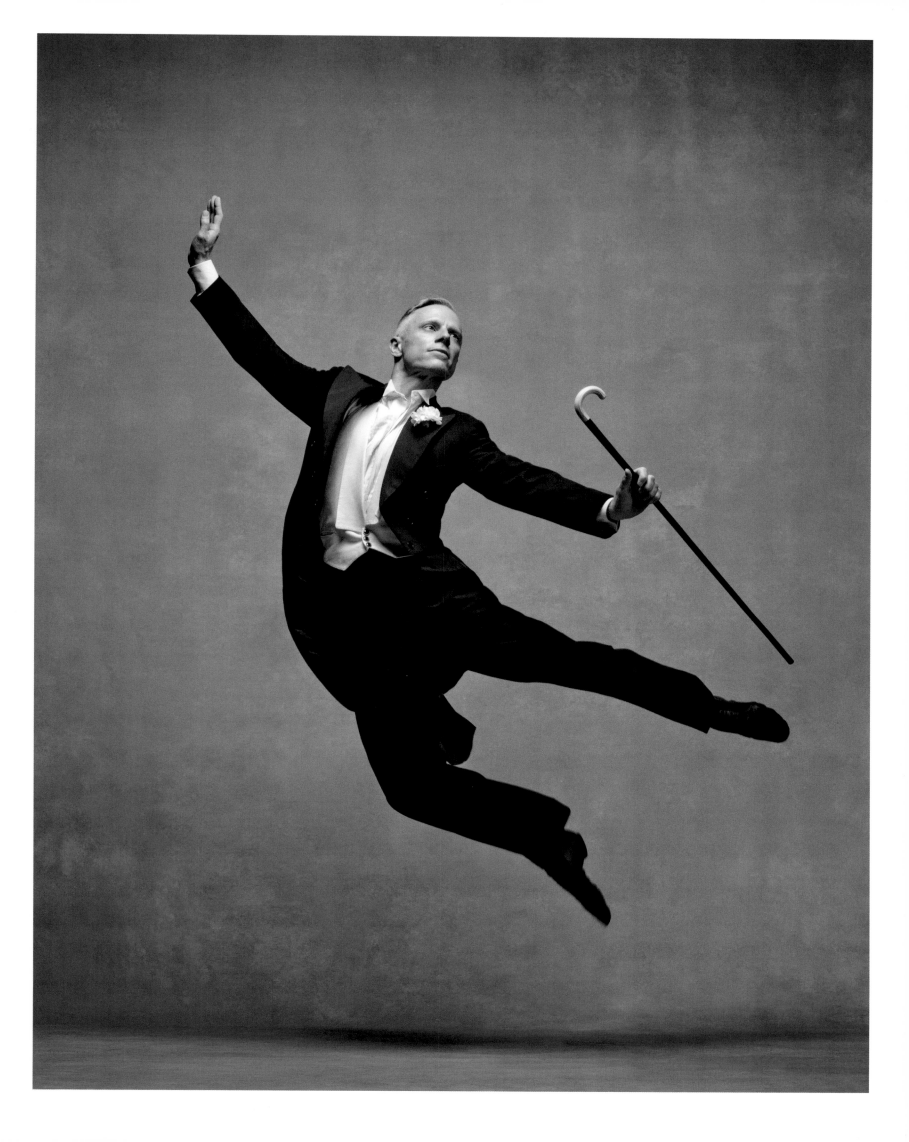

"I took great inspiration from the work of a number of artists,
including Loïe Fuller, Isadora Duncan, Martha Graham,
and Pina Bausch, who used dance as a way of breaking free."

—MARIA GRAZIA CHIURI, ARTISTIC DIRECTOR, DIOR

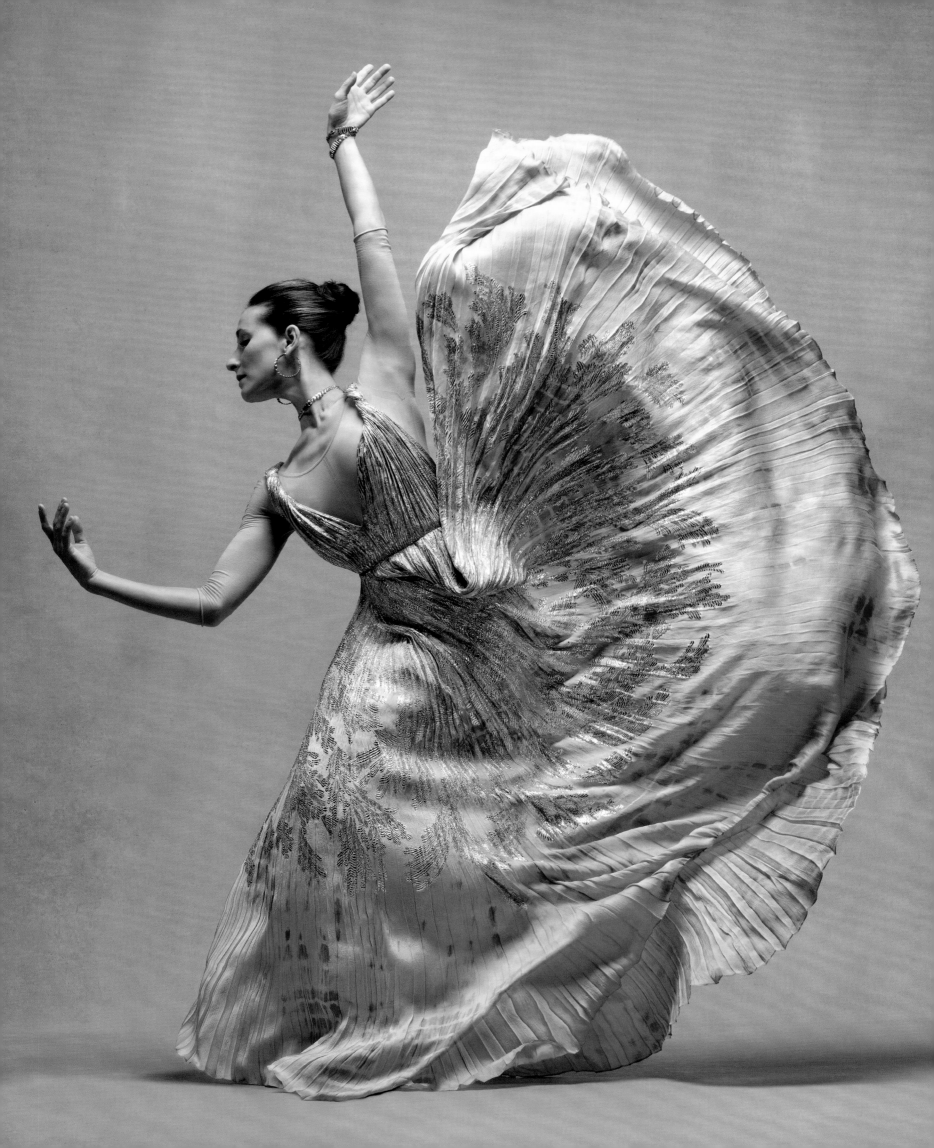

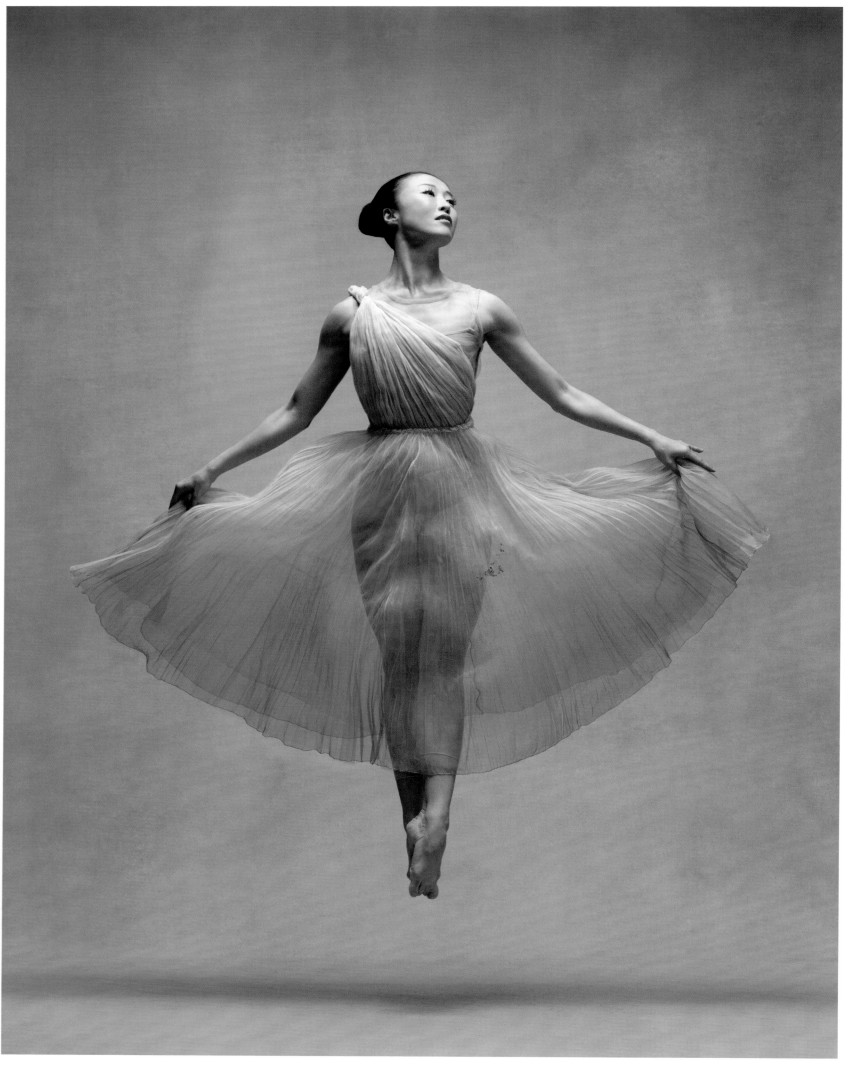

PeiJu Chien-Pott, Charlotte Landreau, and Masha Dashkina Maddux | Martha Graham Dance Company | *Clothing by Dior*

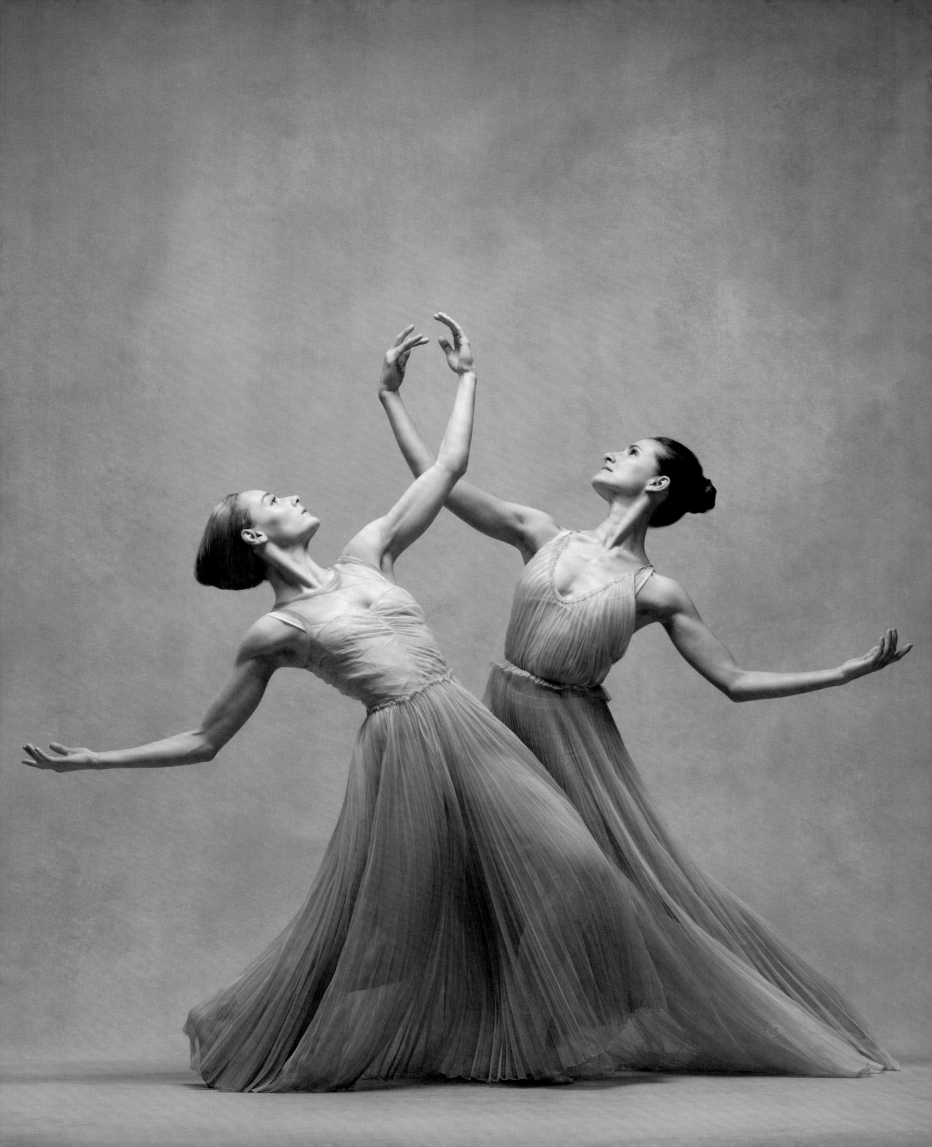

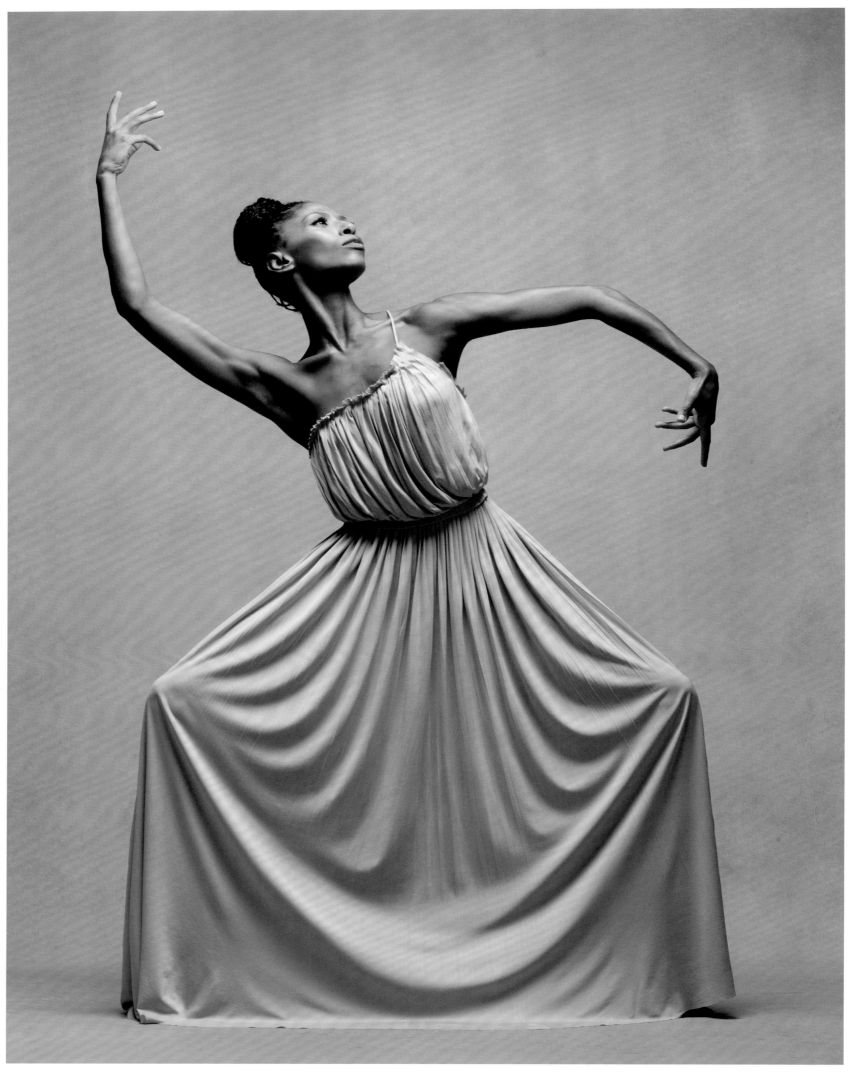

Jacqueline Green | Alvin Ailey American Dance Theater | *Clothing by Dior*

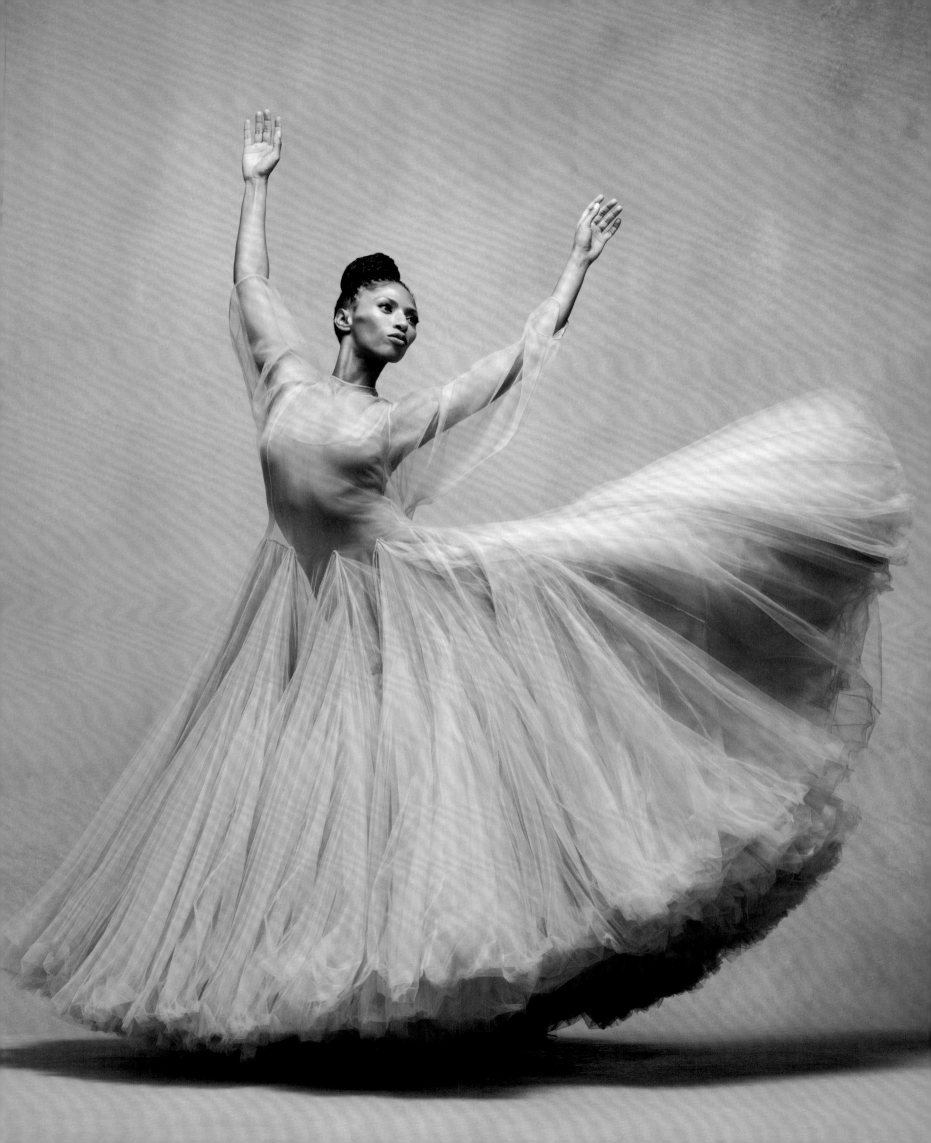

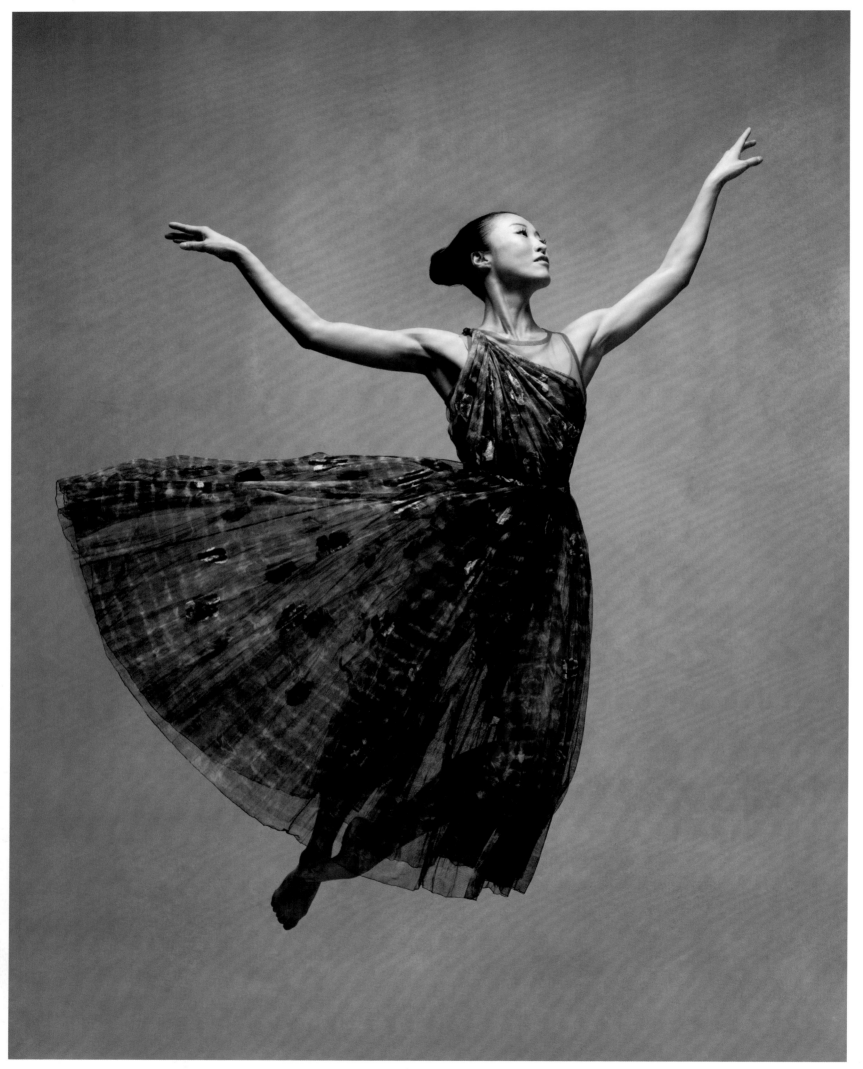

PeiJu Chien-Pott and **Charlotte Landreau** | Martha Graham Dance Company | *Clothing by Dior*

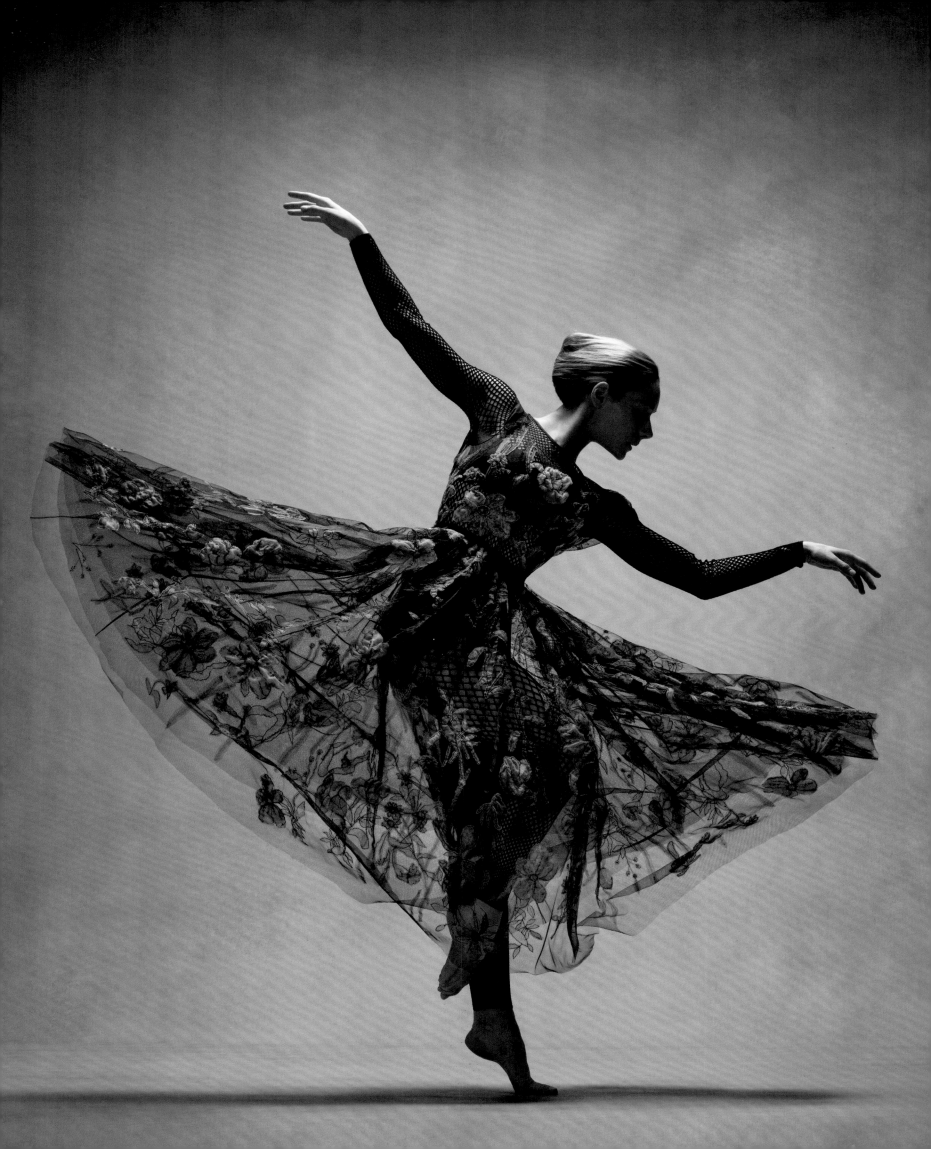

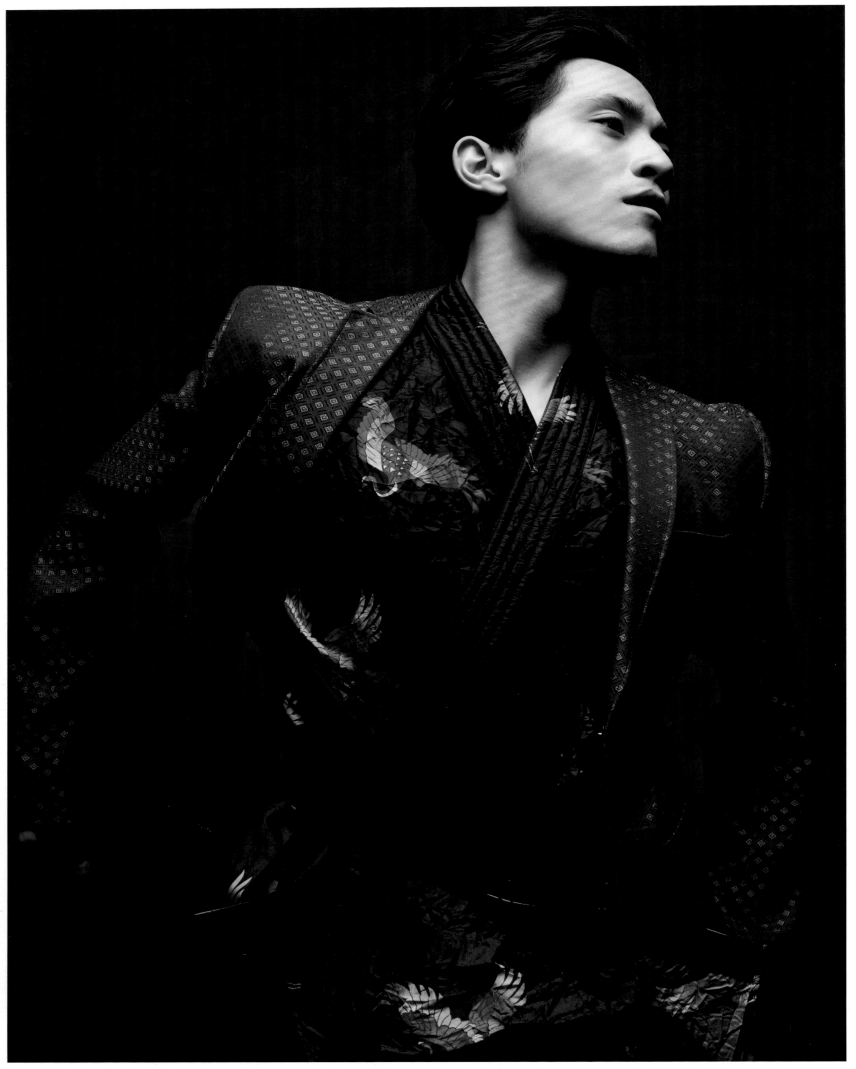

Jeffrey Cirio | Principal, English National Ballet | *Clothing by Emporio Armani*

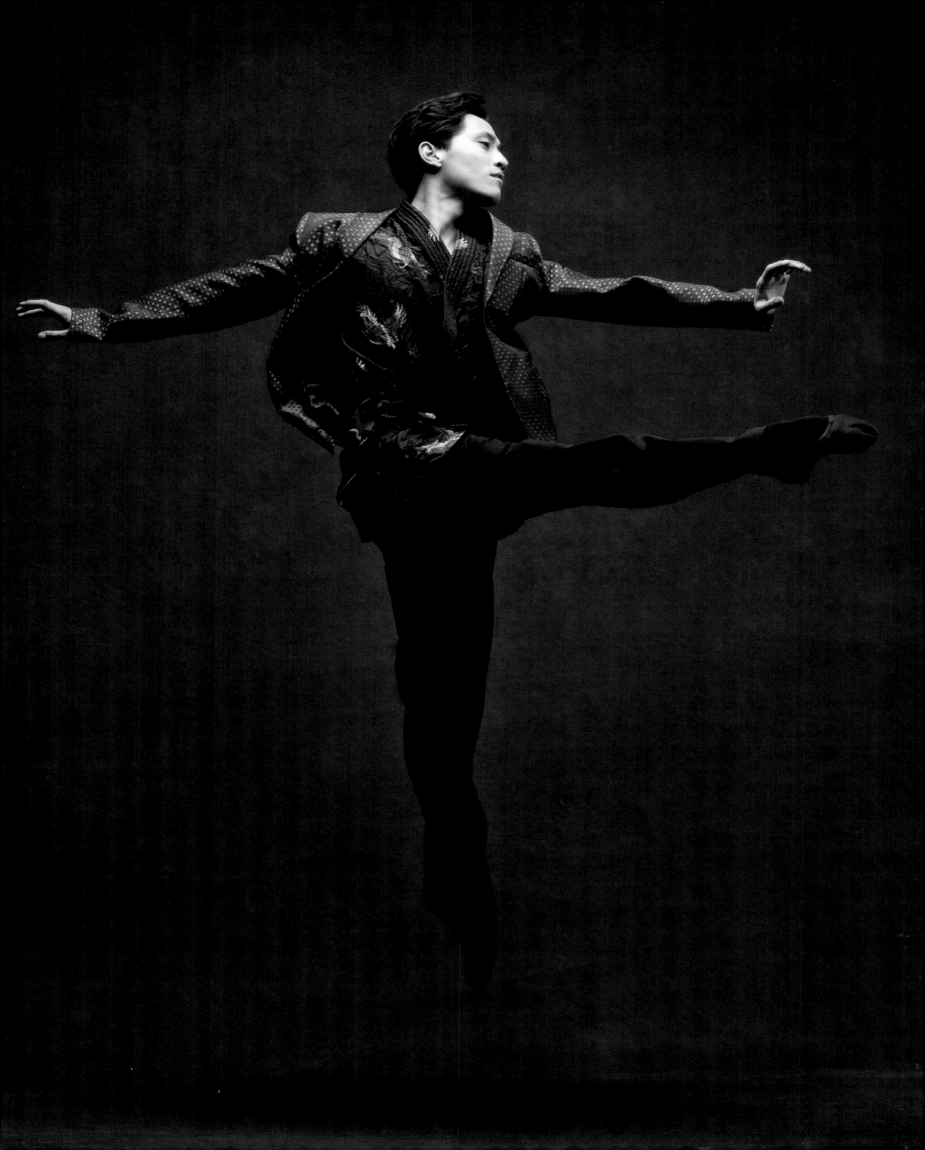

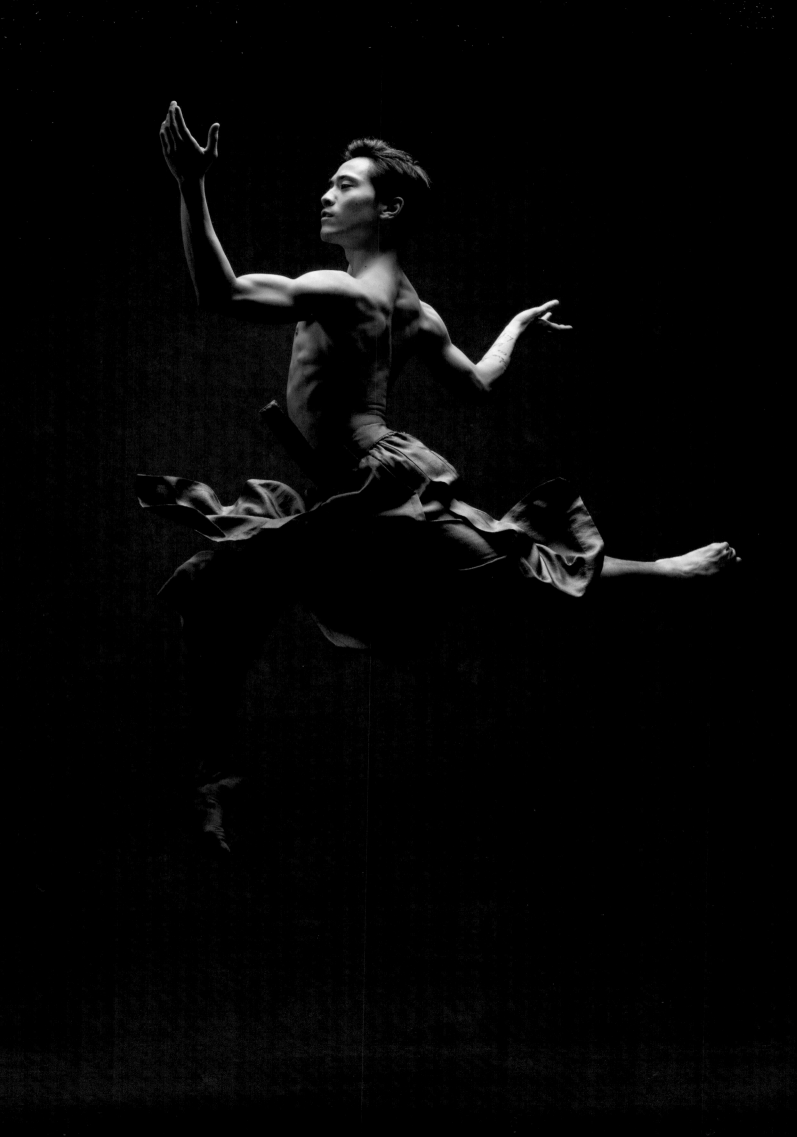

Eric Underwood | Former Soloist, Royal Ballet | *Clothing by KeithLink*

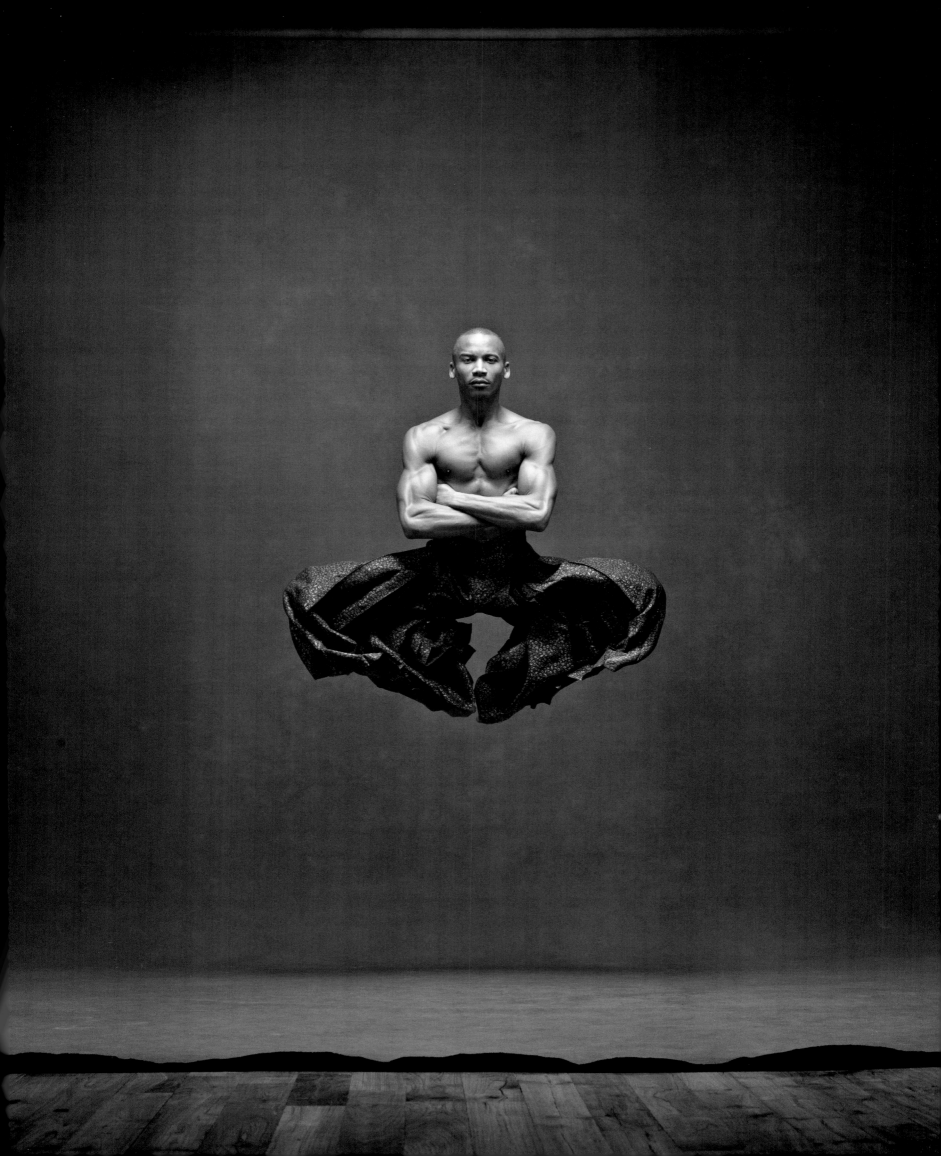

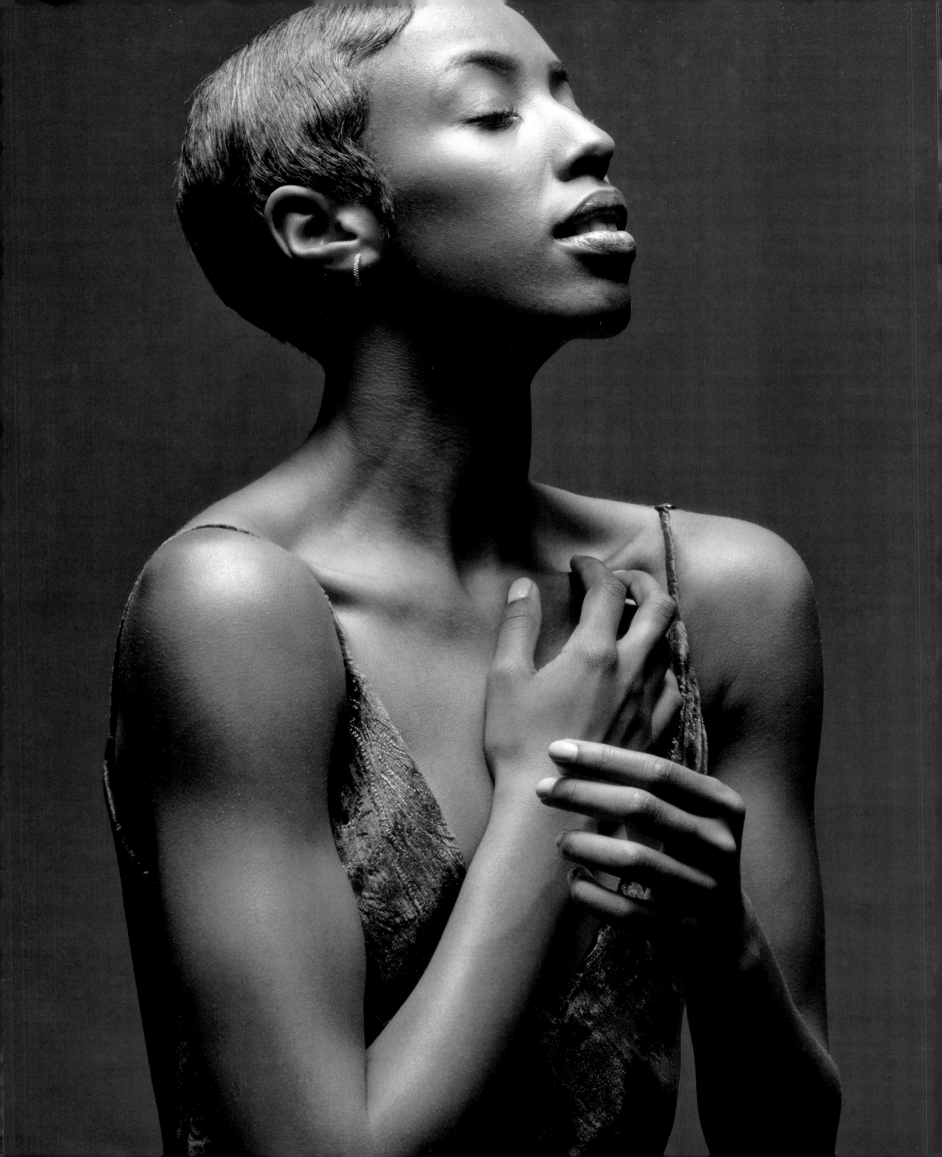

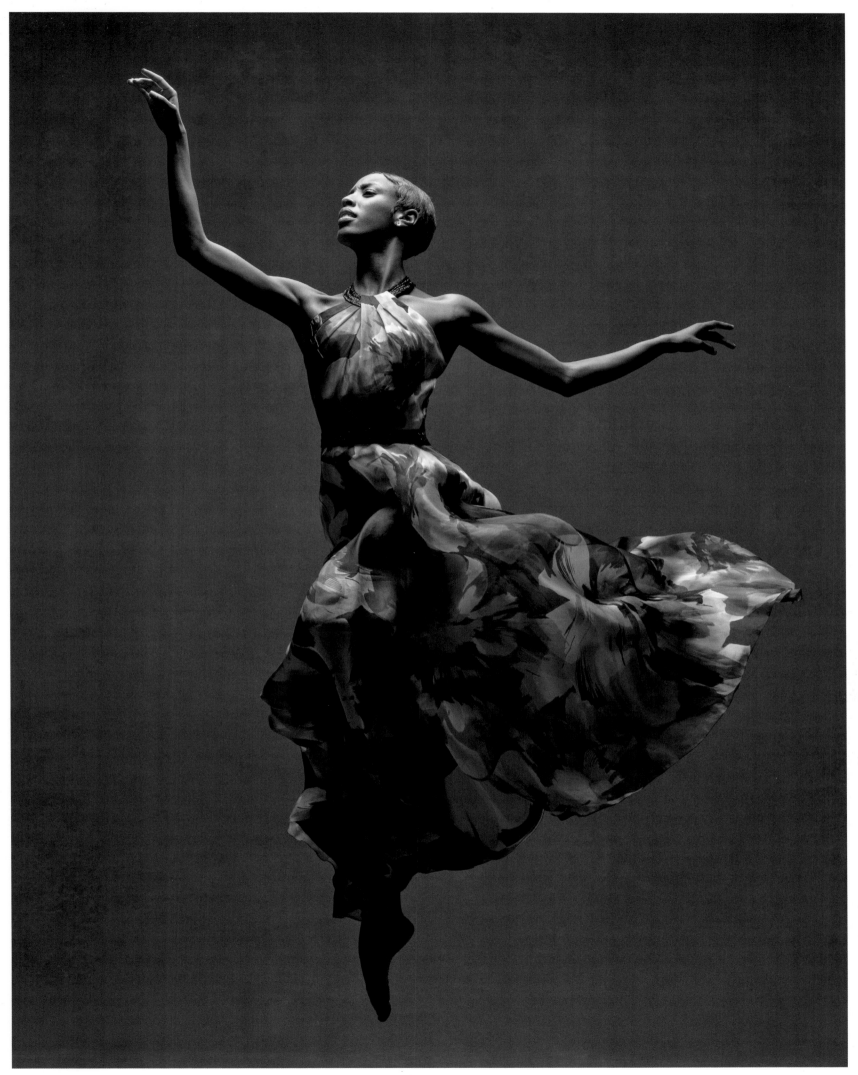

Courtney Spears | Alvin Ailey American Dance Theater | *Clothing by Carmen Marc Valvo*

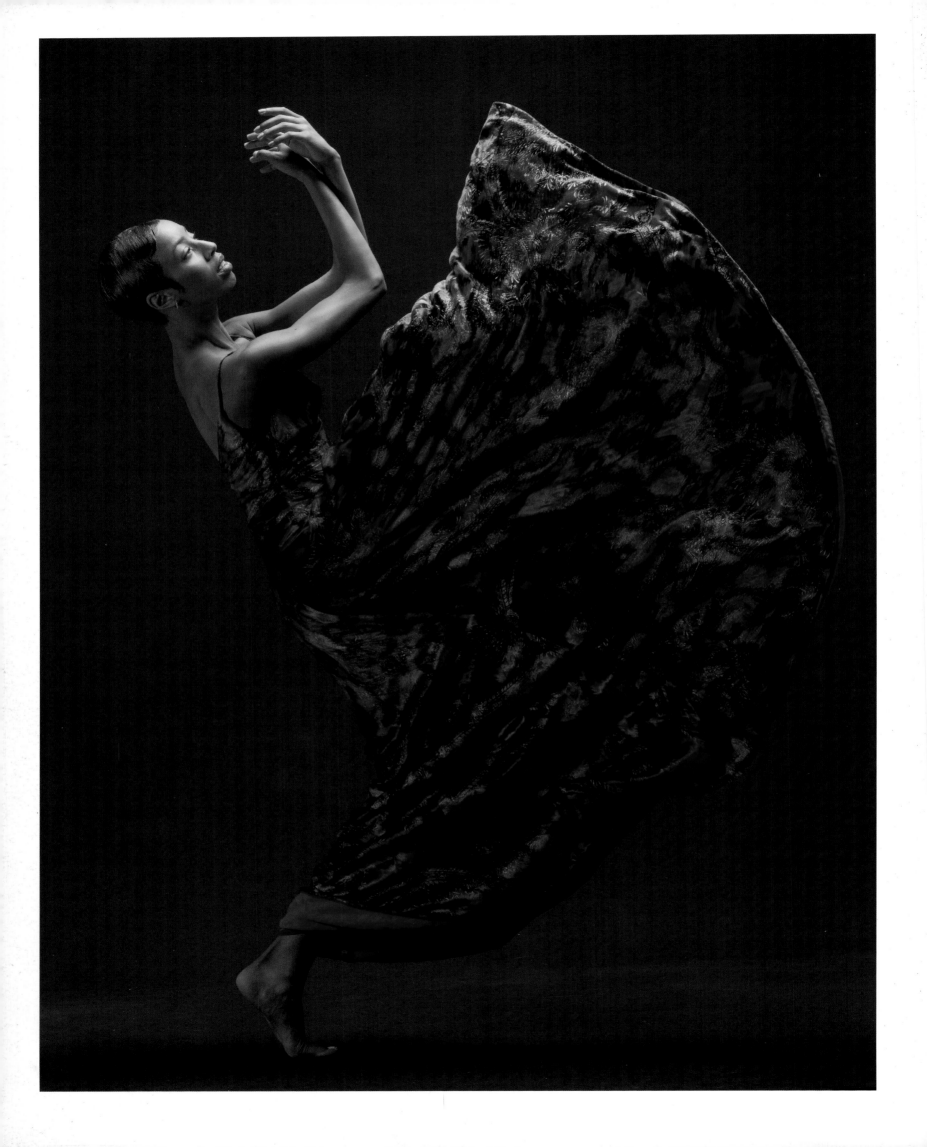

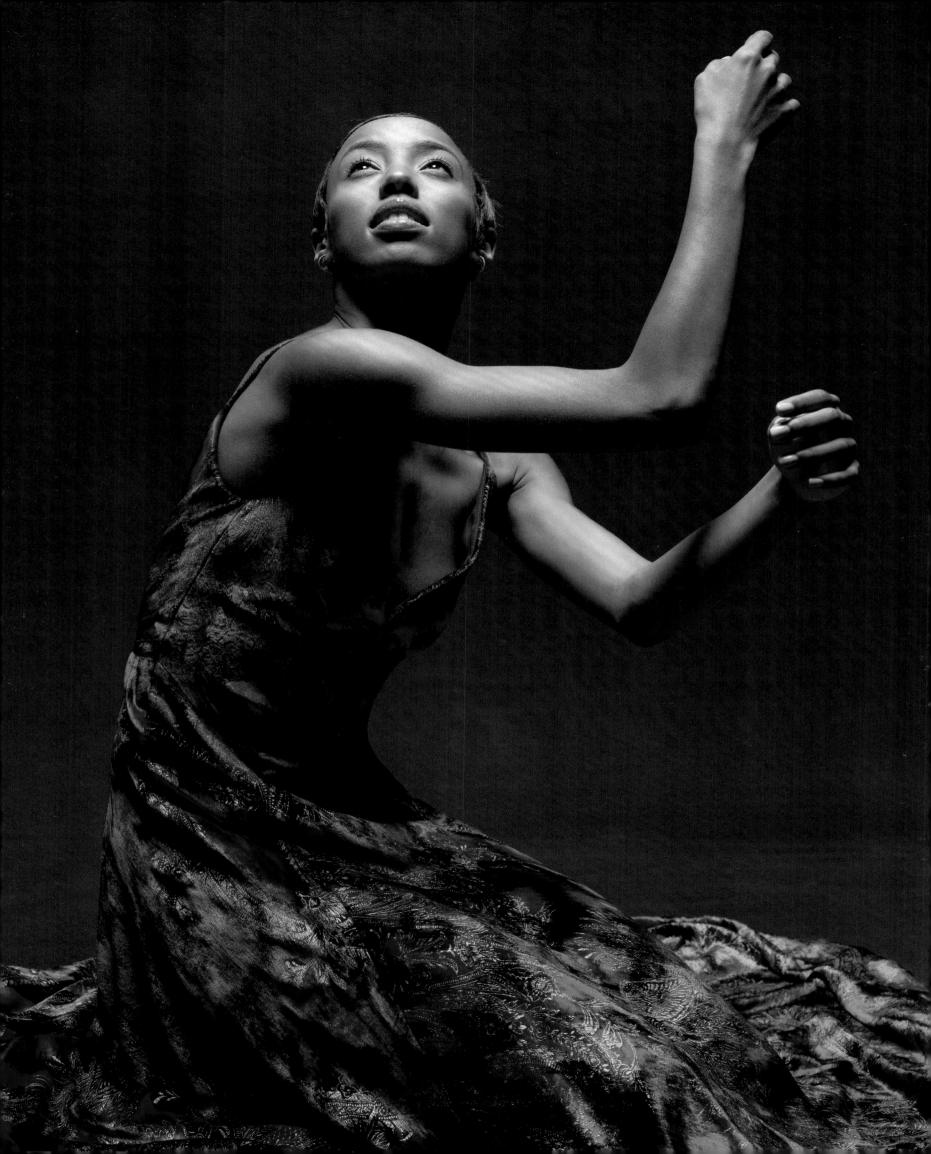

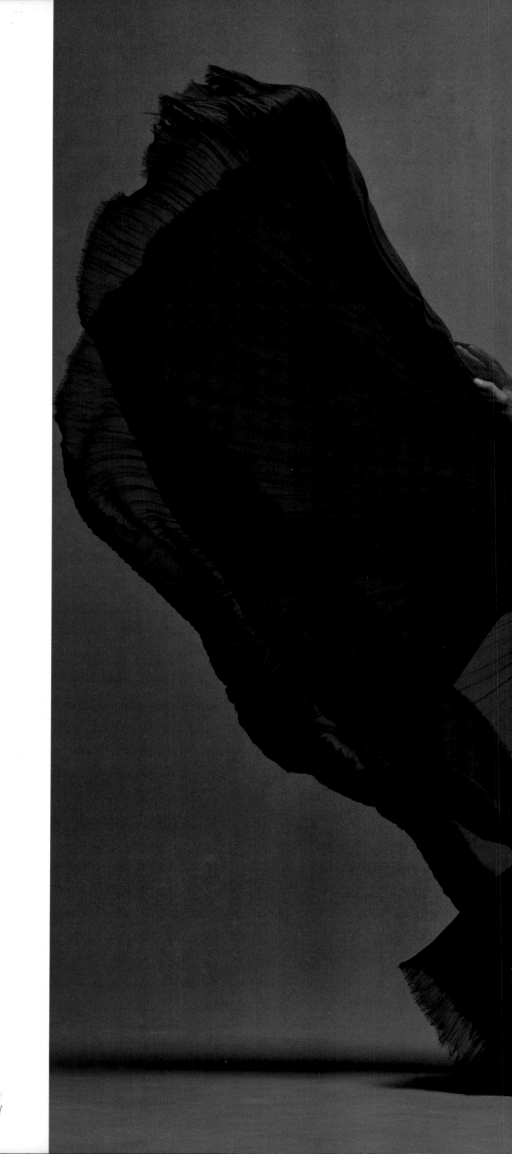

Masha Dashkina Maddux | Principal, Martha Graham Dance Company
Dress by J. Mendel

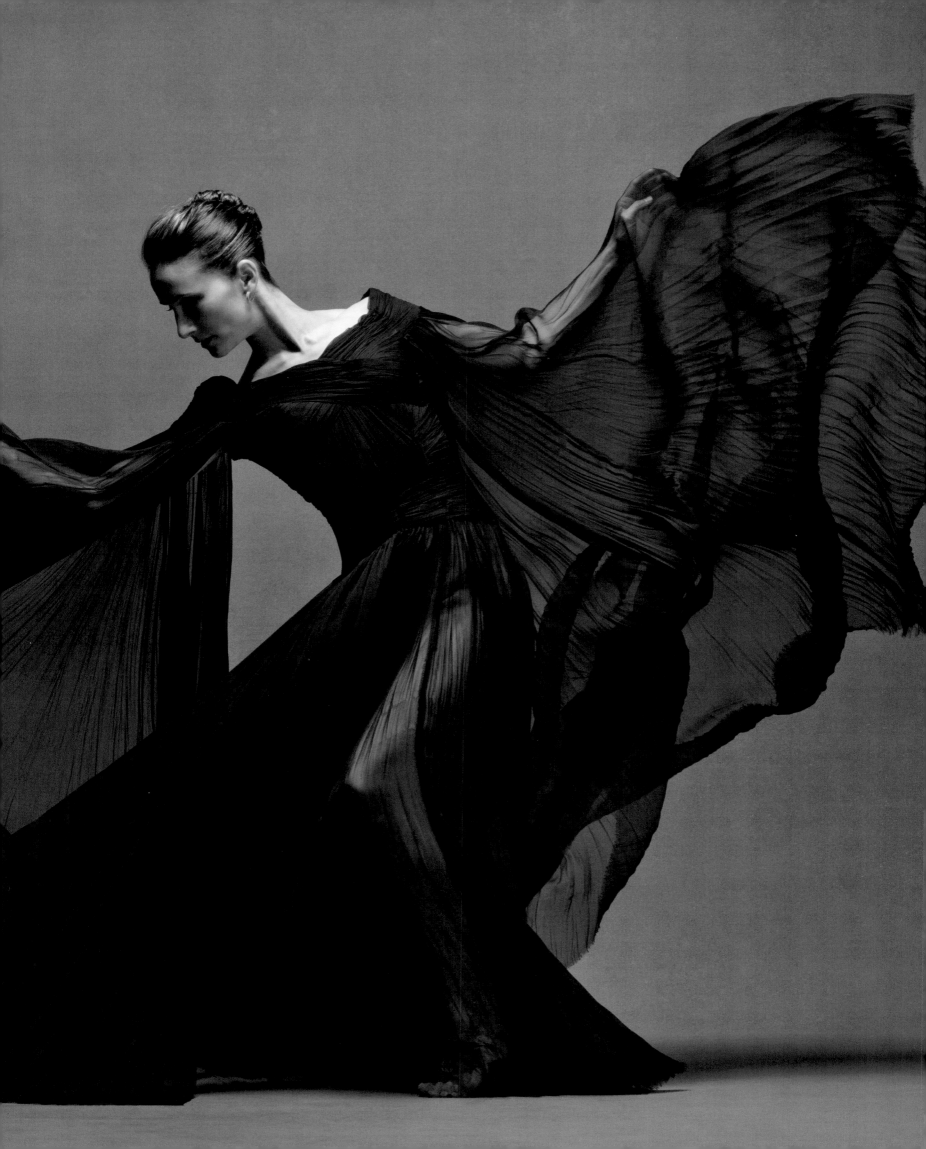

Pontus Lidberg | Choreographer | *Antlers by Pontus Lidberg for* Faune

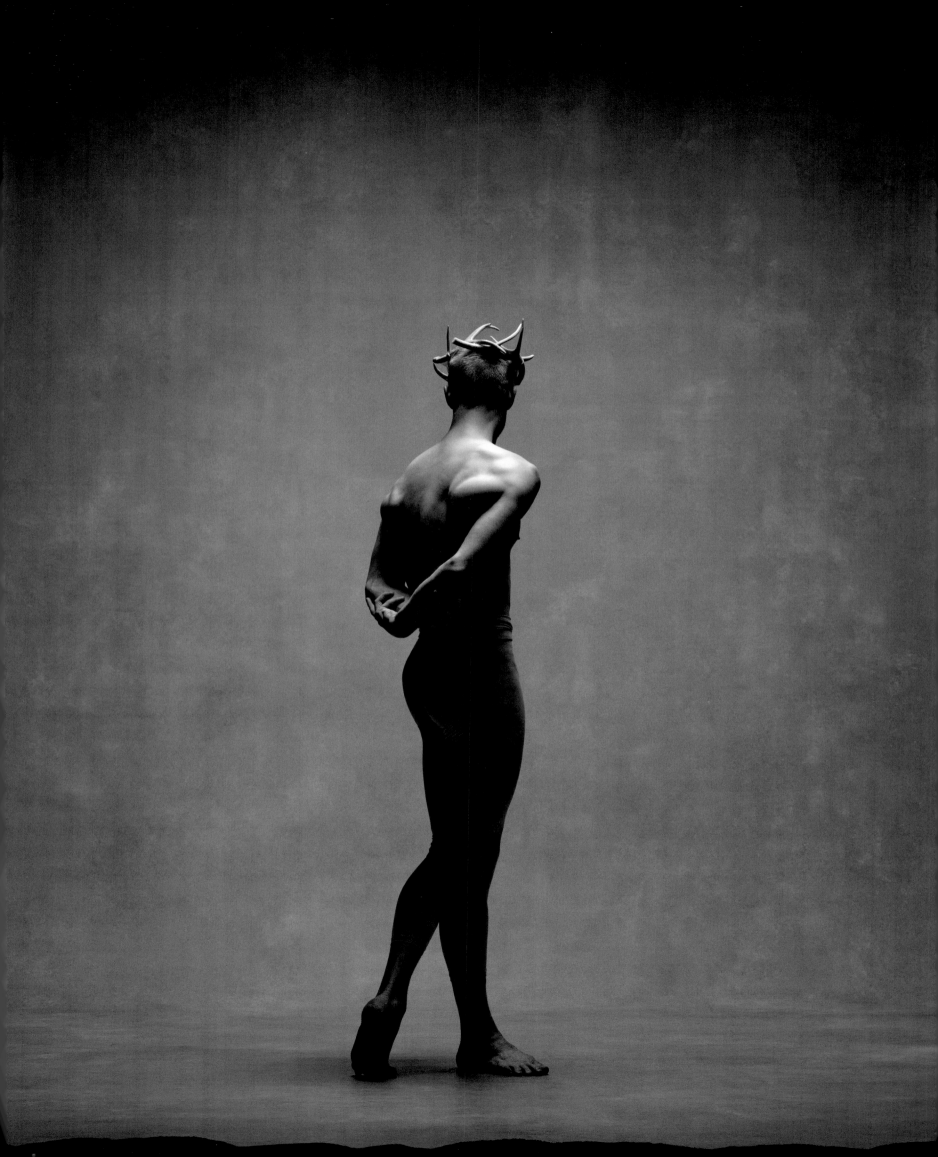

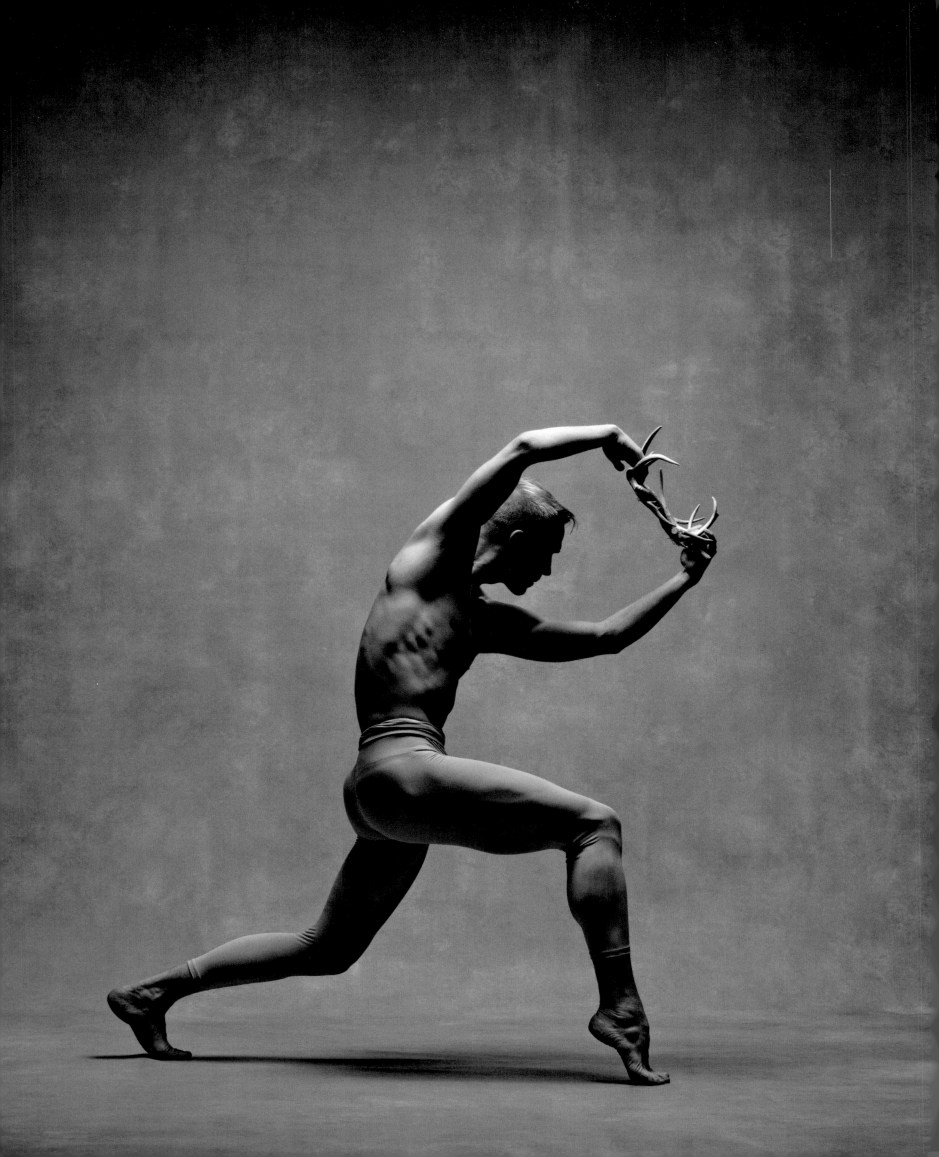

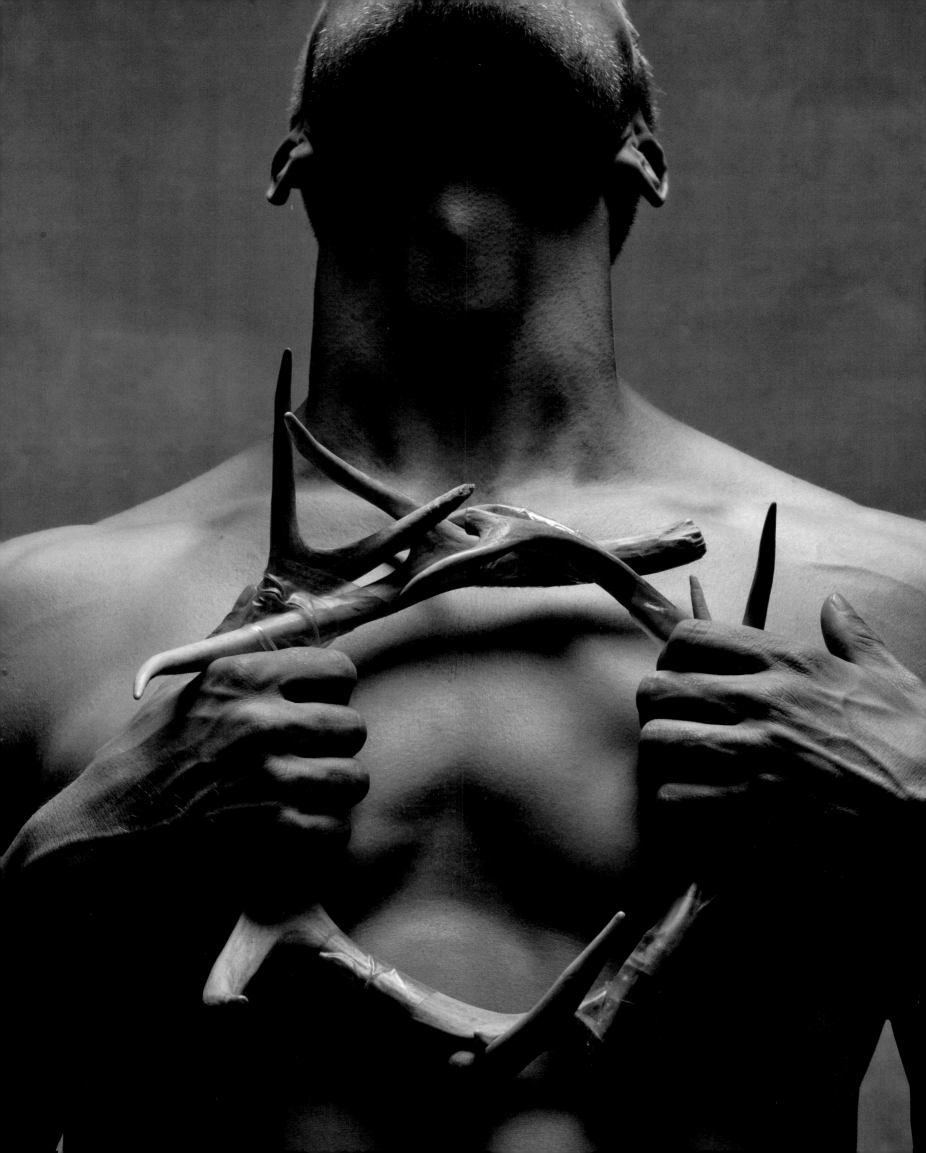

Pontus Lidberg | Choreographer | *Costume by Rachel Quarmby-Spadaccini*

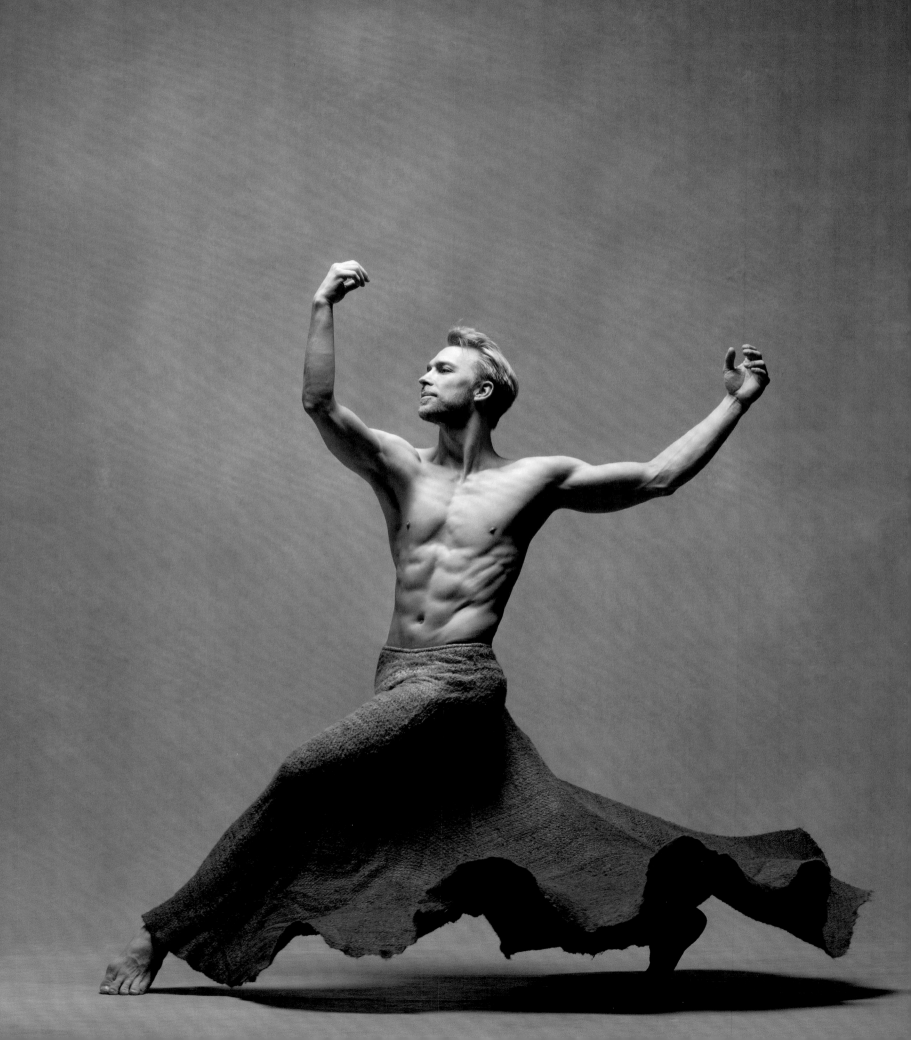

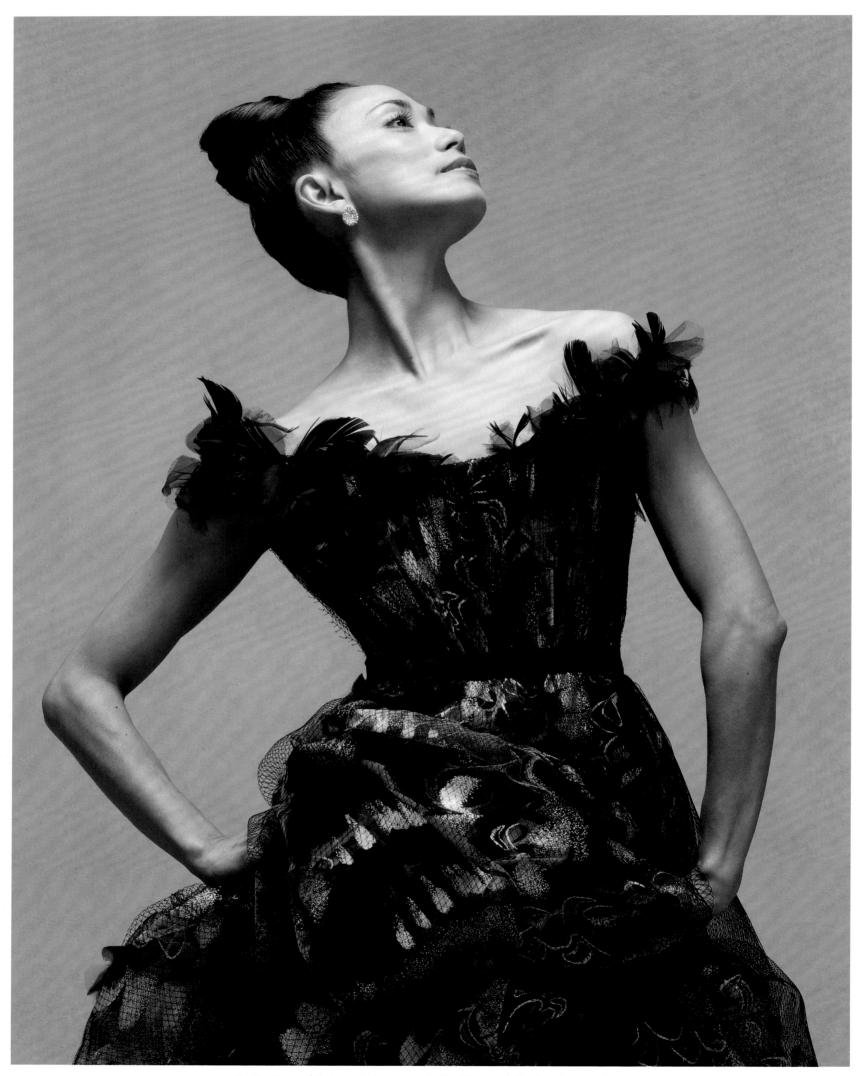

Stella Abrera | Principal, American Ballet Theatre | *Clothing by Marchesa*

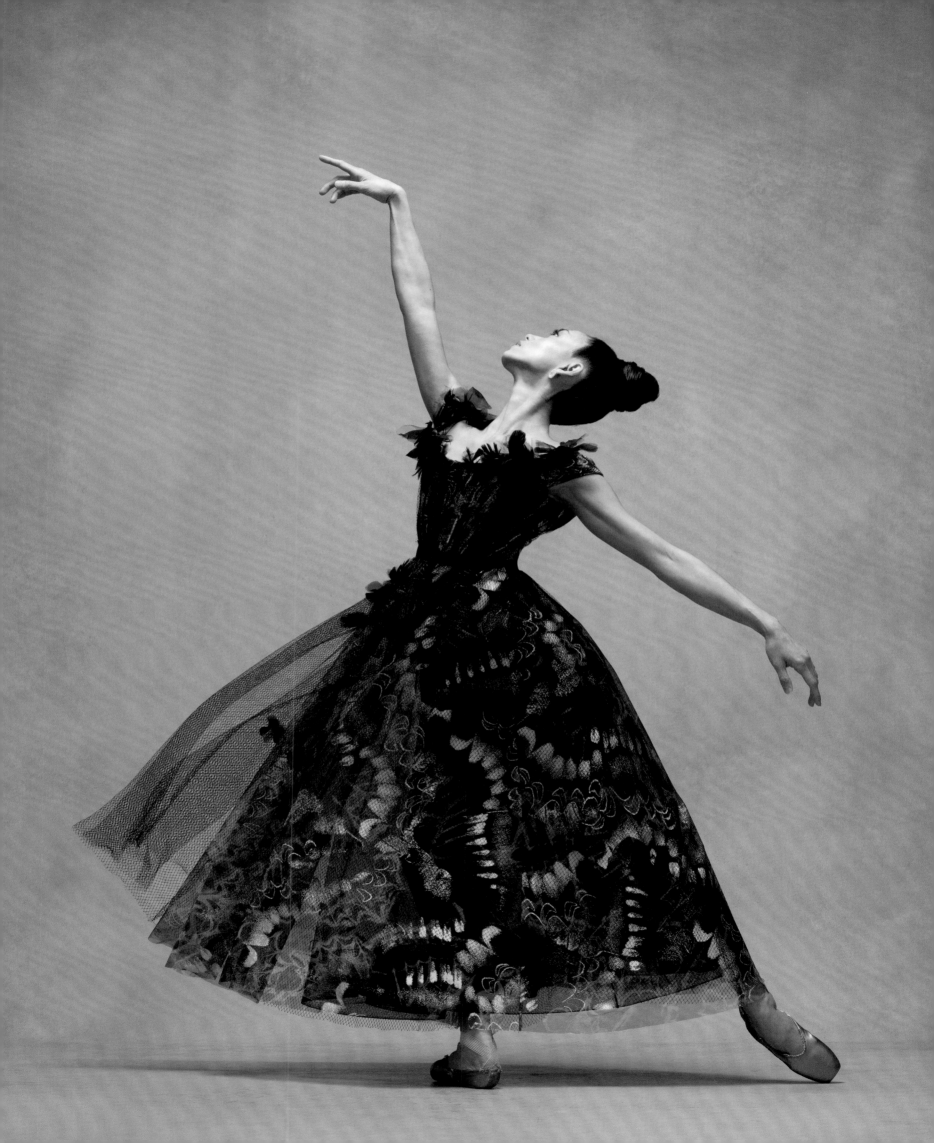

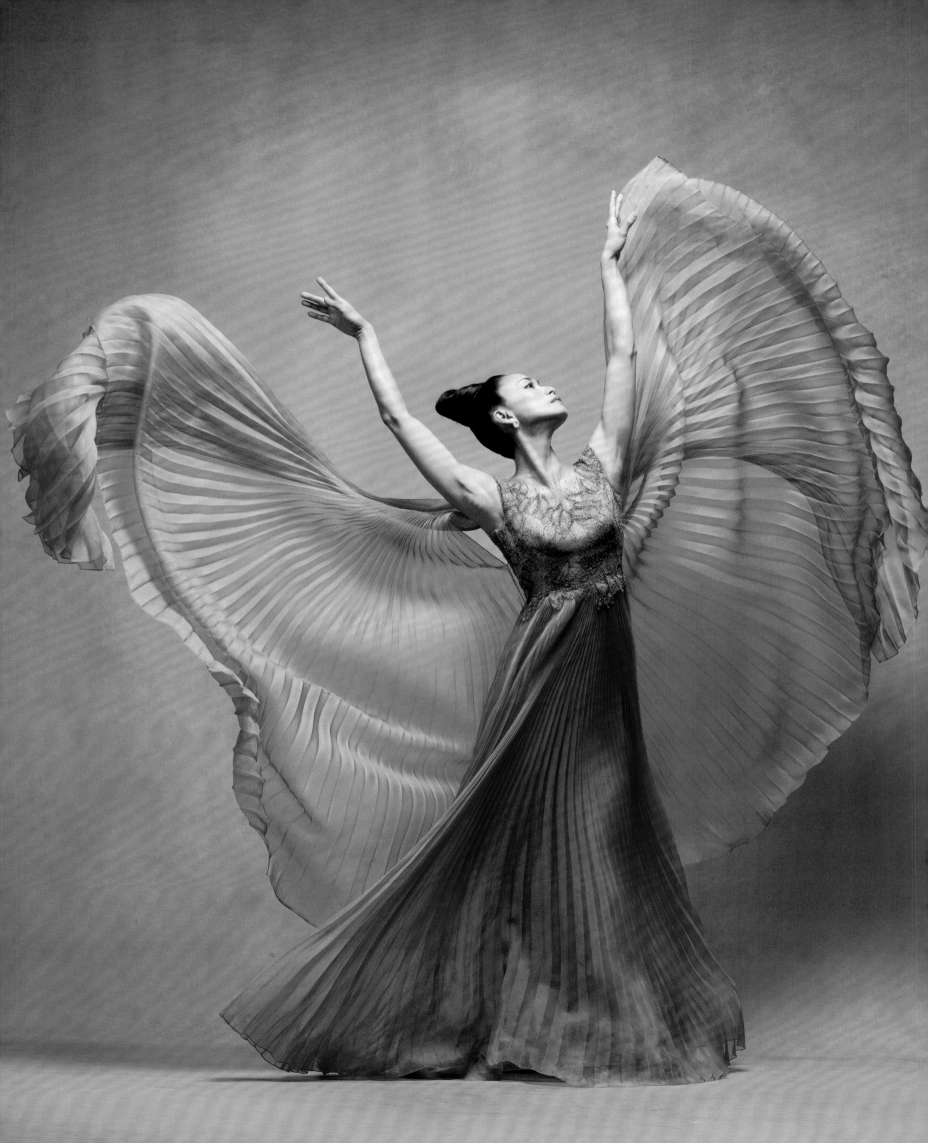

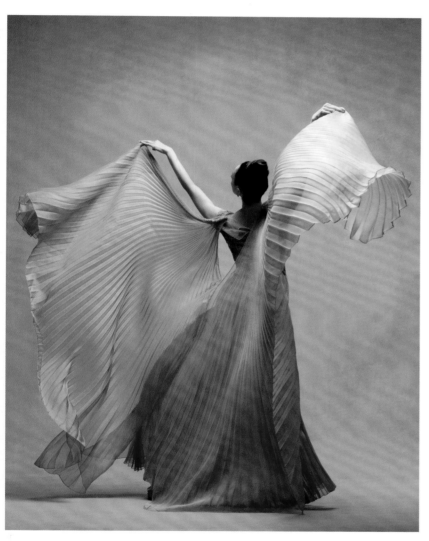
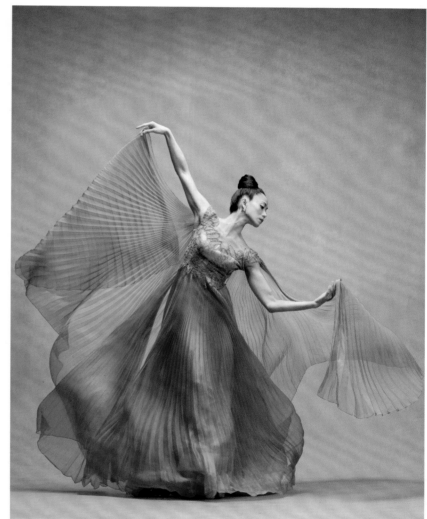

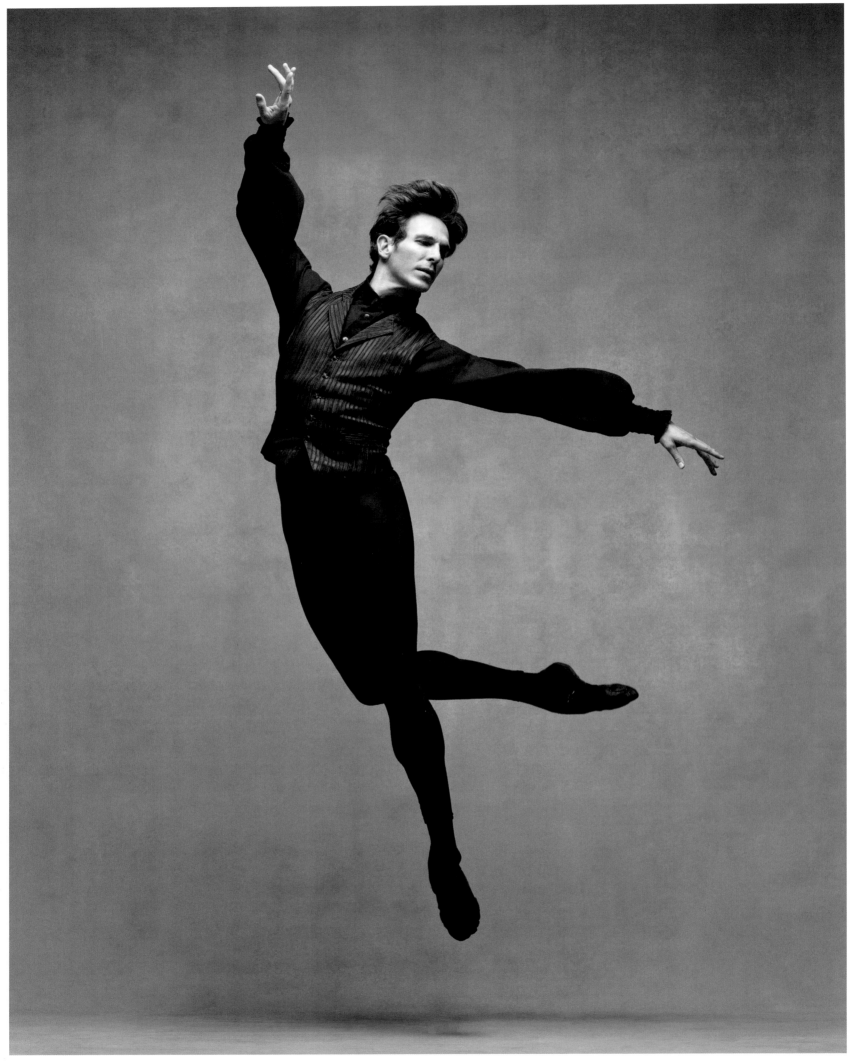

Evan McKie | Principal, National Ballet of Canada and Stuttgart Ballet | *Costume from* Onegin *designed by Santo Loquasto*

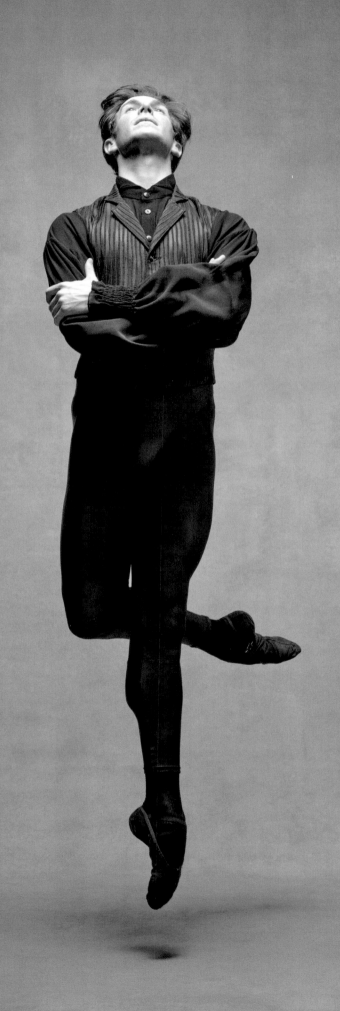

Isadora Loyola, Brittany De Grofft, Paulina Waski | American Ballet Theatre
Clothing by Versace, c. 1985, courtesy New York Vintage

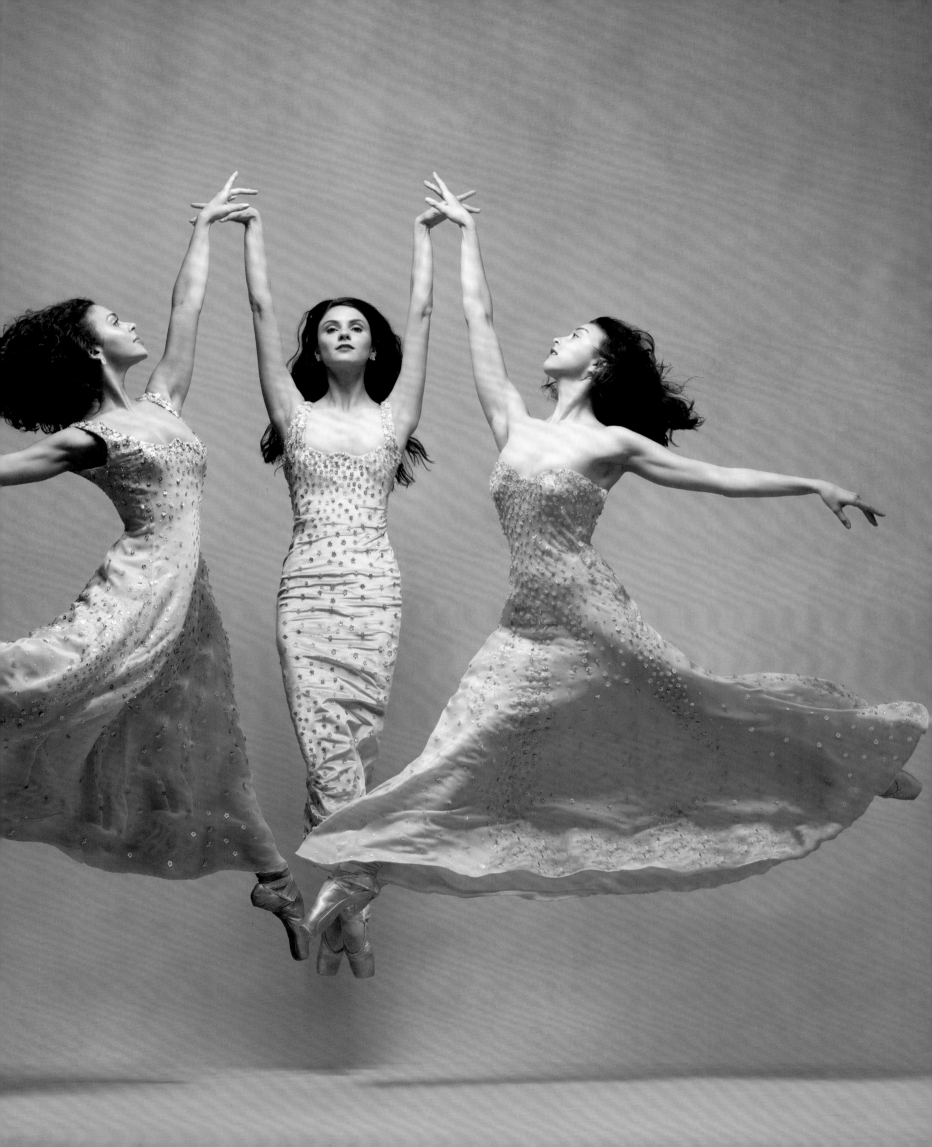

Jonathan Klein | American Ballet Theatre | *Clothing by Paul Smith*

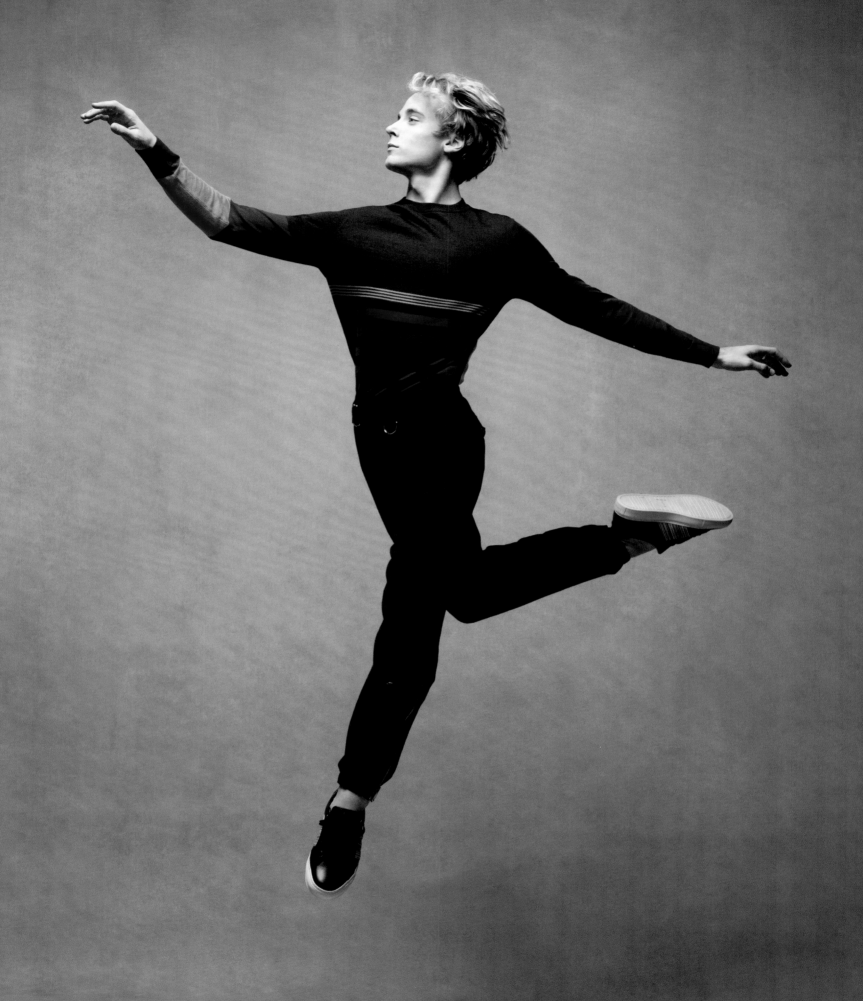

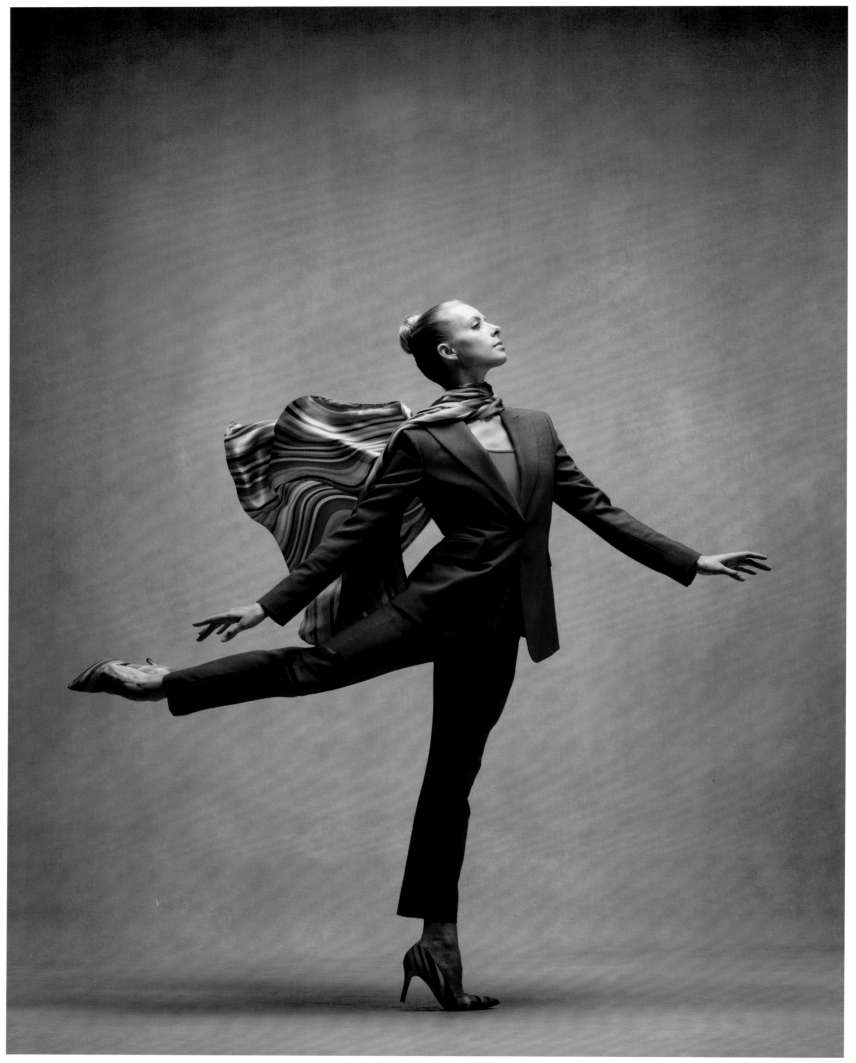

Emily Hayes and **Jonathan Klein** | American Ballet Theatre | *Clothing by Paul Smith*

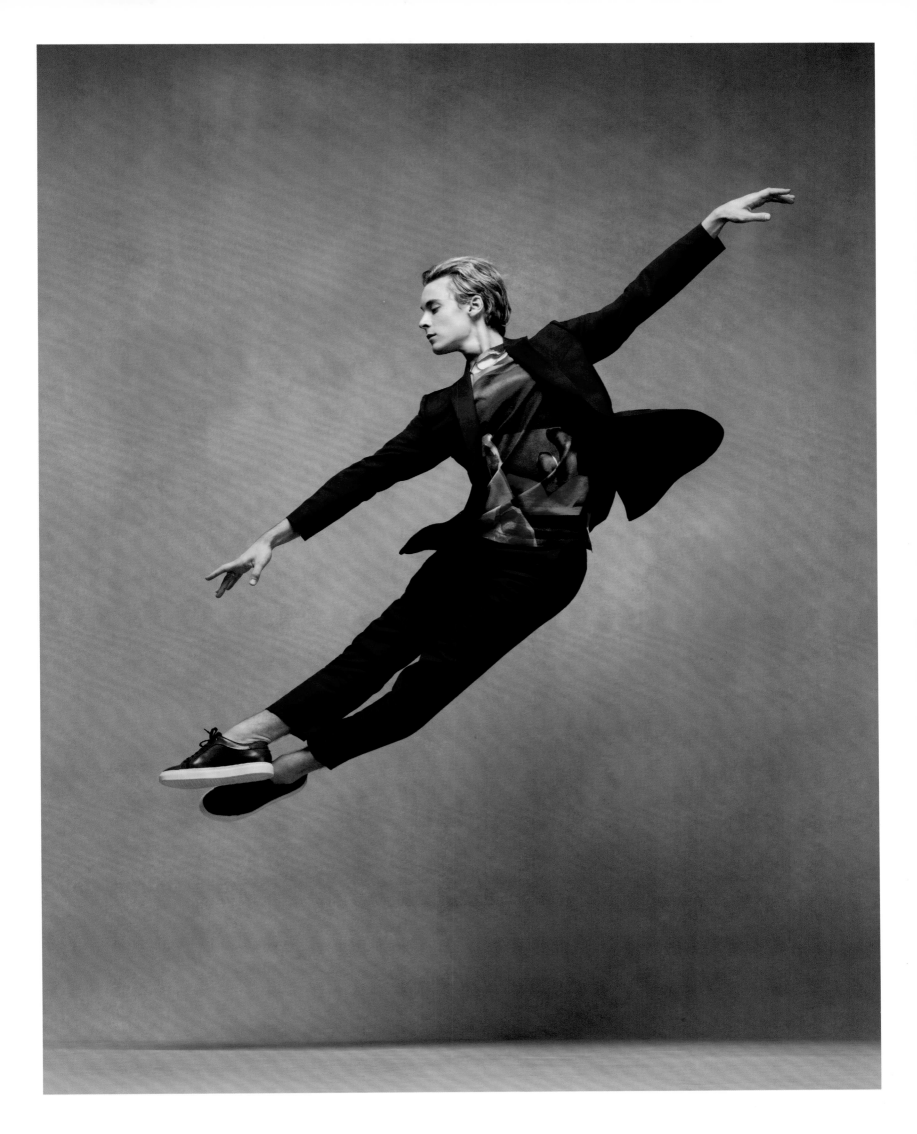

Laura Halzack | Paul Taylor Dance Company | *Silk parachute dress by Norma Kamali*

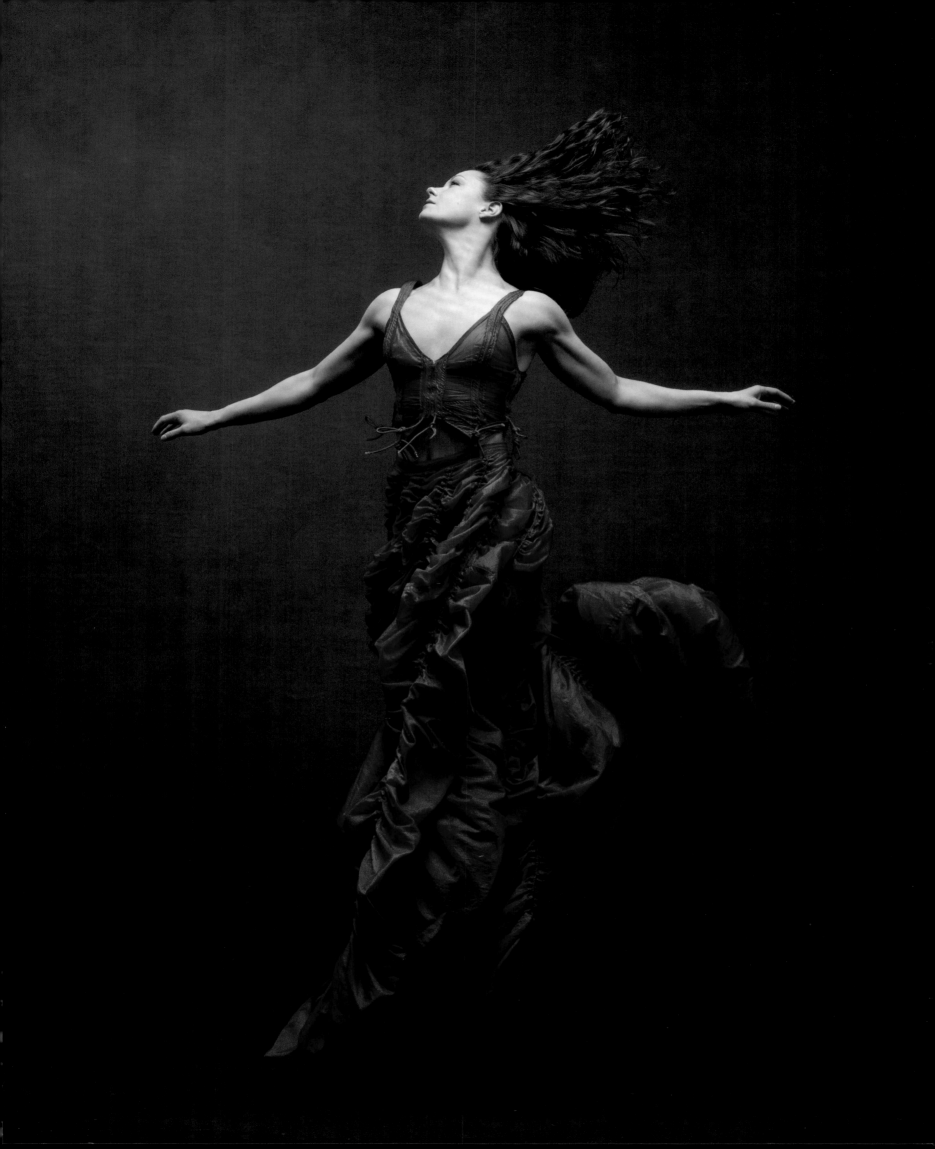

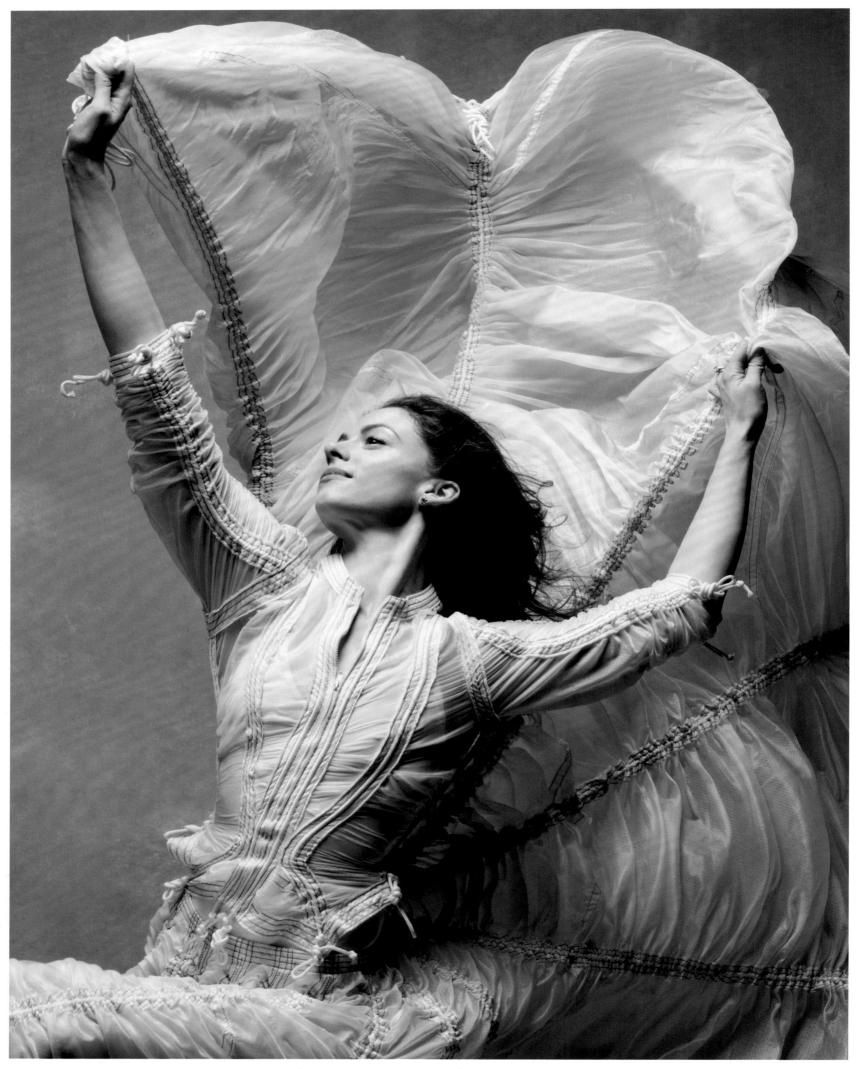

Heather McGinley | Paul Taylor Dance Company | *Silk parachute dress by Norma Kamali*

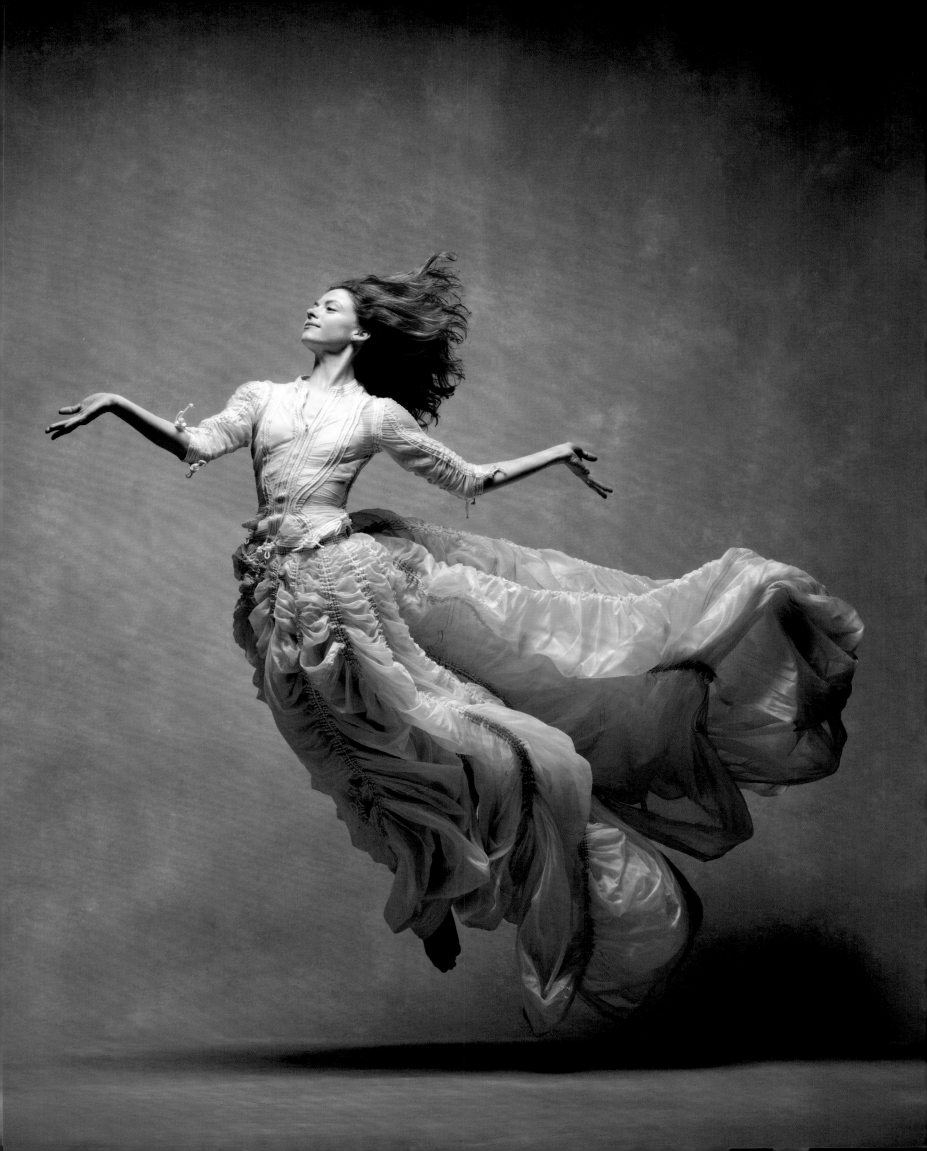

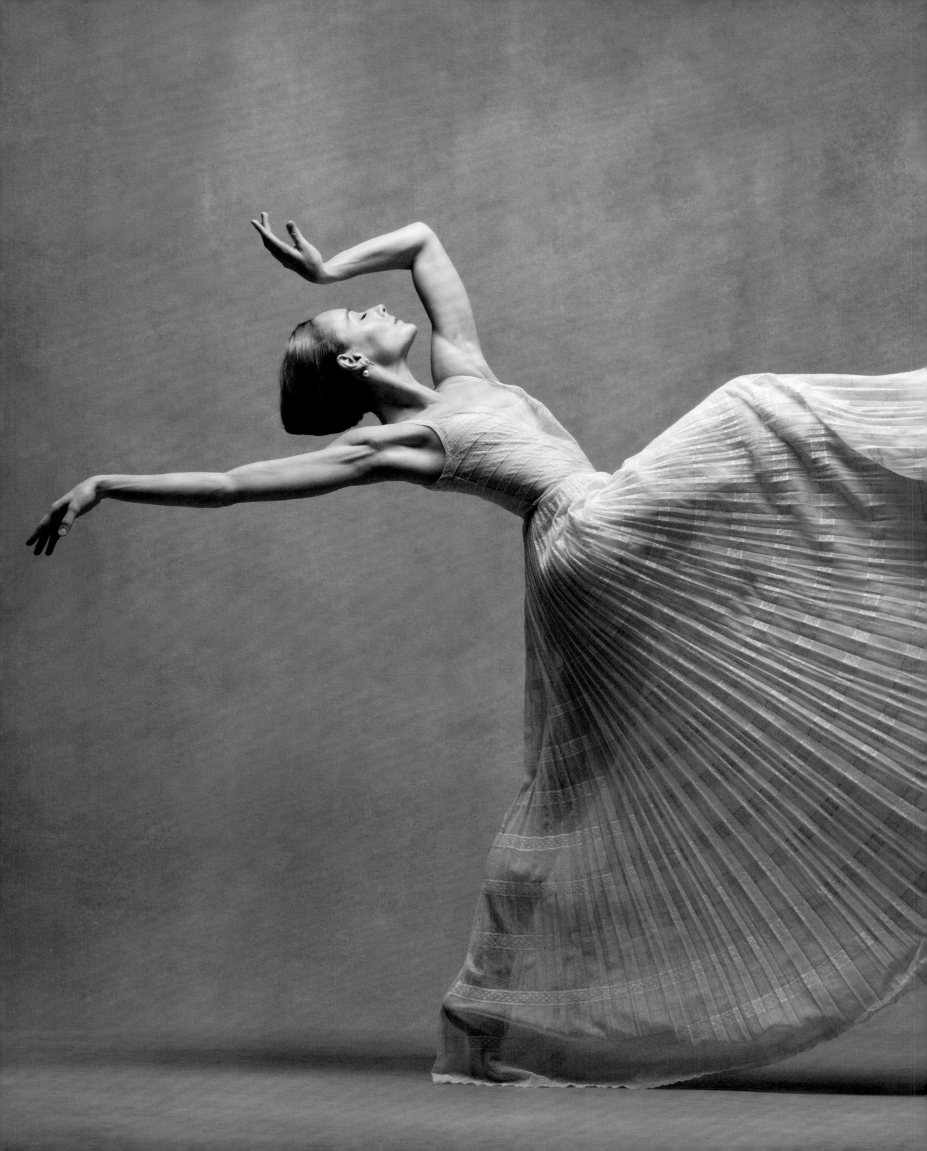

"Dance speaks to the body and freedom; fashion speaks to the same."

—MARIA GRAZIA CHIURI, ARTISTIC DIRECTOR, DIOR

Charlotte Landreau | Soloist, Martha Graham Dance Company | *Dress by Dior*

PeiJu Chien-Pott | Prinicpal, Martha Graham Dance Company | *Dress by Dior*

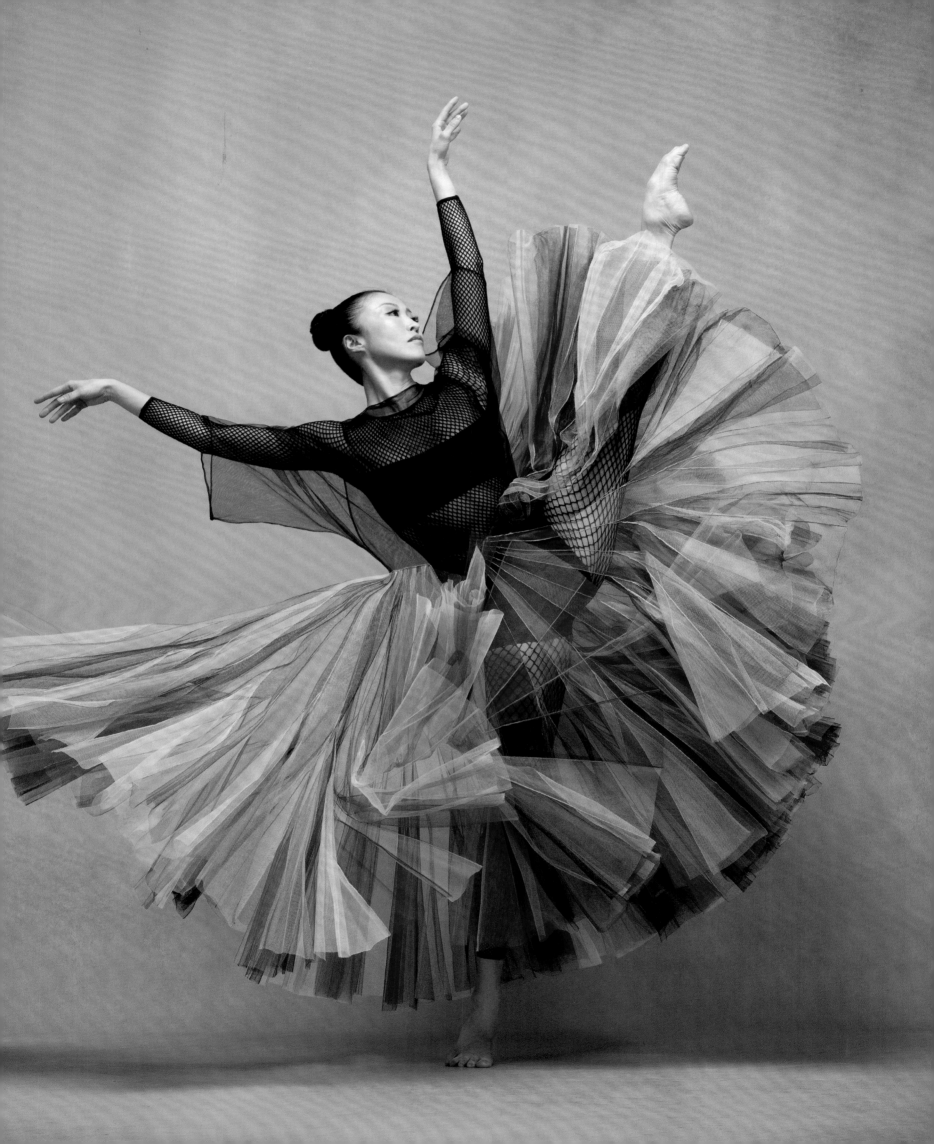

"Costume designer William Ivey Long once told me,
'When in doubt, Cary Grant.'
I always loved looks that are timeless."

—MICHAEL NOVAK

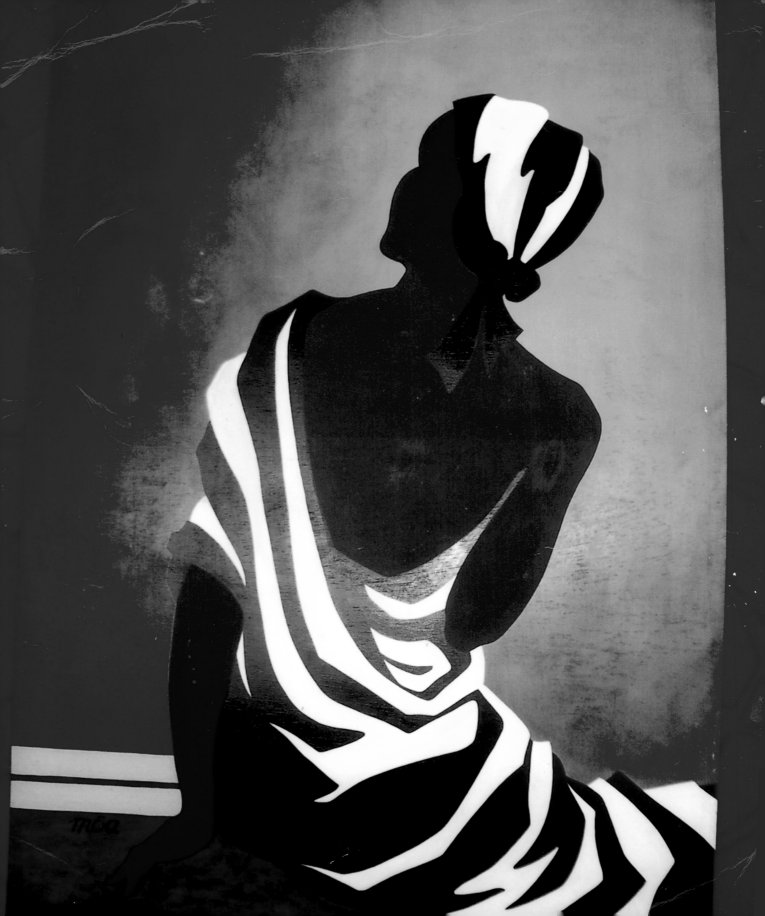

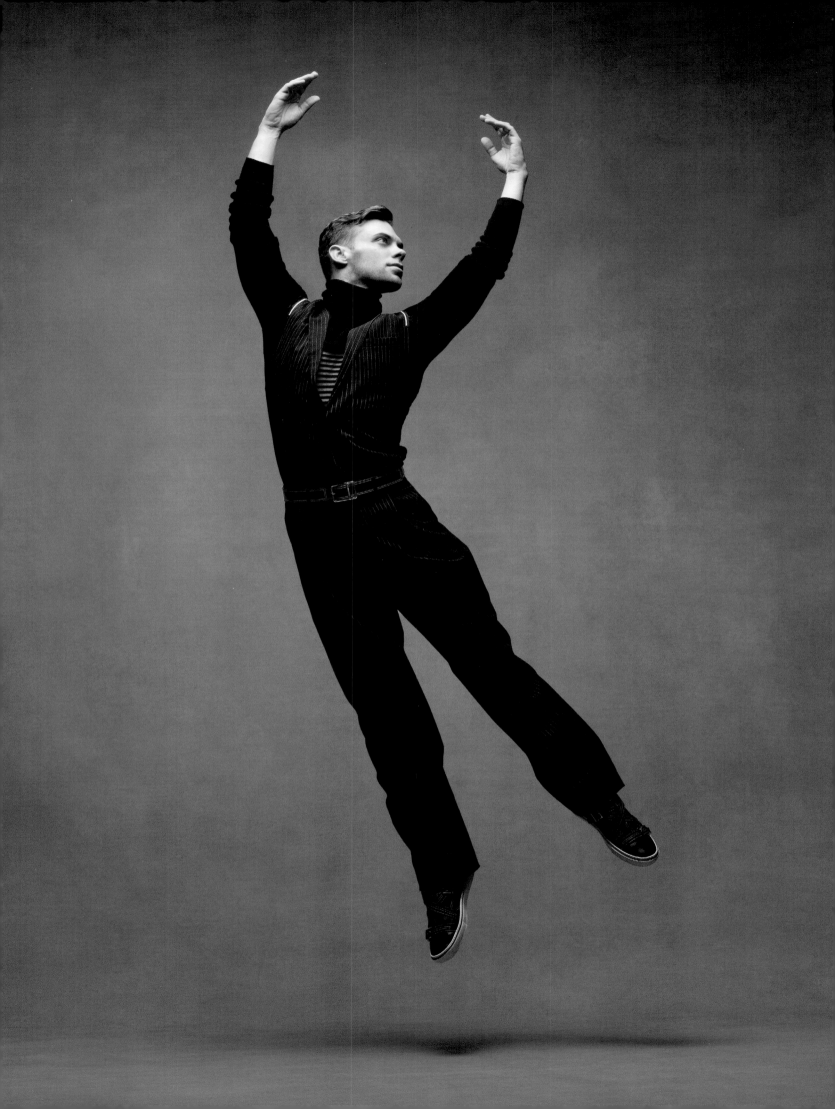

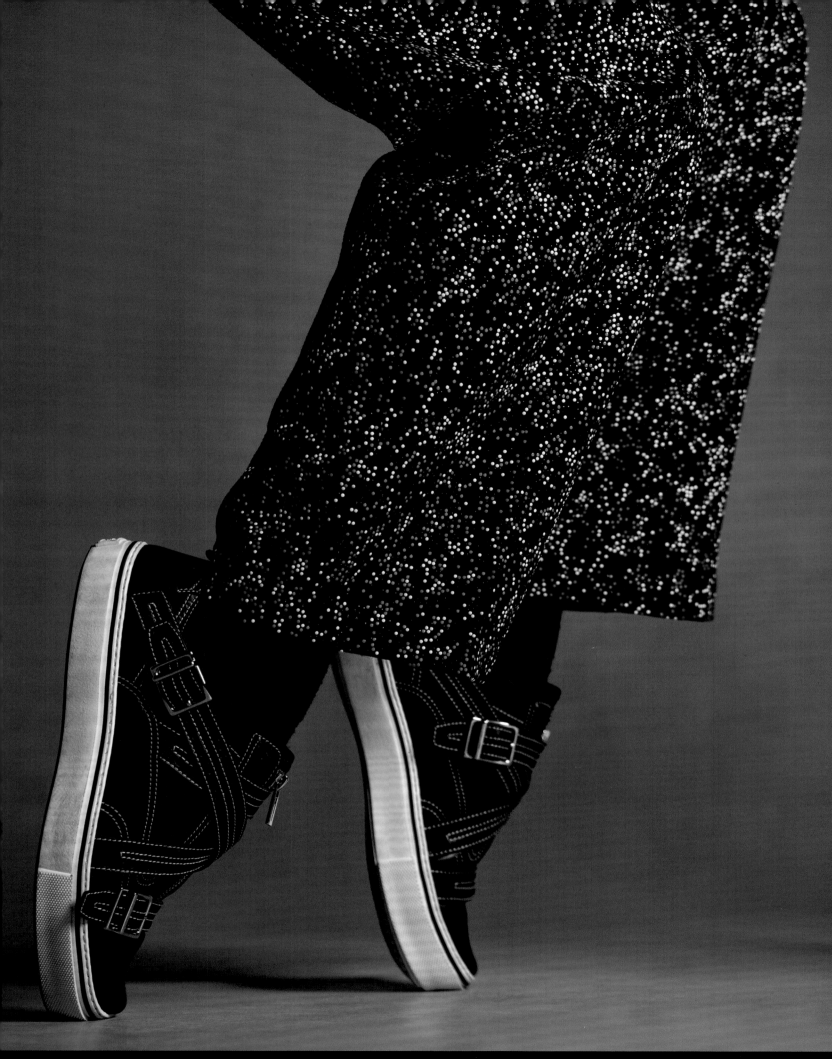

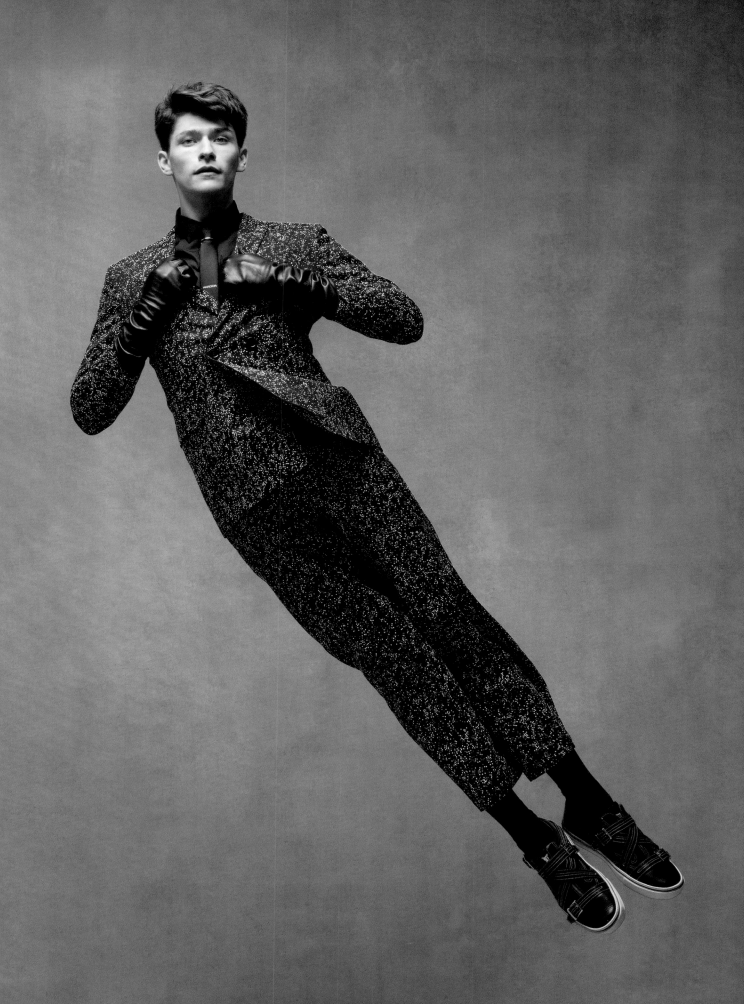

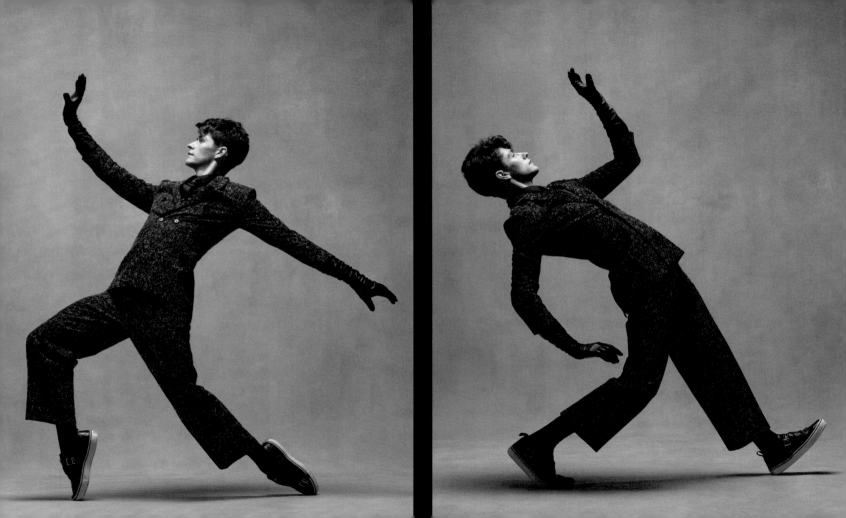

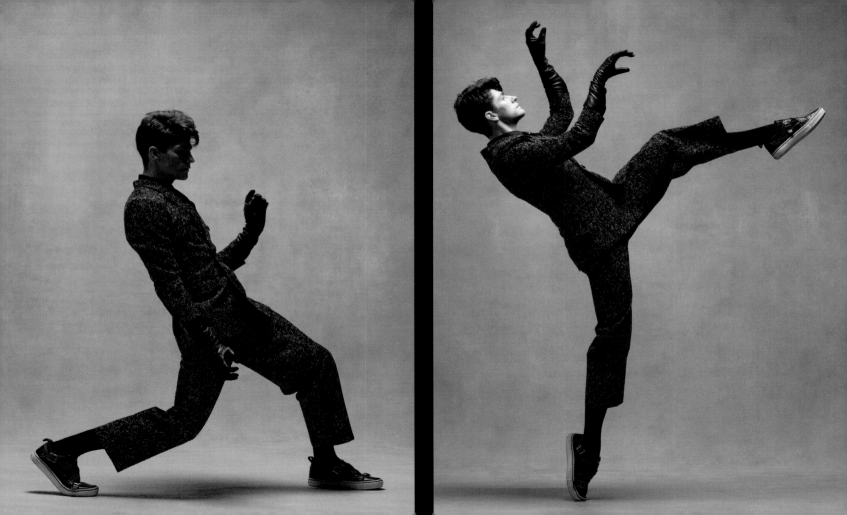

Anne Souder | Soloist, Martha Graham Dance Company | *Clothing by Naeem Khan*

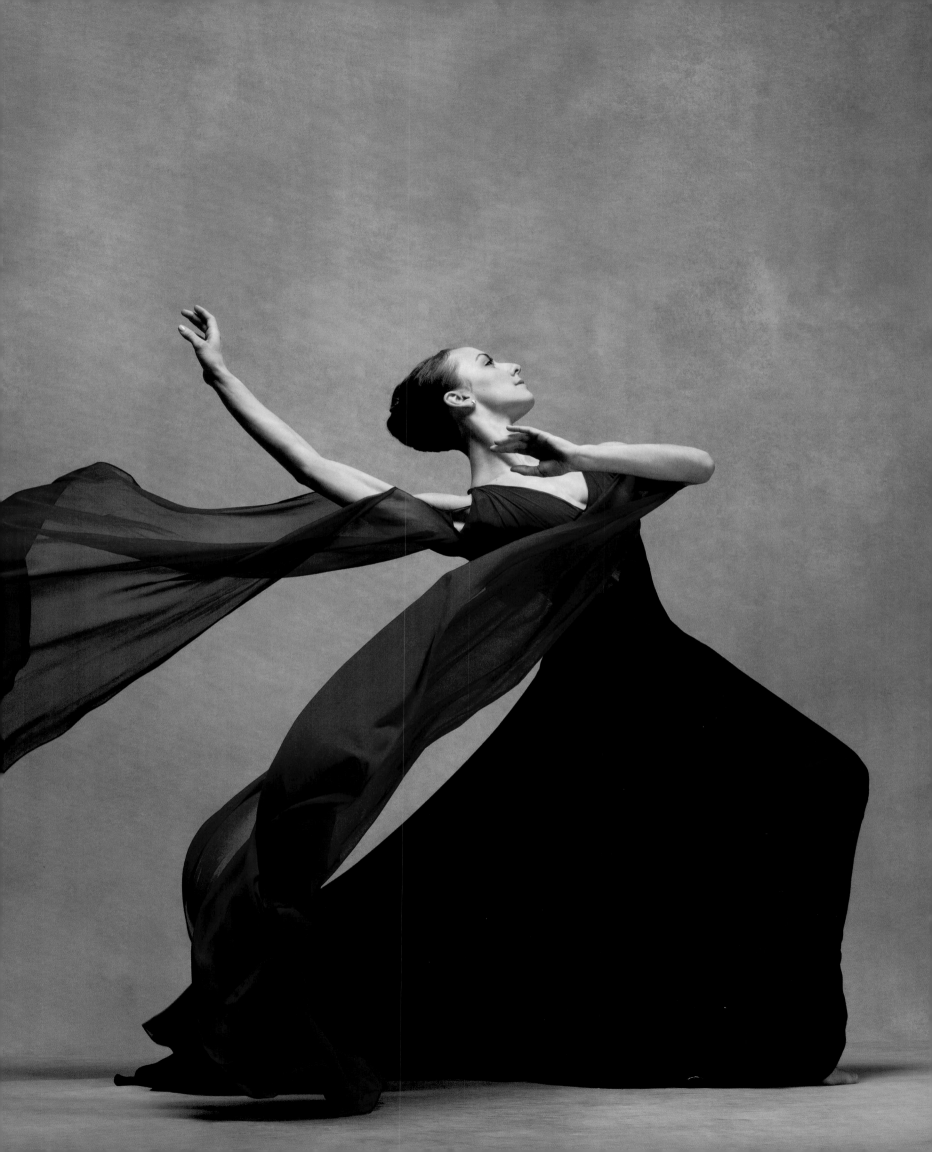

"It always touches me to see a creation in action.
The movement of the dress, the sound it makes,
the light and shadow, its adherence to the anatomy
of the body: all this was my purpose when I designed it.
It is a drawing that comes to reality, alive and kicking."

—PIERPAOLO PICCIOLI, CREATIVE DIRECTOR, VALENTINO

Tiler Peck | Principal, New York City Ballet | *Clothing by Valentino*

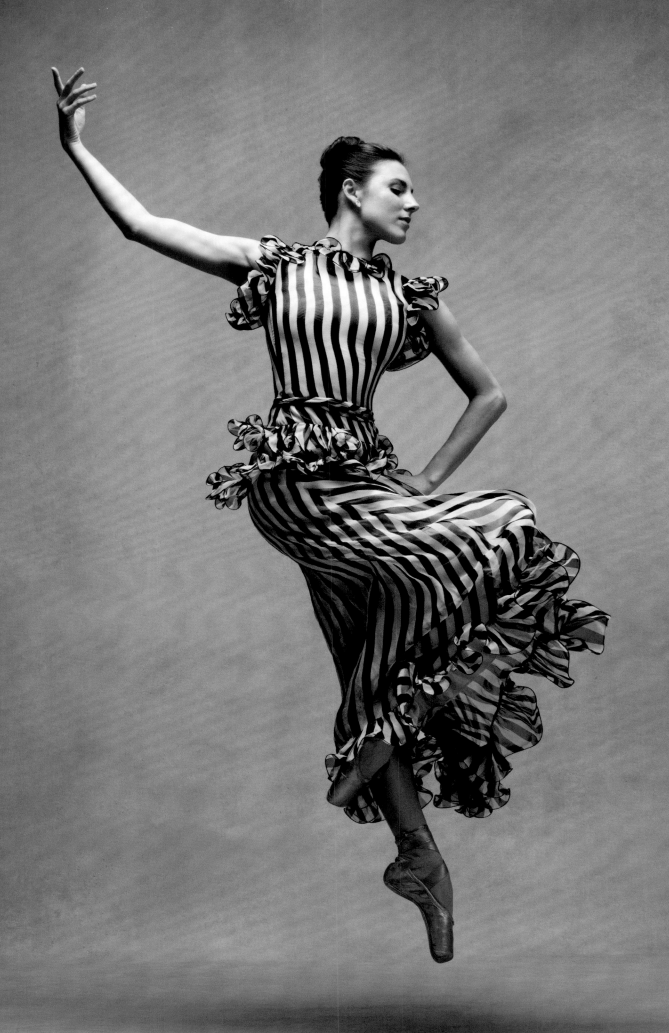

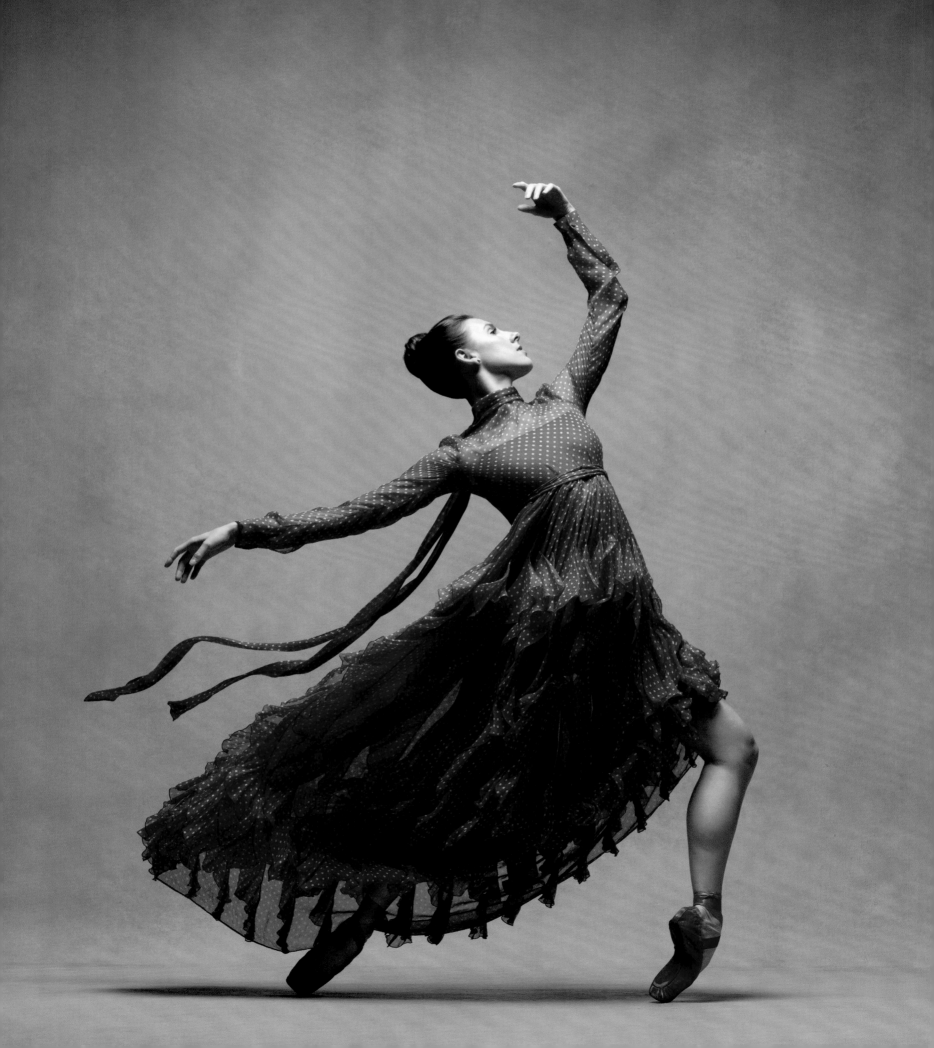

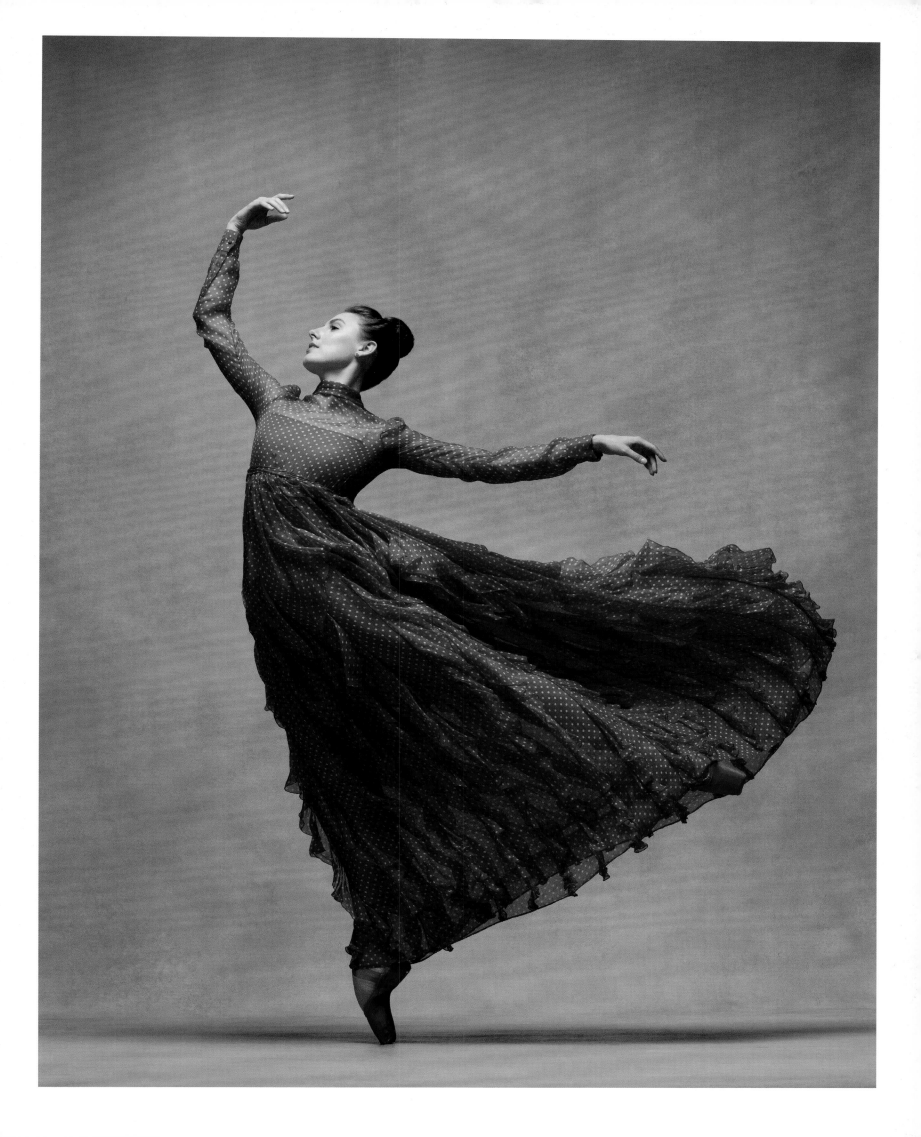

"Dance emphasizes the volumes and the lightness of a dress, it expresses all its possibilities, those shapes that the static vision cannot reveal. The movement also alters the perception of the color, giving value to the creation, making it more complex and interesting."

—PIERPAOLO PICCIOLI, CREATIVE DIRECTOR, VALENTINO

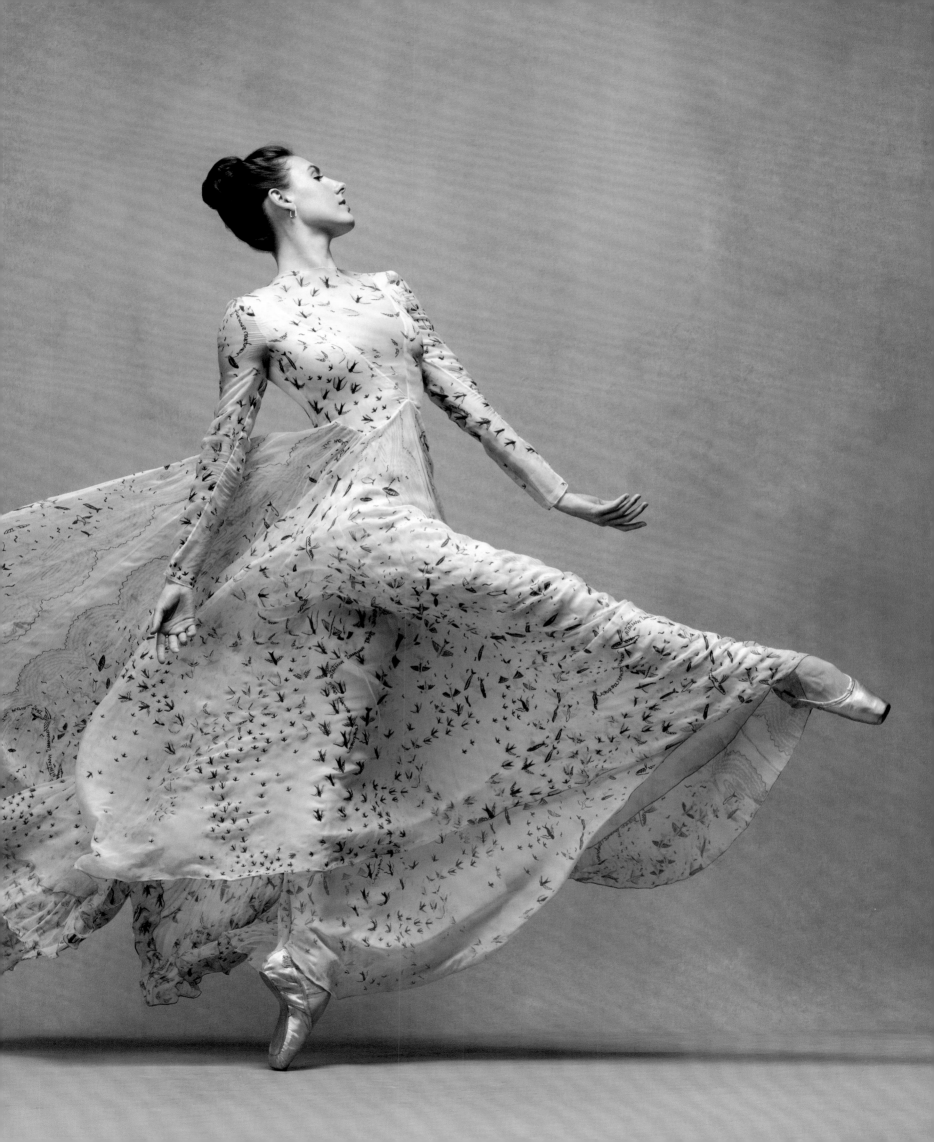

"Sometimes you just have to let your clothes speak for themselves."

—DANIIL SIMKIN

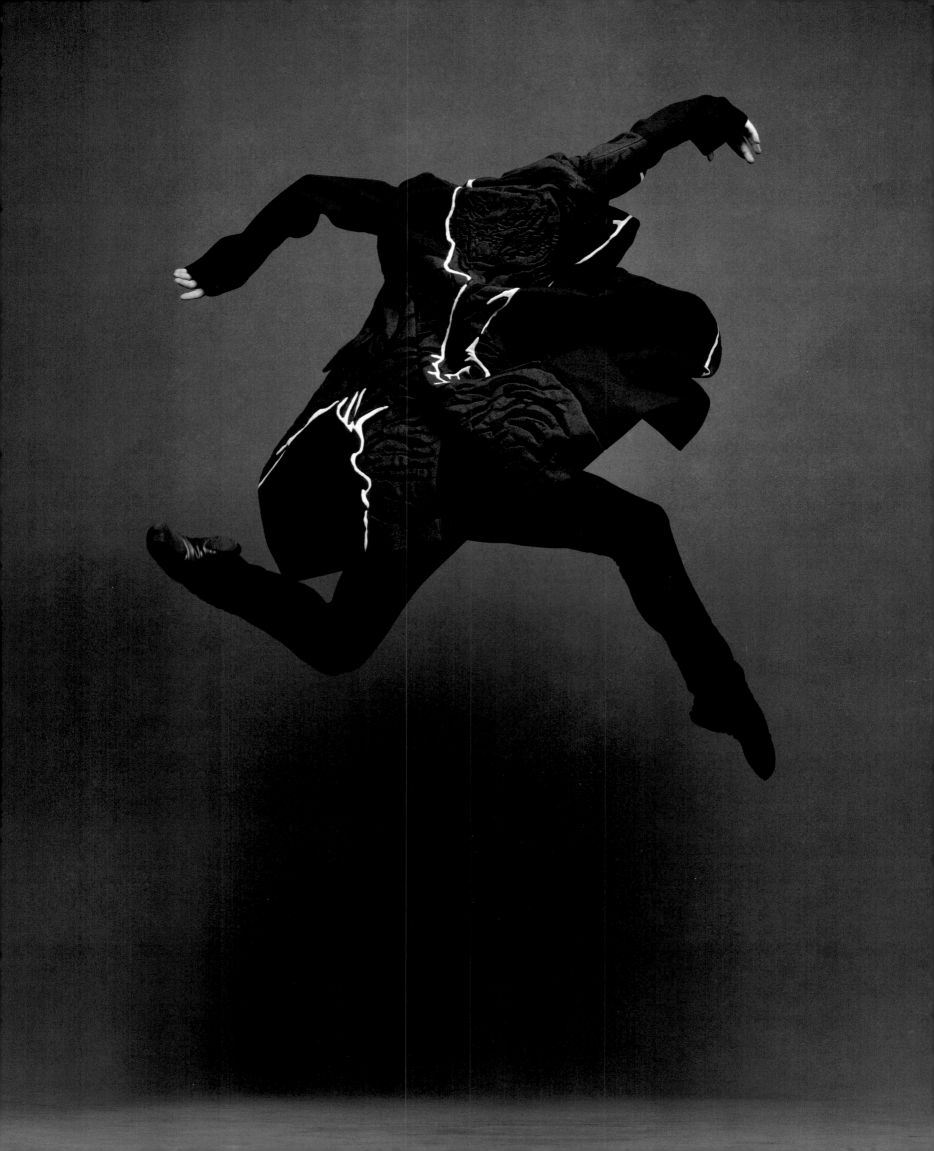

"Your style should reflect and match what you're feeling on the inside. And the way I feel on the inside right now is high-waisted pants, a t-shirt, and white sneakers. Just like Gene Kelly!"

—GAREN SCRIBNER

Garen Scribner | *Costumes by Bob Crowley for* An American in Paris

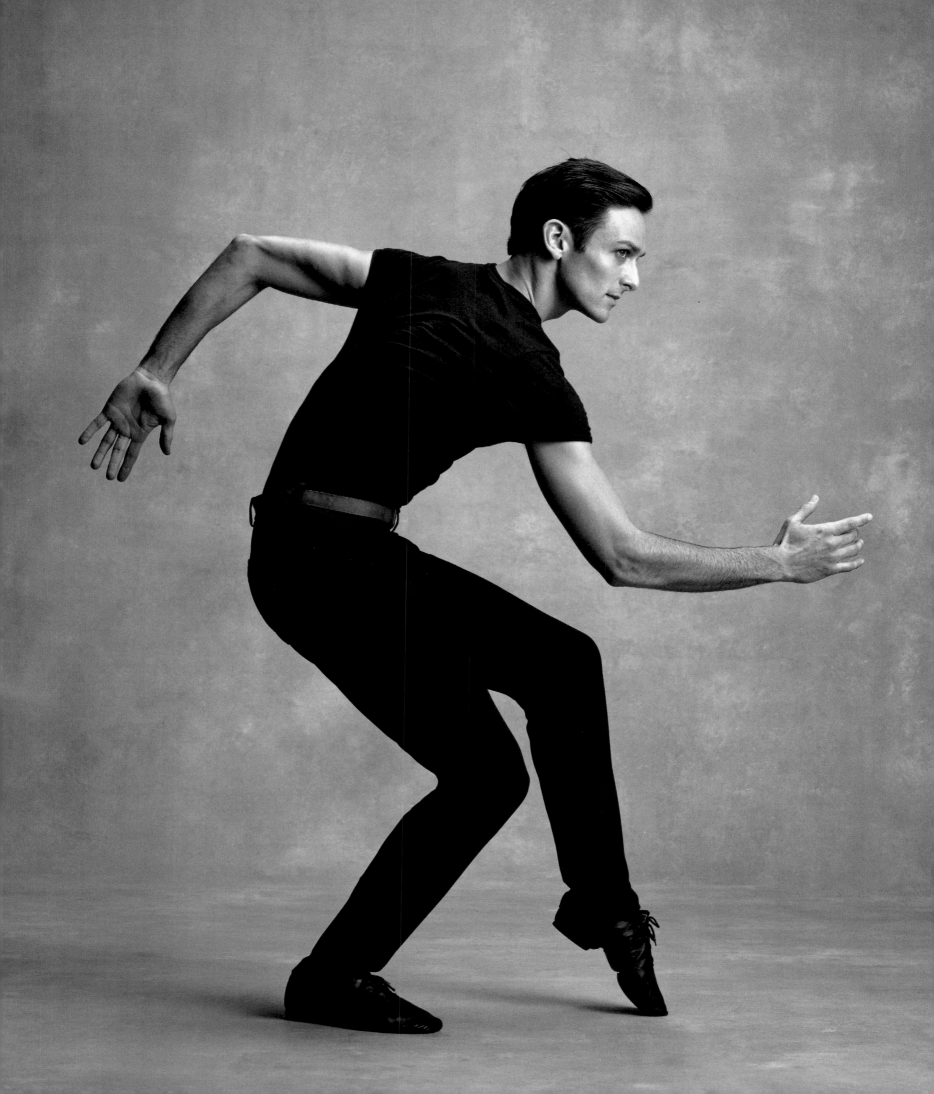

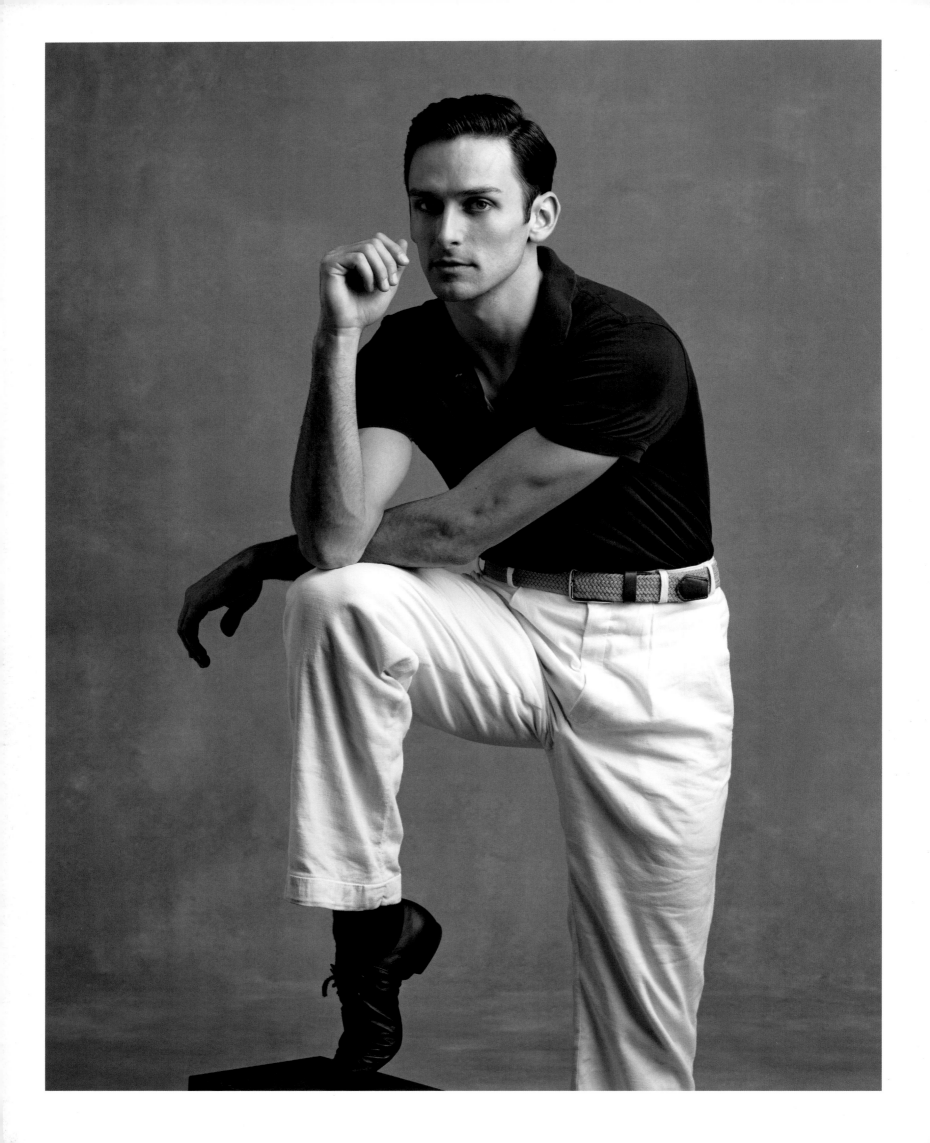

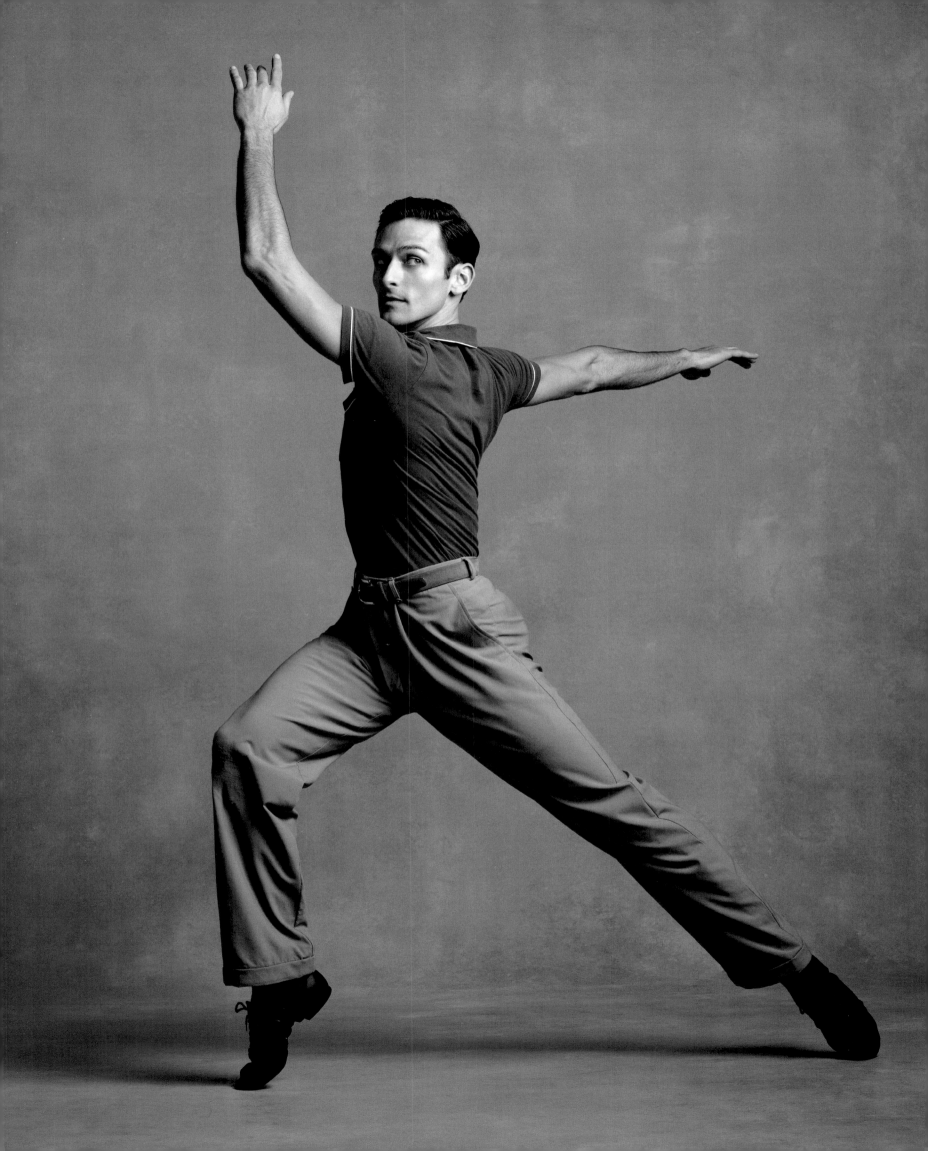

"The dress must follow the body of a woman,
not the body following the shape of the dress."

—HUBERT DE GIVENCHY

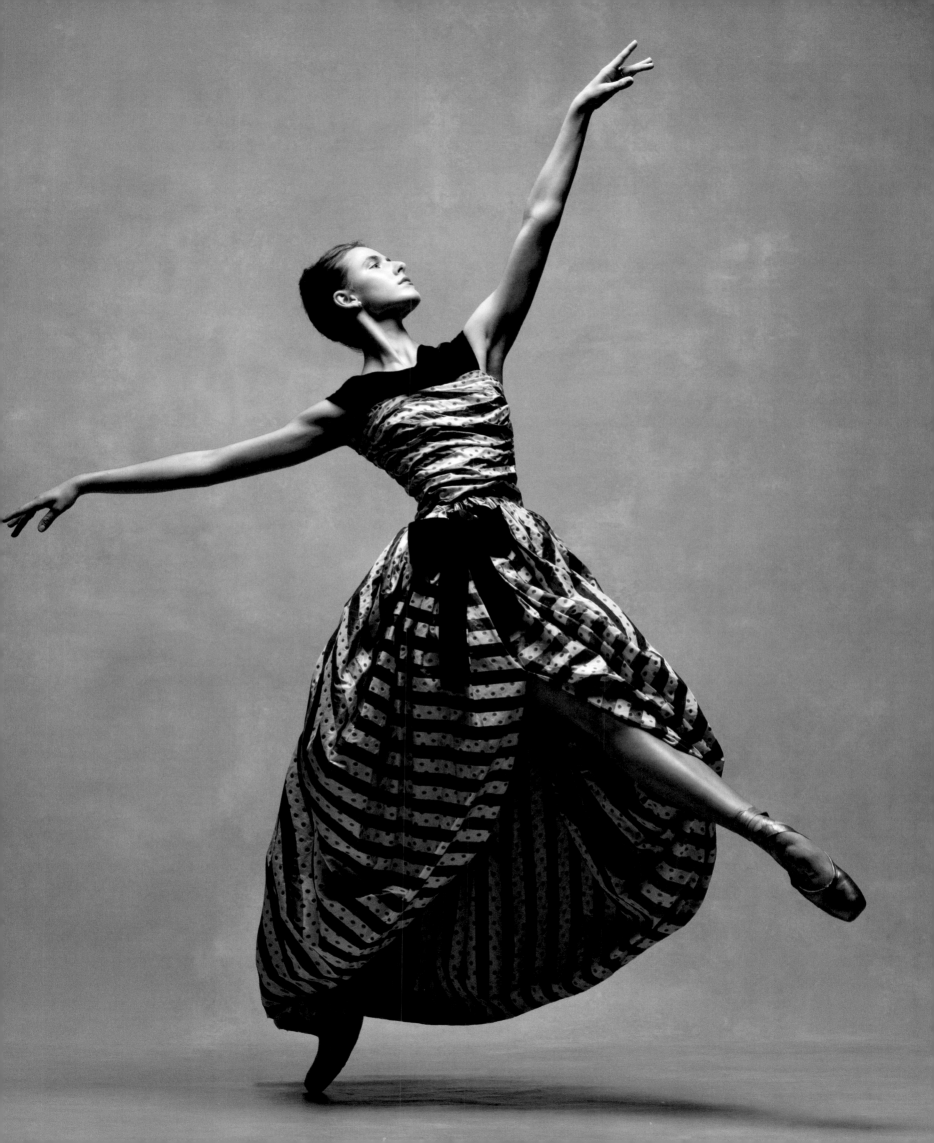

Tina Pereira | First Soloist, National Ballet of Canada | *Vintage dress courtesy New York Vintage*

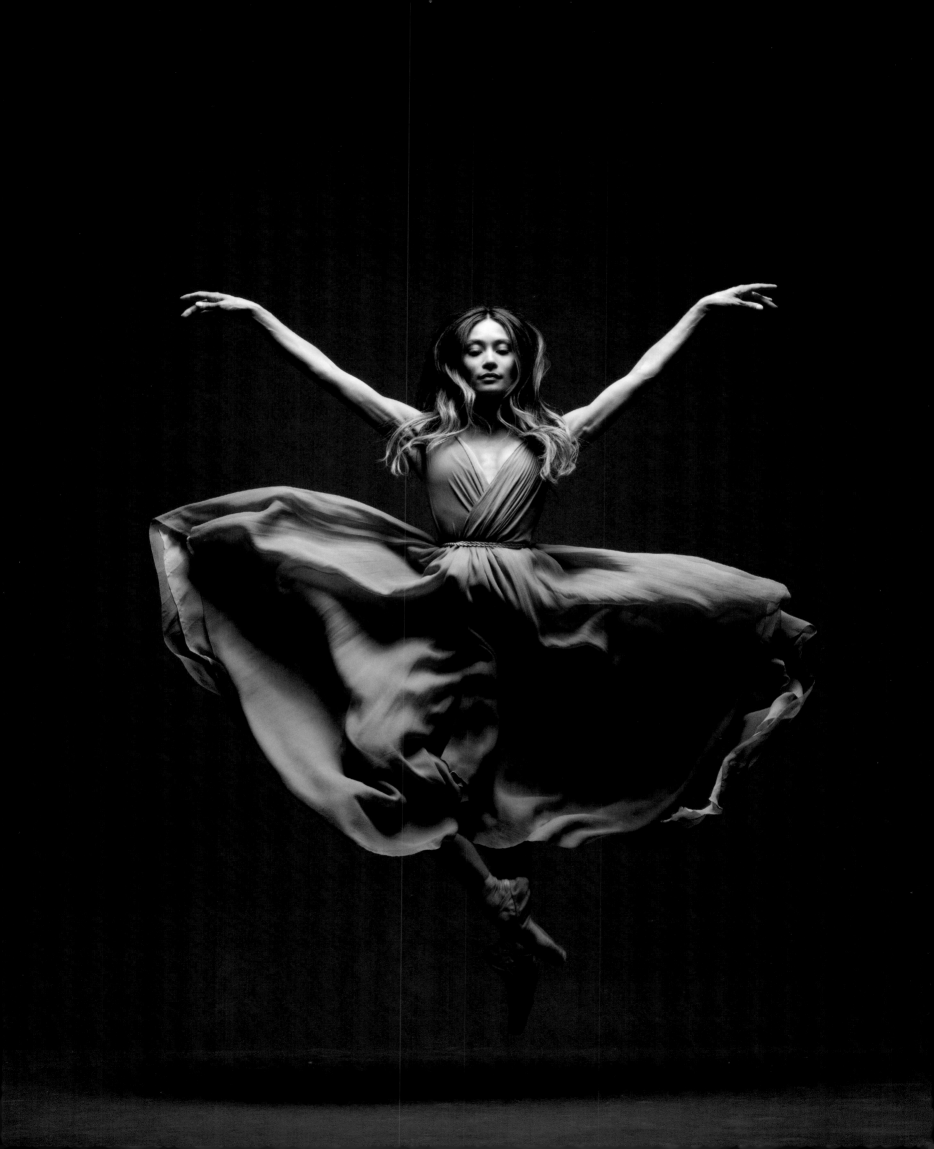

Alexander Hammoudi, Joo Won Ahn, Jonathan Klein, Bruce Zhang, Kento Sumitani, and Garegin Pogossian | American Ballet Theatre
Costumes by Eric Winterling

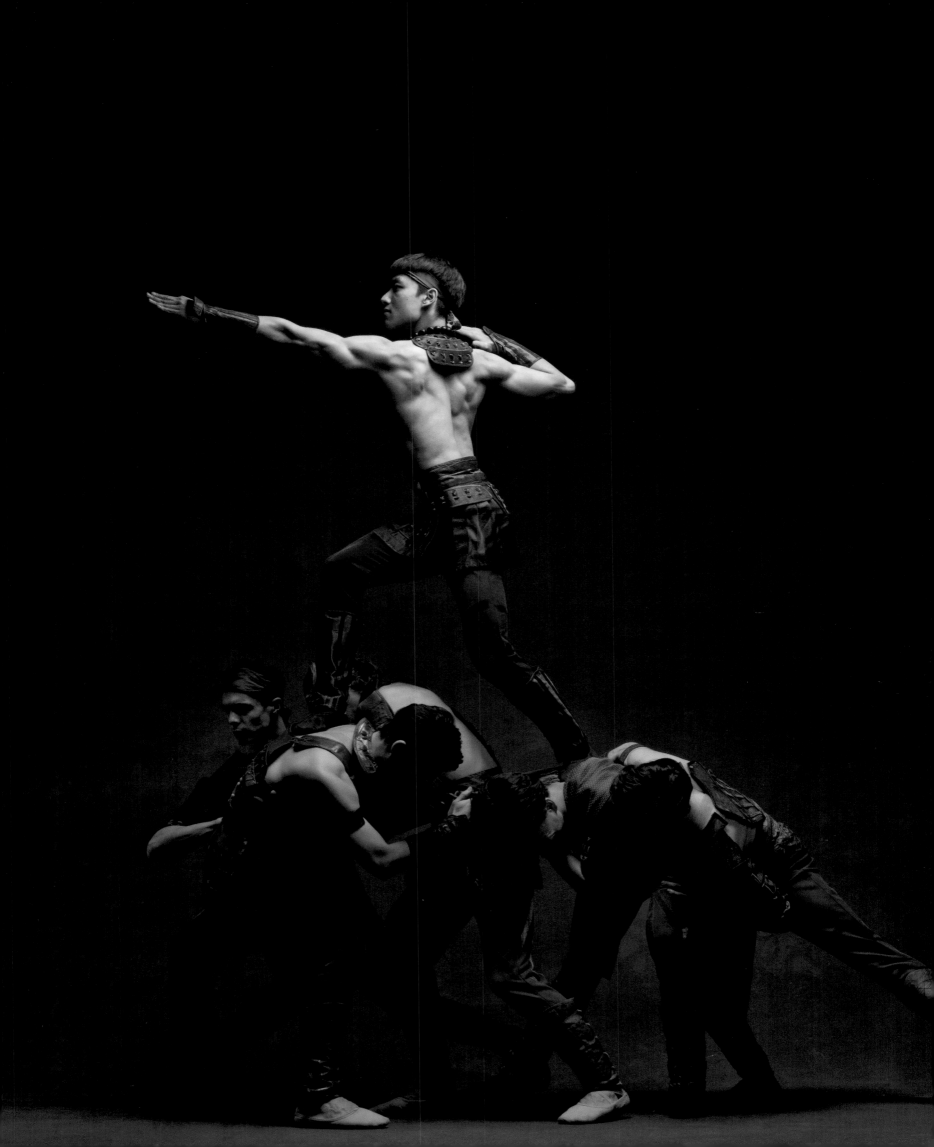

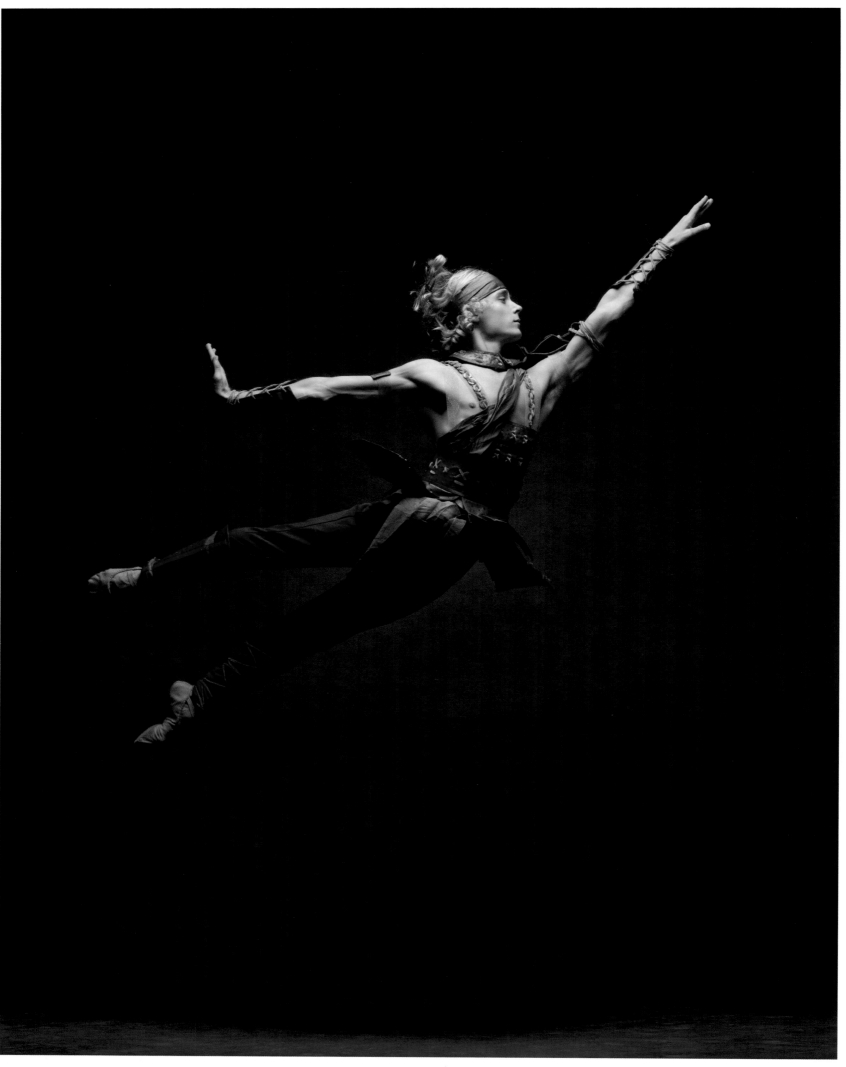

Jonathan Klein and Joo Won Ahn | American Ballet Theatre

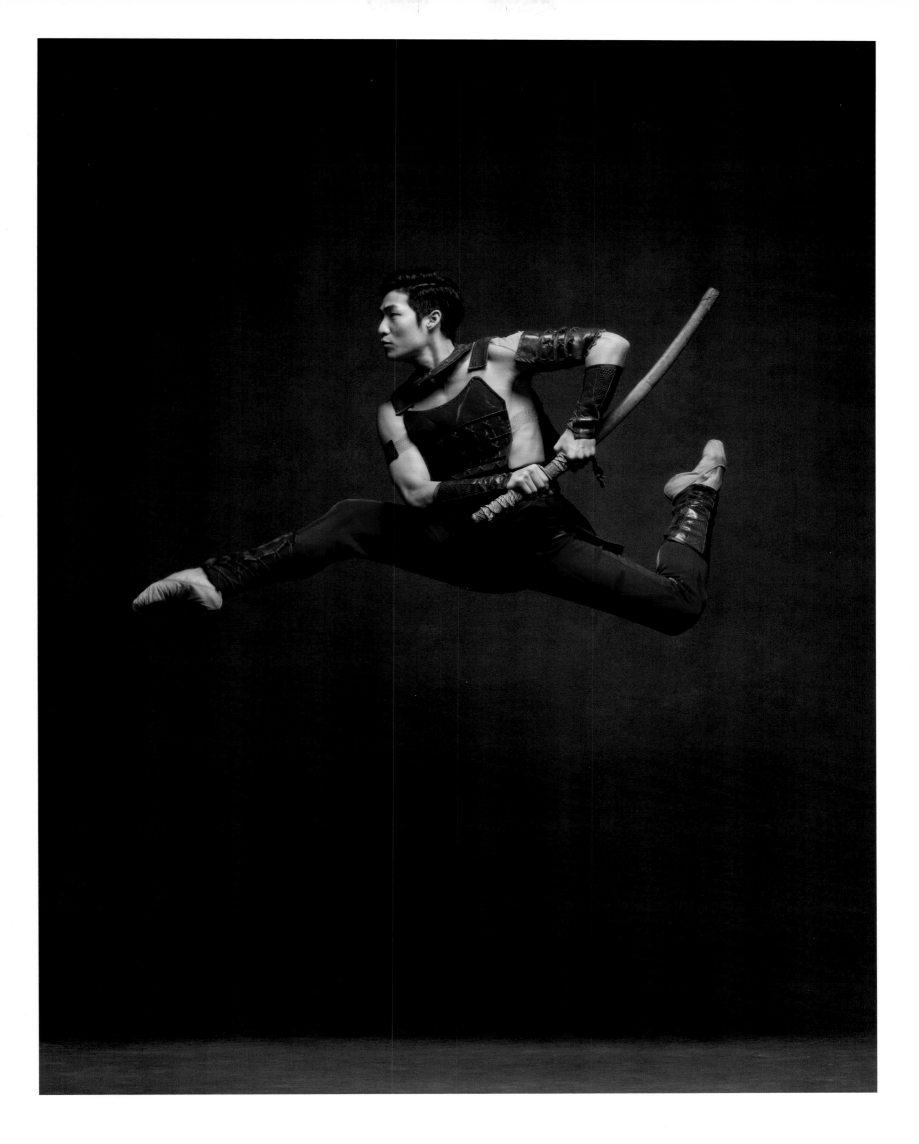

Misty Copeland | Principal, American Ballet Theatre | *Dress by Trash-Couture*

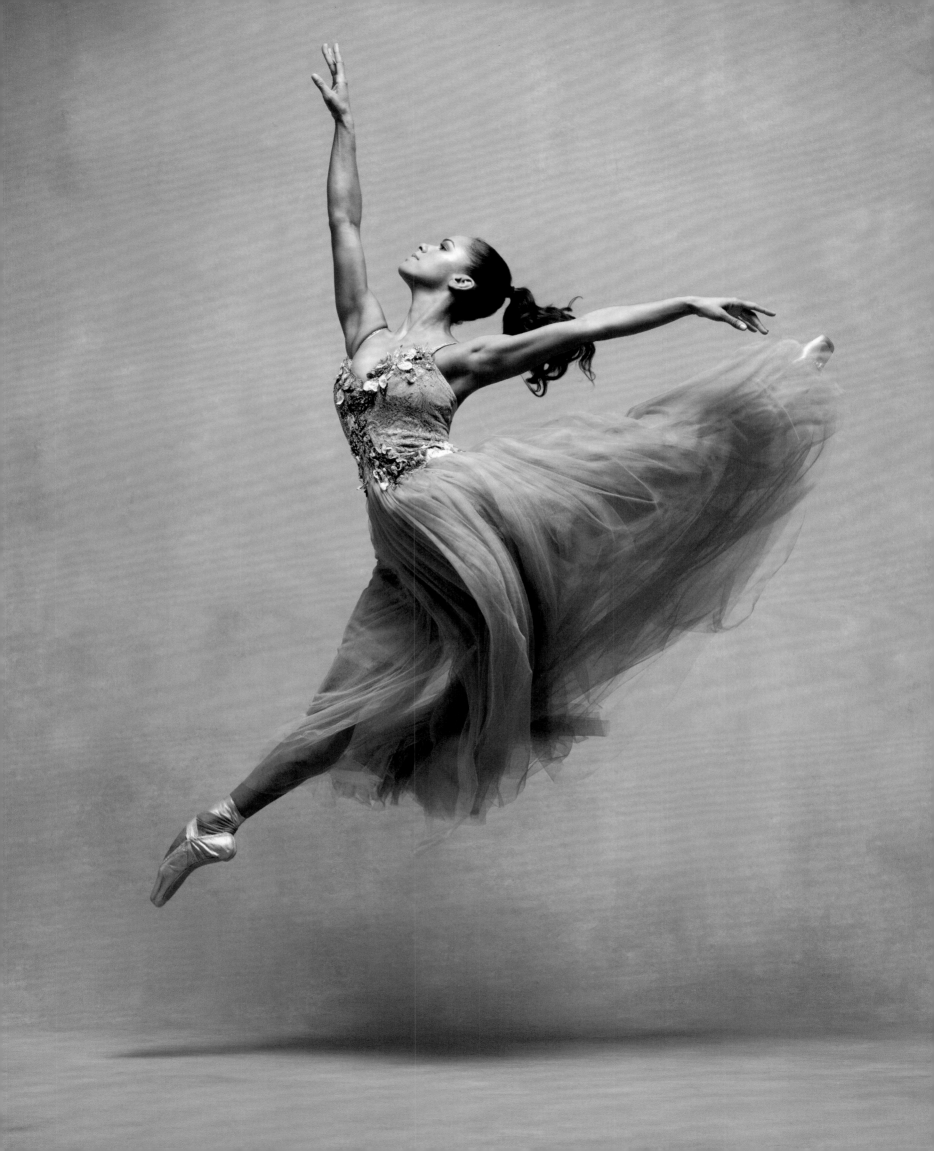

"The true alchemy comes down to the dancers themselves. Their grace and athleticism bring the clothes, quite literally, to new heights."

—GILLES MENDEL, CREATIVE DIRECTOR, J. MENDEL

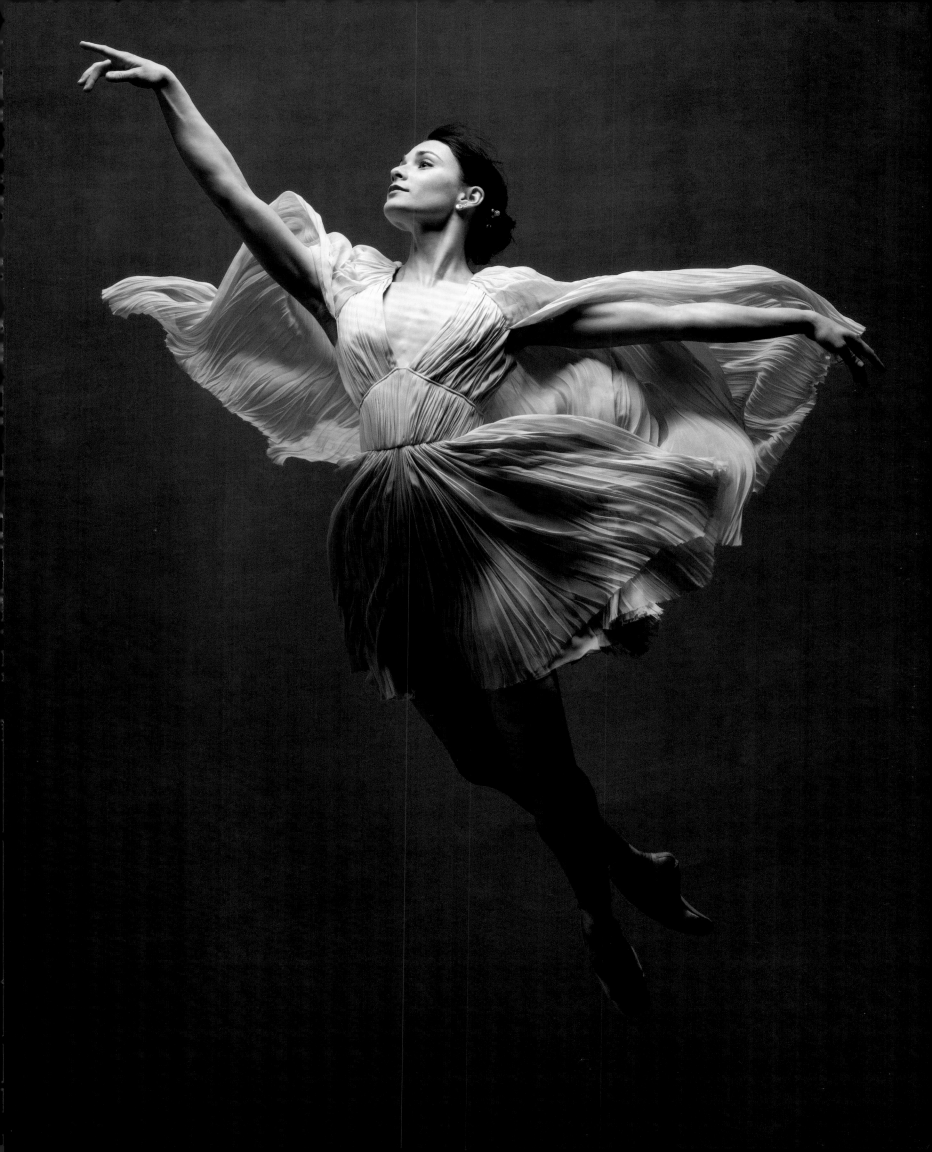

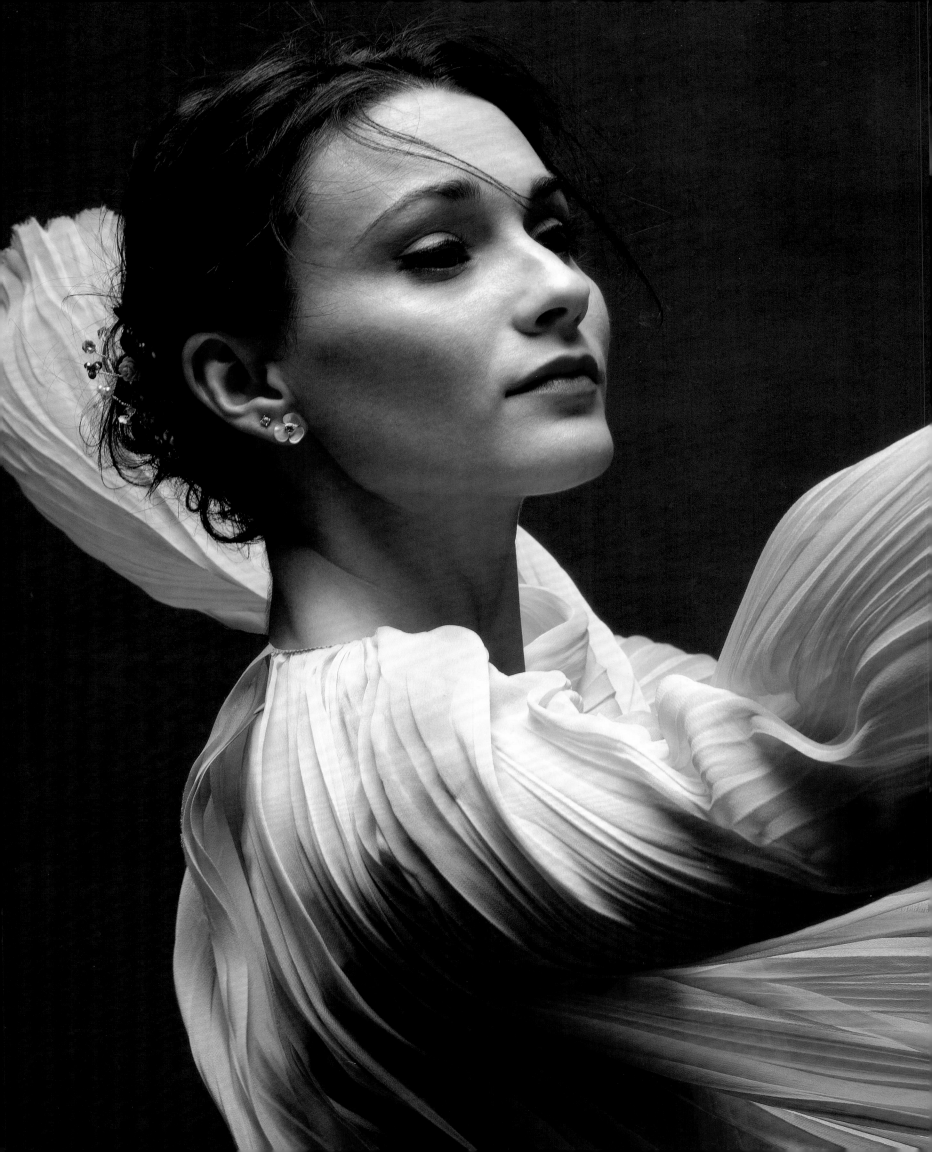

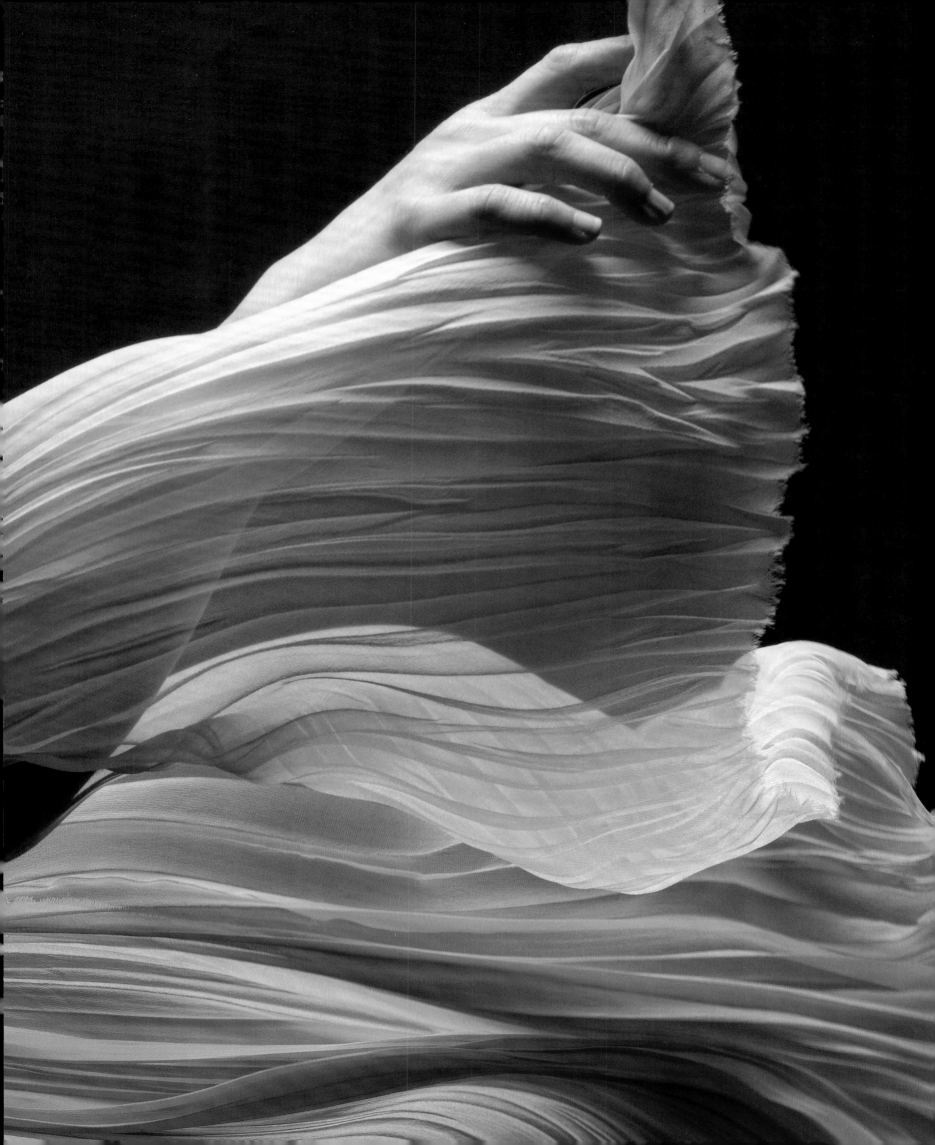

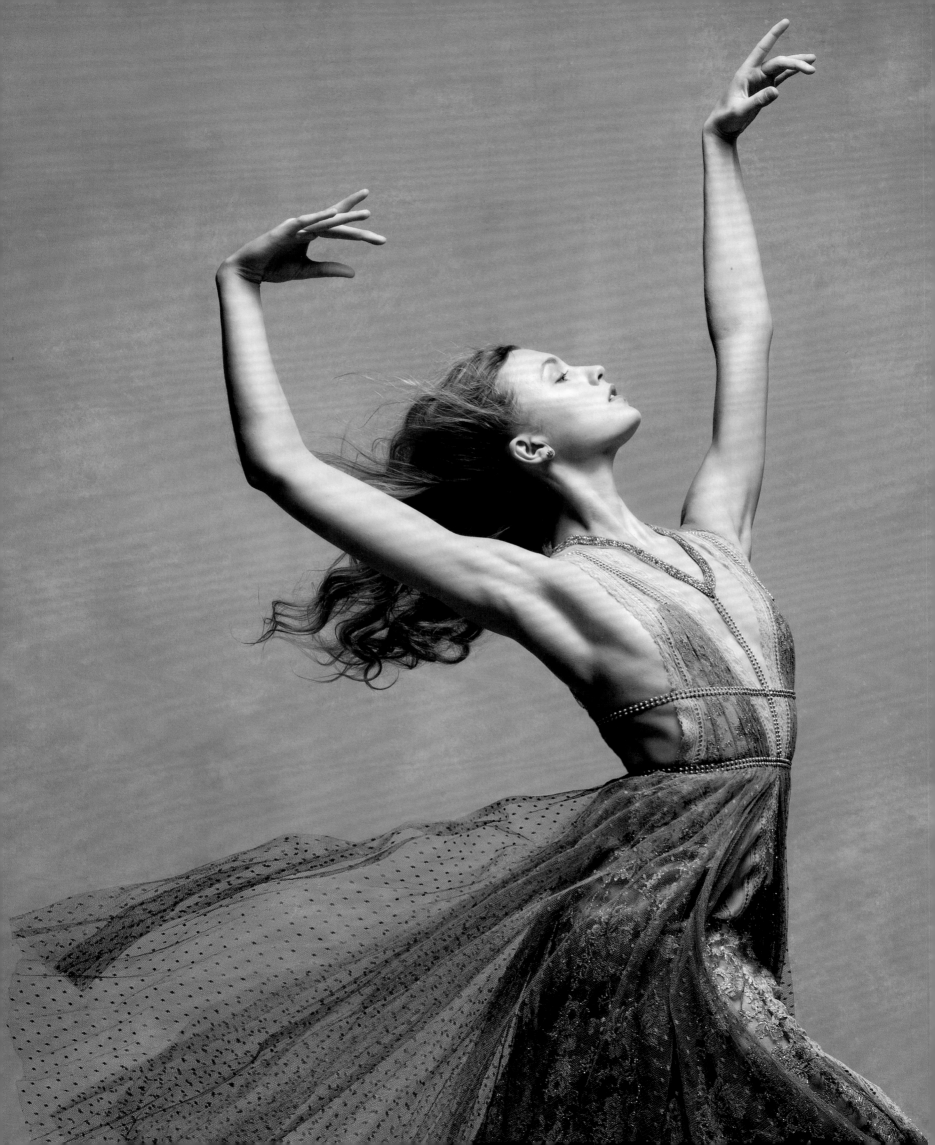

"The movement of fabric—with the extraordinary movement of the human body—creates an image that can give the eye a rare delight."

—REEM ACRA

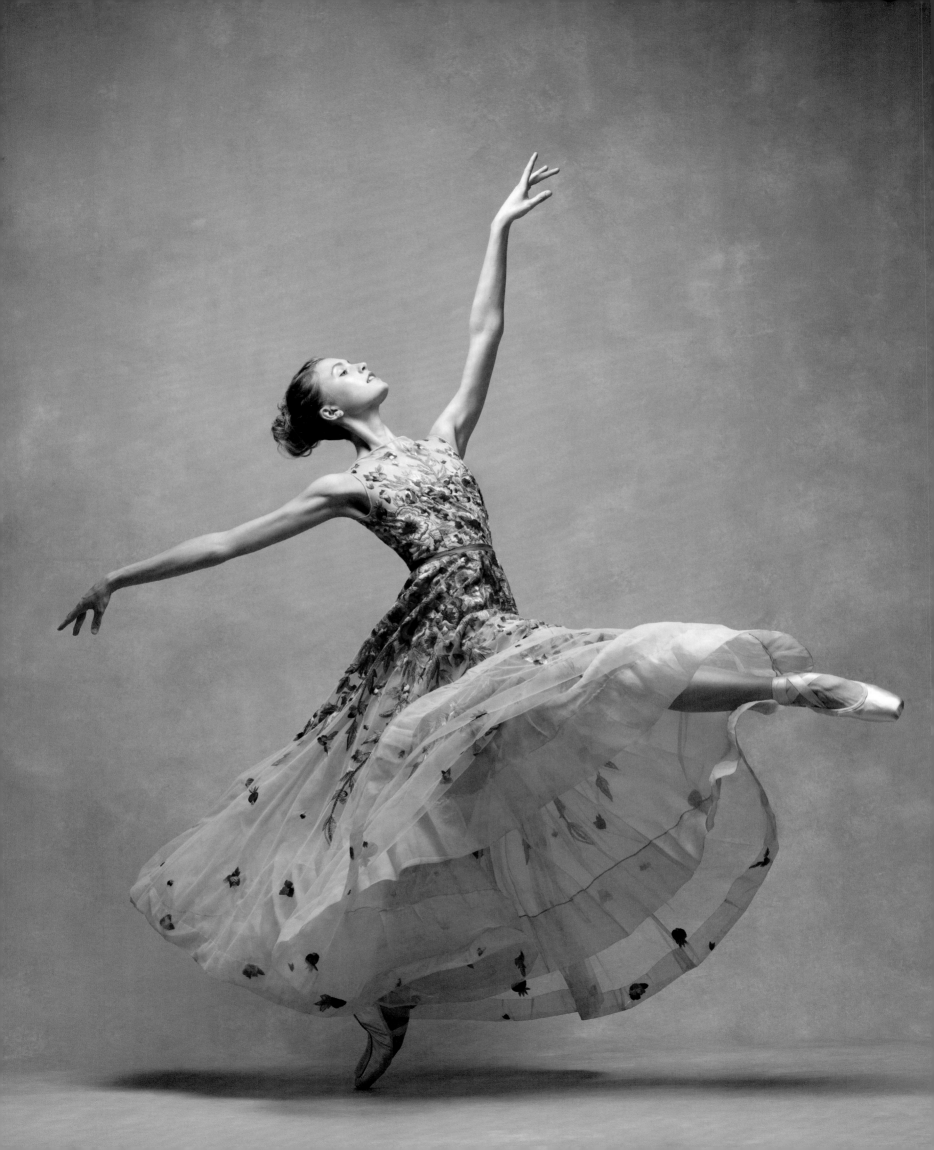

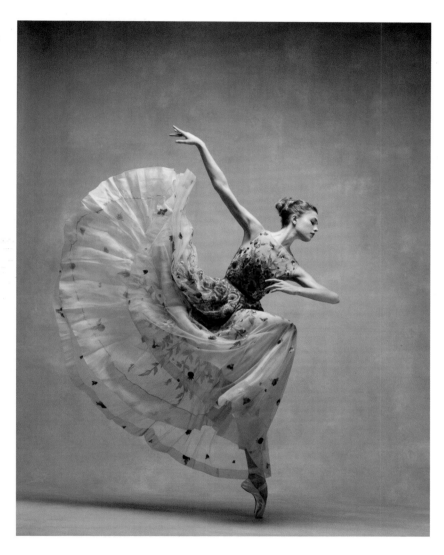
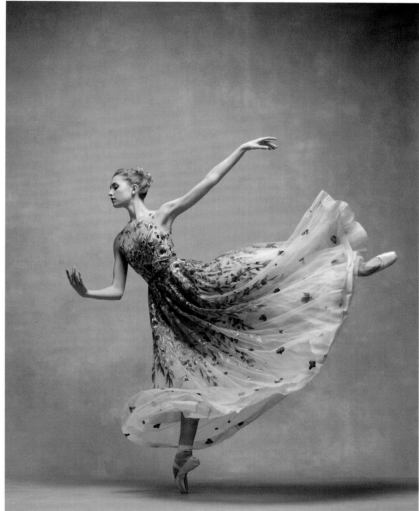

Miriam Miller | New York City Ballet | *Dress by Naeem Khan*

"Kilts and clan tartans were always part of my upbringing
and education as I lived in Celtic culture for a few years.
So, to dance with some tartan on always grounds me back
to my roots. For a chap, it's always a luxury to dance in a kilt
as it brings so much breadth and freedom. One is able to feel
the weight of the fabric whilst moving at complete liberty,
hoping that some modesty is kept, of course."

—LLOYD MAYOR

Lloyd Mayor | Soloist, Martha Graham Dance Company | *Clothing by Glasgow Kilt Company*

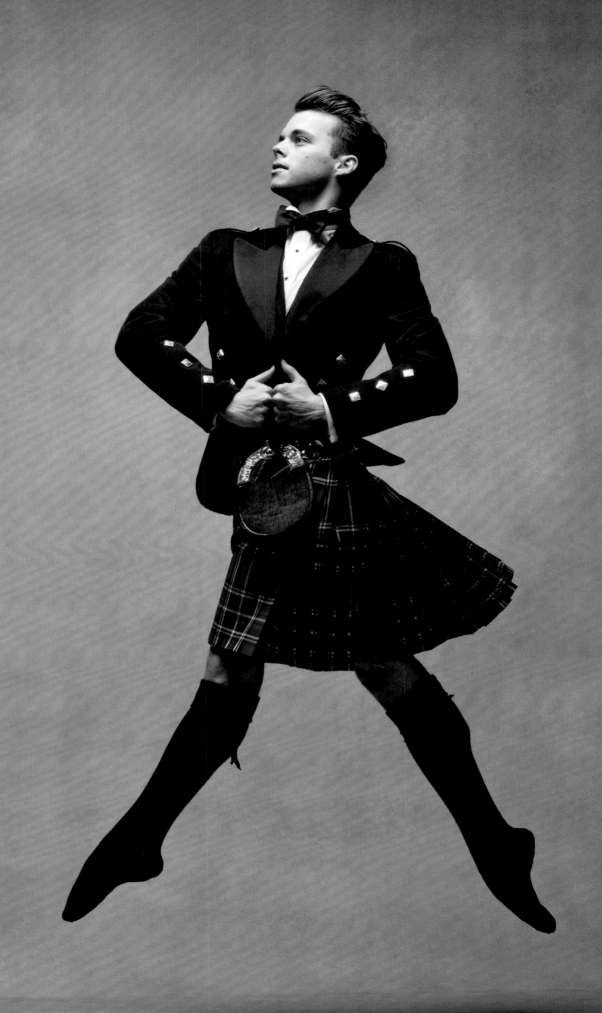

Artem Ovcharenko and **Olga Smirnova** | Principals, Bolshoi Ballet | *Dress by Reem Acra*

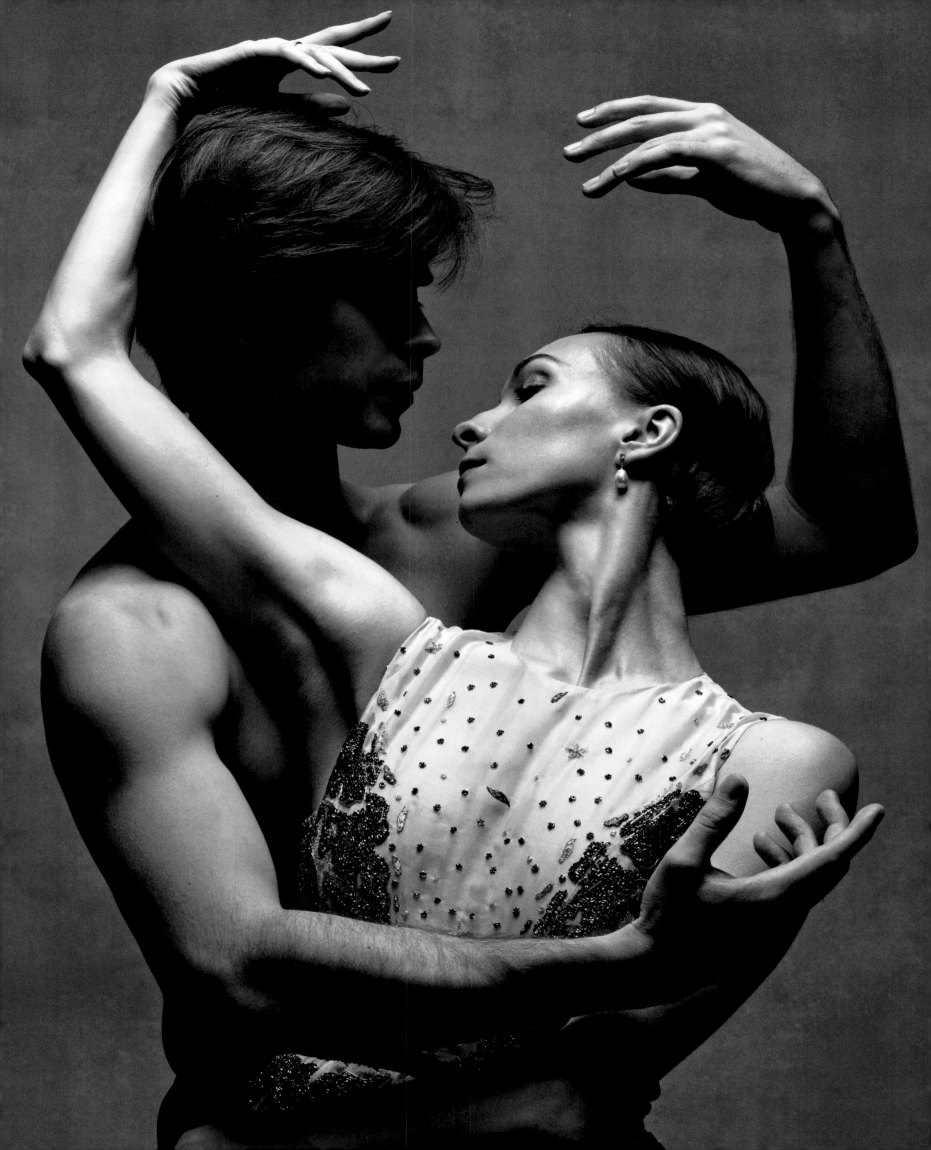

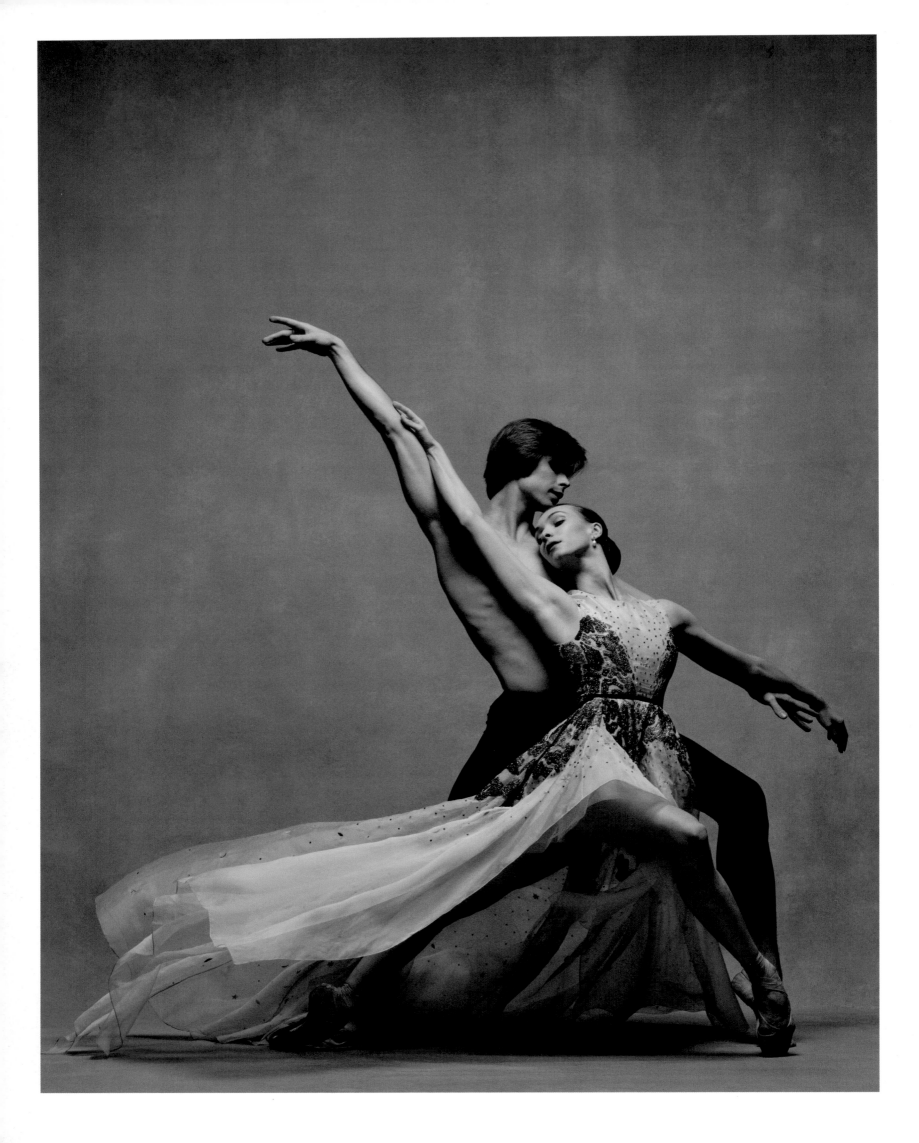

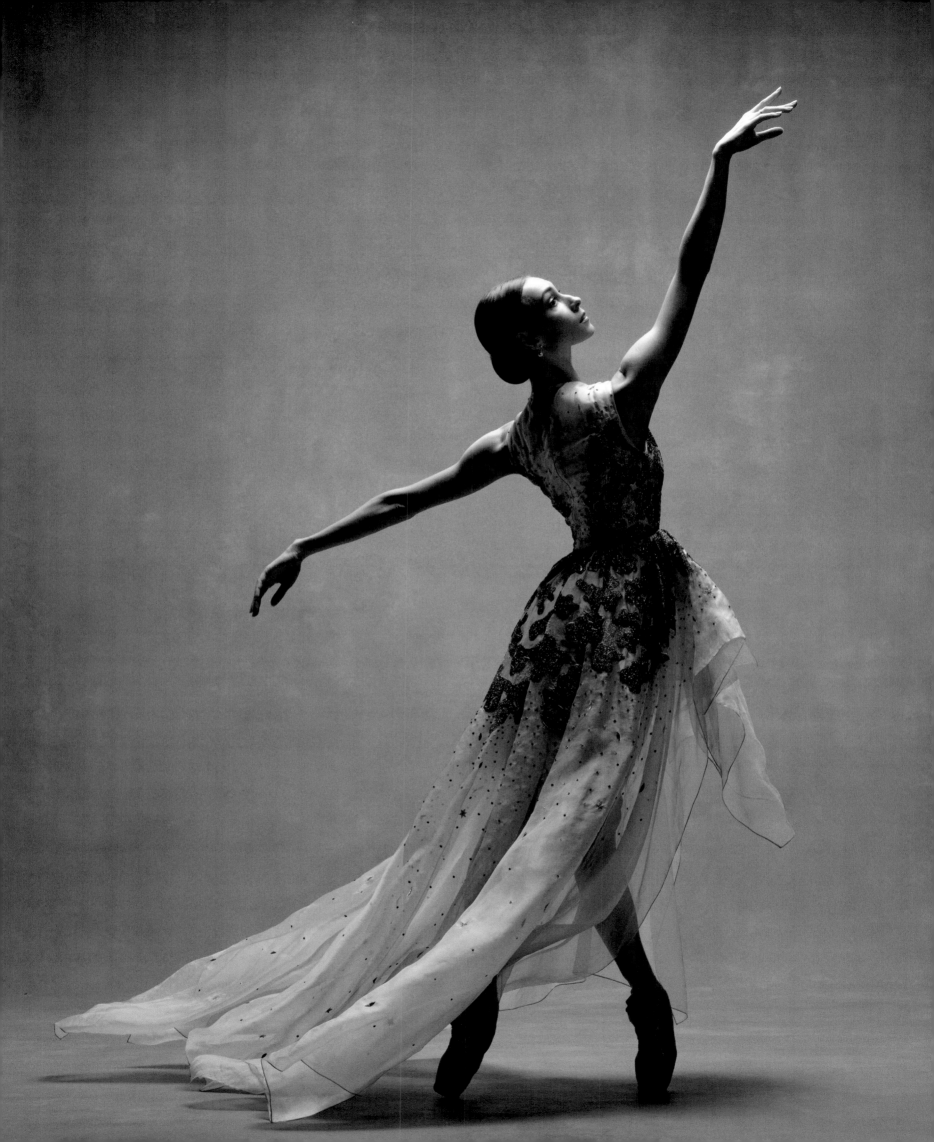

"I love designing for dancers—imagining how fabric, form, and design will react to movement, and how each piece might inspire movement. Designing for dancers offers a beautifully complex puzzle: When muscles expand and contract, the body's shape transforms, impacting the function, form, and artistry of a garment. When dancers move with costumes, they put their own stamp on it and their personalities shine through, breathing life into a design. When a child puts on a dress, often the first thing she does is spin to feel how it moves with her. Dance and fashion speak to each other in a language that transcends words."

—BELINDA PIERIS

Dores André | Principal, San Francisco Ballet | *Clothing by Belinda Pieris*

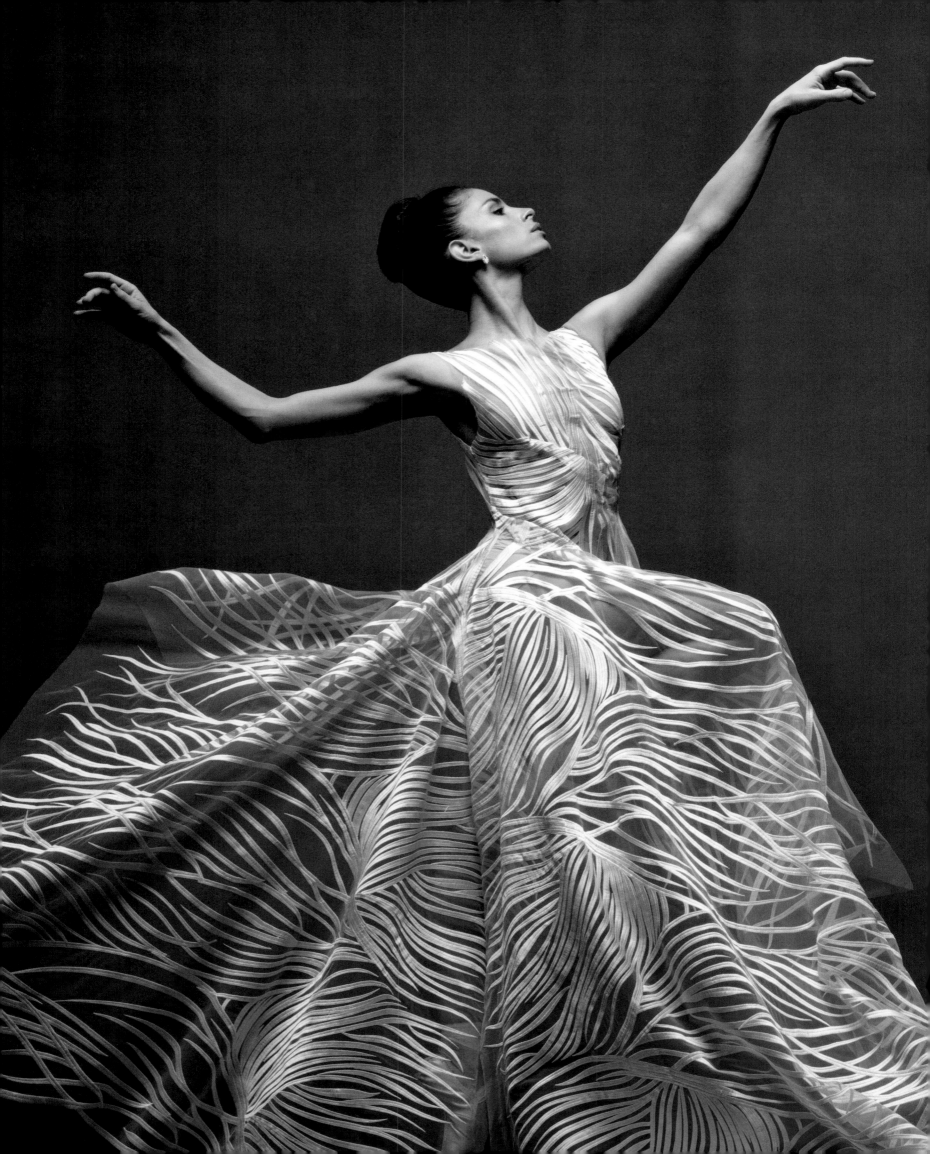

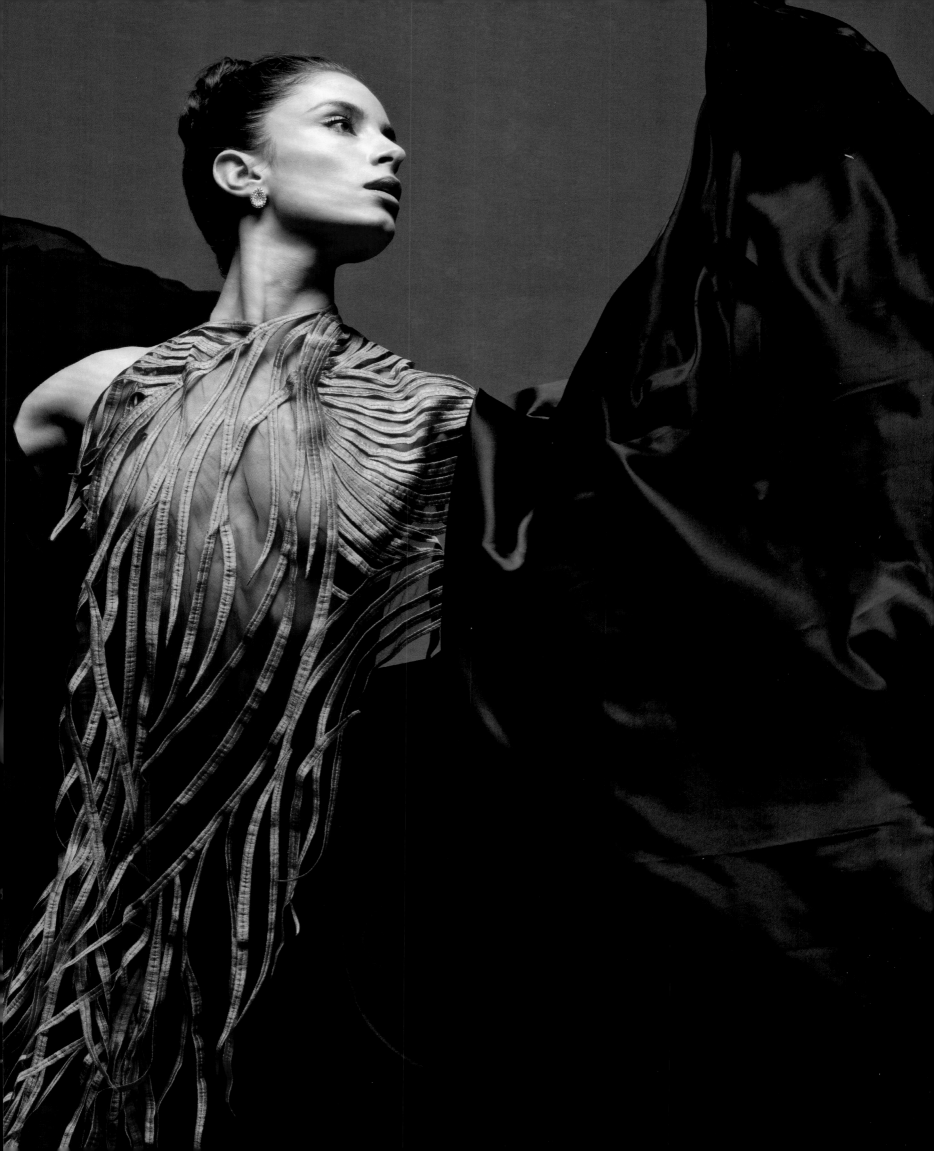

Natasha Diamond-Walker | Soloist, Martha Graham Dance Company | *Clothing by Han Feng*

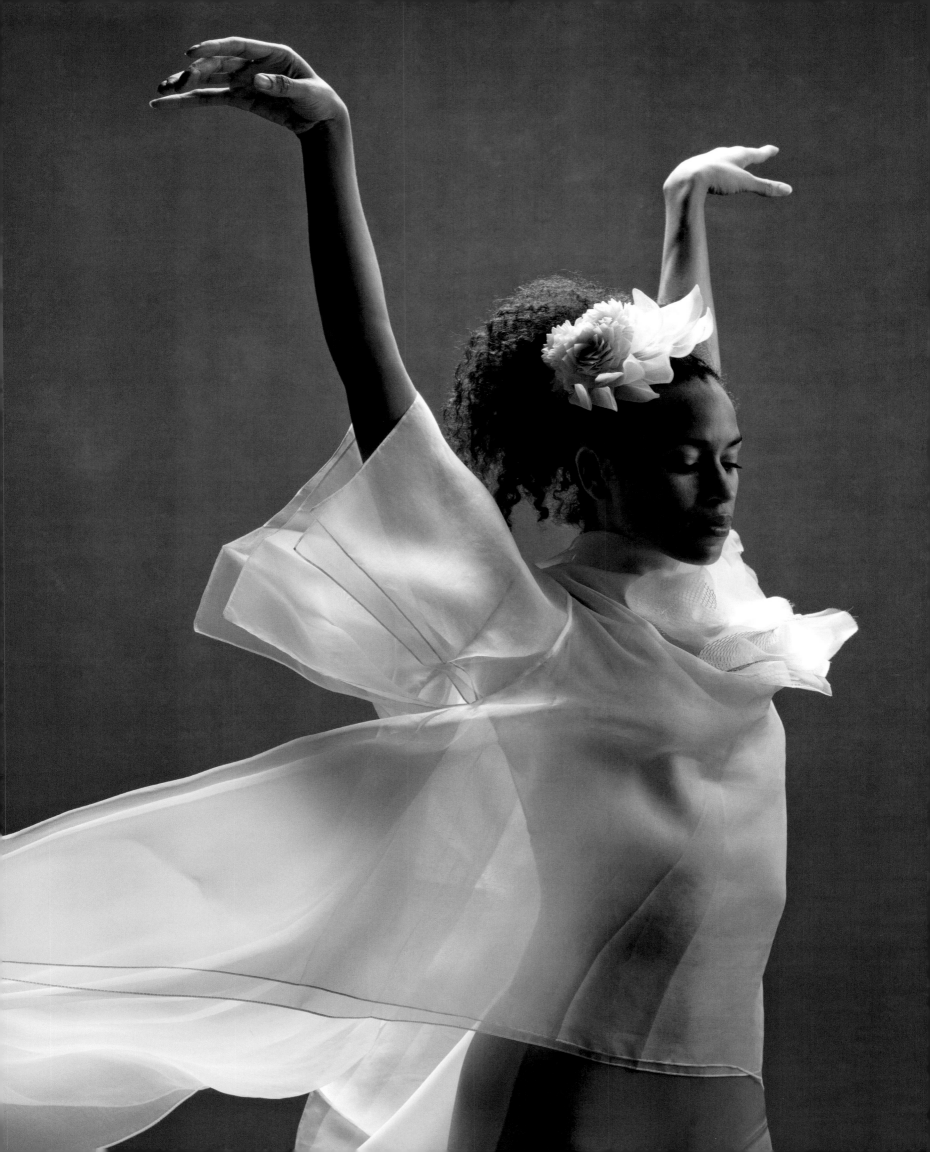

"I believe costumes are what set the storyline for the piece a dancer is performing in. The costume is what brings that performance to life. It sets a tone for the performances all the way down to the color, lines, and texture of the fabric. This will affect the tone of the piece; the lighting and the choreography behind it. For example, a costume with darker colors may inspire powerful, intense, and strong movements while lighter colors inspire more elegant and graceful movements."

—ALYSSA CEBULSKI

Alyssa Cebulski and Jacob Larsen | Martha Graham Dance Company | *Clothing by Irene Luft*

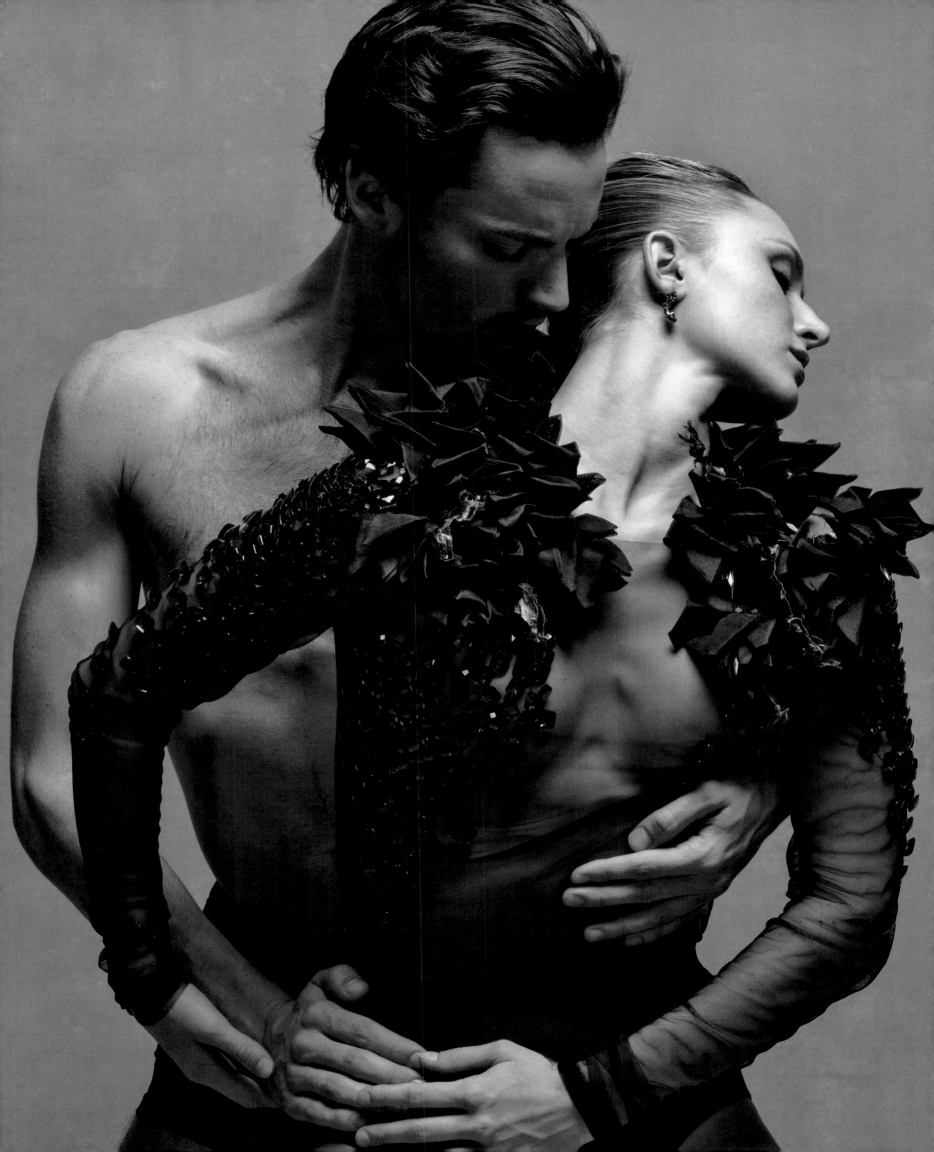

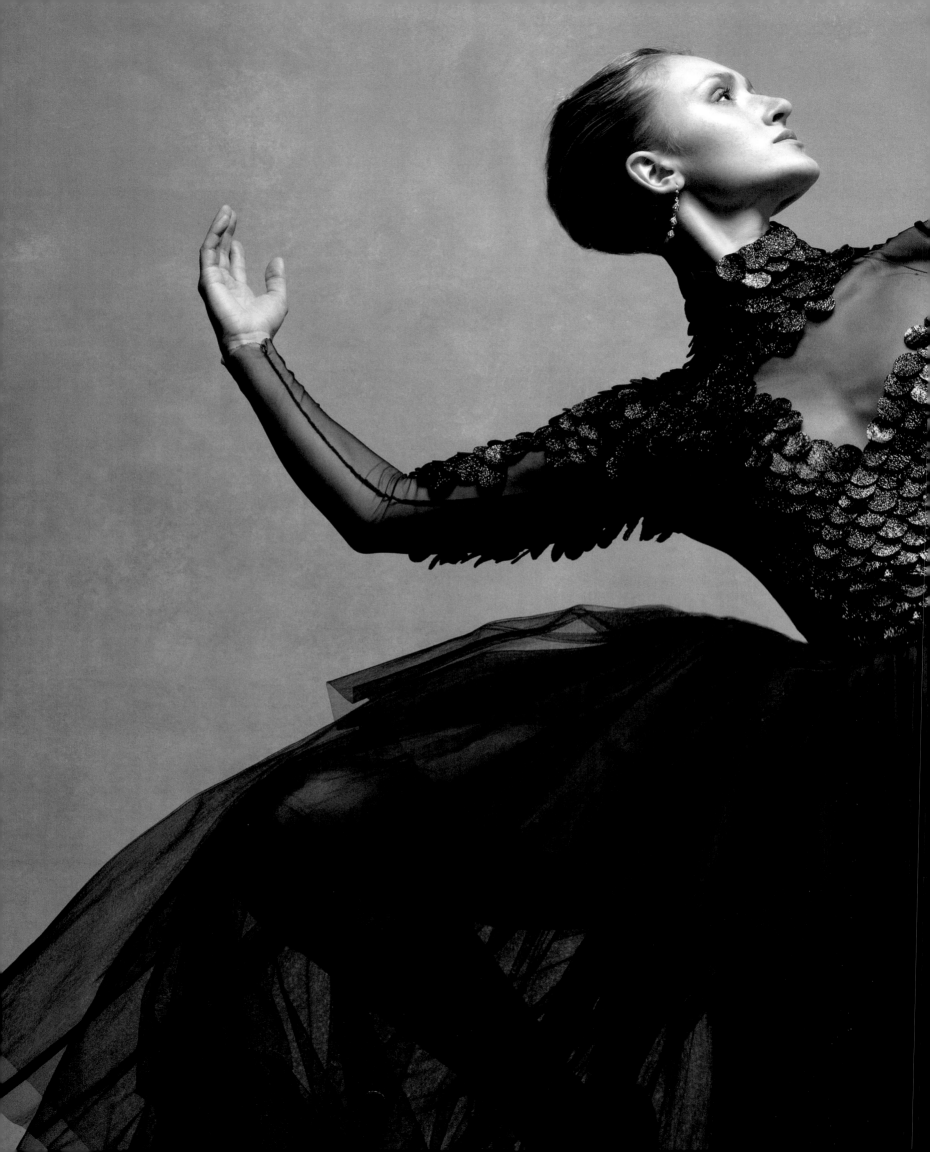

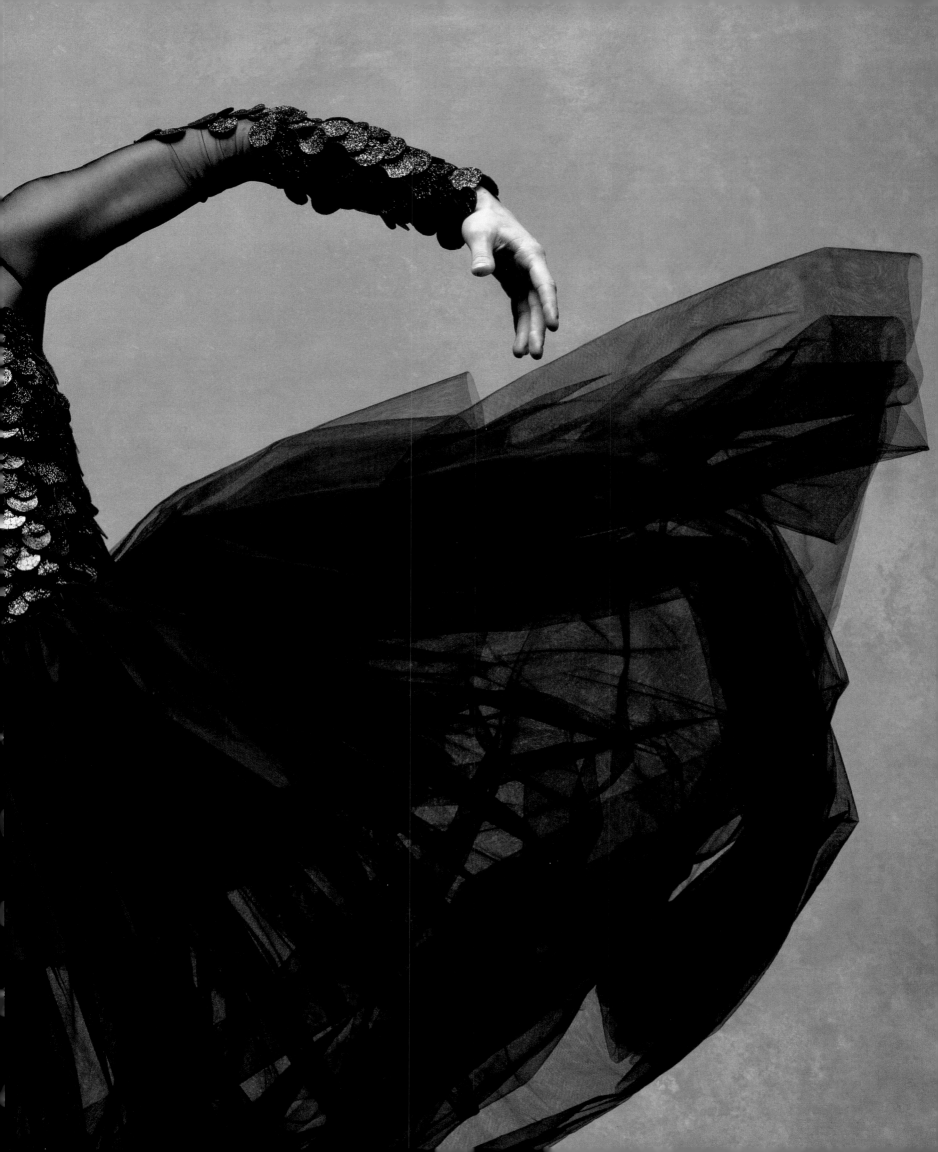

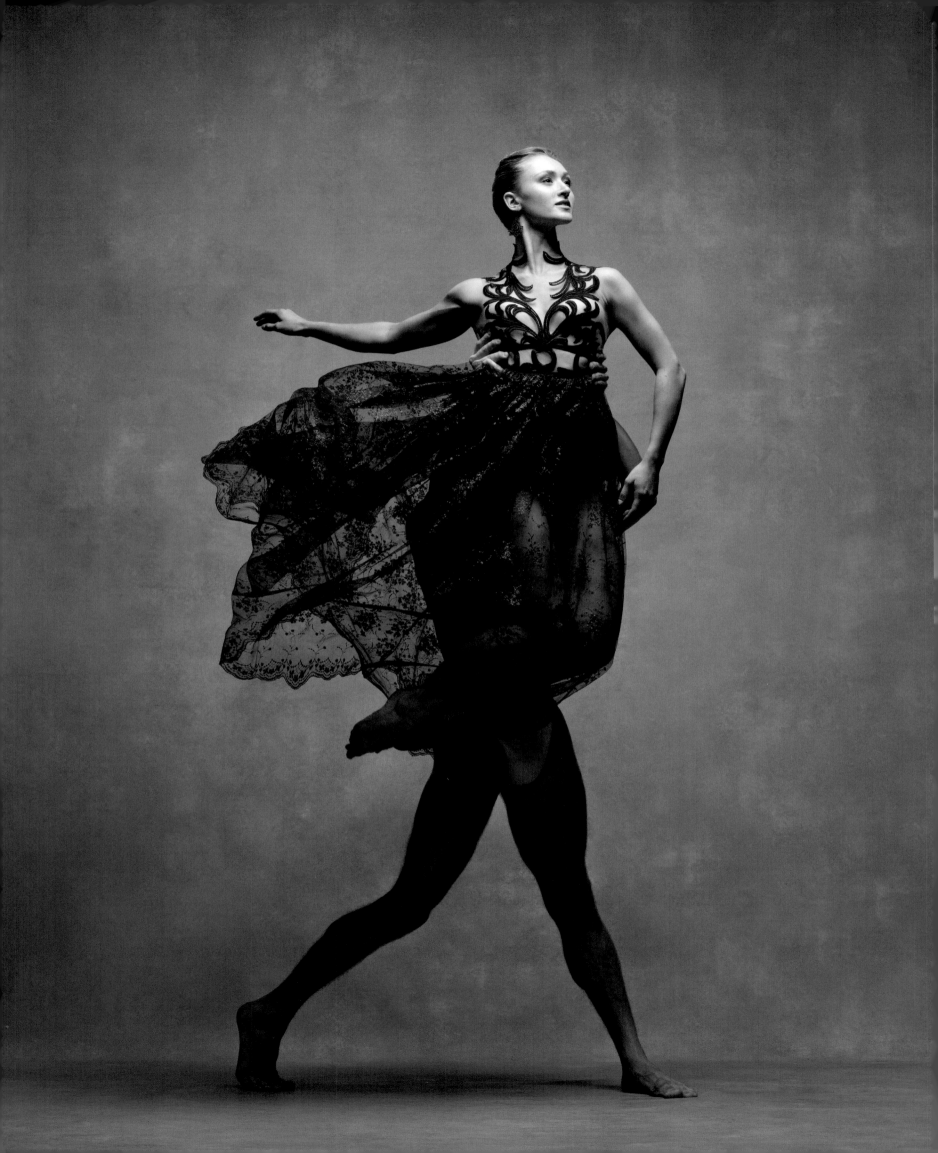

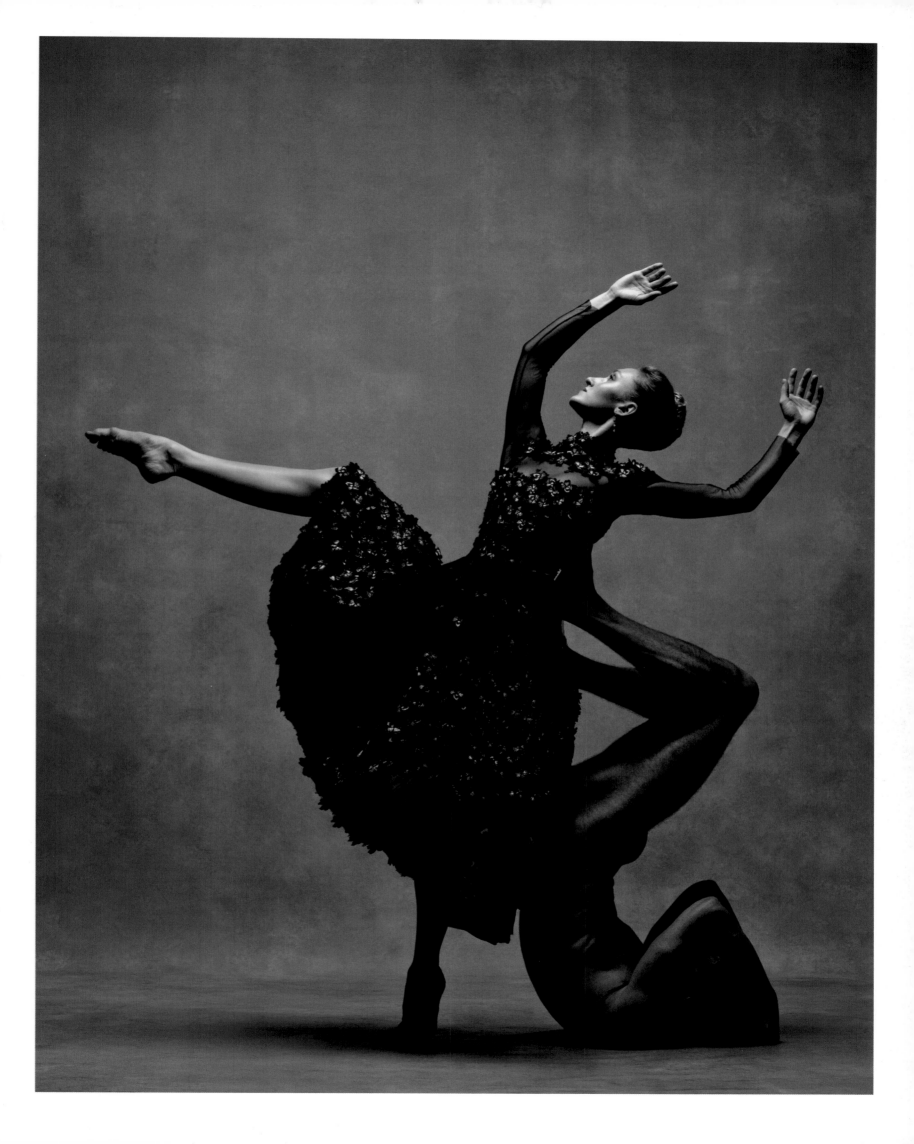

Artem Ovcharenko and Olga Smirnova | Principals, Bolshoi Ballet | *Dress by Leanne Marshall*

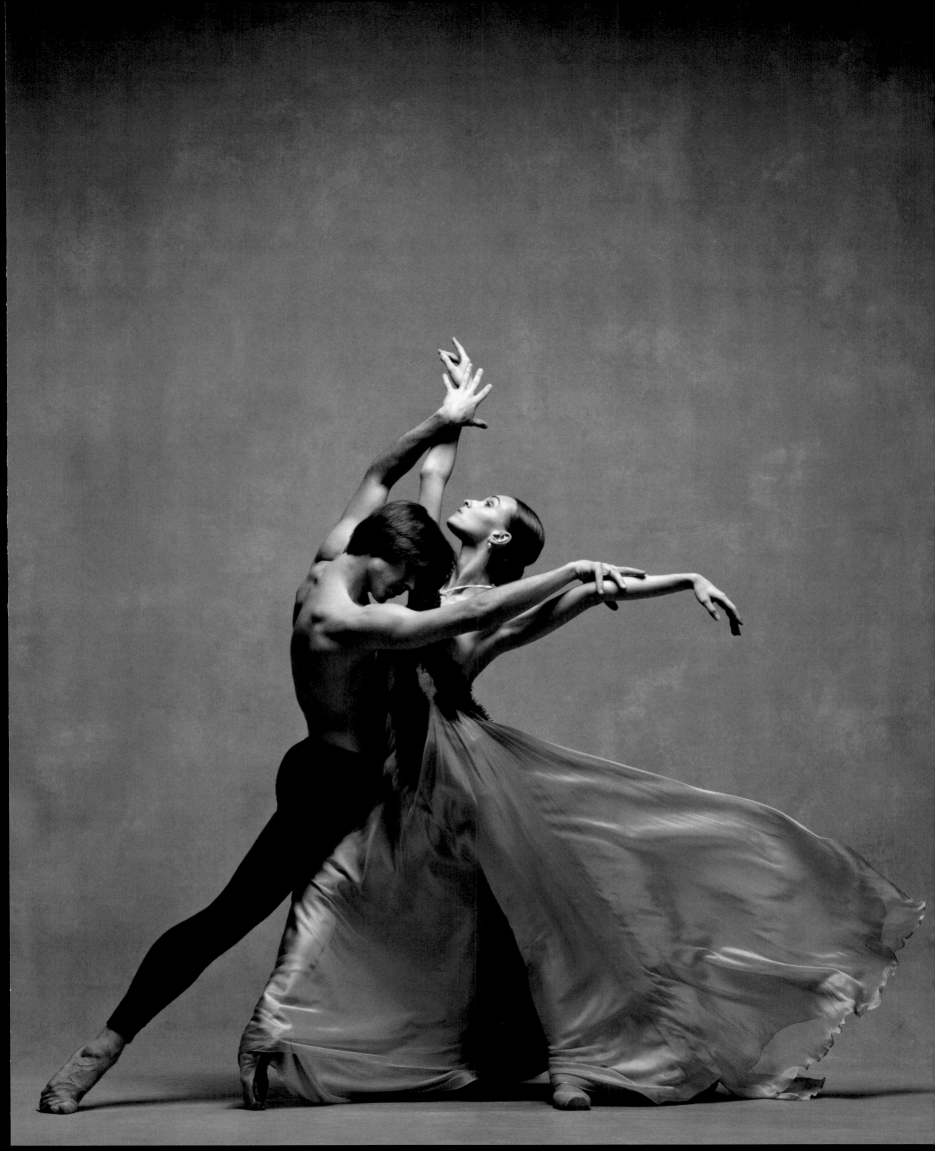

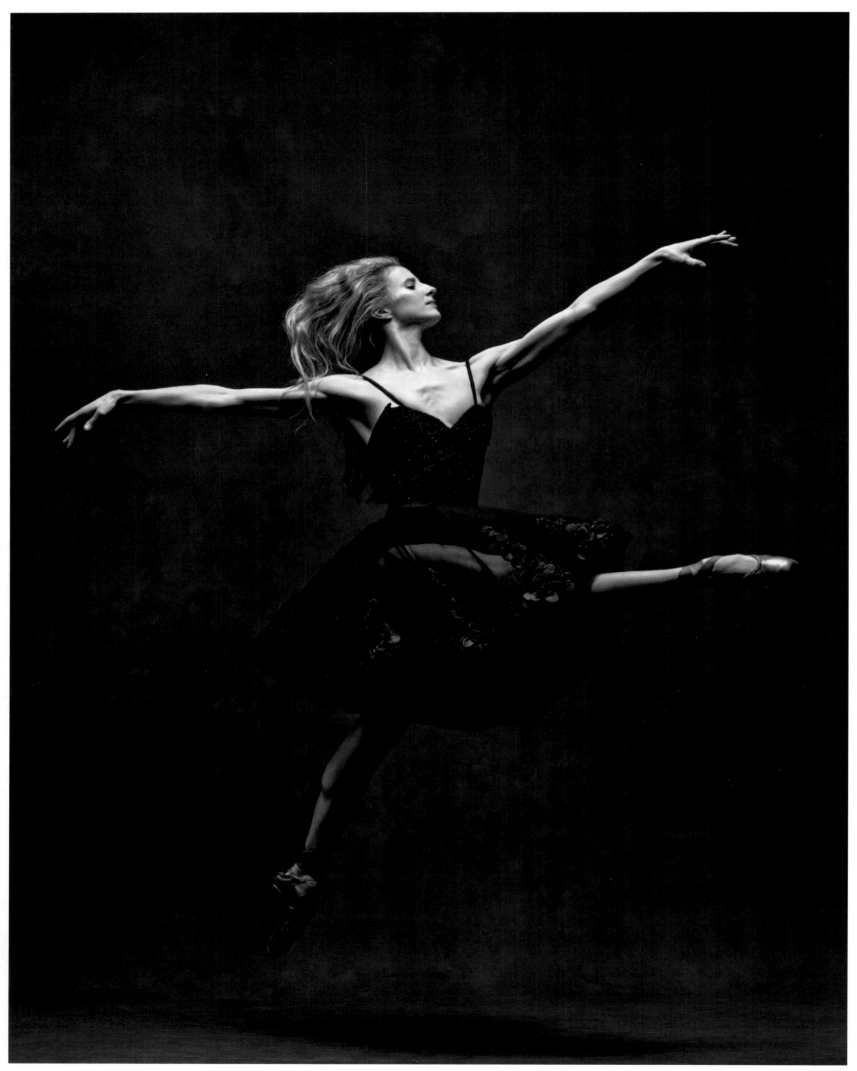

Sterling Hyltin | Principal, New York City Ballet | *Clothing by Tony Ward Couture*

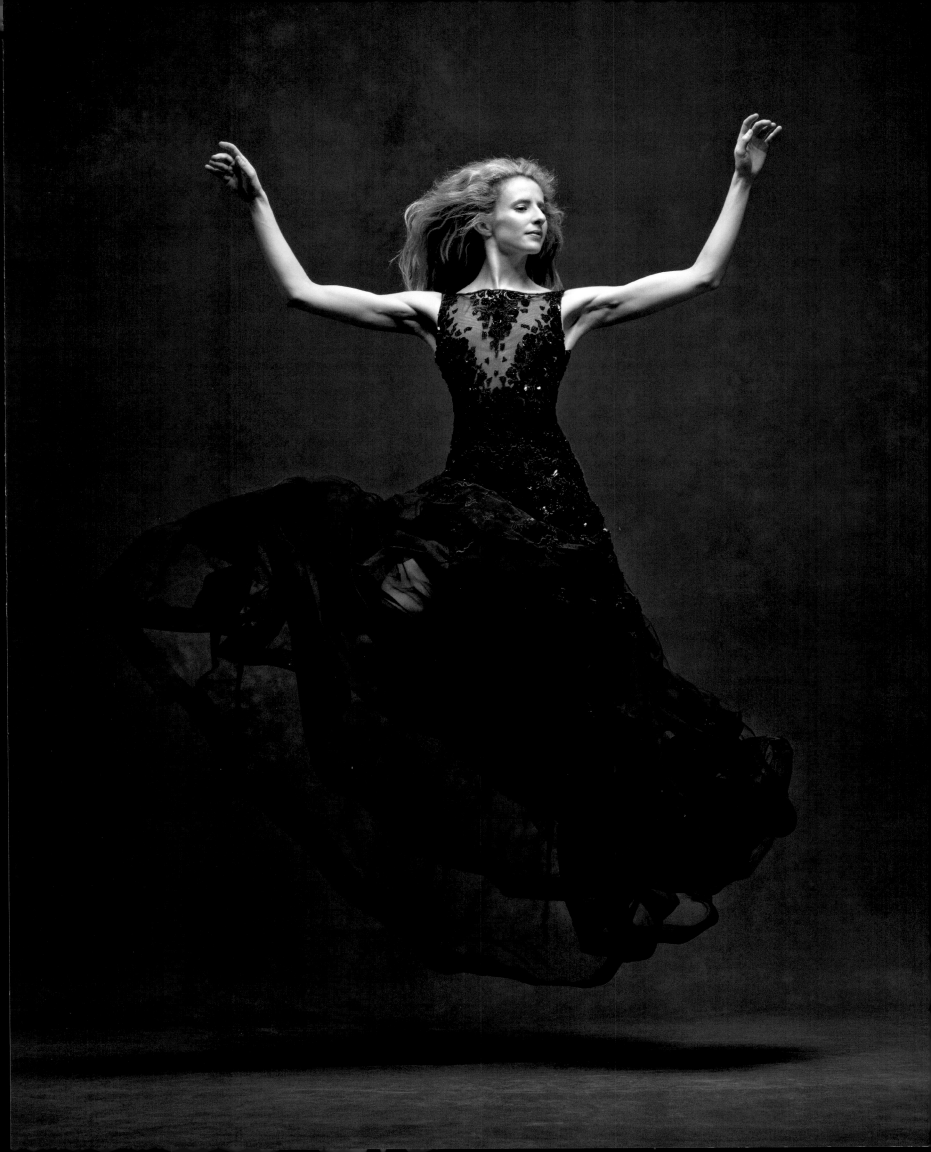

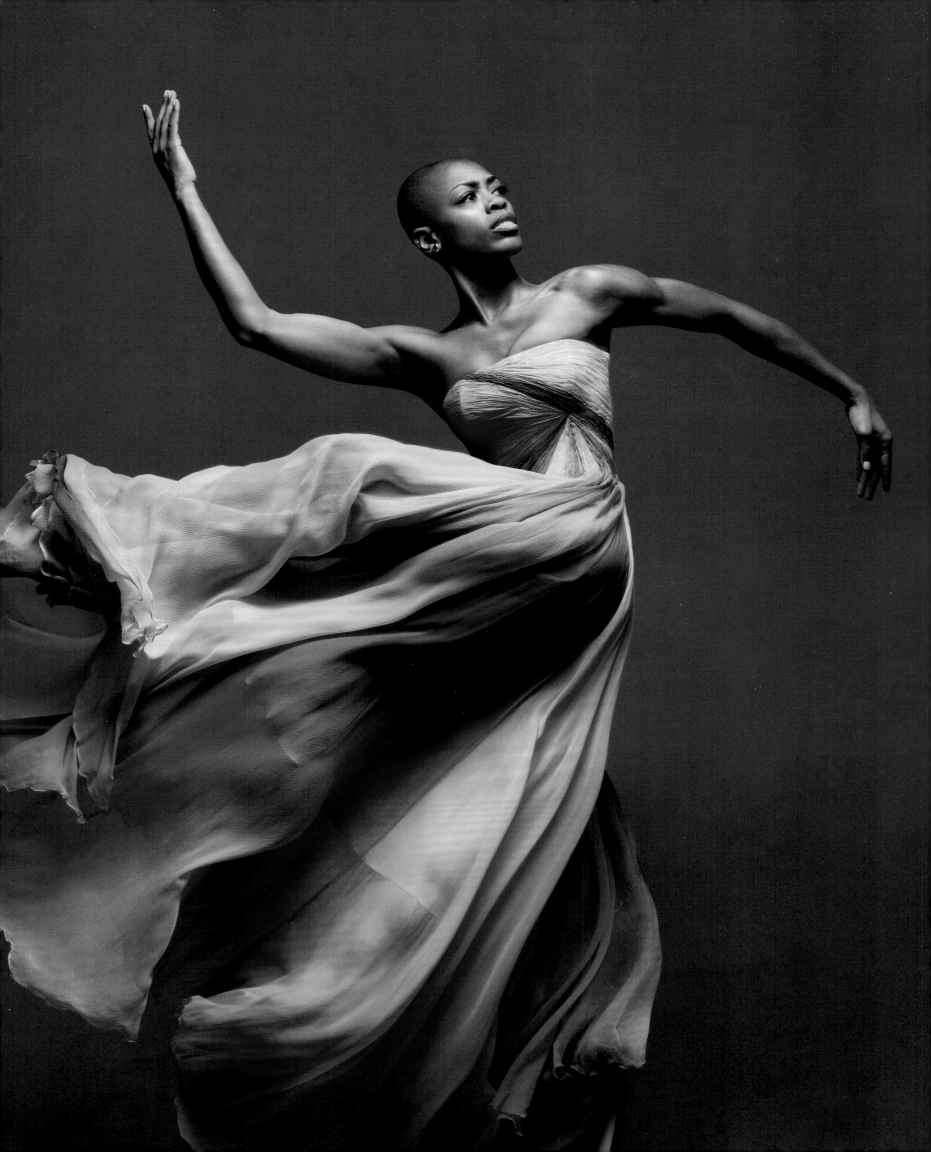

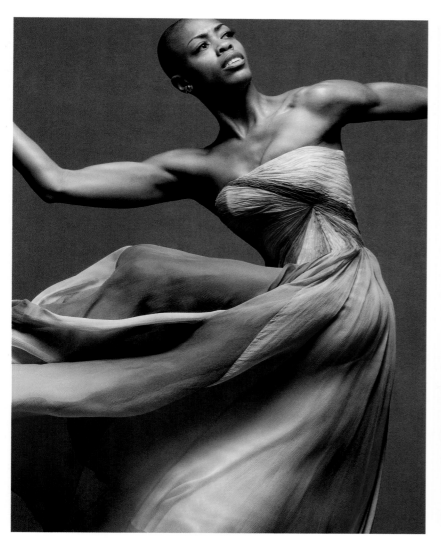
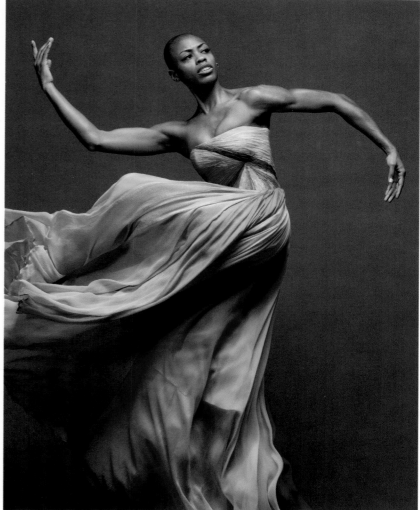

Martha Nichols | *Dress by Bill Blass, c. 2004, courtesy New York Vintage*

Daniil Simkin | Principal, American Ballet Theatre and Staatsballet Berlin | *Vintage suit by Comme des Garçons*

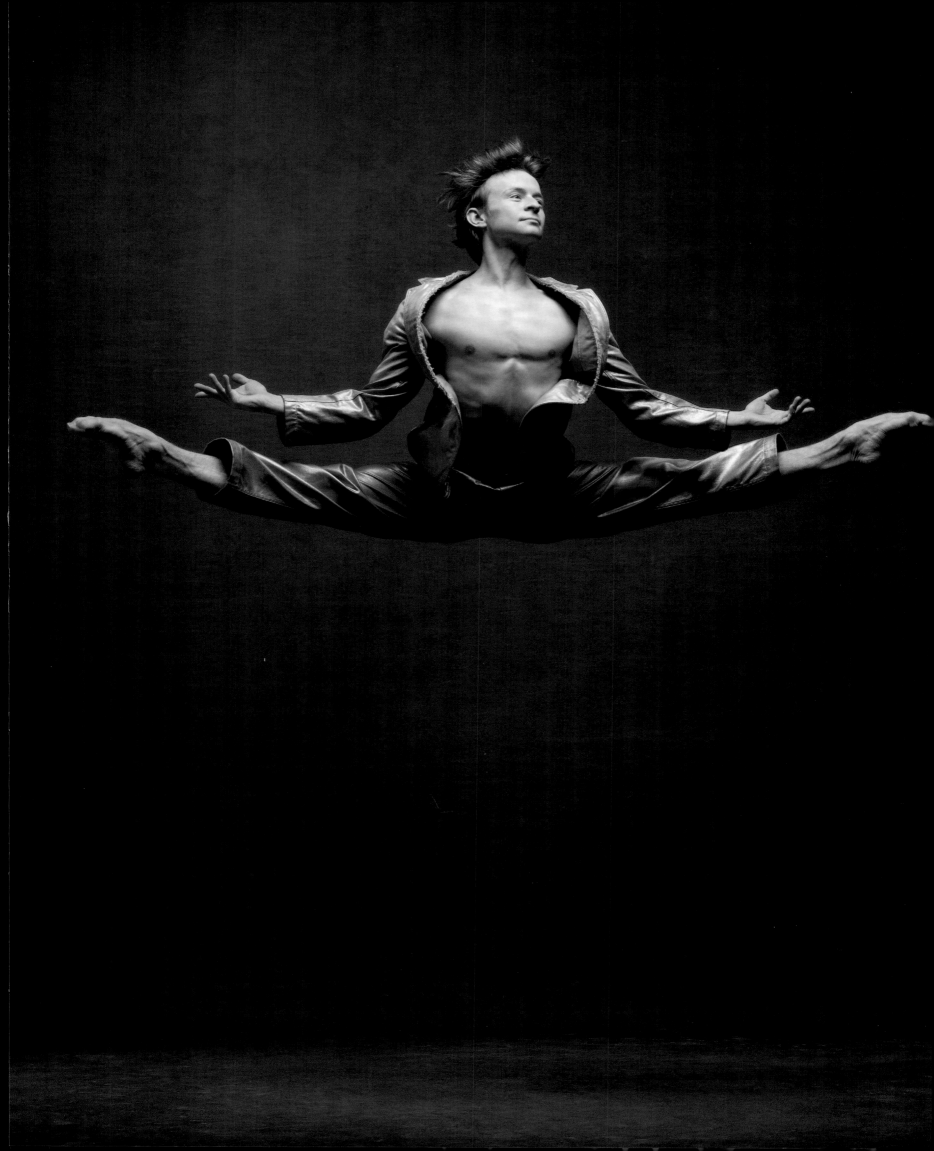

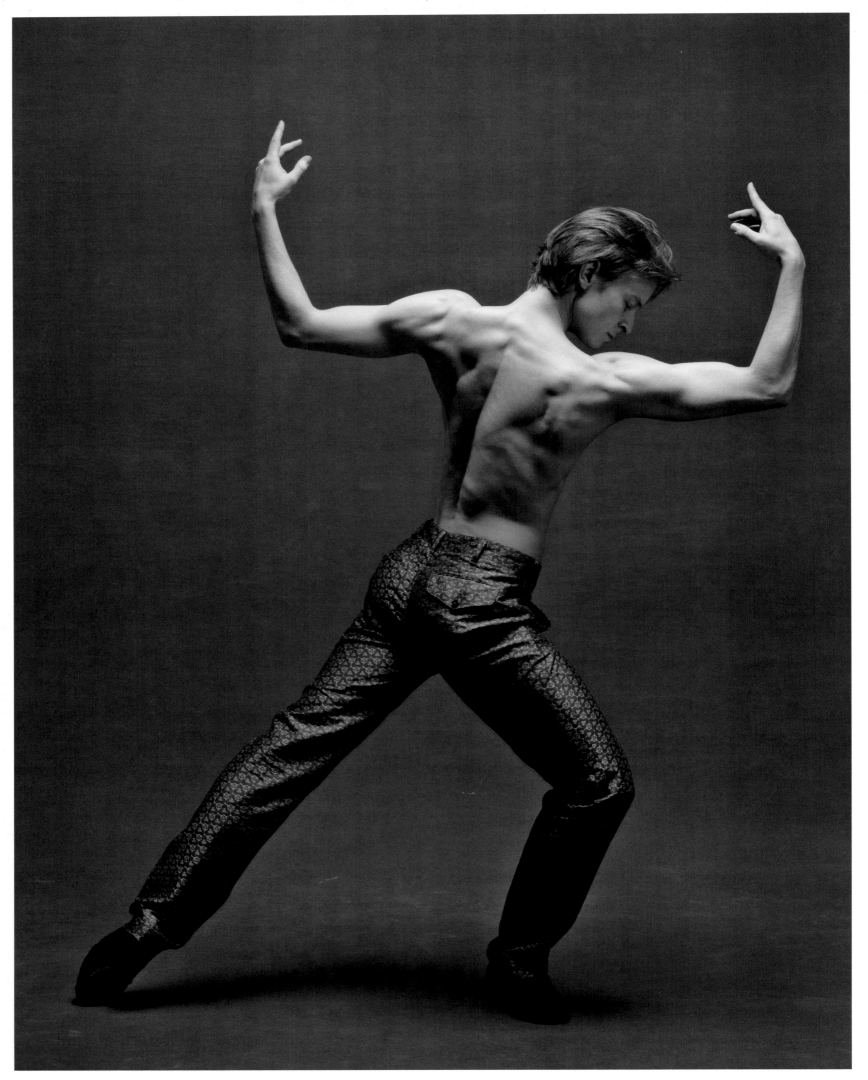

Daniil Simkin | Principal, American Ballet Theatre and Staatsballet Berlin | *Clothing by Ann Demeulemeester*

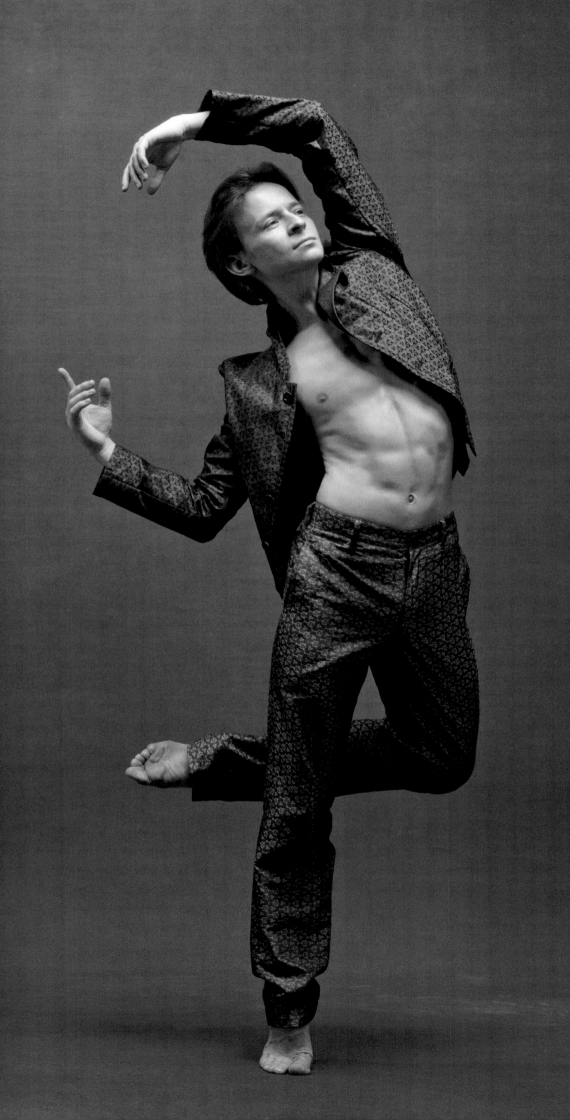

"For me, fashion is a voice; it's a way of walking into a room and saying who you are before you've even spoken."

—GEORGINA CHAPMAN, CO-FOUNDER AND CREATIVE DIRECTOR, MARCHESA

Gillian Murphy | Principal, American Ballet Theatre | *Clothing by Marchesa*

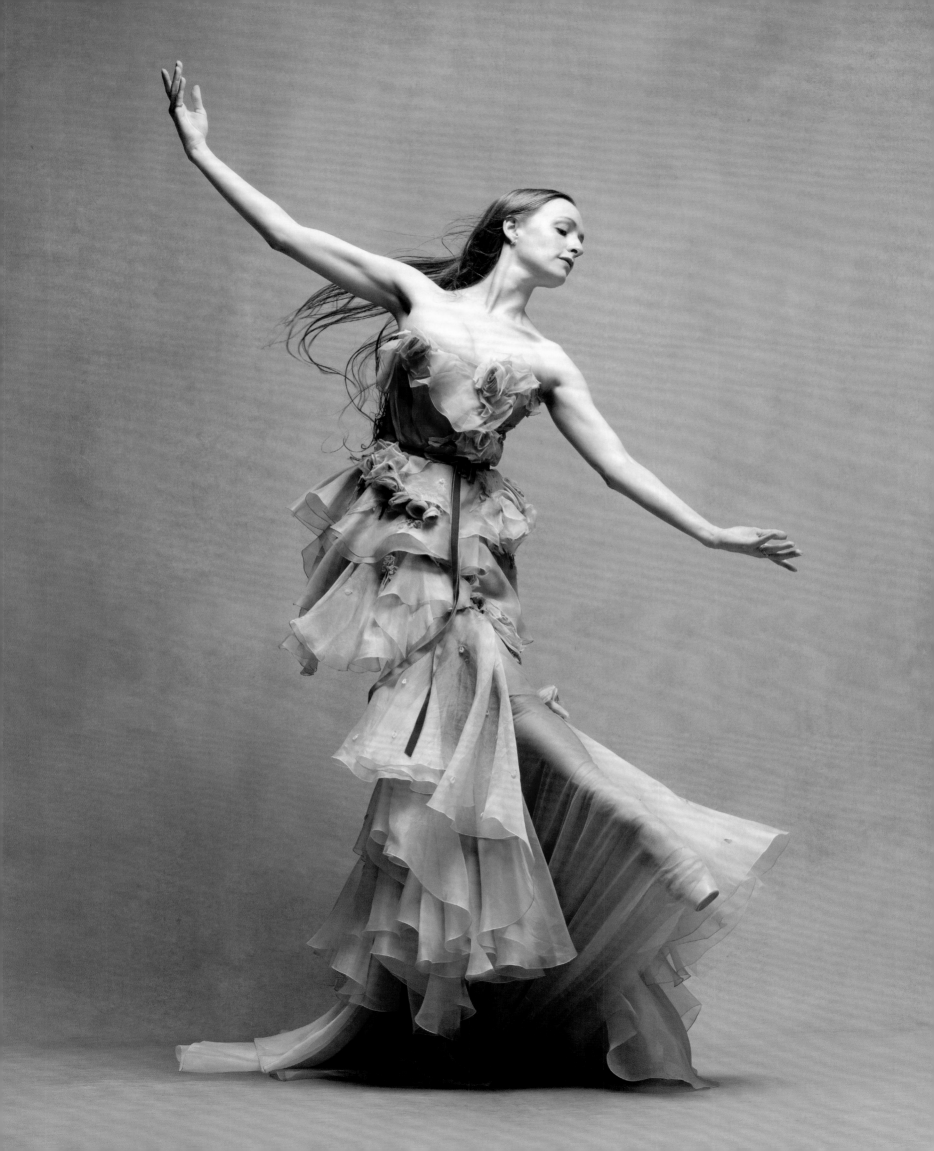

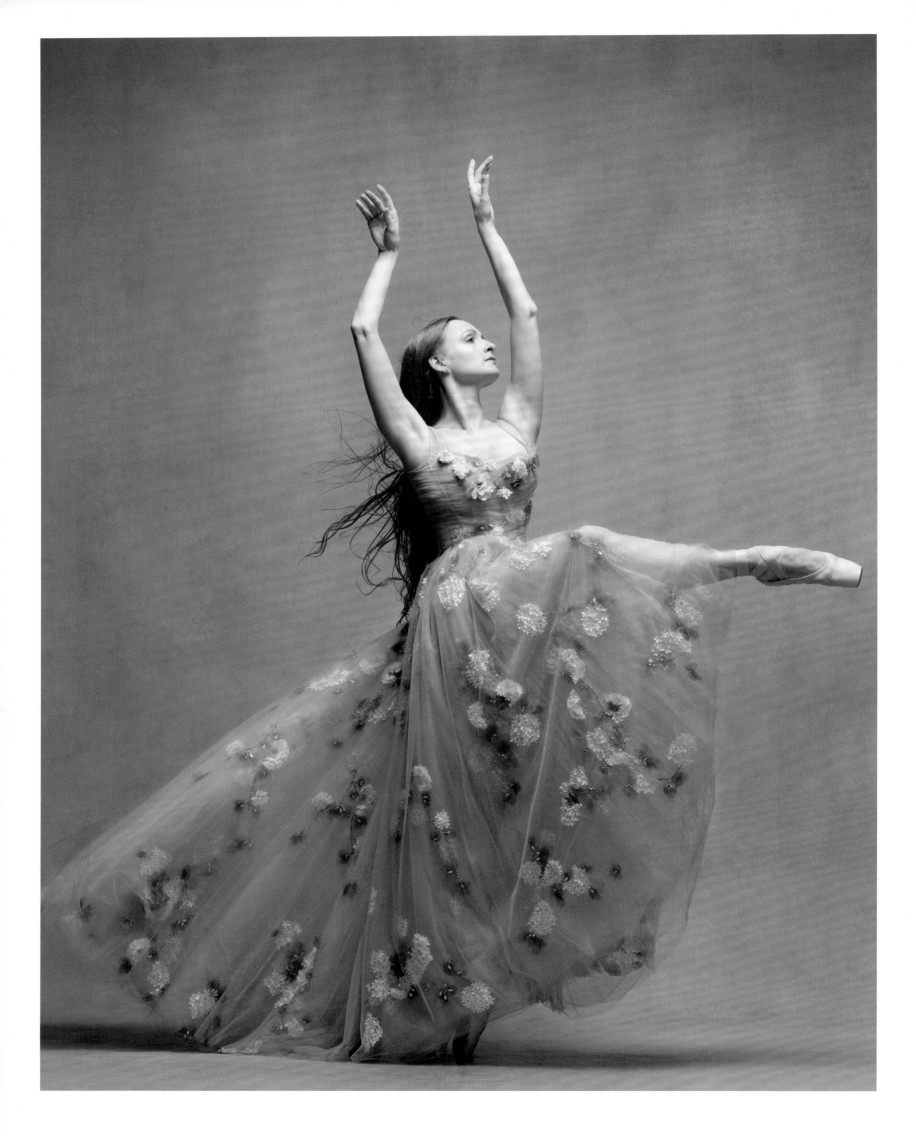

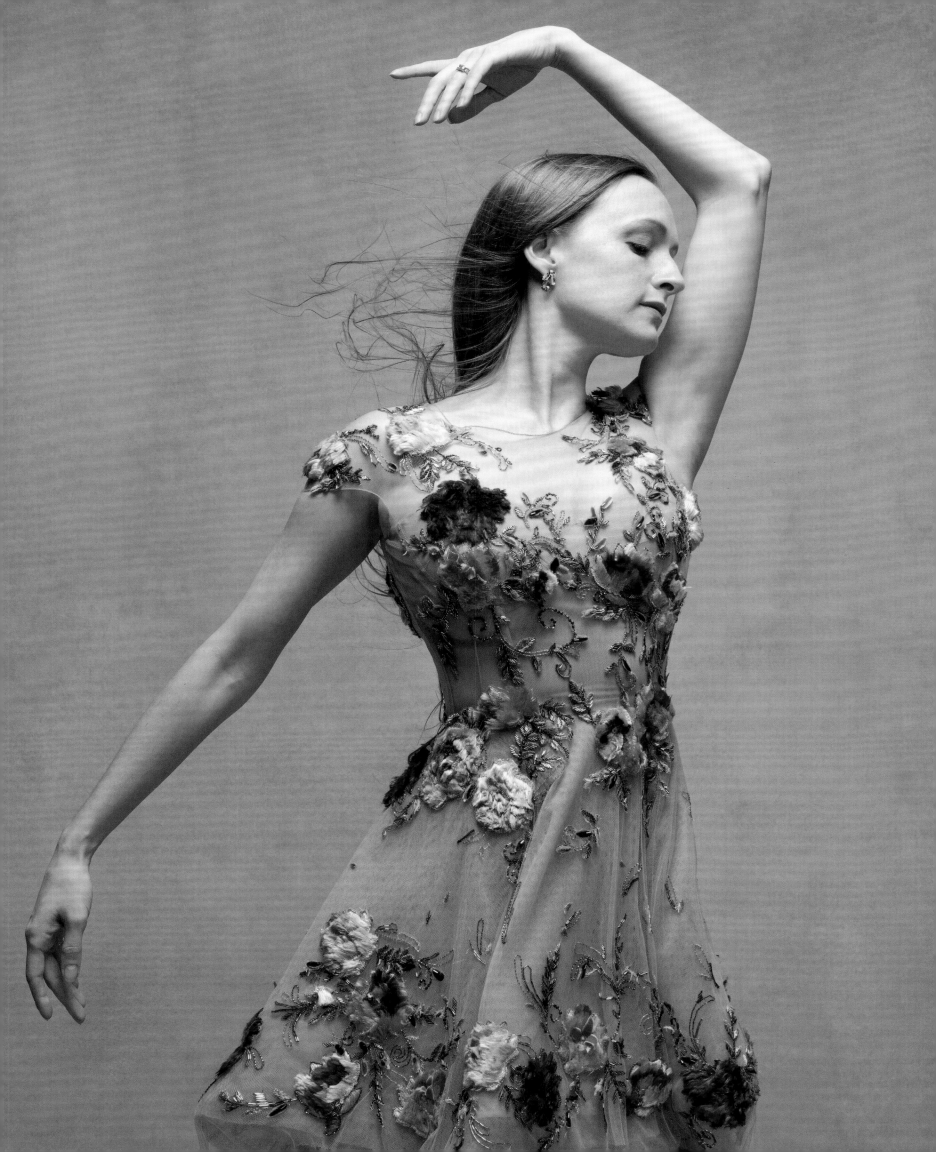

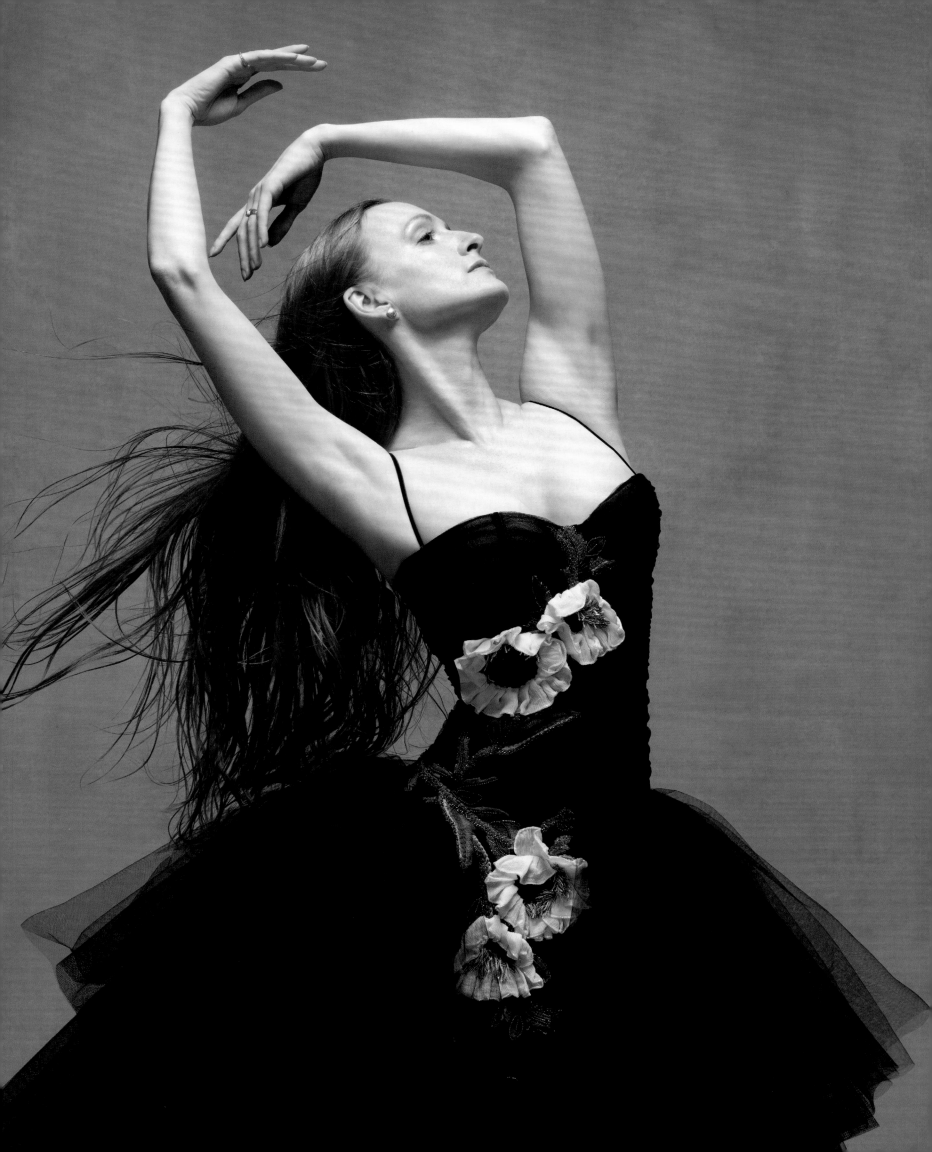

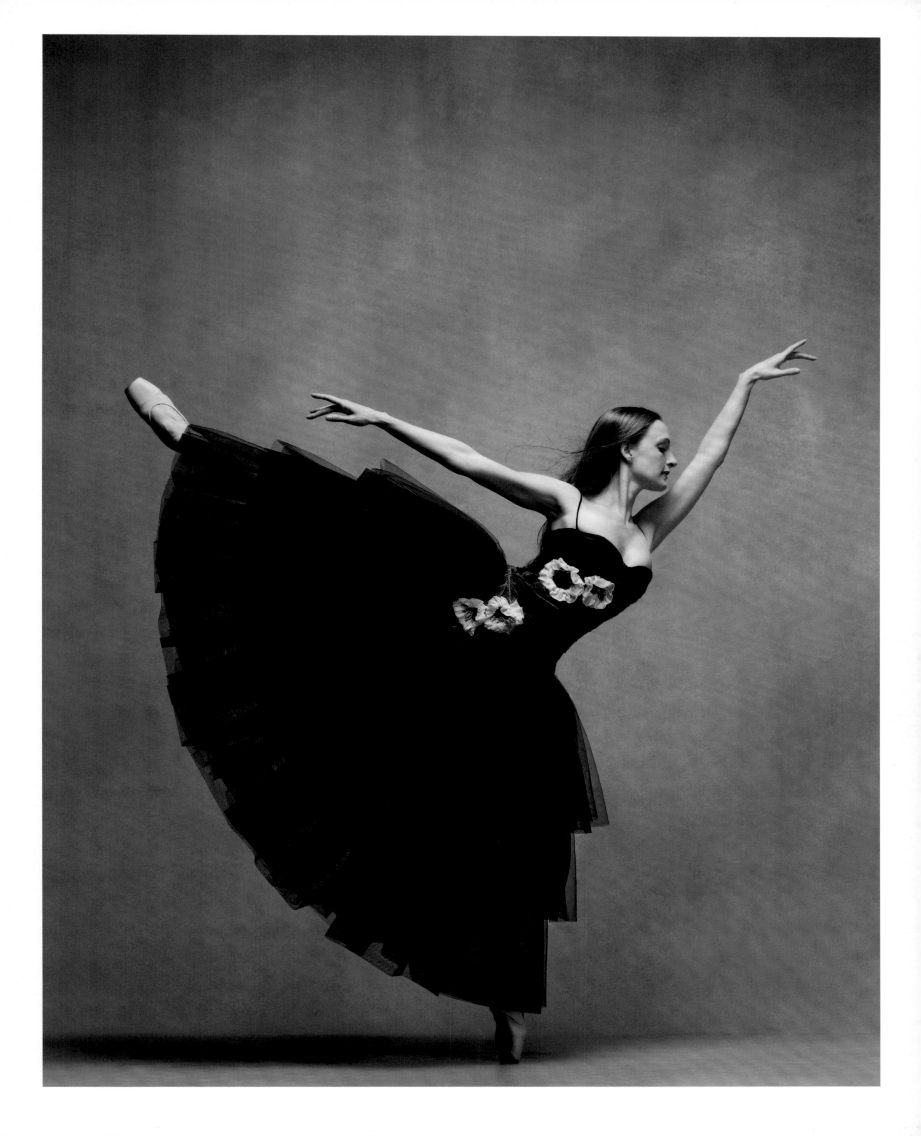

John Lam | Principal, Boston Ballet | *Jacket by Tom Ford*

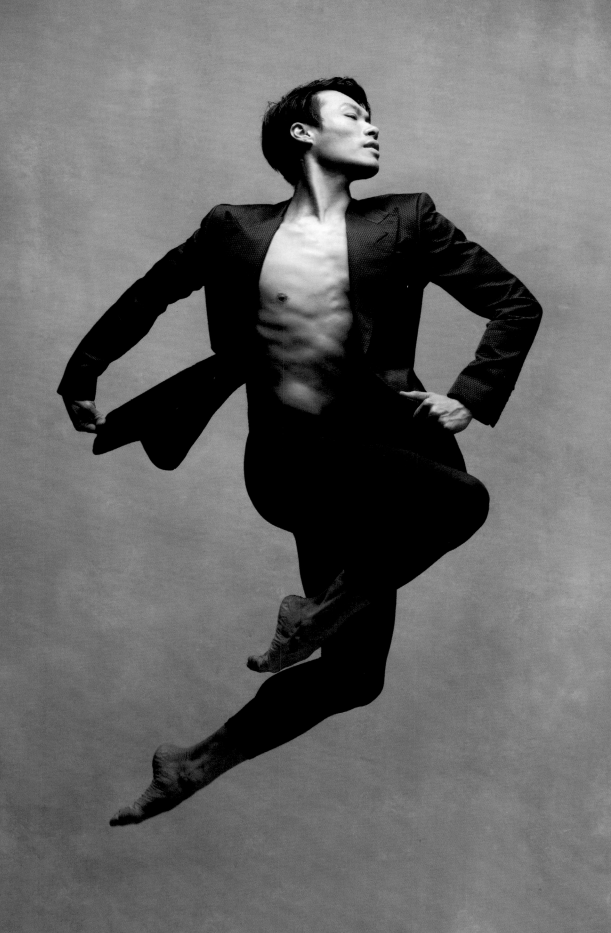

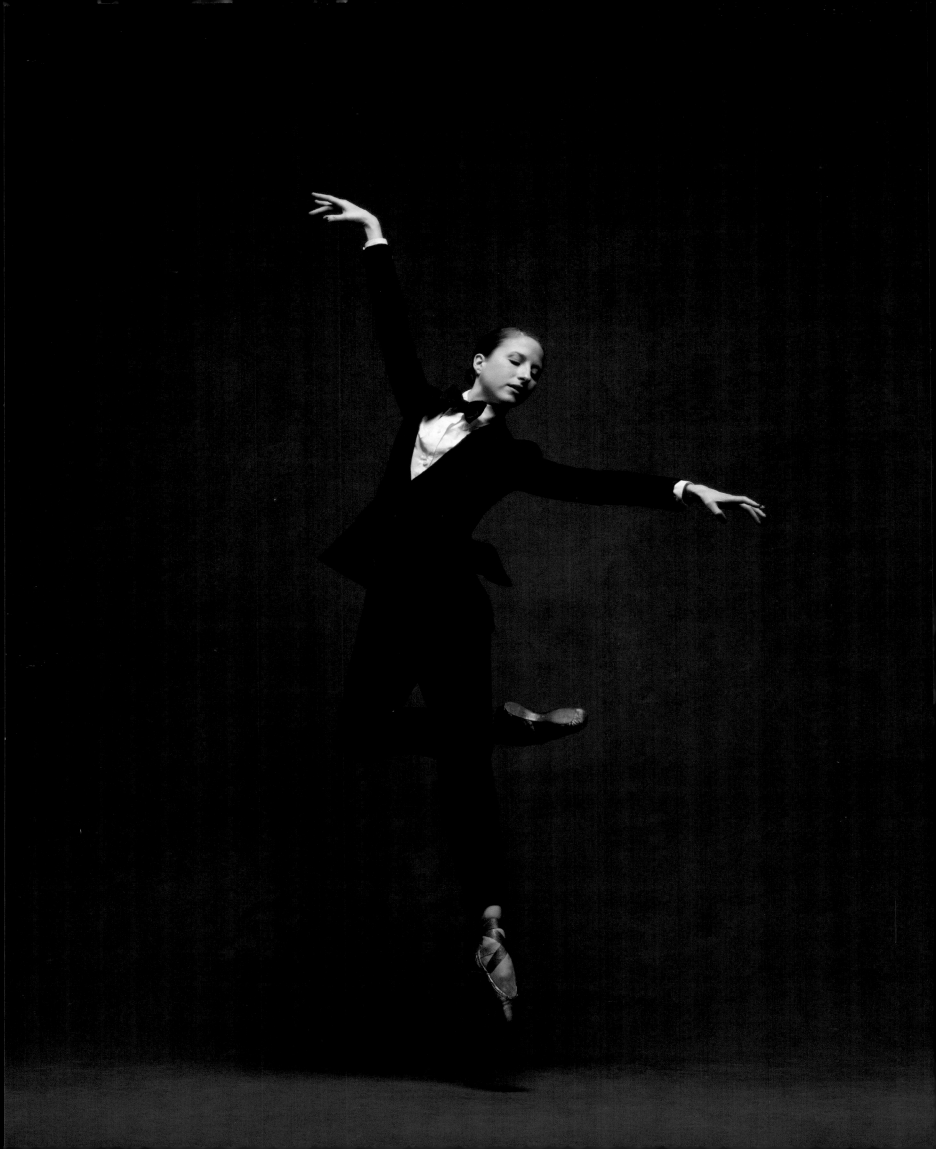

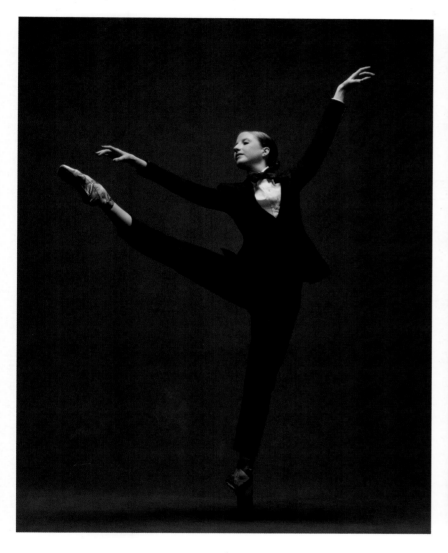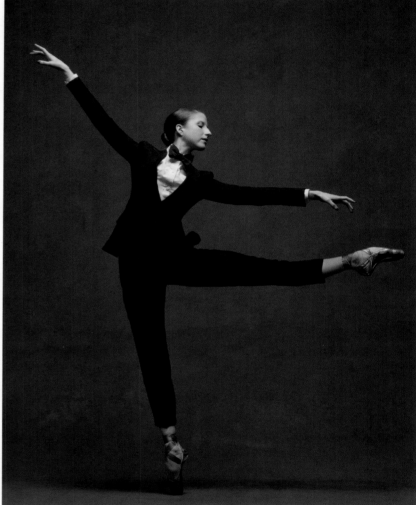

Sara Adams | Soloist, New York City Ballet | *Clothing by Thom Browne*

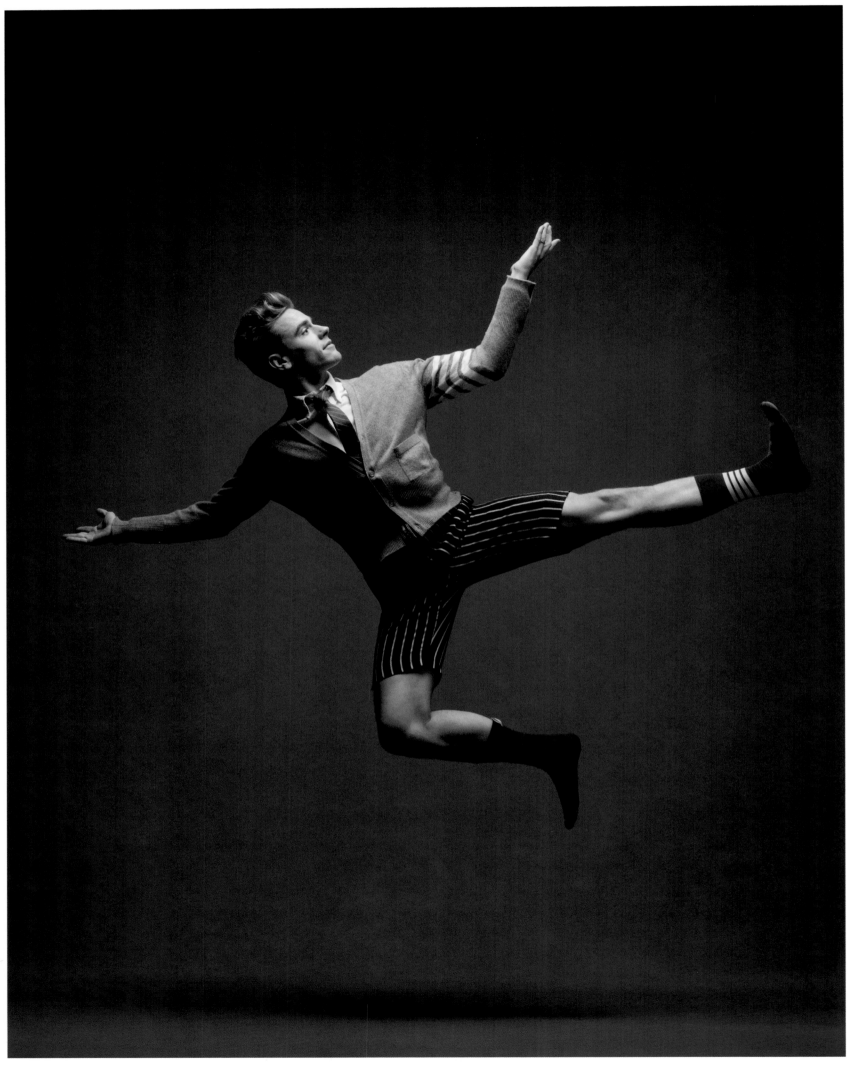

Michael Francis McBride | Alvin Ailey American Dance Theater | *Clothing by Thom Browne*

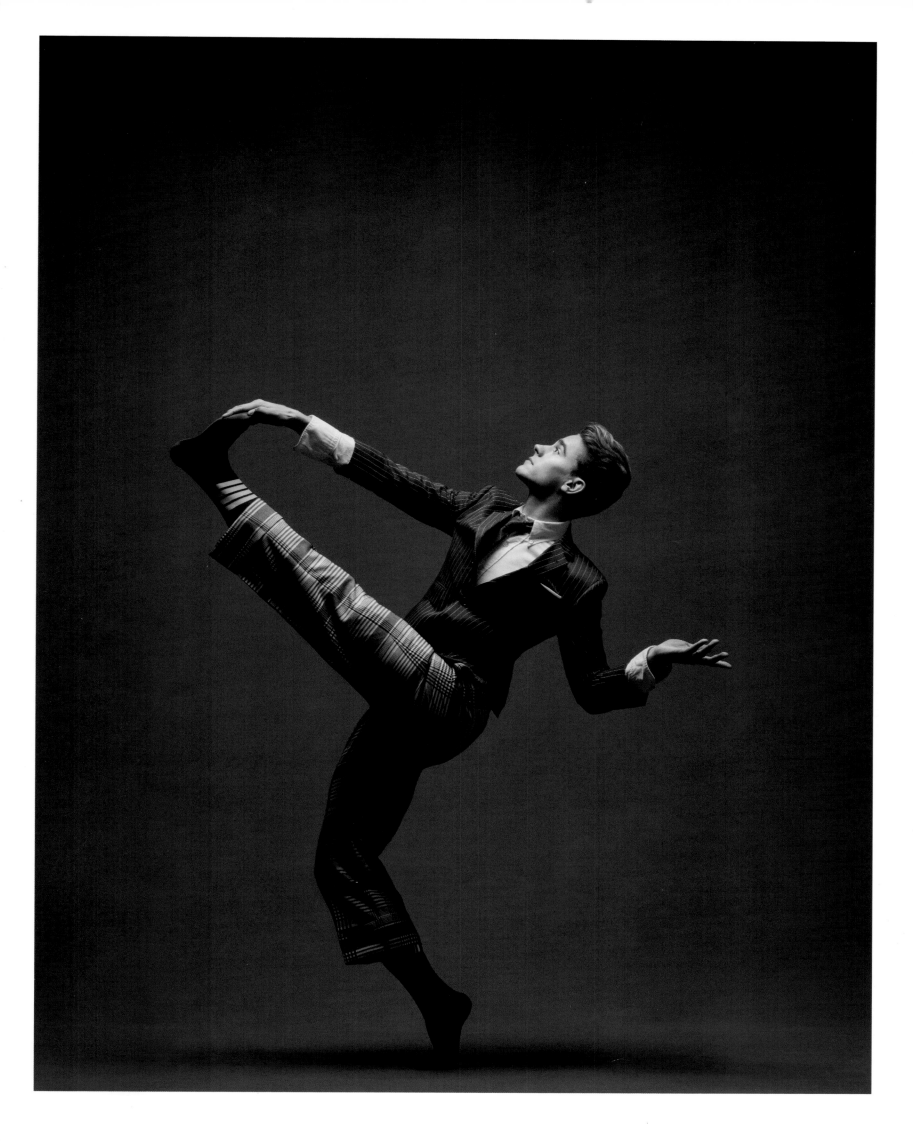

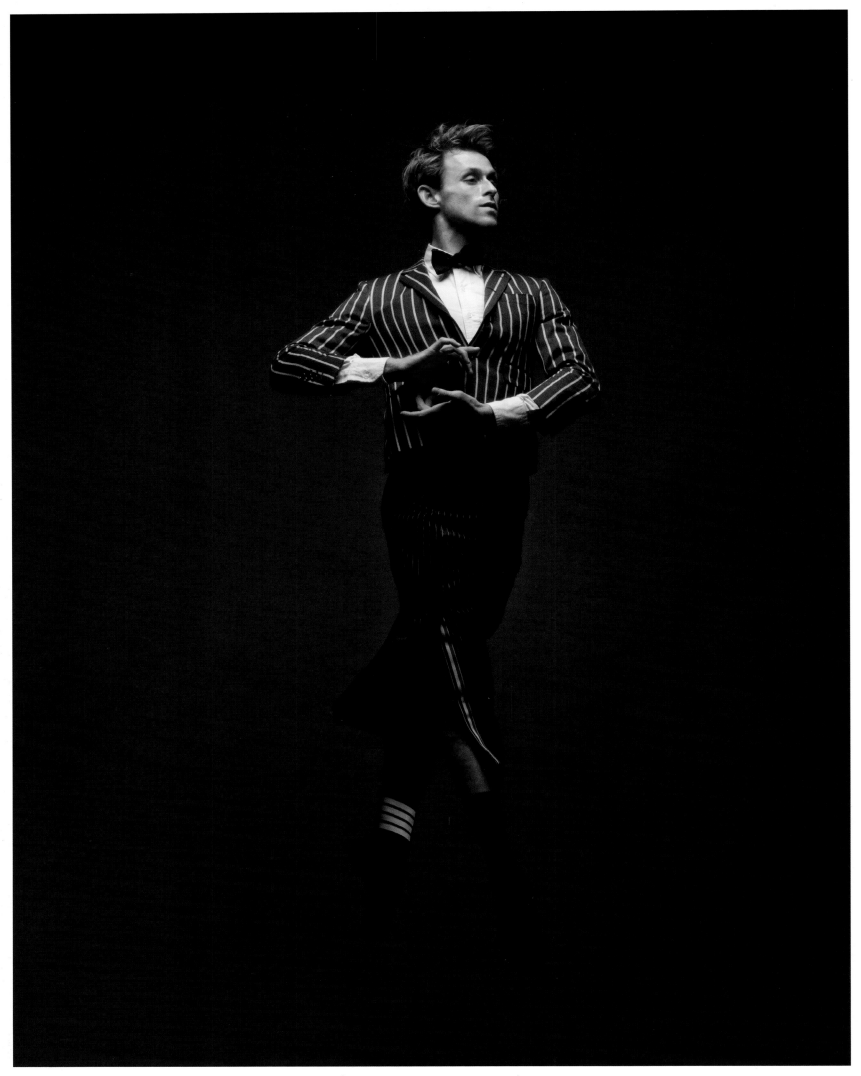

Adrian Danchig-Waring | Principal, New York City Ballet | *Clothing by Thom Browne*

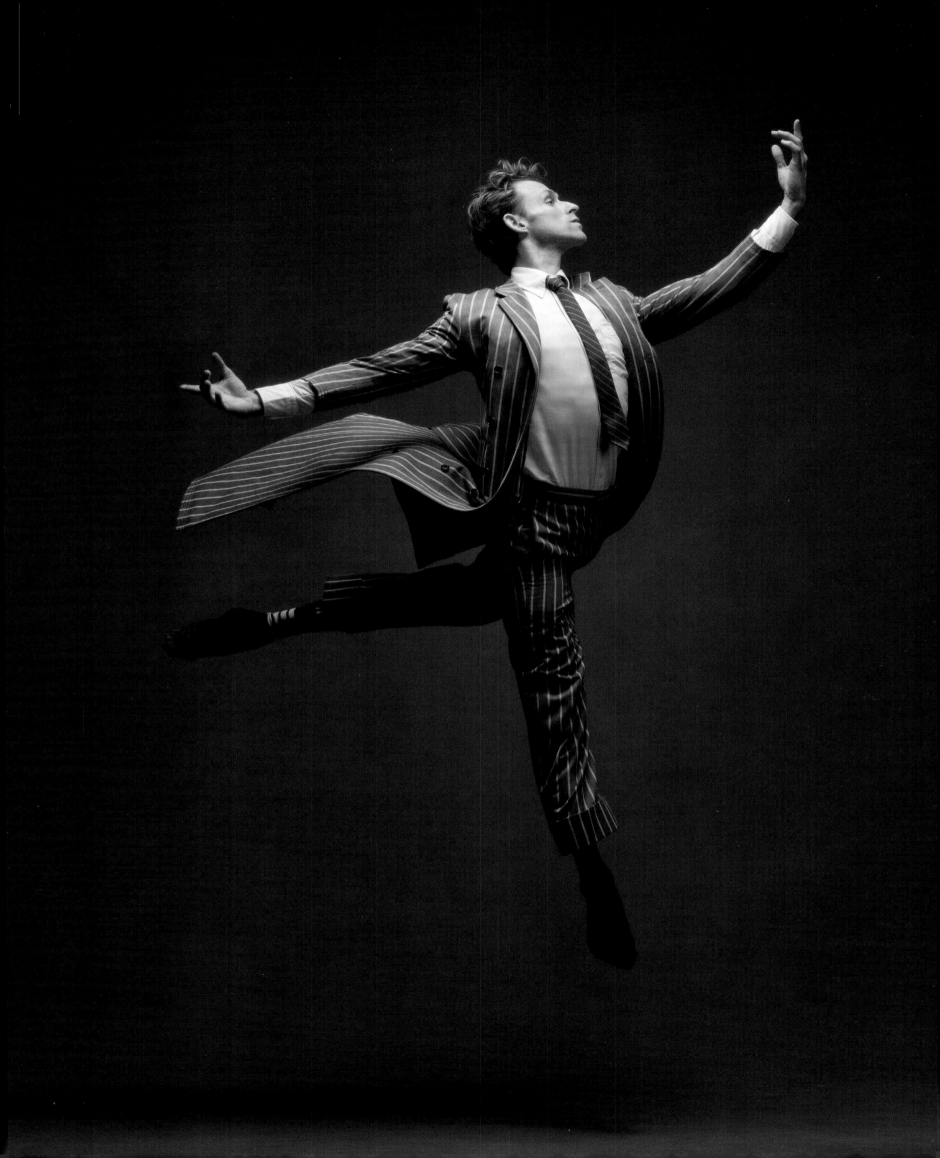

Michael Novak | Artistic Director, Paul Taylor Dance Company | *Wetsuit by Thom Browne*

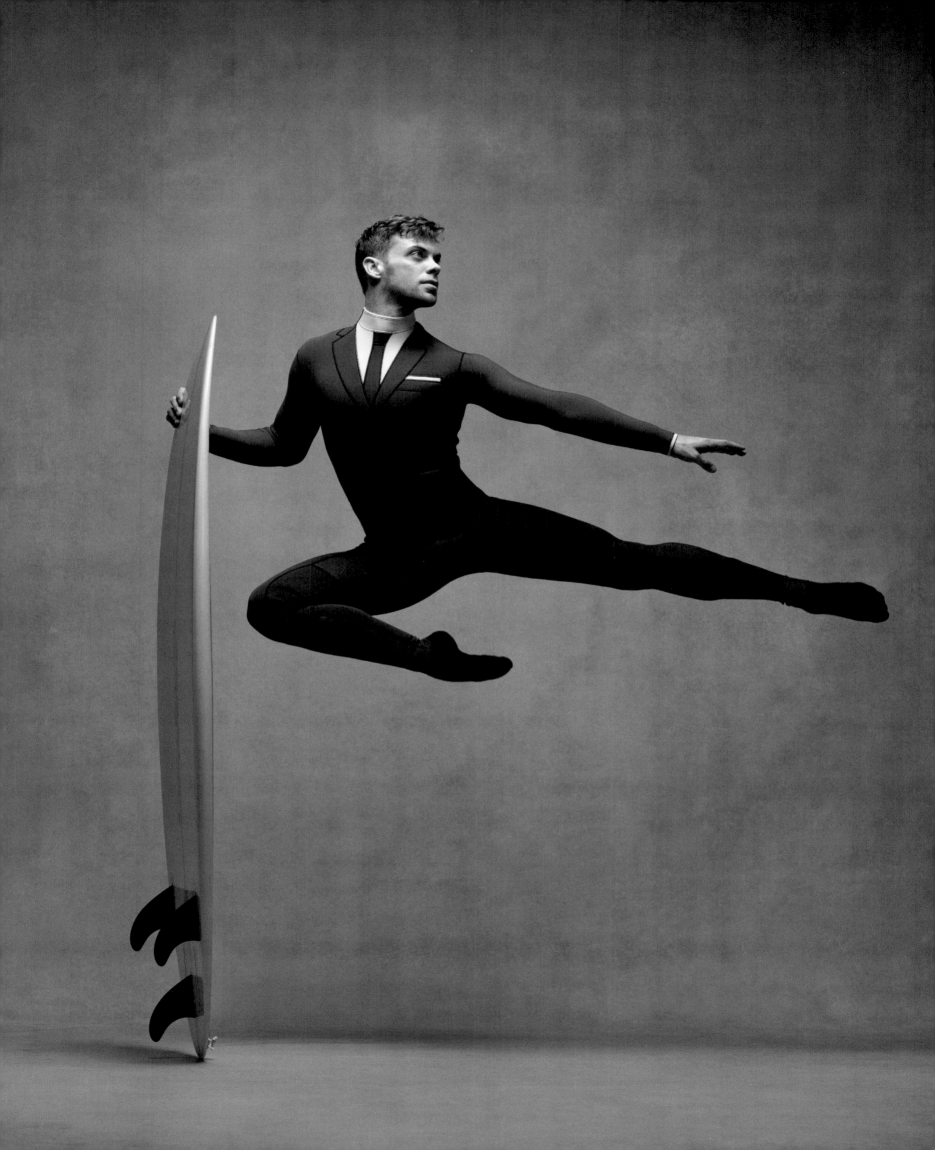

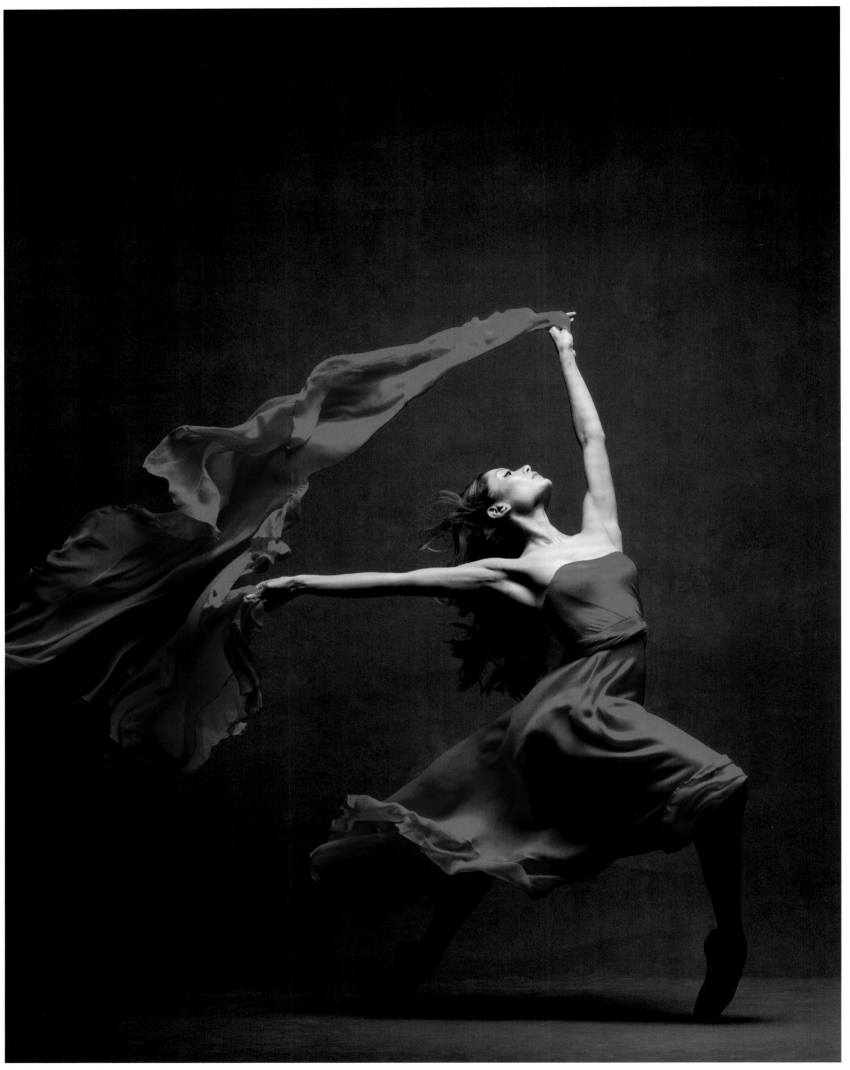

Tina Pereira | First Soloist, National Ballet of Canada | *Clothing by Halston, c. 1970, courtesy New York Vintage*

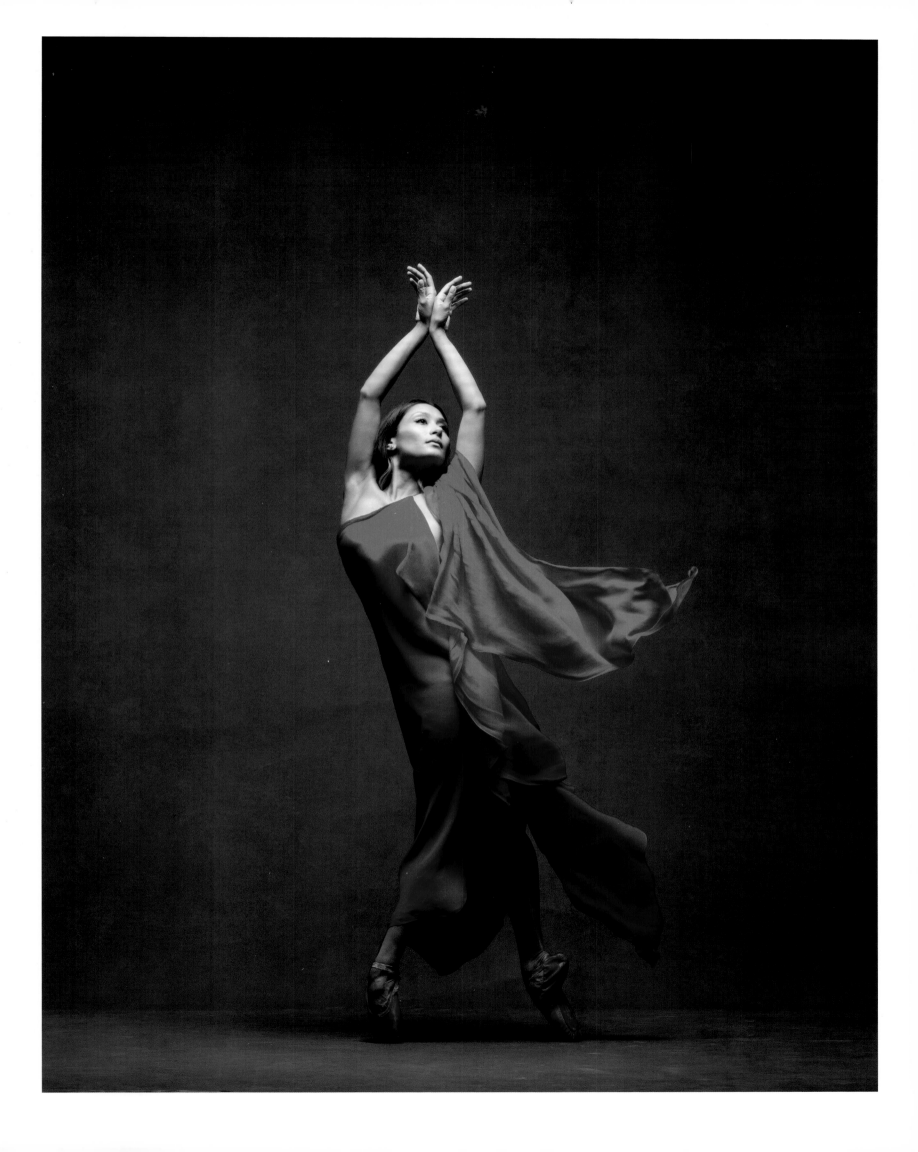

Nayara Lopes | Soloist, Pennsylvania Ballet | *Clothing by I.D. Sarrieri*

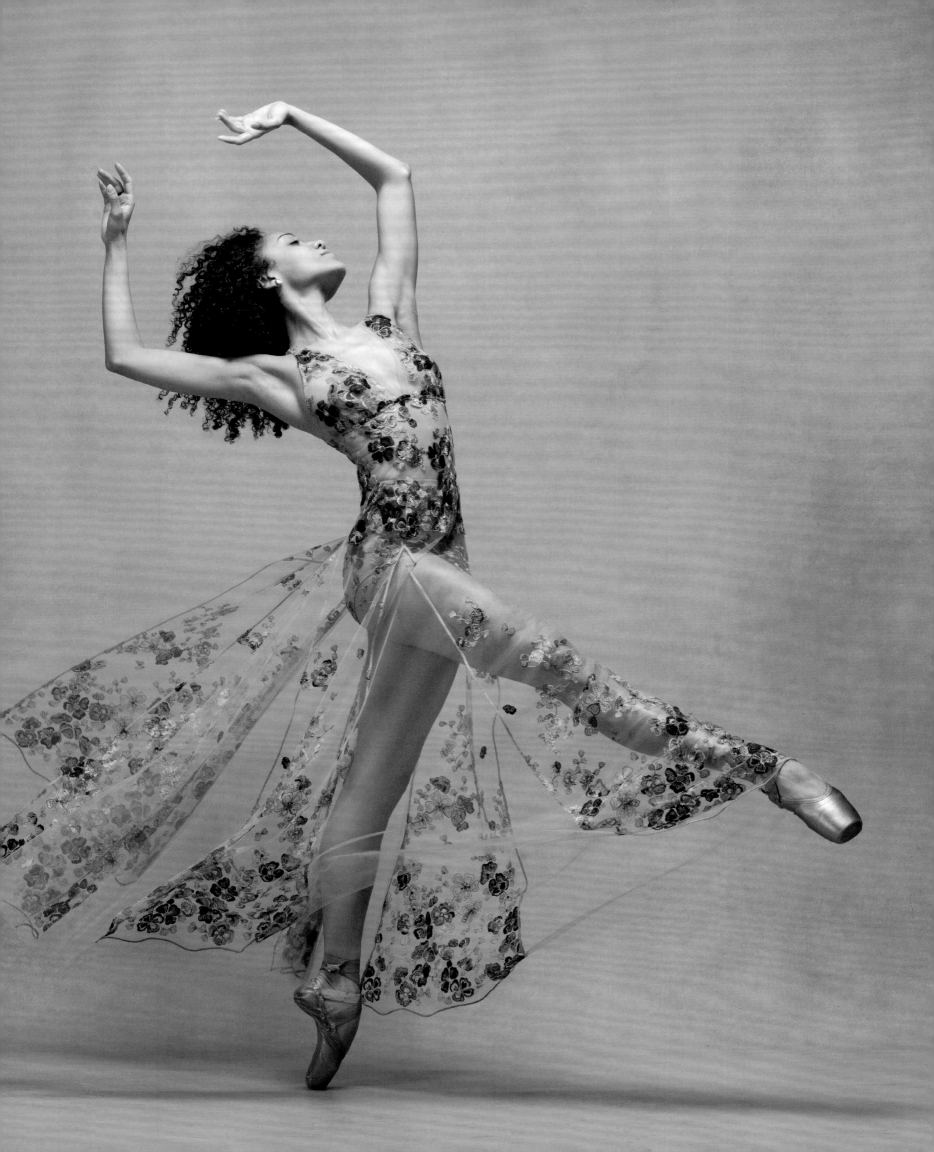

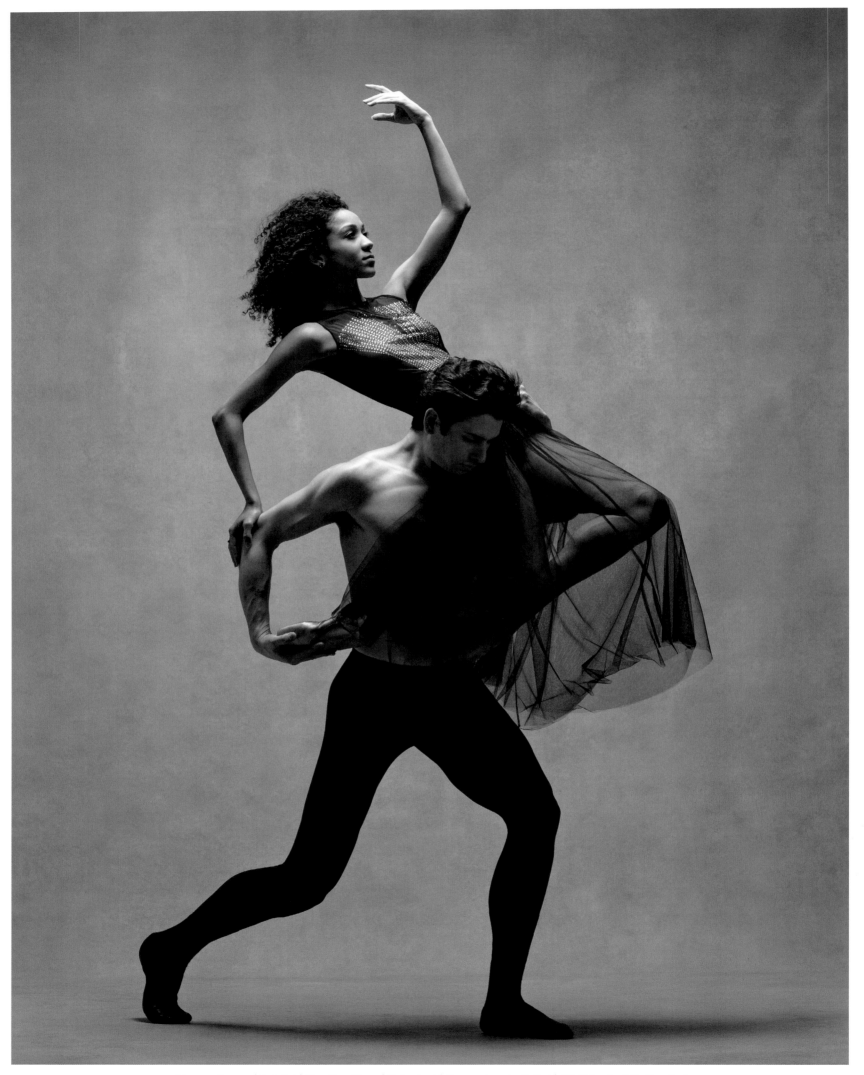

Nayara Lopes | Soloist | **Sterling Baca** | Principal | Pennsylvania Ballet | *Clothing by I.D. Sarrieri*

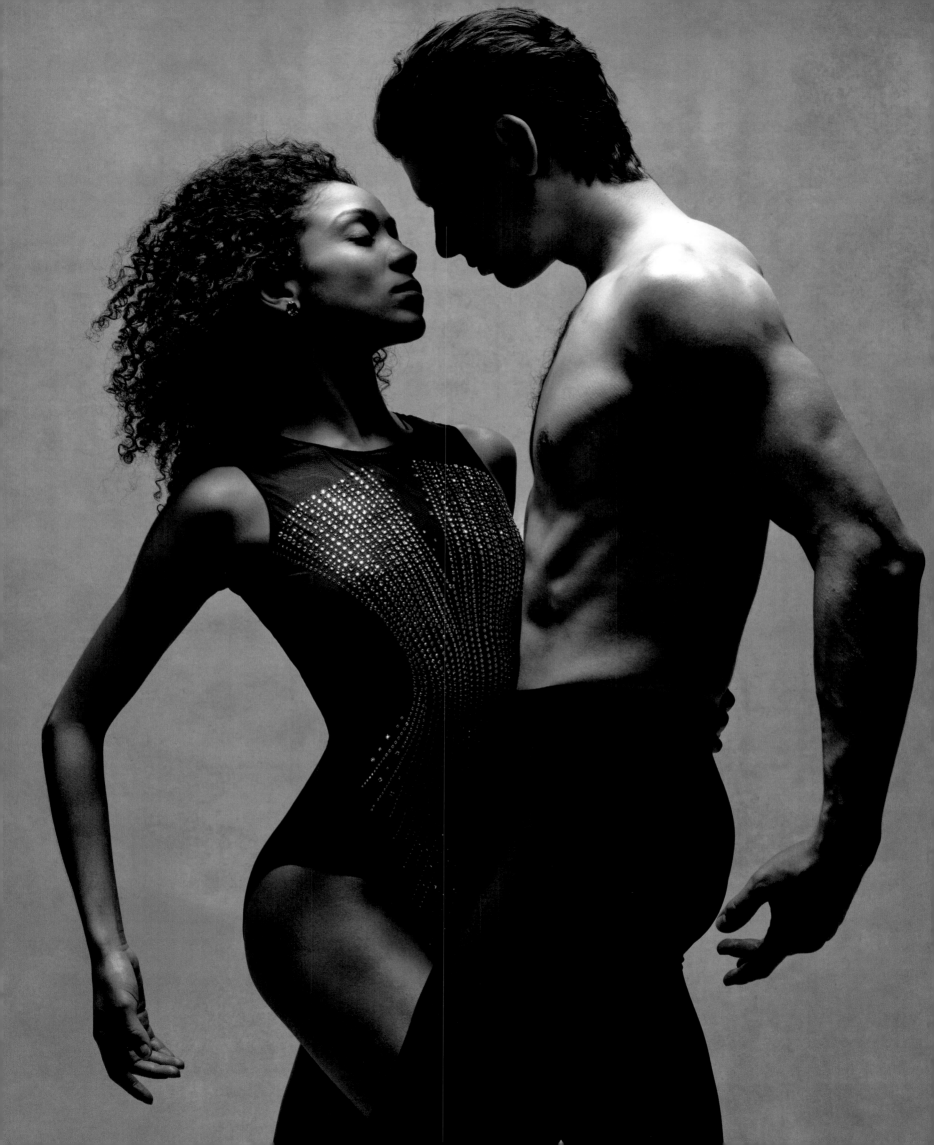

Joseph Gordon | Principal, New York City Ballet | *Clothing by Thom Sweeney*

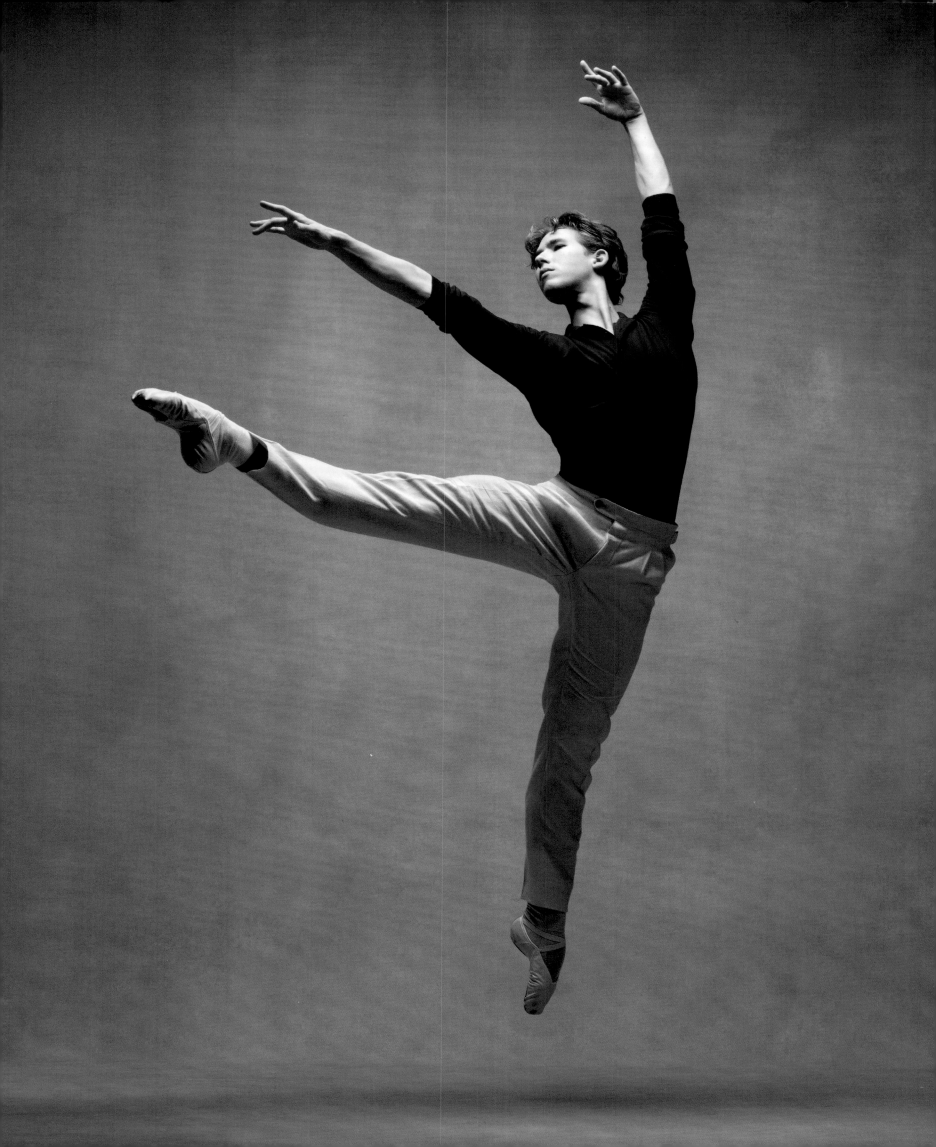

"Fashion is an ode to the art of movement:
the two unfold like light through a prism,
giving life to fabrics, colors, and silhouettes."

—VERONICA ETRO, CREATIVE DIRECTOR OF ETRO WOMAN

Unity Phelan | Soloist, New York City Ballet | *Clothing by Etro*

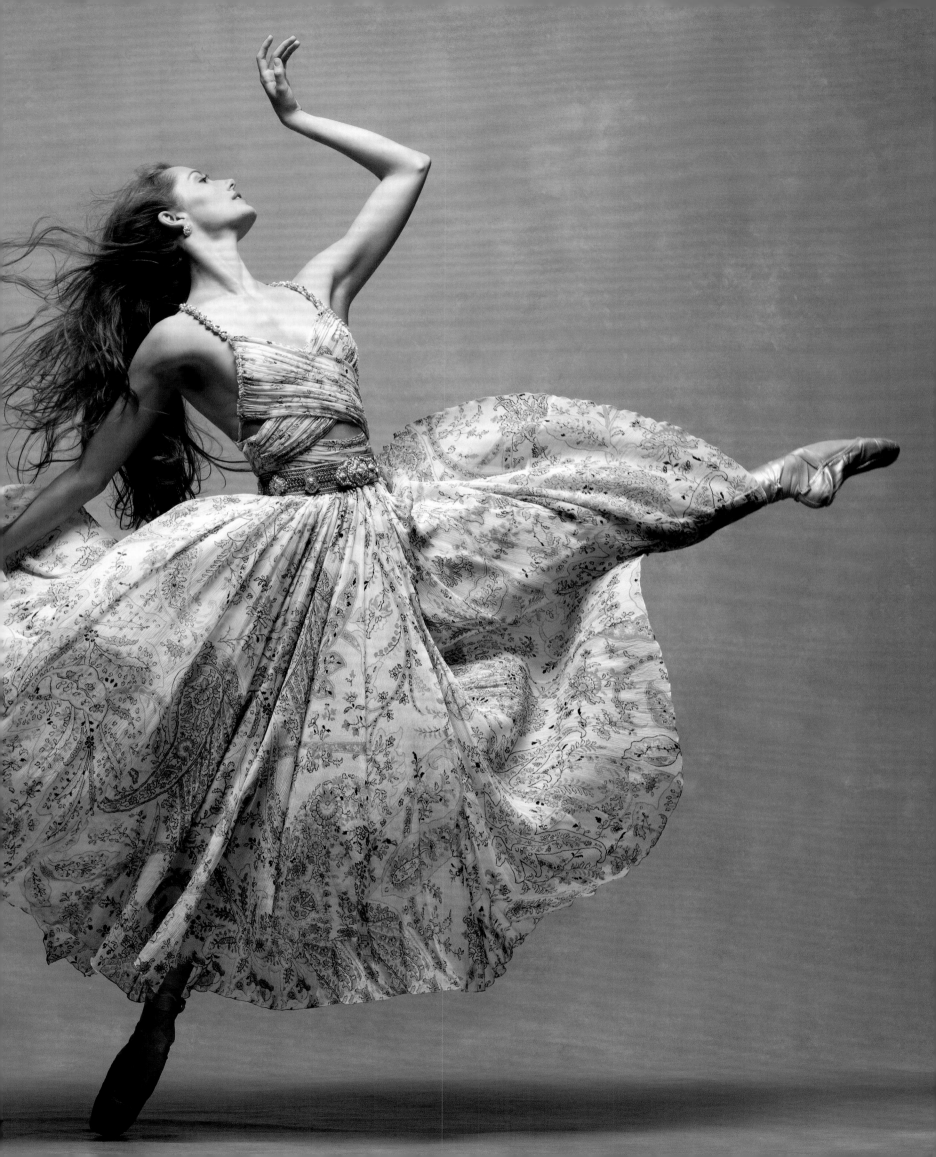

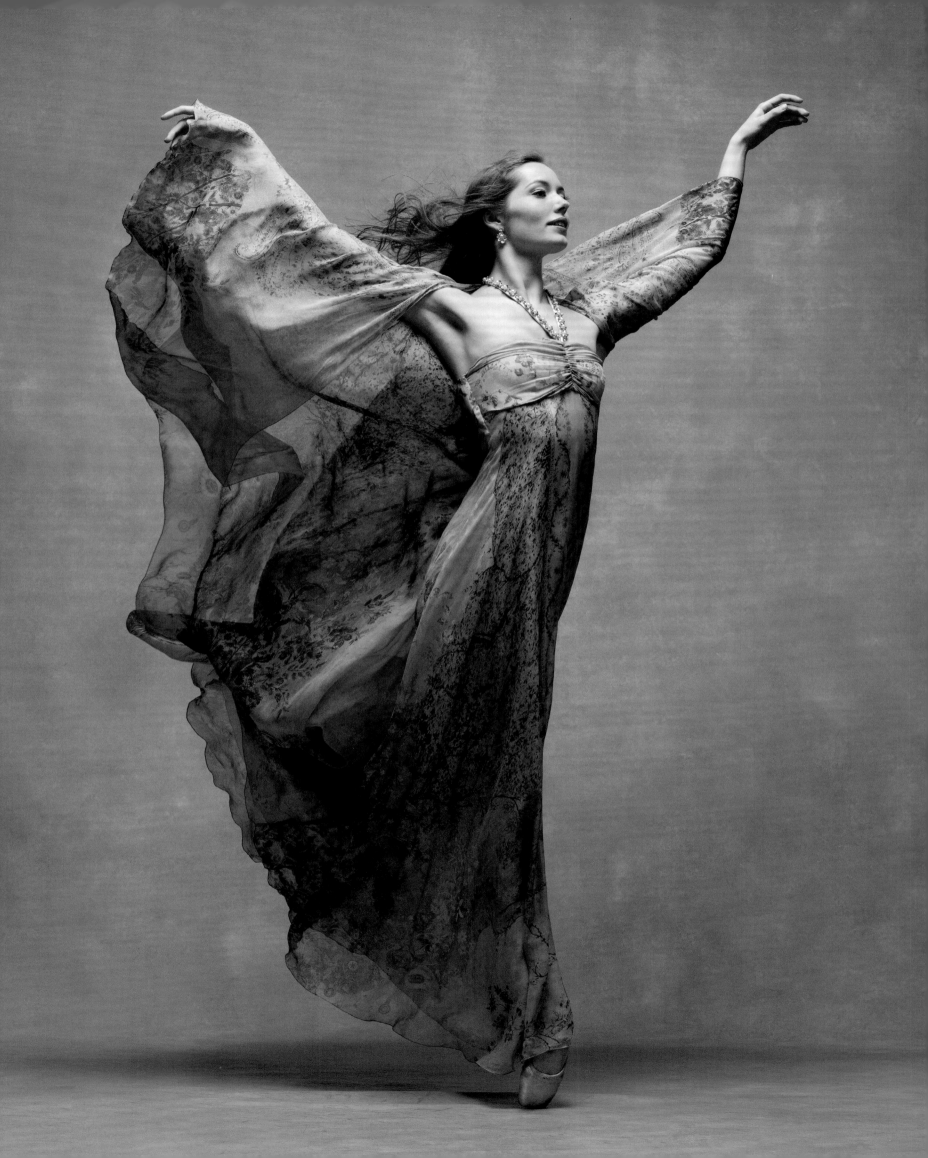

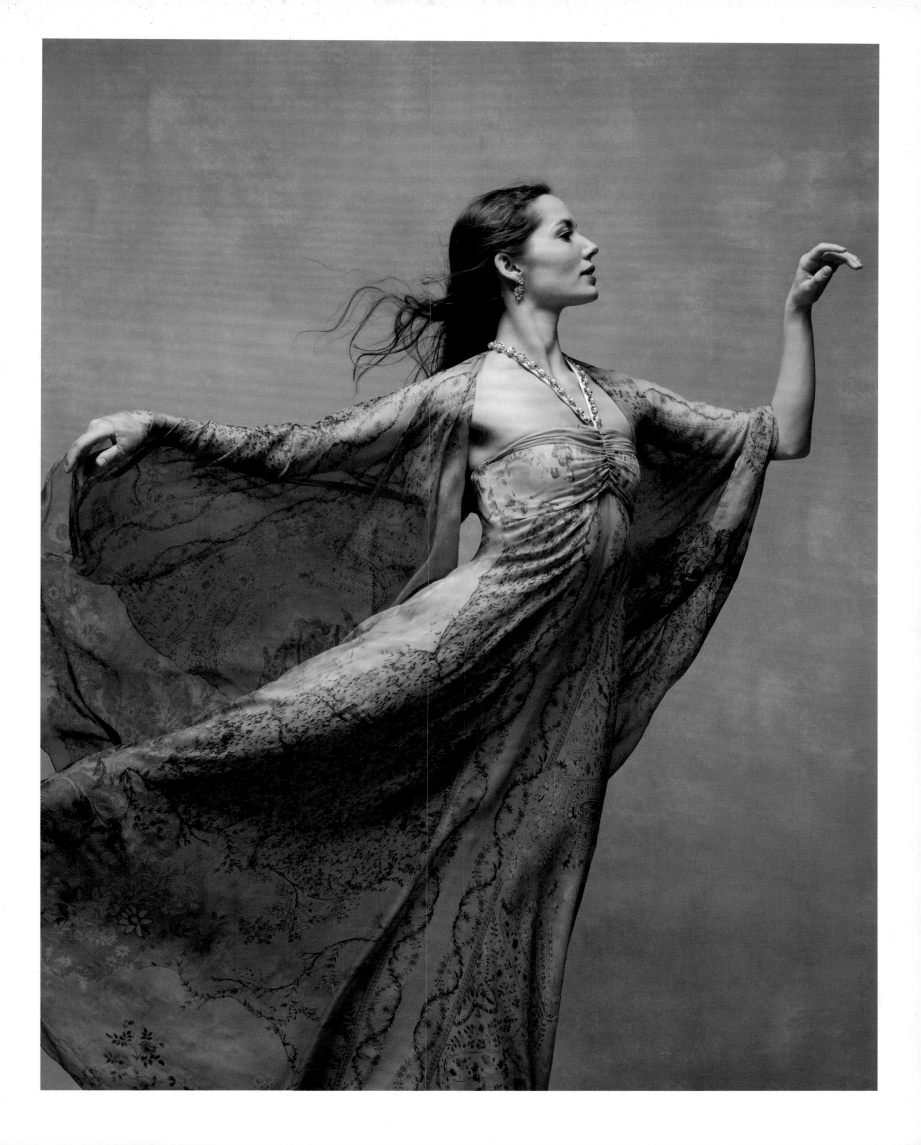

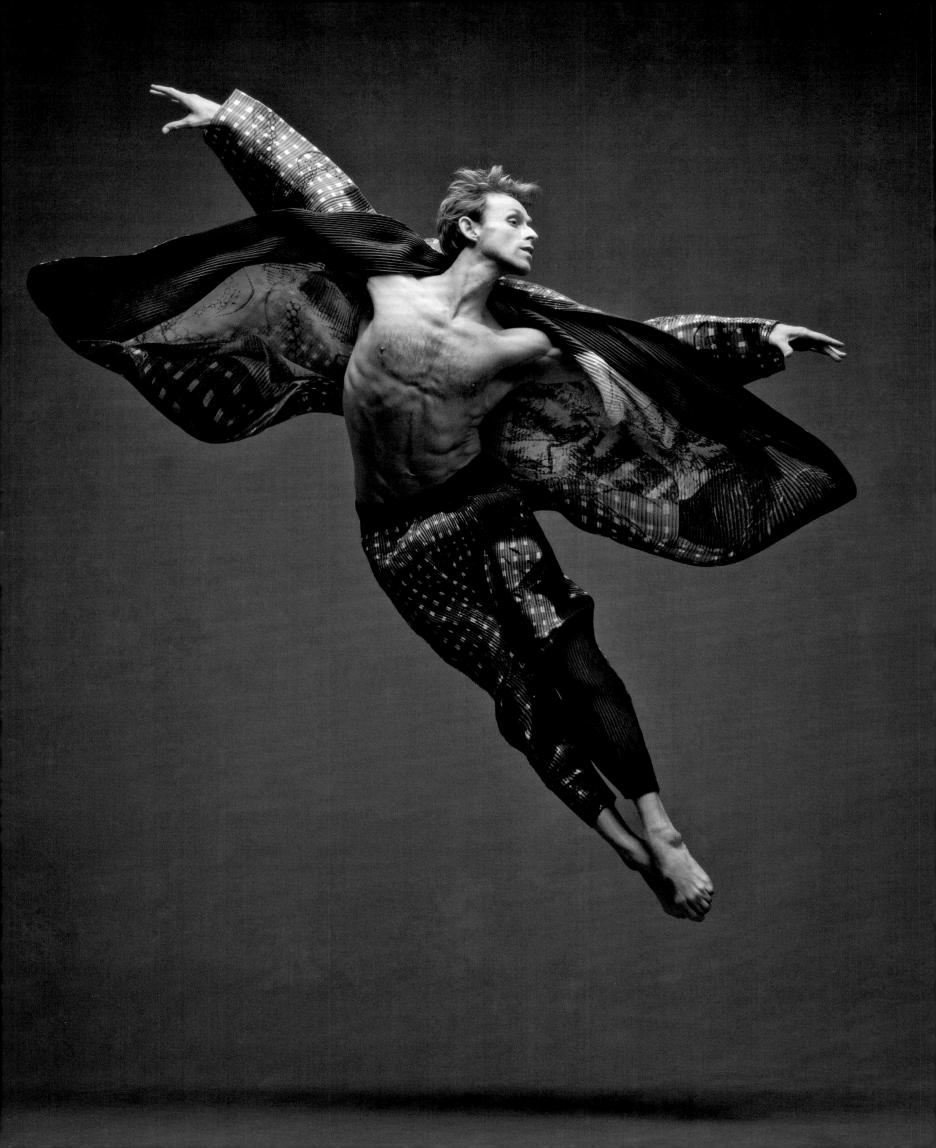

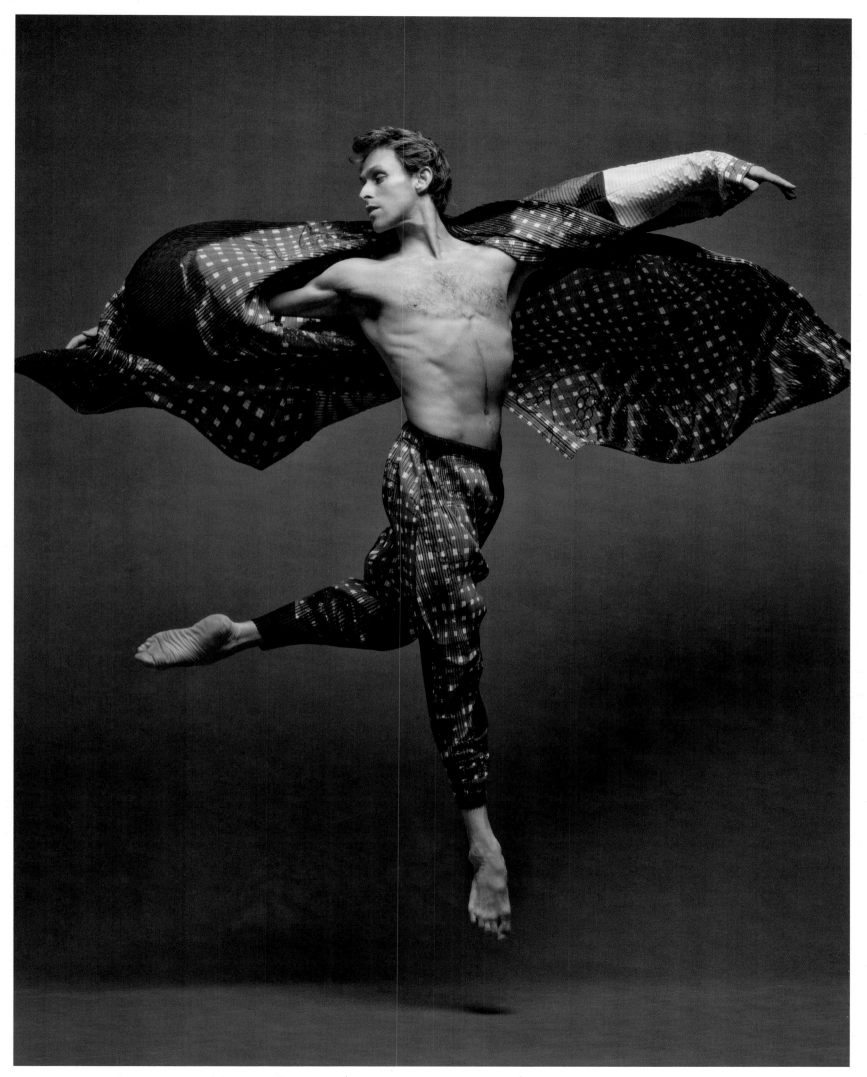

Adrian Danchig-Waring | Principal, New York City Ballet | *Clothing by Issey Miyake*

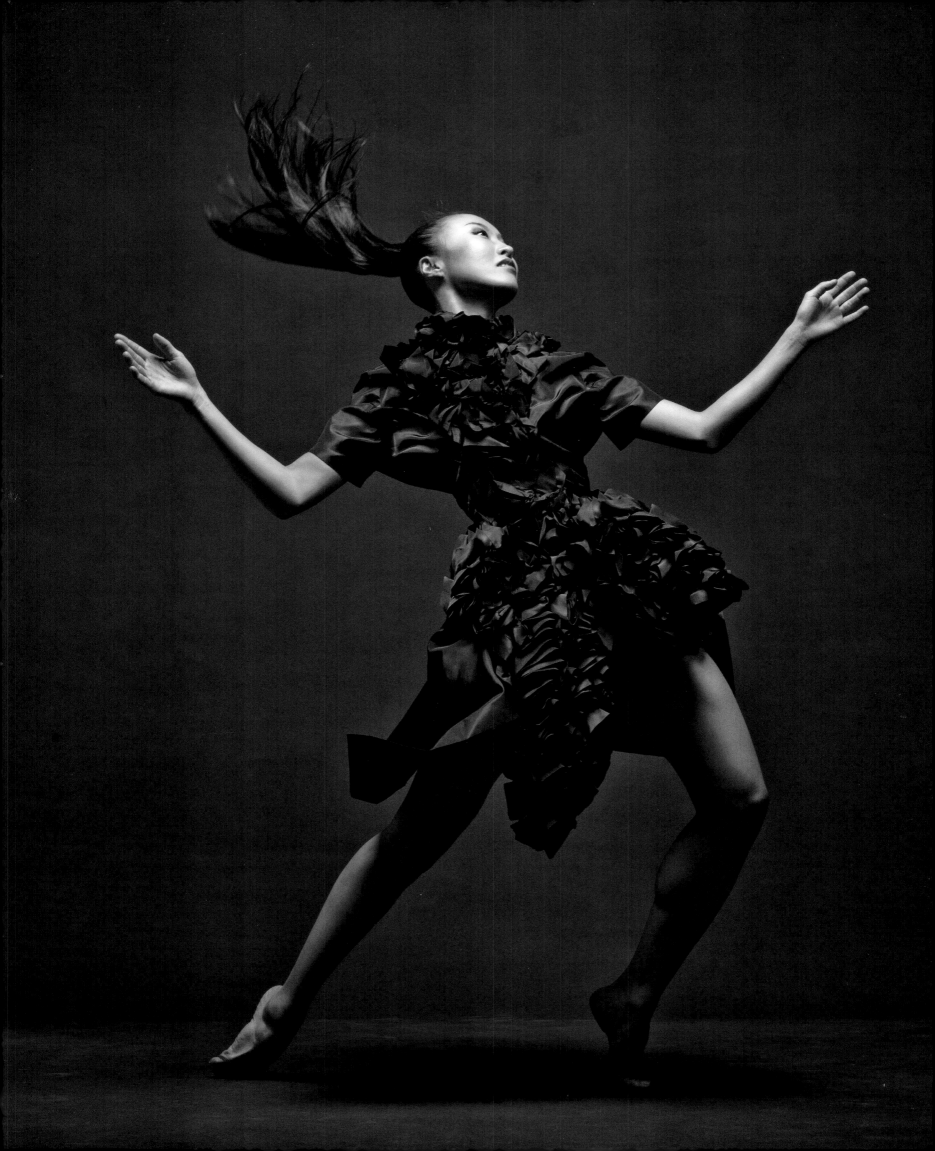

Violetta Komyshan | *Clothing by Wolford*

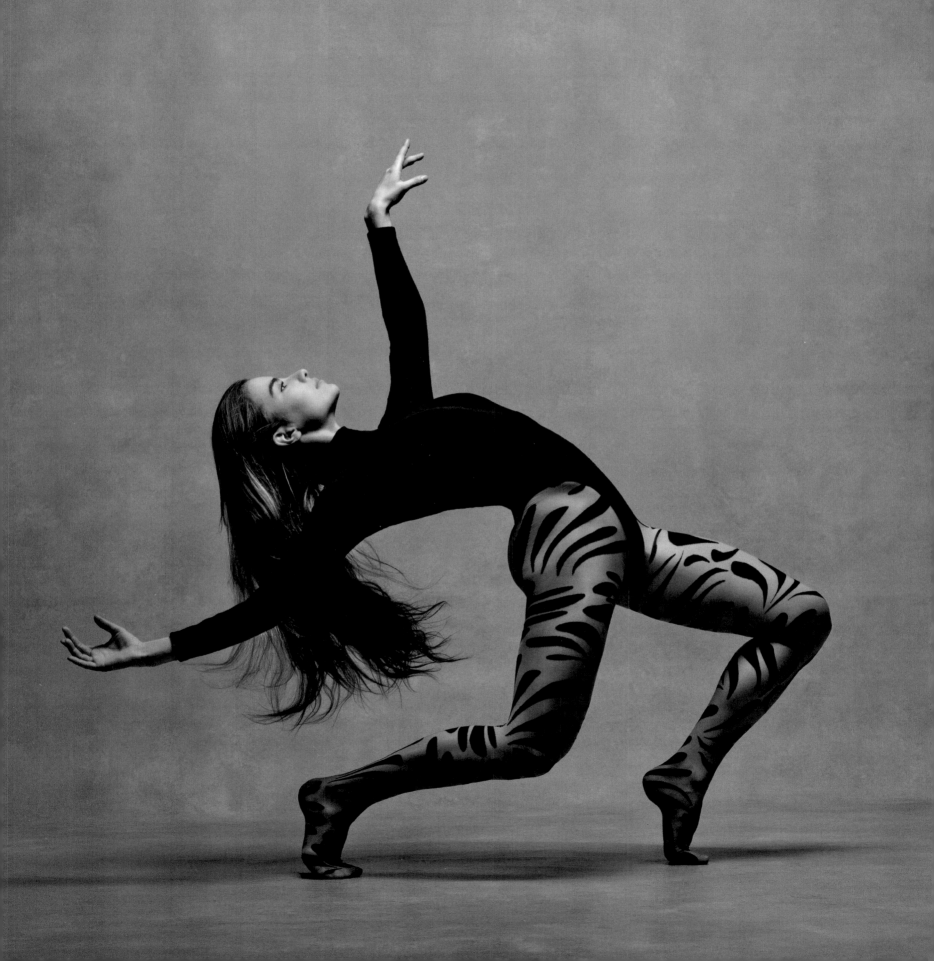

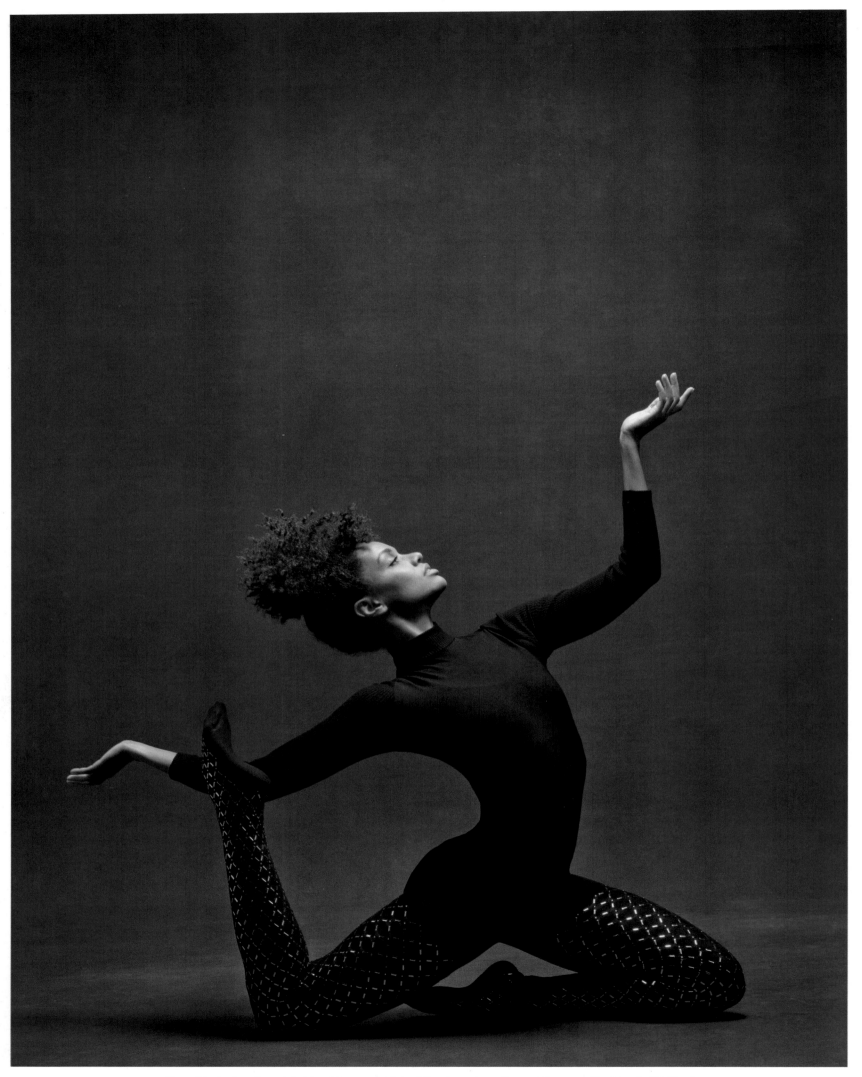

Fana Tesfagiorgis and **Ashley Mayeux** | Alvin Ailey American Dance Theater | *Clothing by Wolford*

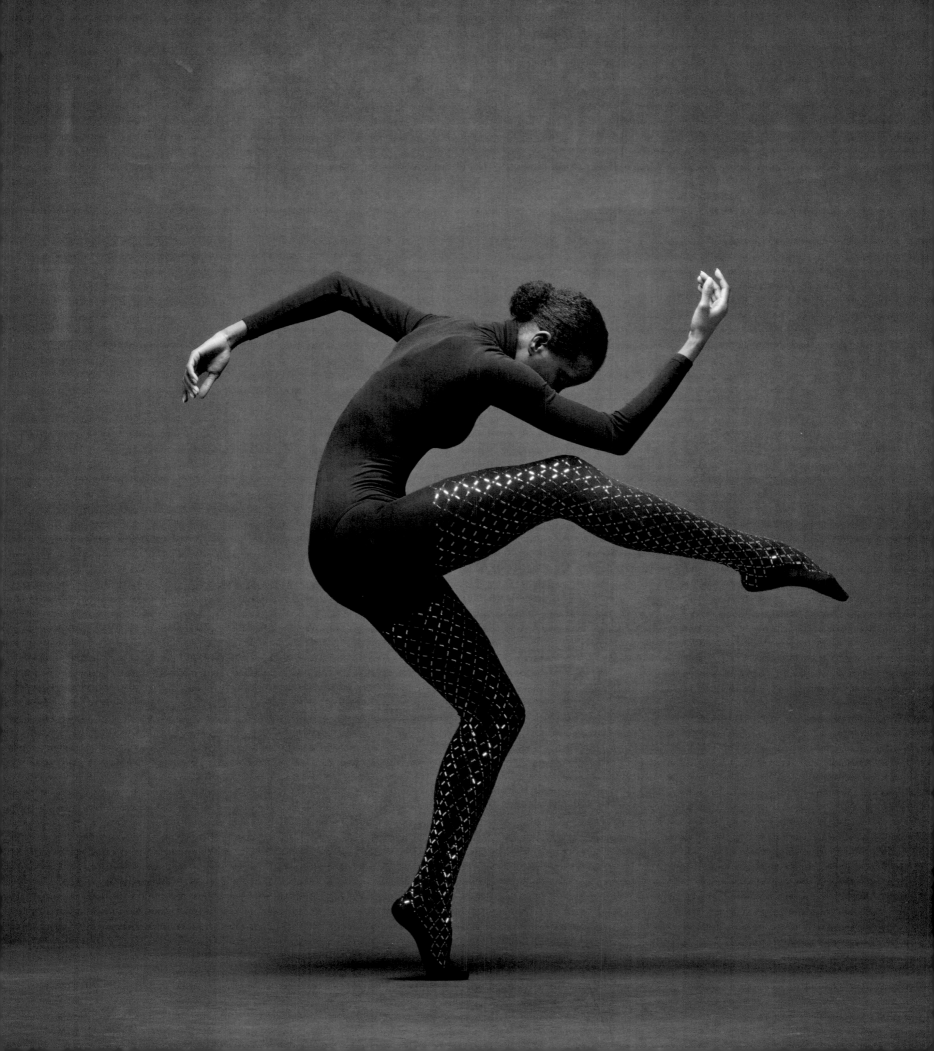

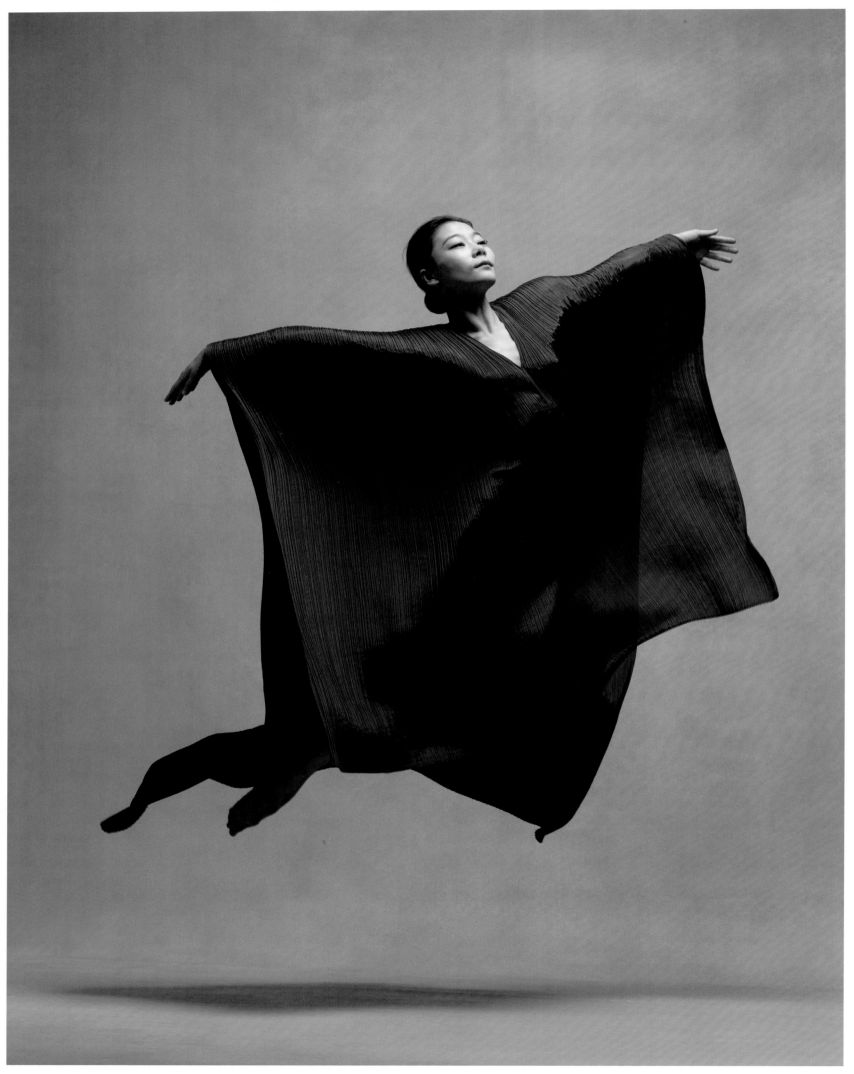

Xin Ying | Principal, Martha Graham Dance Company | *Clothing by Issey Miyake*

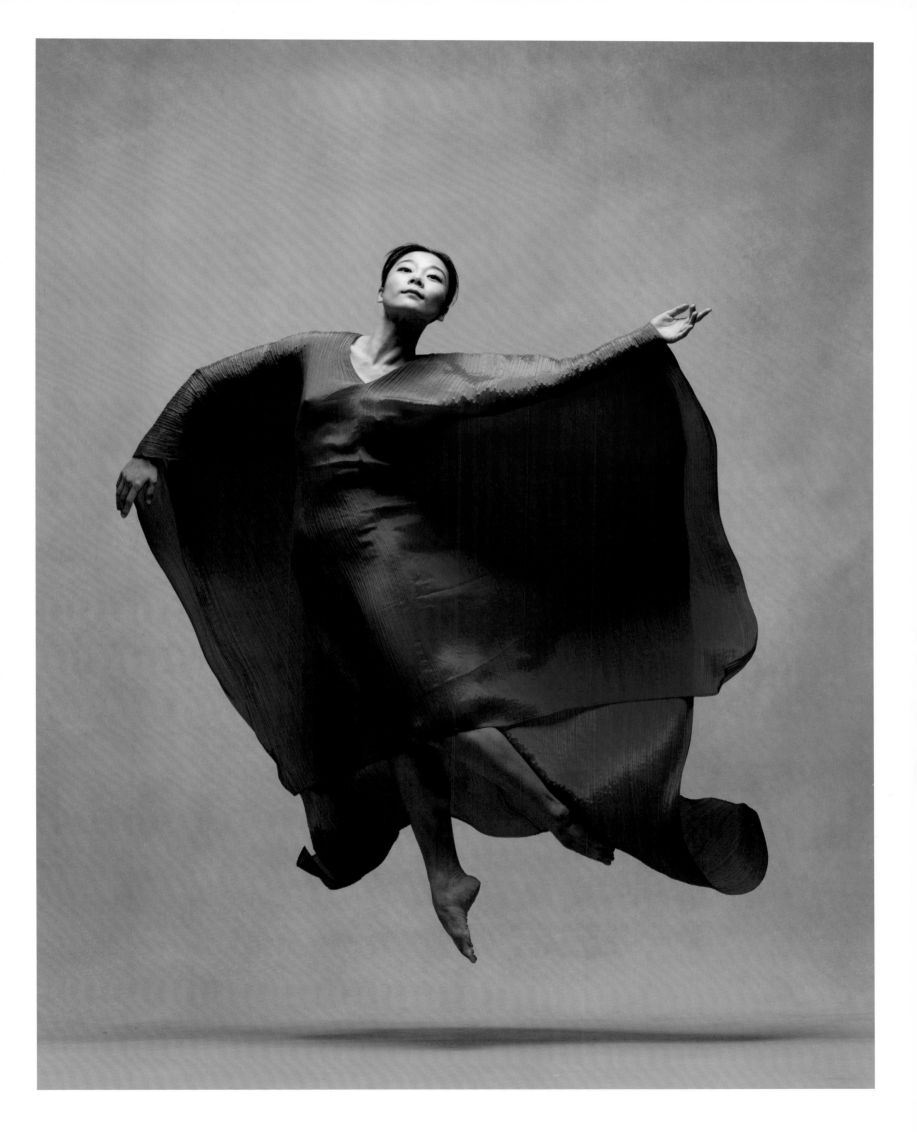

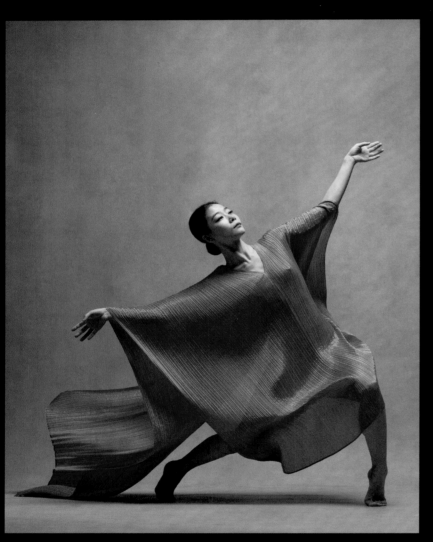
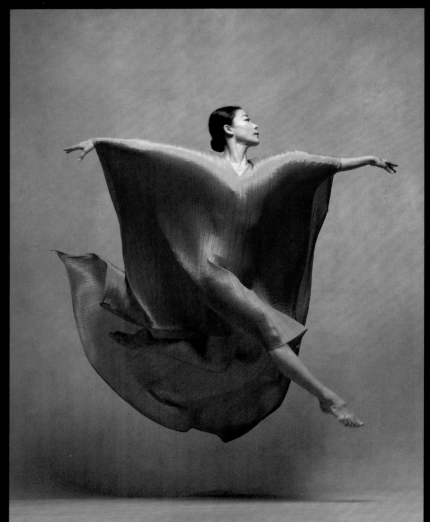

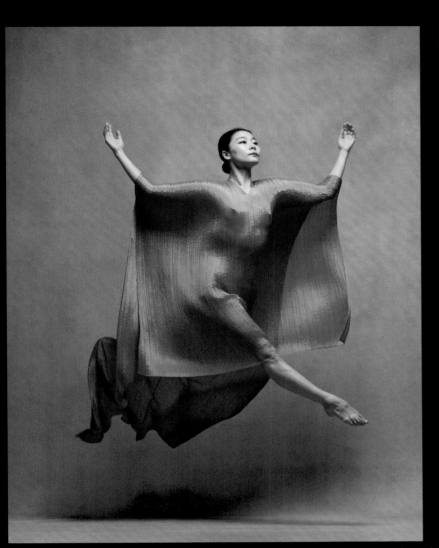
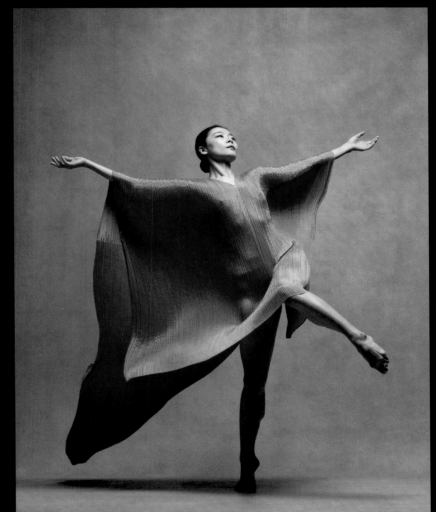

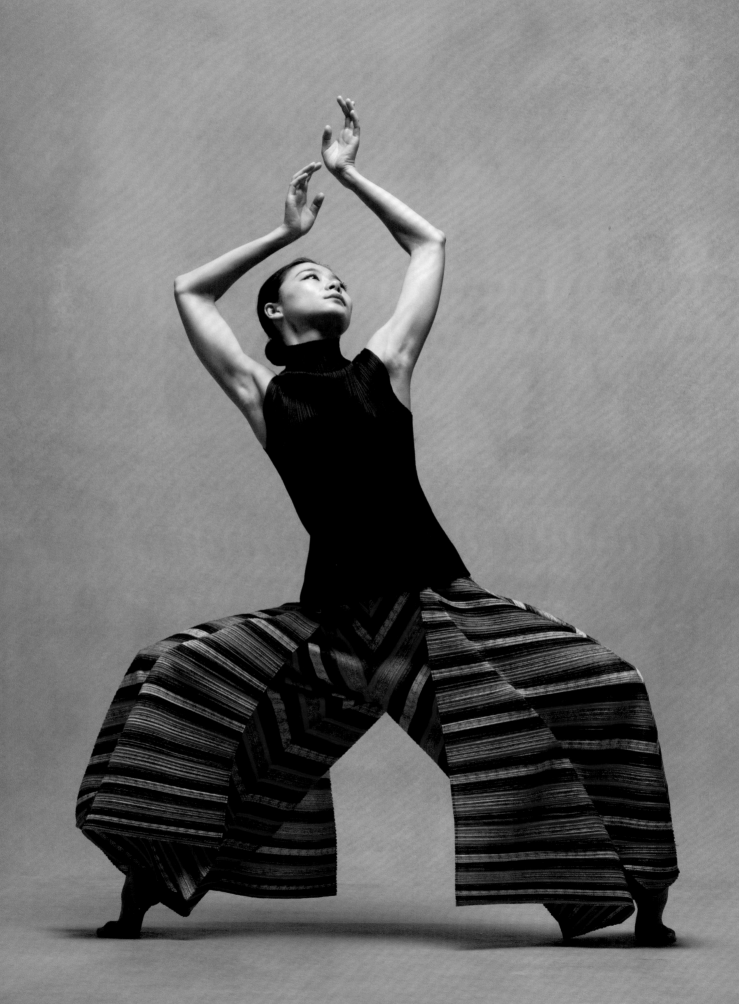

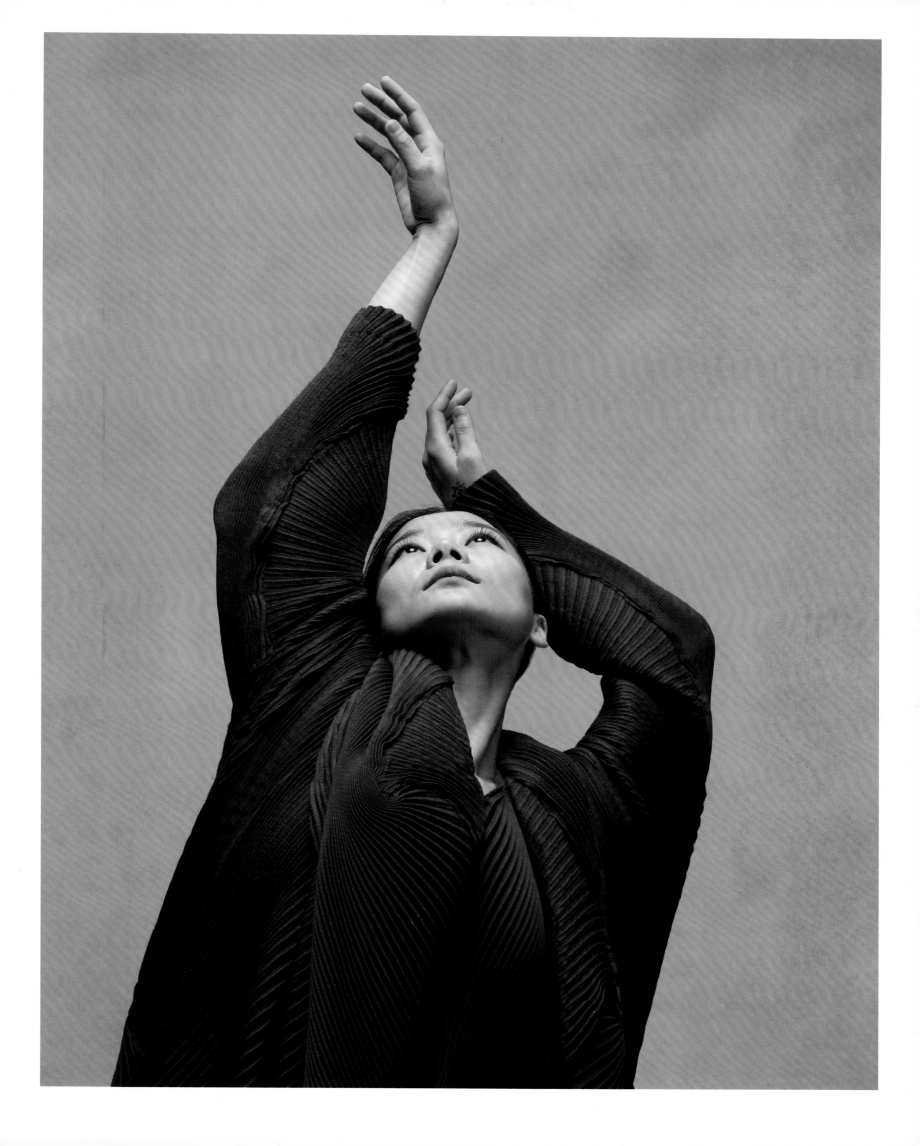

"As with everything in life—including fashion and style—
sometimes the adage 'less is more' fits perfectly."

—XANDER PARISH

Xander Parish | Principal, Mariinksy Ballet | *Clothing by Versace*

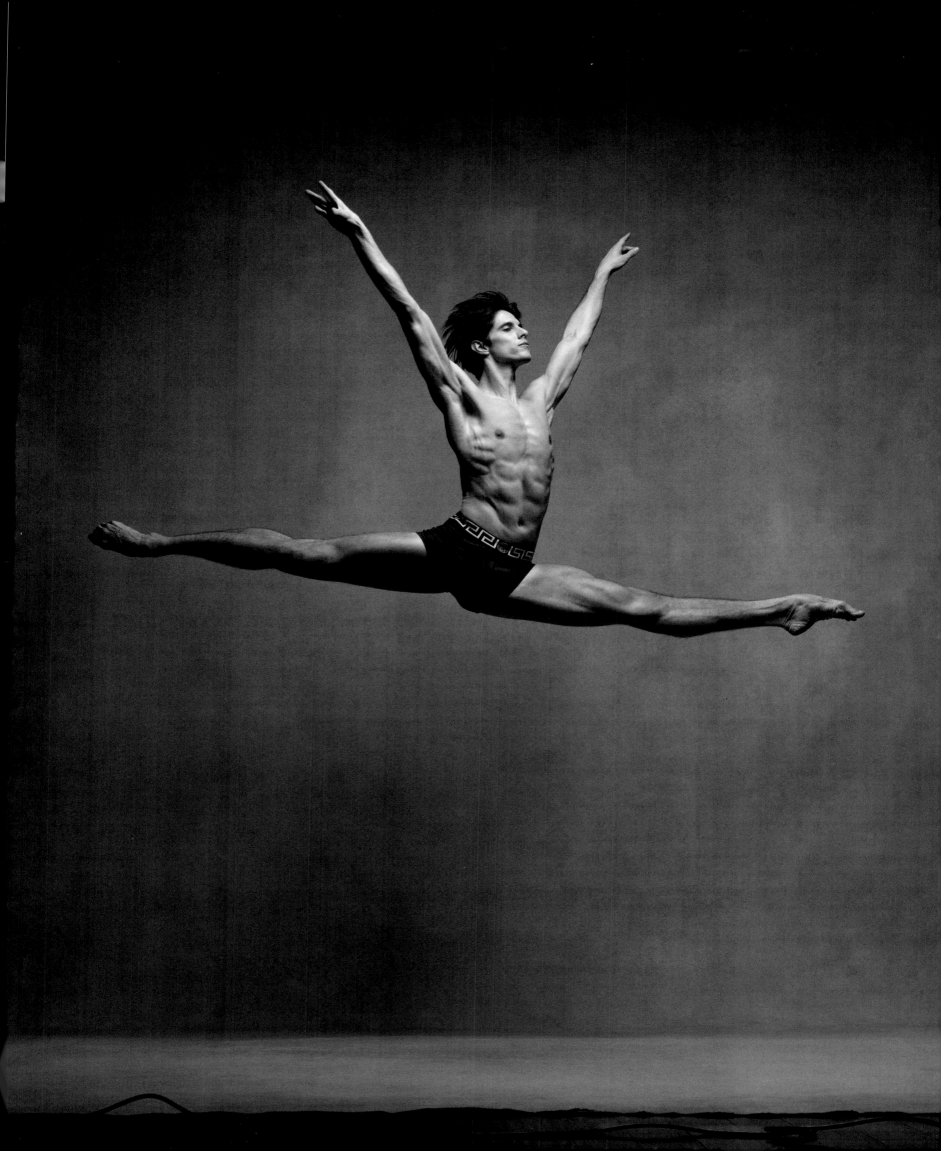

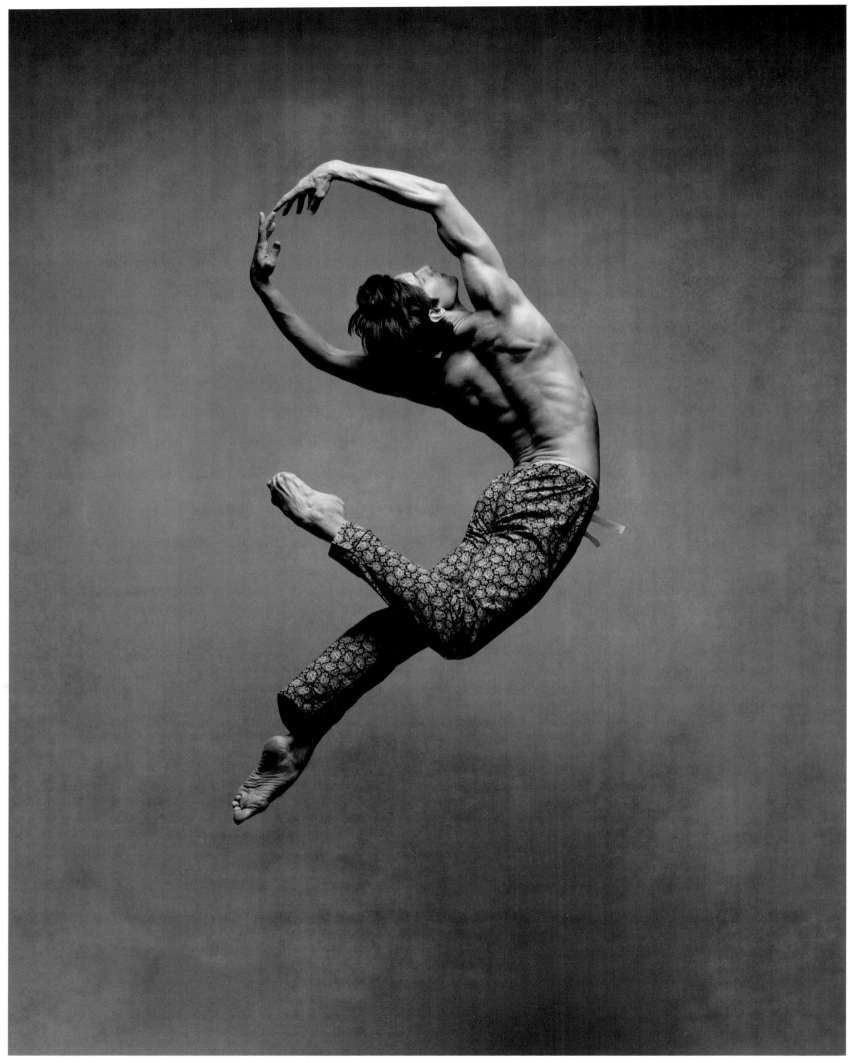

Xander Parish | Principal, Mariinksy Ballet | *Clothing by Maison Marcy*

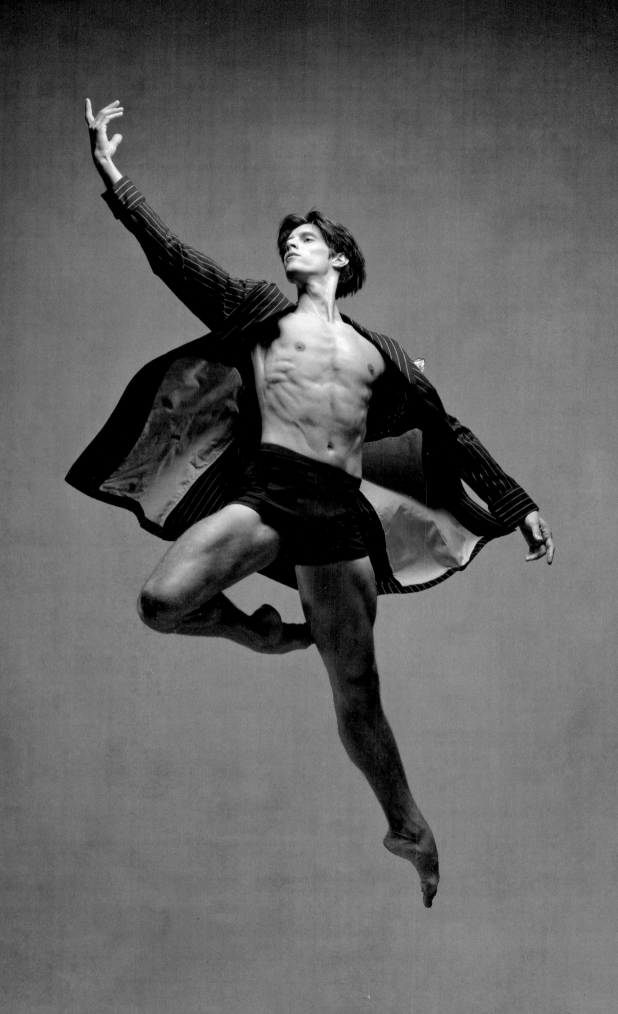

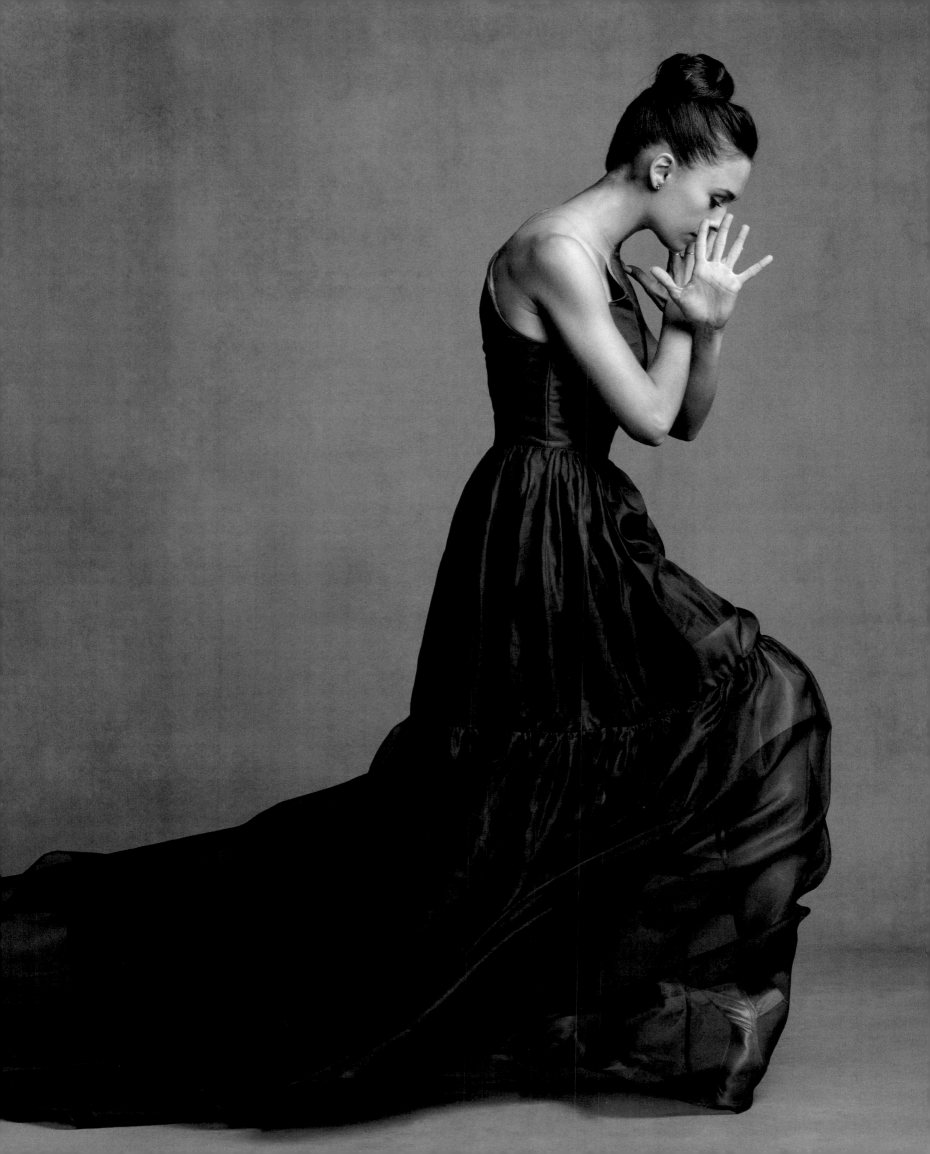

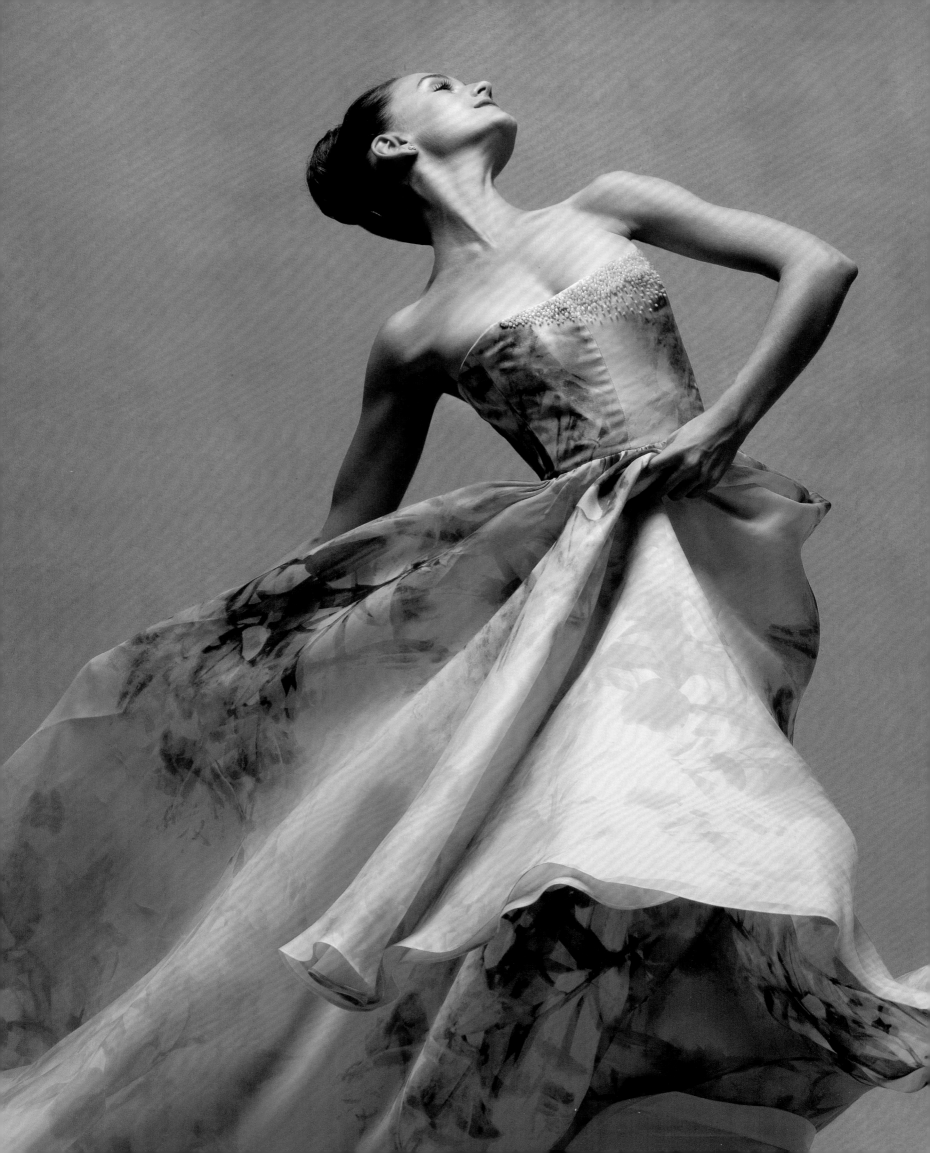

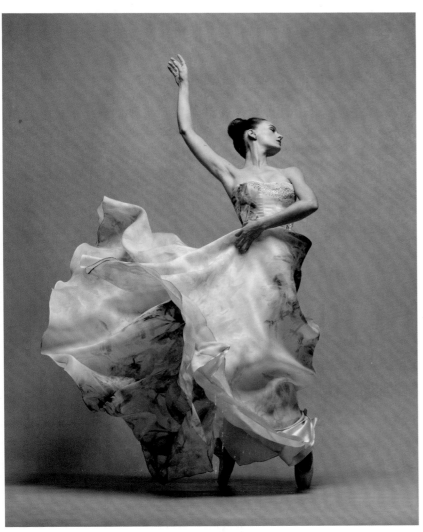
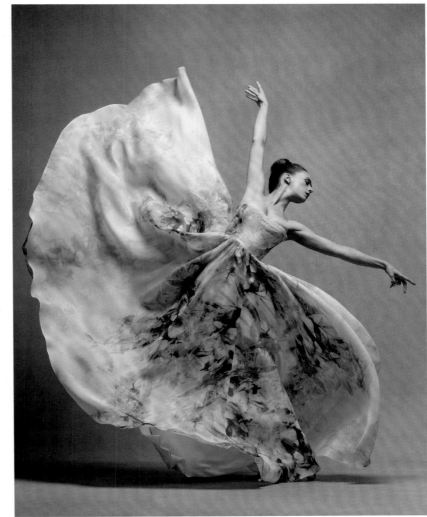

"There is nothing in the world like tap dancing: the movement *itself* born to create music. And it is a humbling experience to honor this legacy by dancing in clothes that remind the world of the impact, elegance, sophistication, and pure style of that art form."

—MICHELLE DORRANCE

Michelle Dorrance | Artistic Director, Dorrance Dance | *Clothing by Thom Sweeney*

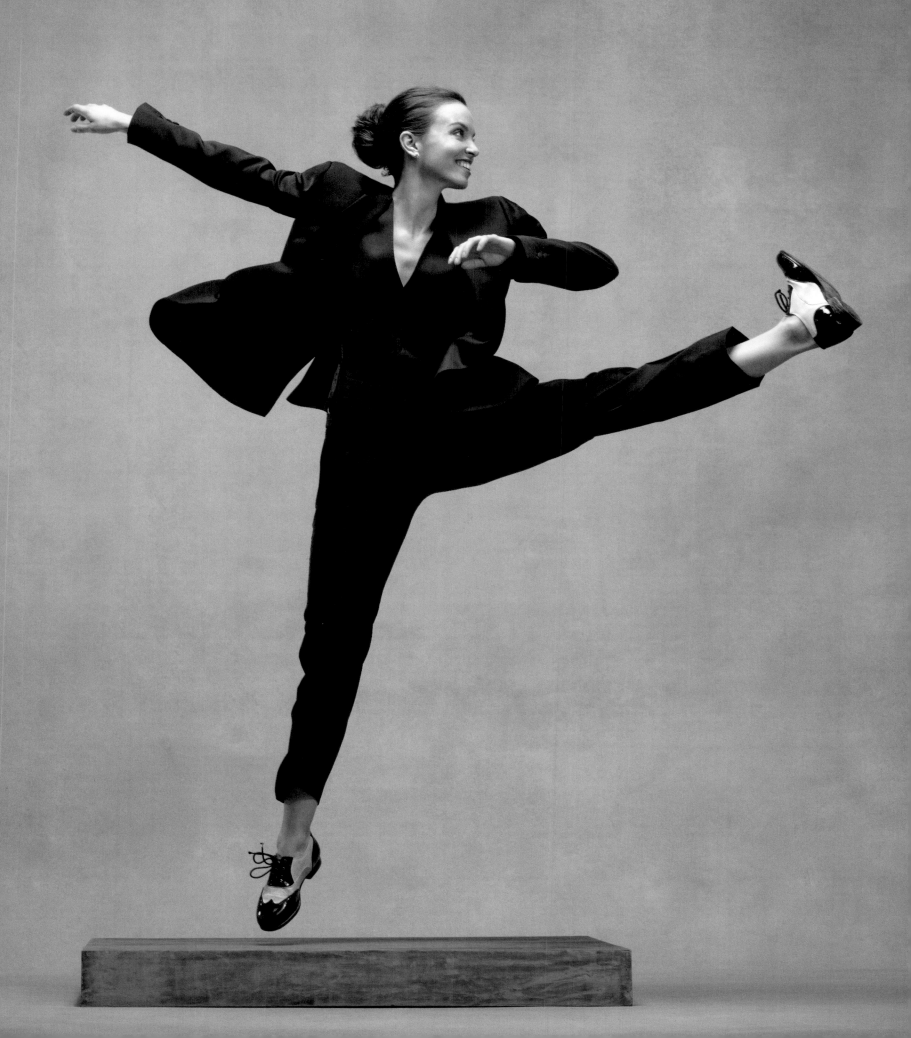

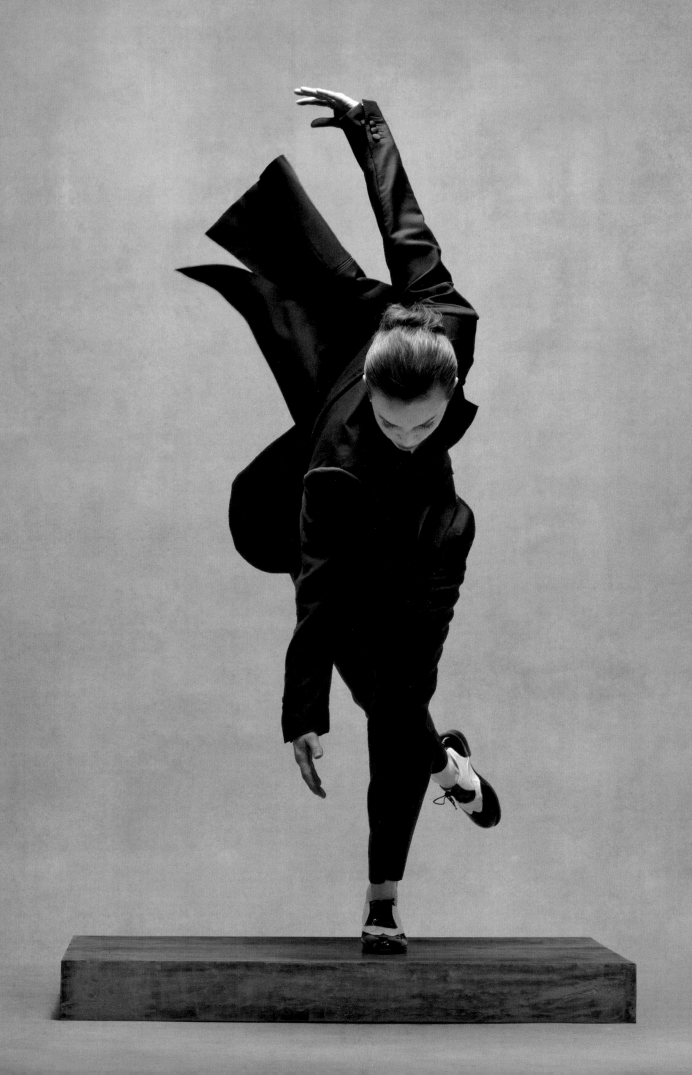

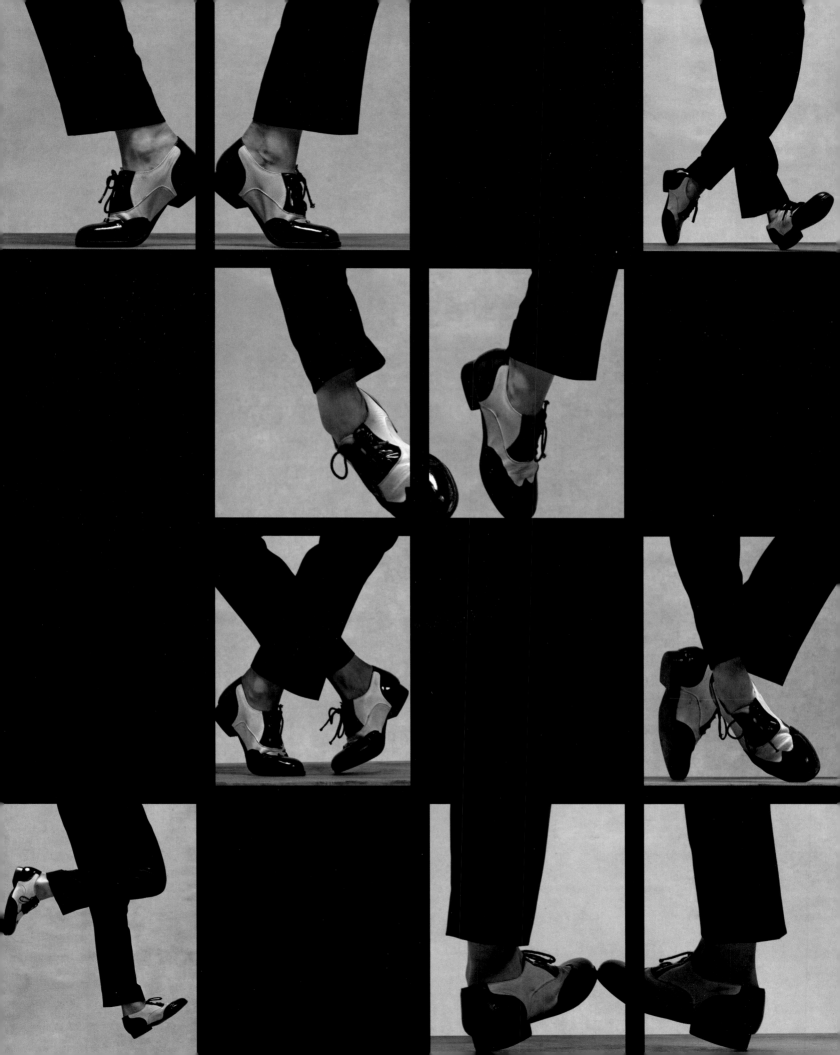

Sarah Lane | Principal, American Ballet Theatre | *Dress by Norman Norell, c. 1960, courtesy New York Vintage*

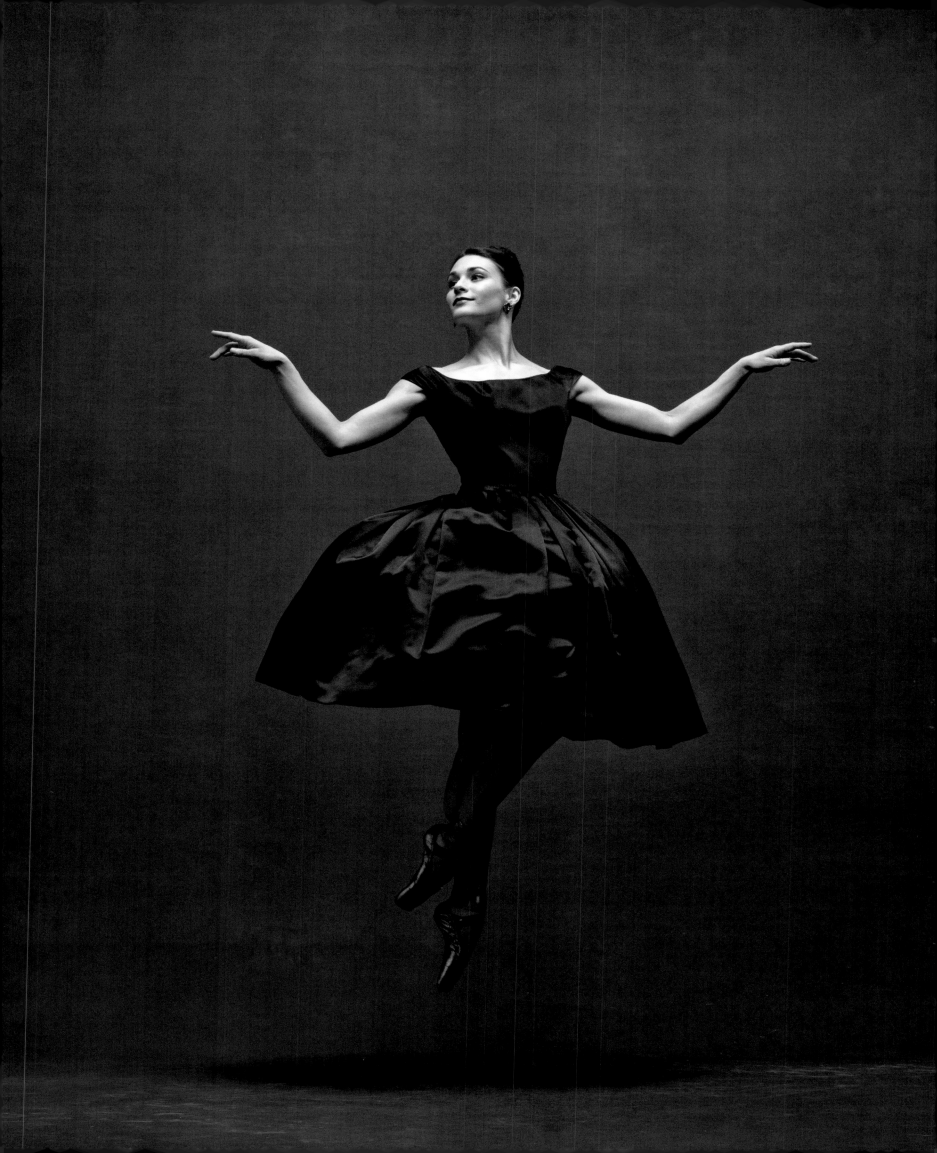

Tiler Peck | Principal, New York City Ballet | *Dress by Valentino, 2003*

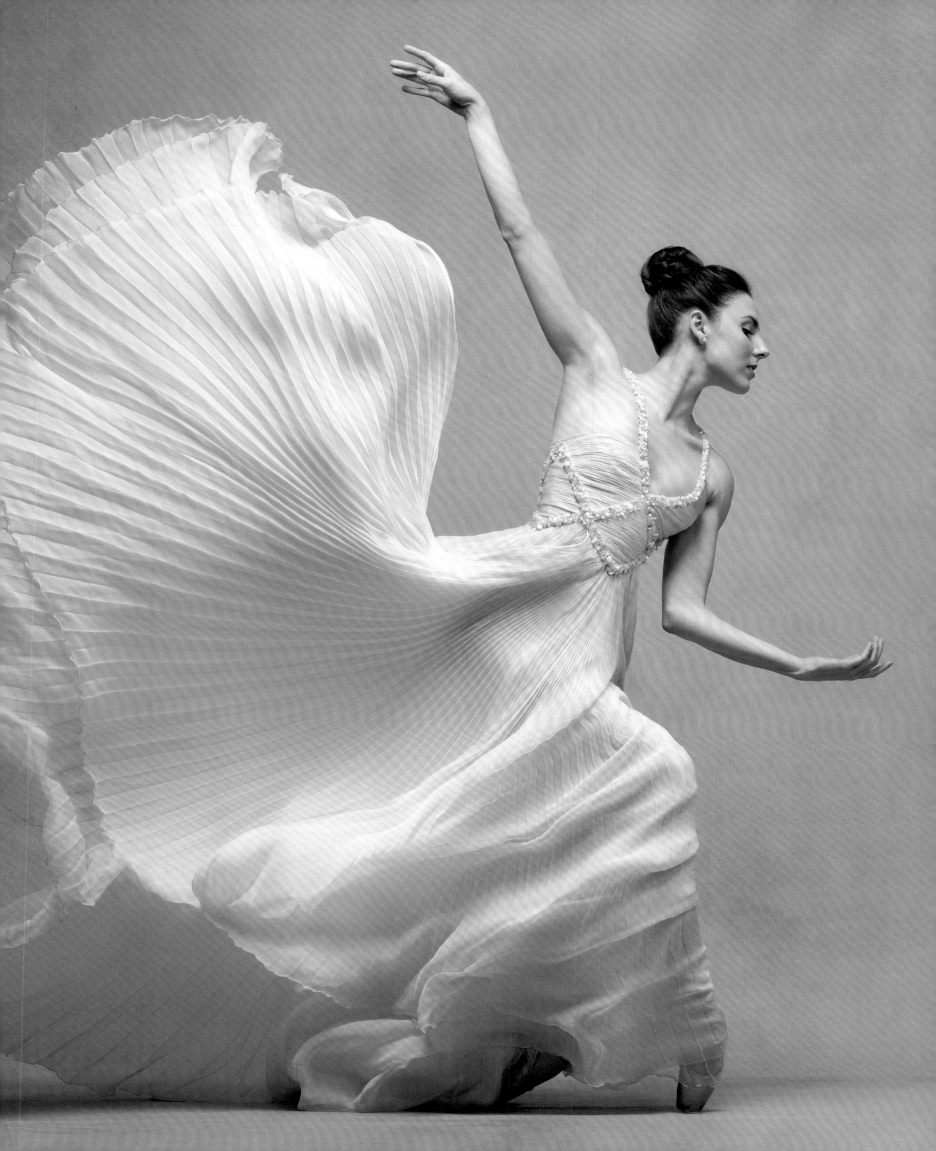

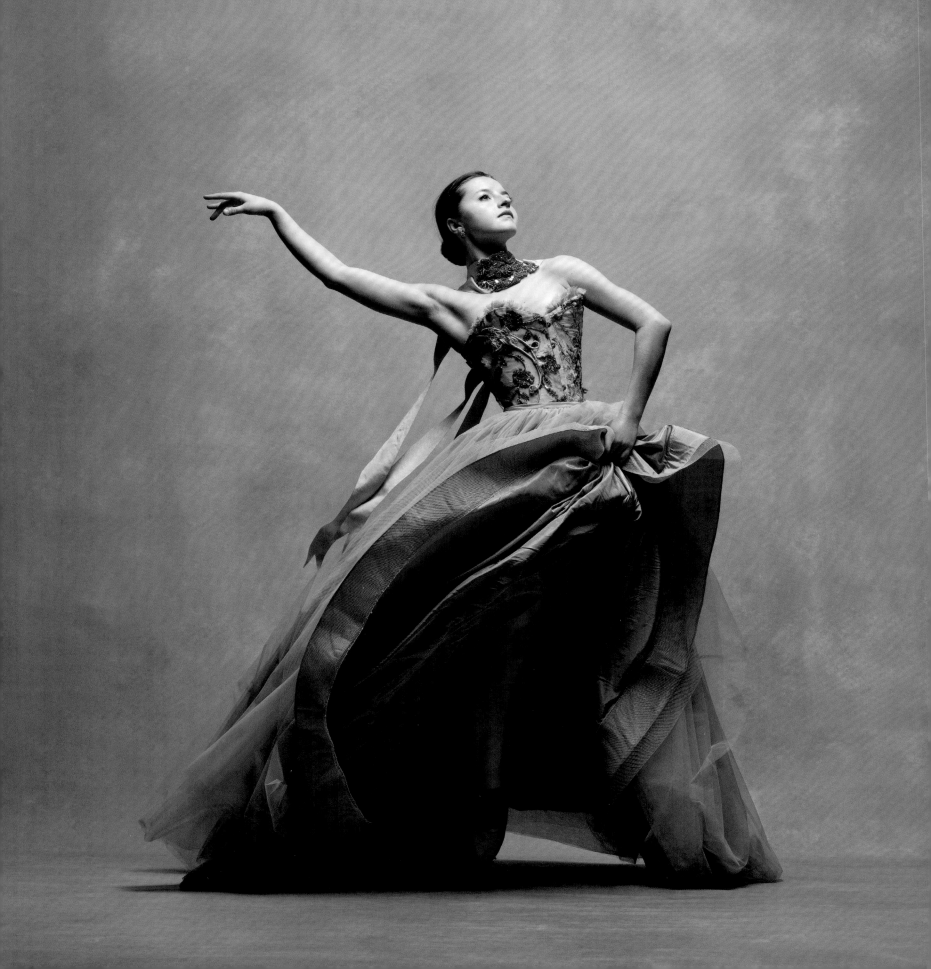

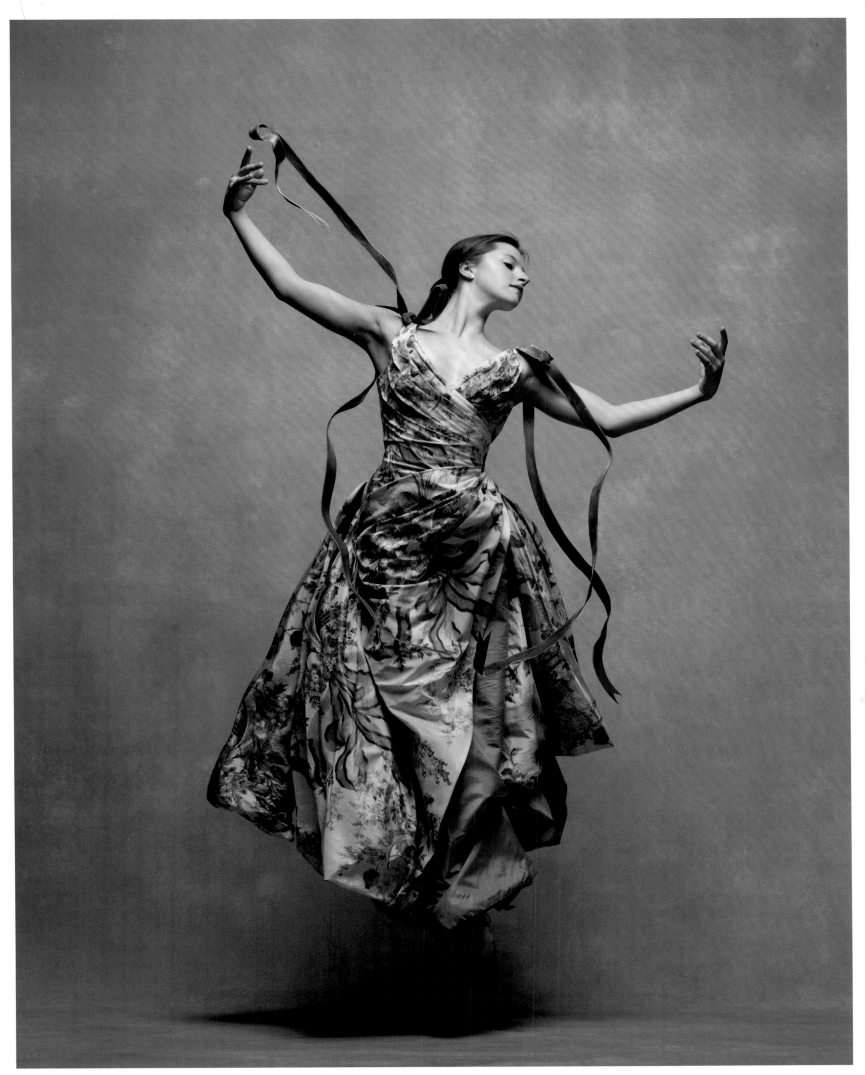

Indiana Woodward | Soloist, New York City Ballet | *Clothing by Maggie Norris*

"Over the years I have learned that what is important in a dress is the woman who is wearing it."

—YVES SAINT LAURENT

Pei.Ju Chien-Pott | Principal, Martha Graham Dance Company | *Clothing by Yves Saint Laurent, c. 2001, courtesy New York Vintage*

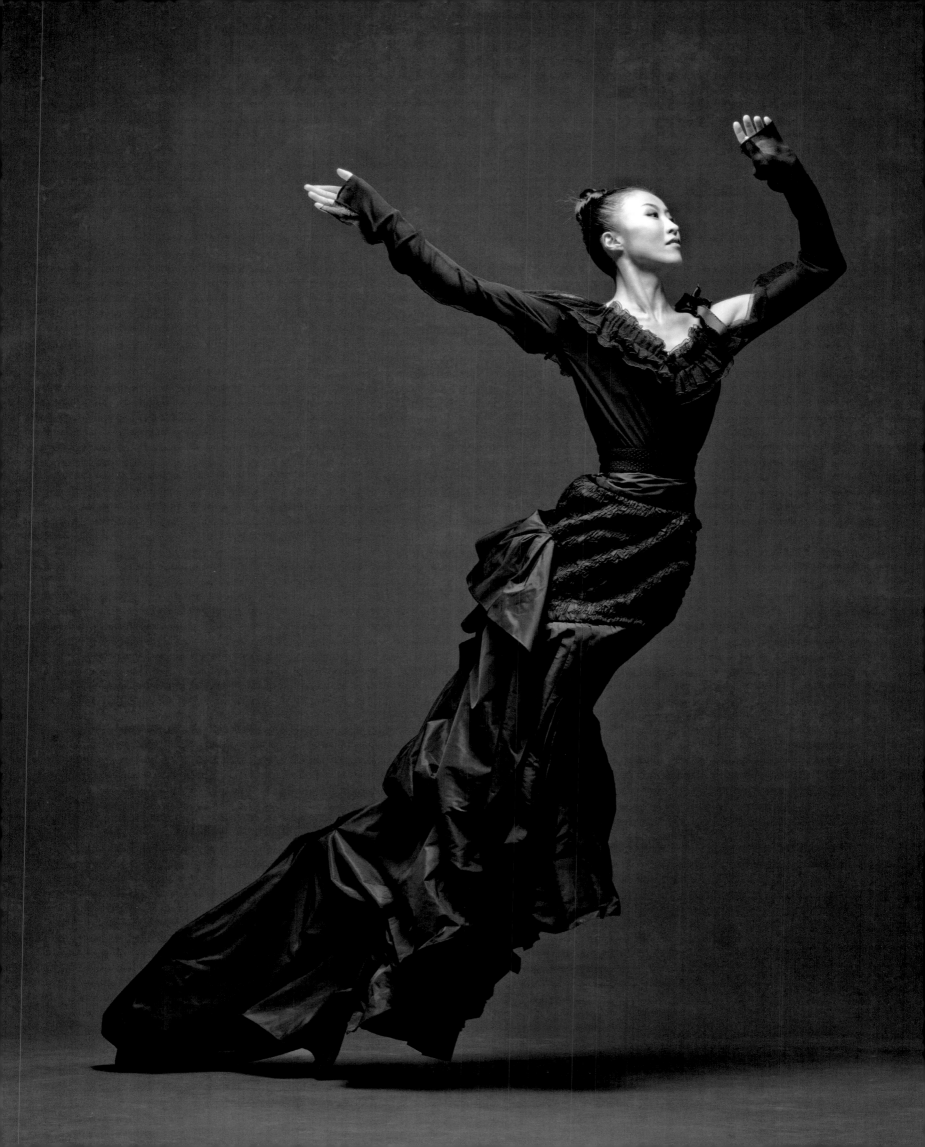

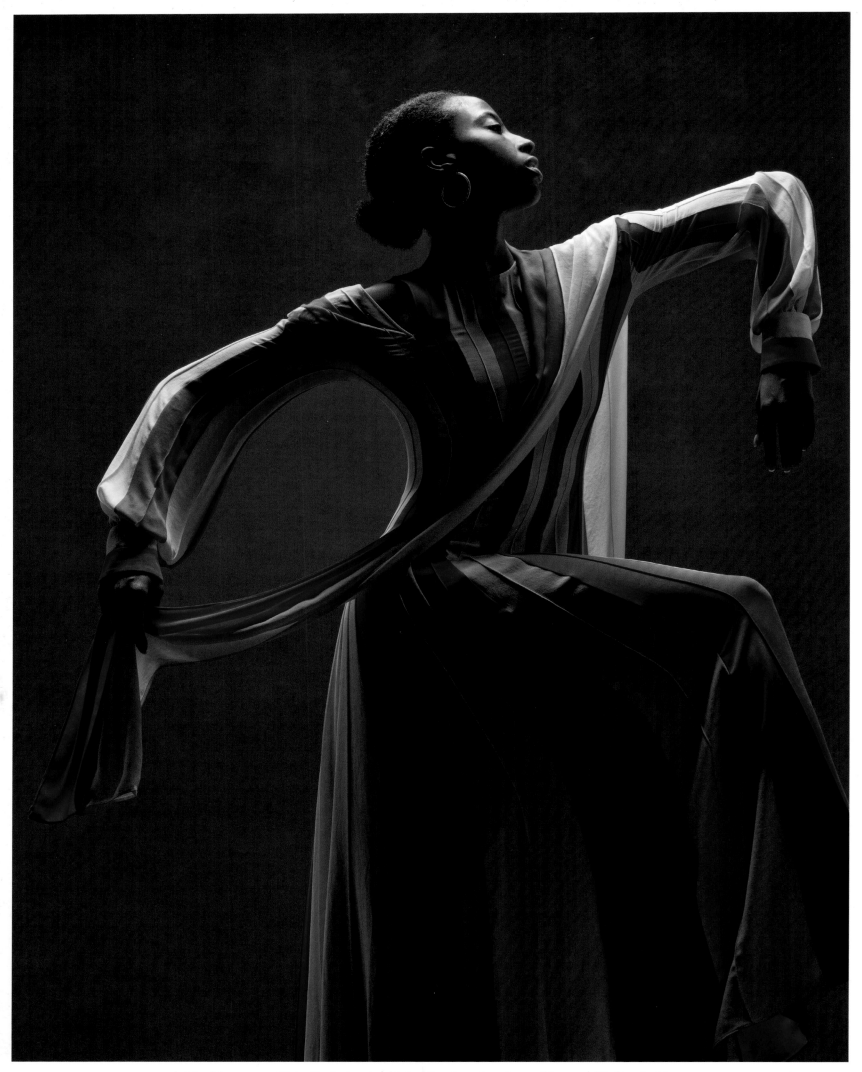

Ashley Mayeux and **Fana Tesfagiorgis** | Alvin Ailey American Dance Theater | *Clothing by Monse*

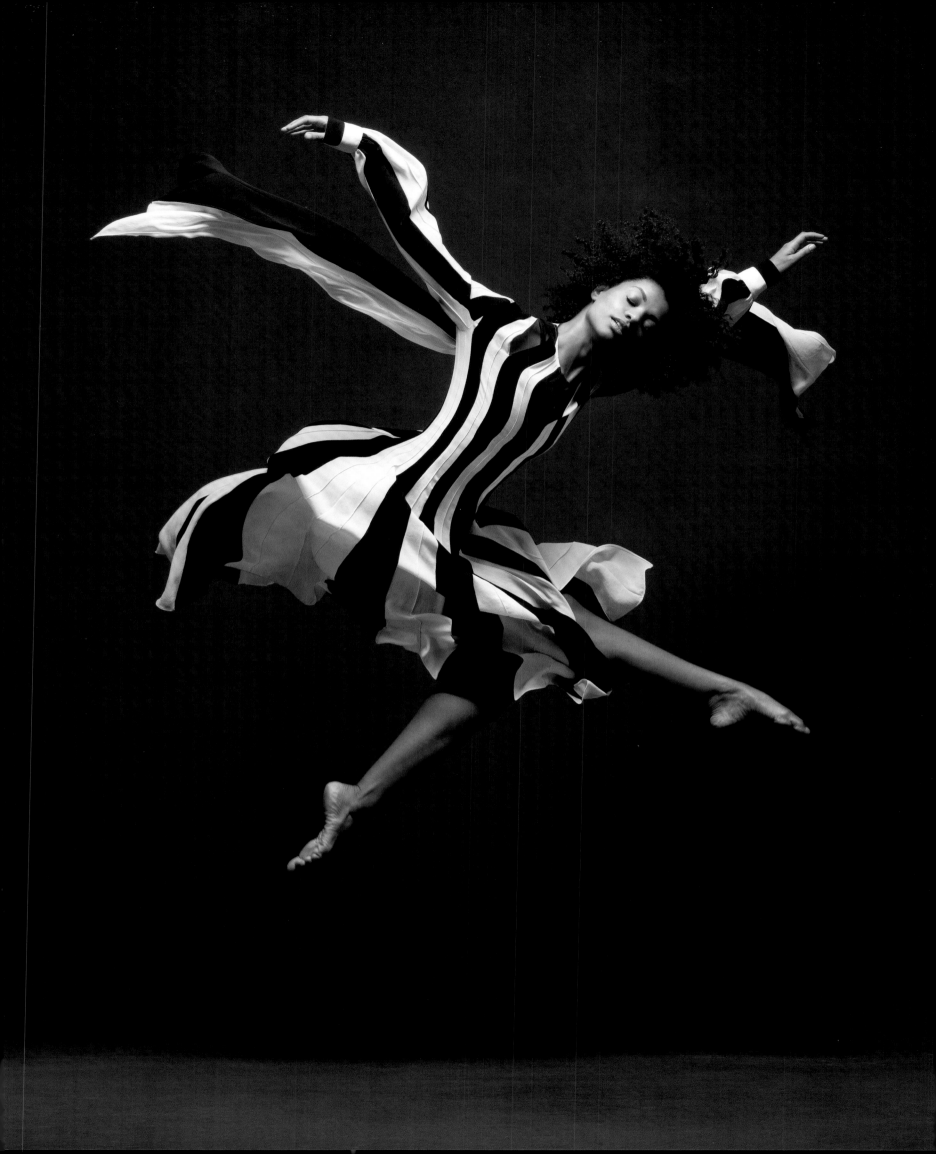

Jacob Larsen | Martha Graham Dance Company | *Clothing by KeithLink*

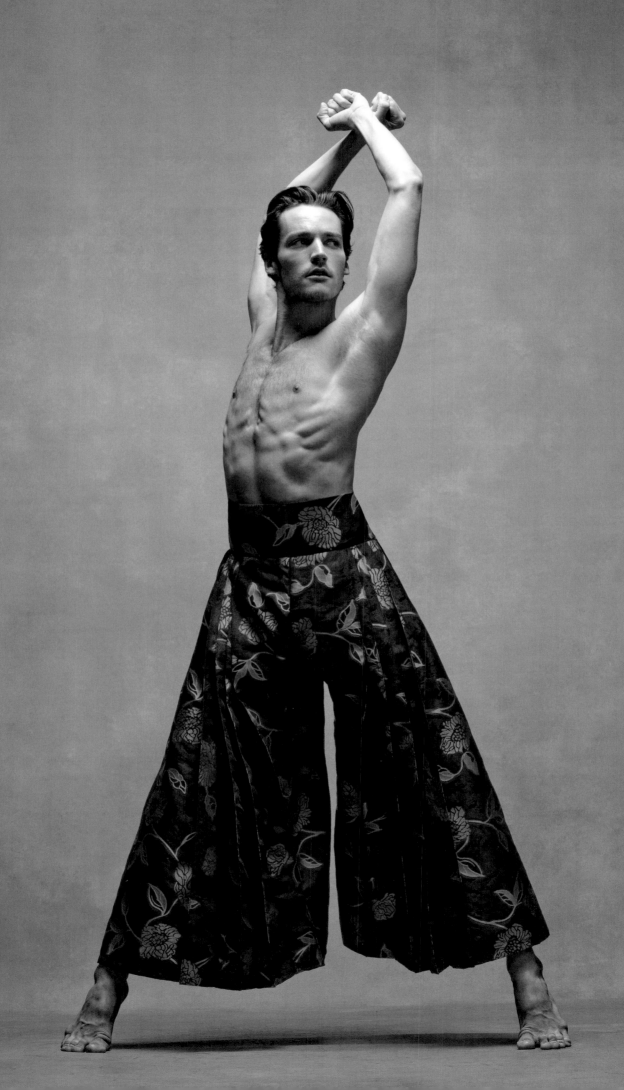

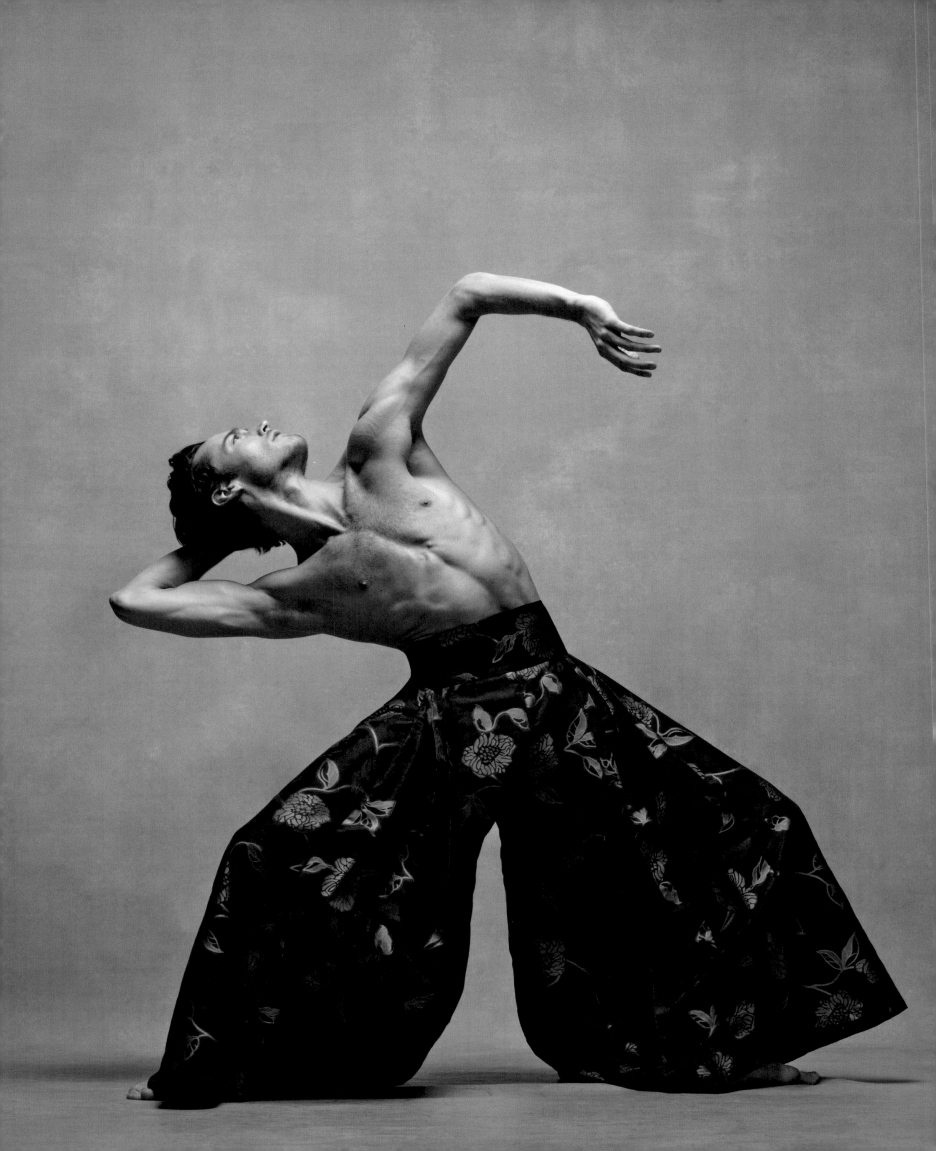

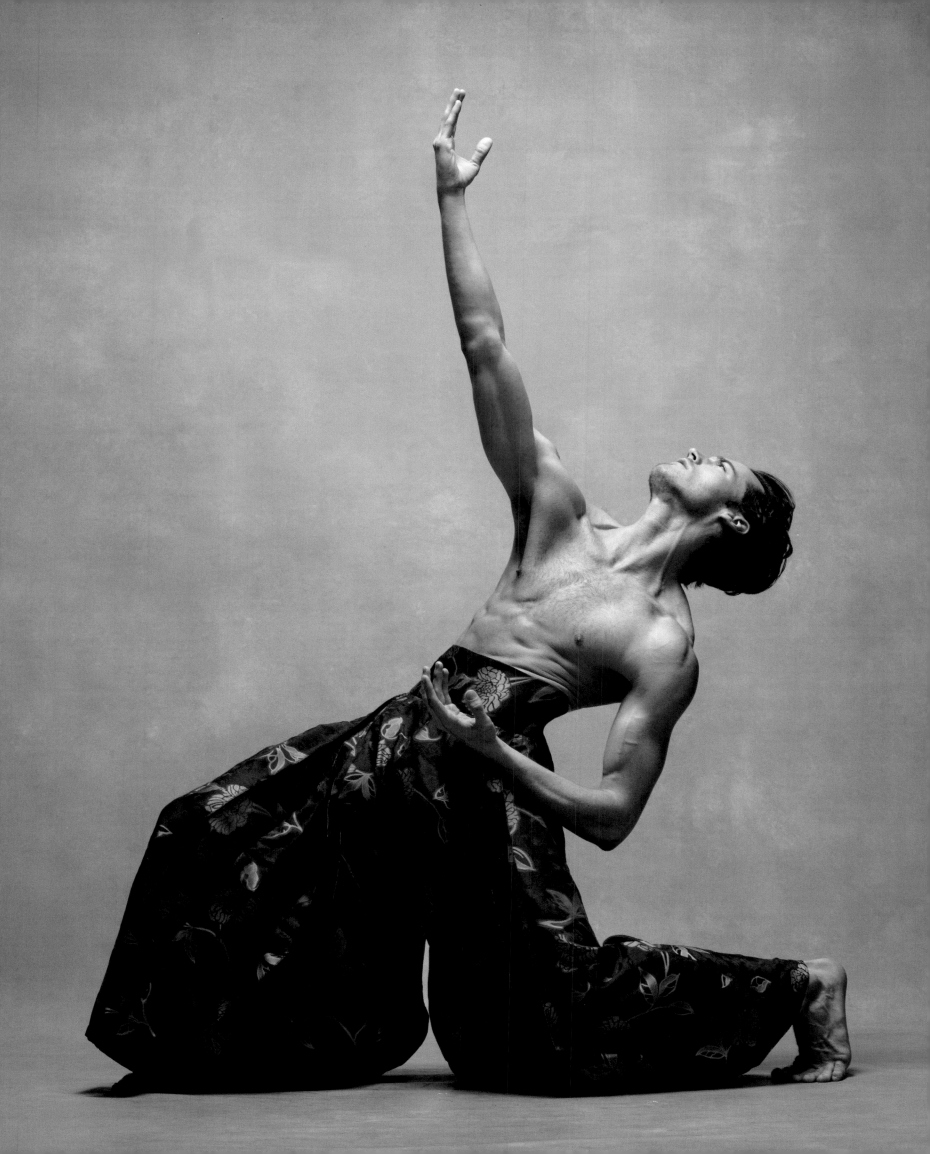

"It's been said that Martha Graham once told Halston to 'Dress the women and undress the men'. It's always been an honor for me to perform in these original Halston costumes designed for Martha Graham; each one is truly a piece of art that makes the whole experience so much grander."

—LLOYD KNIGHT

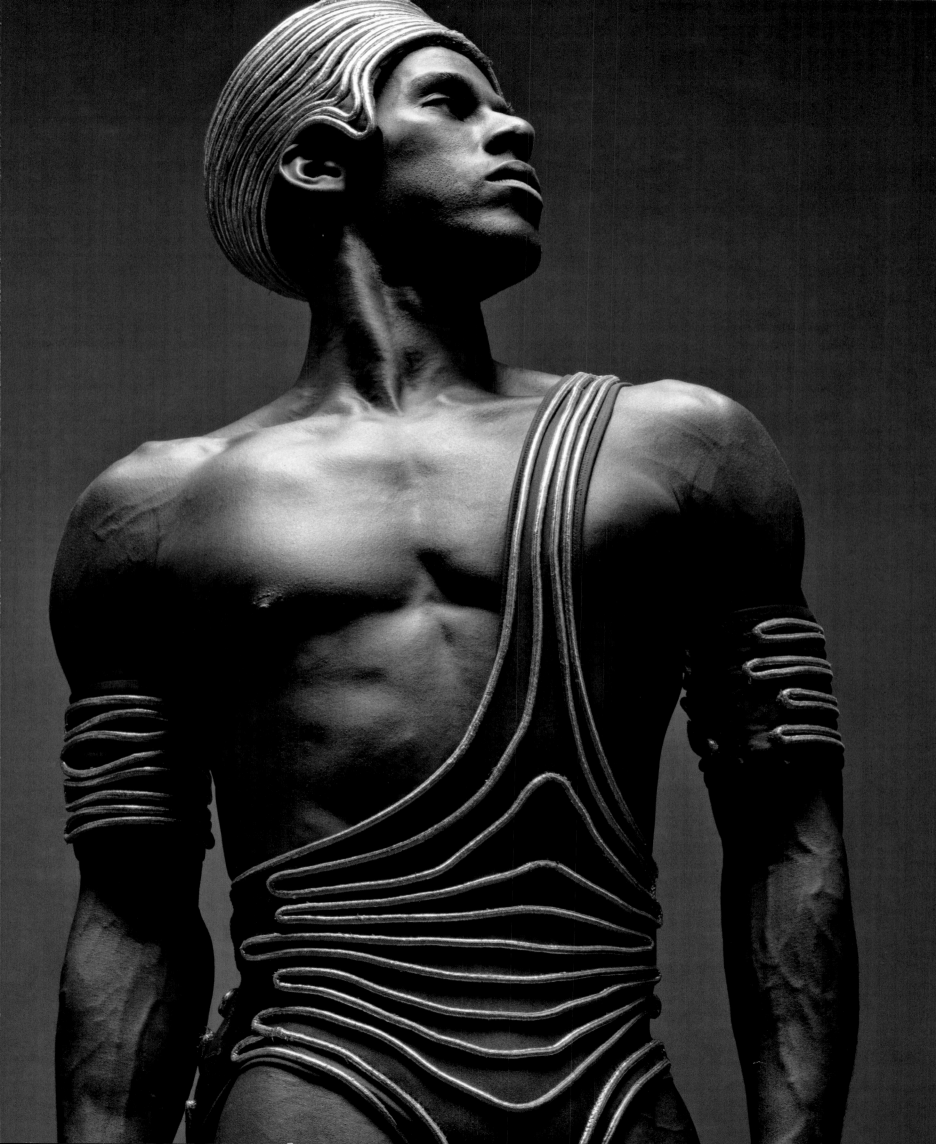

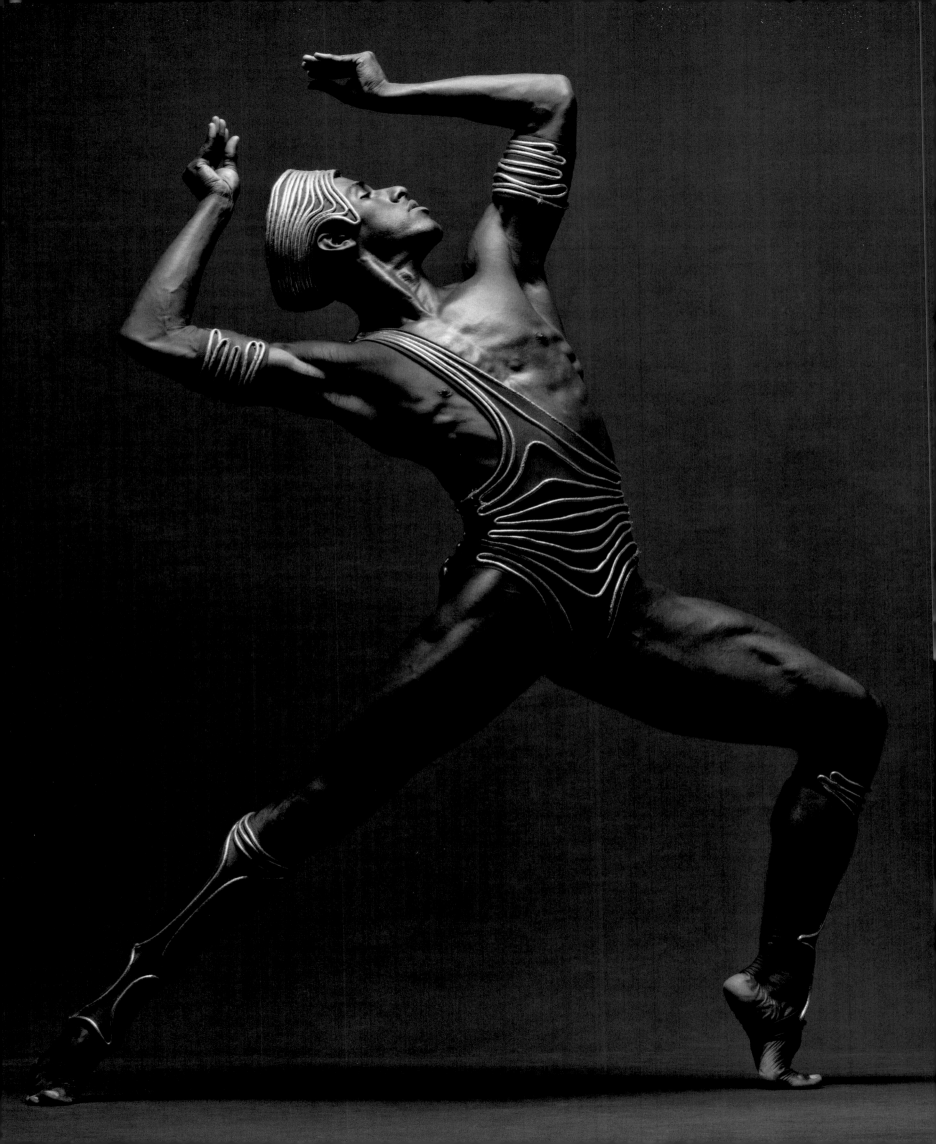

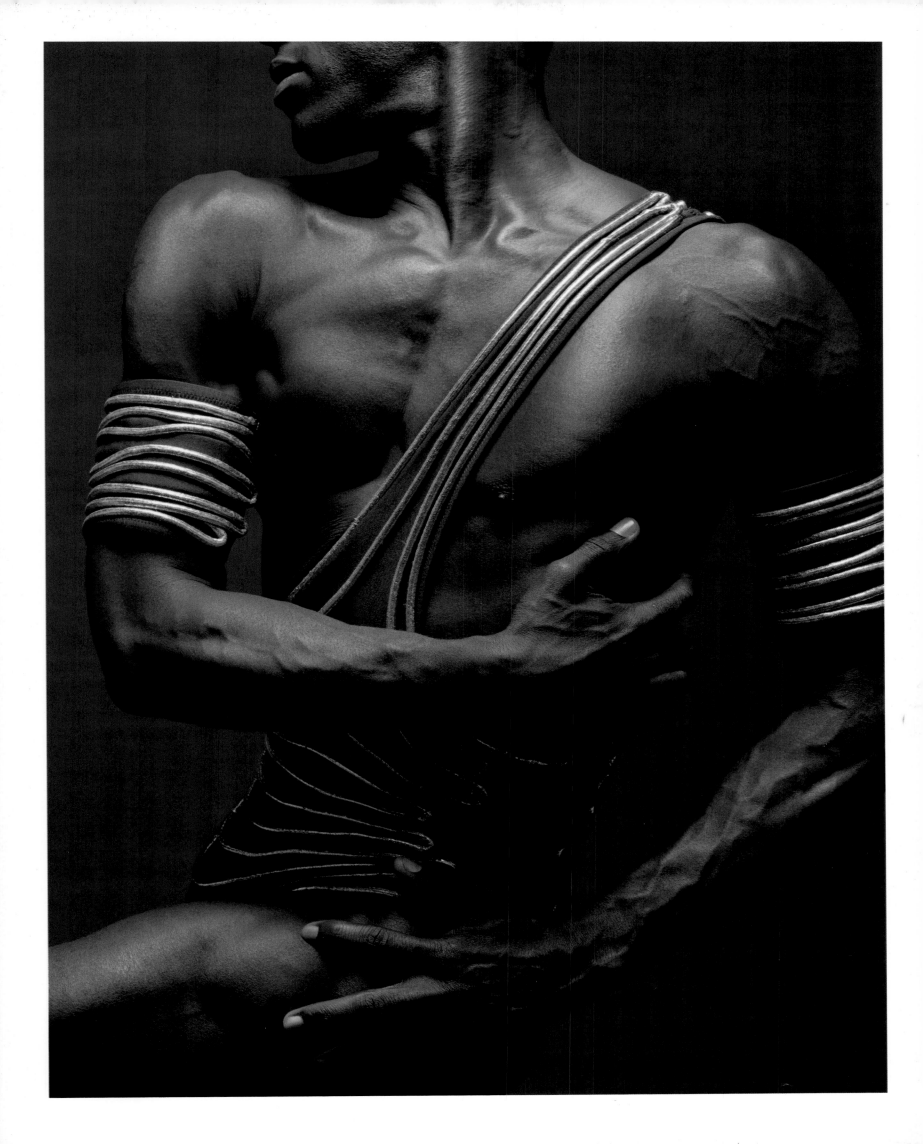

Meng-ke Wu | Nederlands Dans Theater | *Clothing by Wolford*

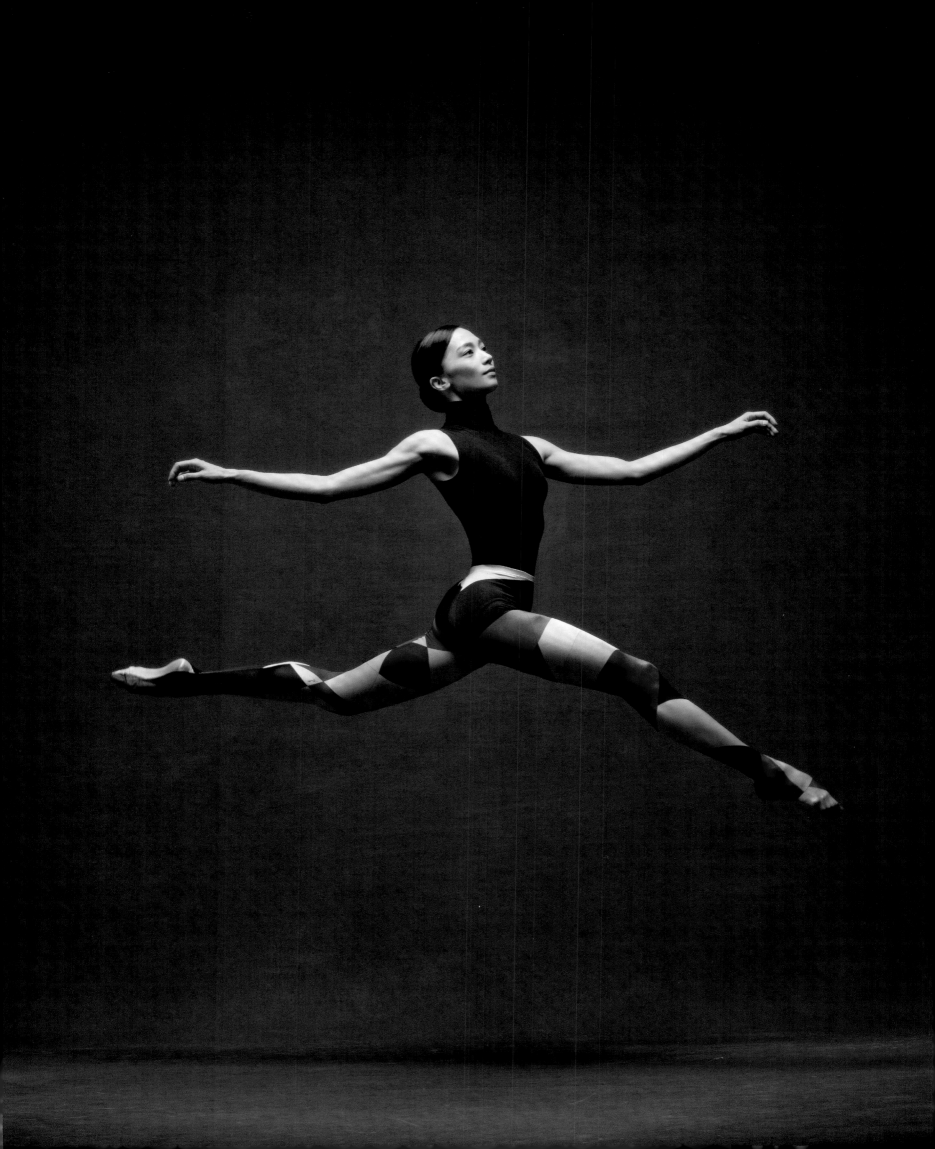

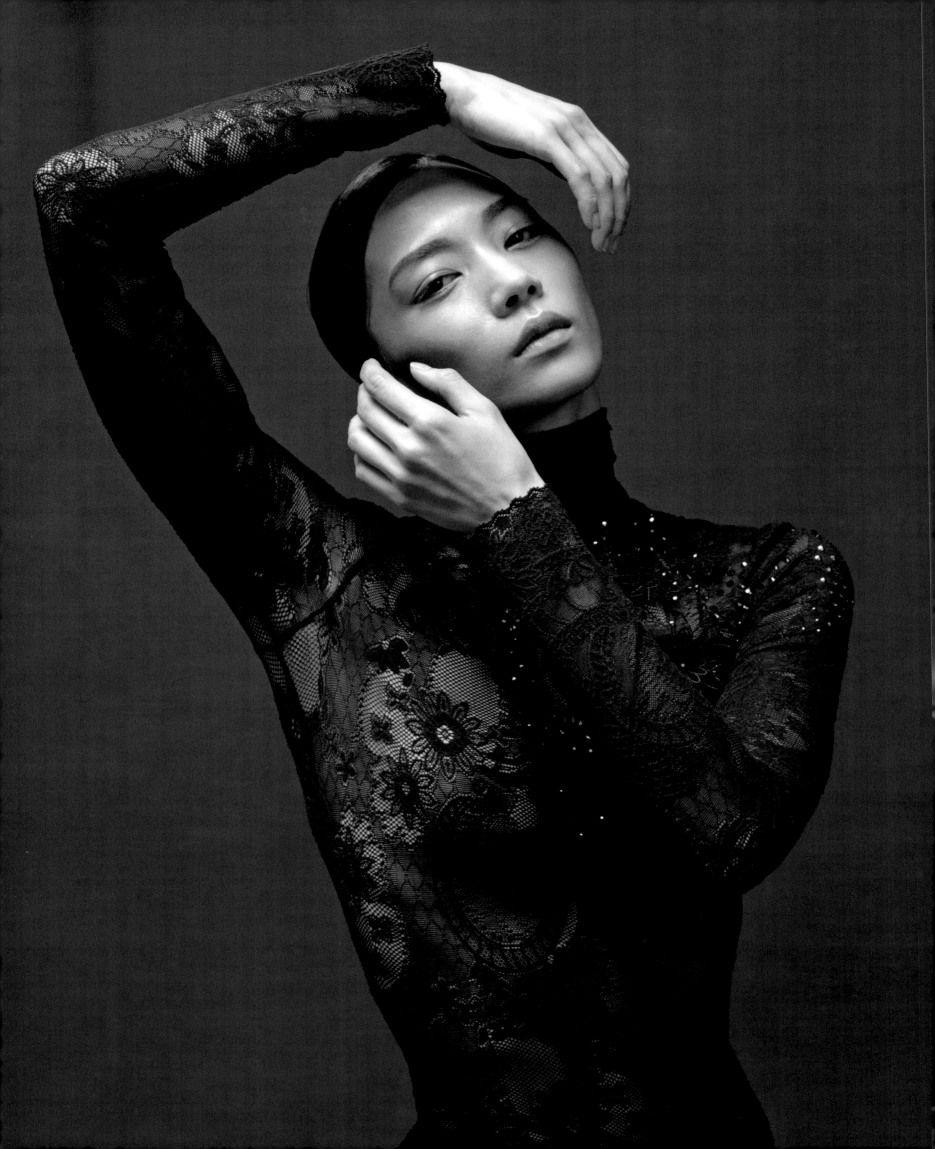

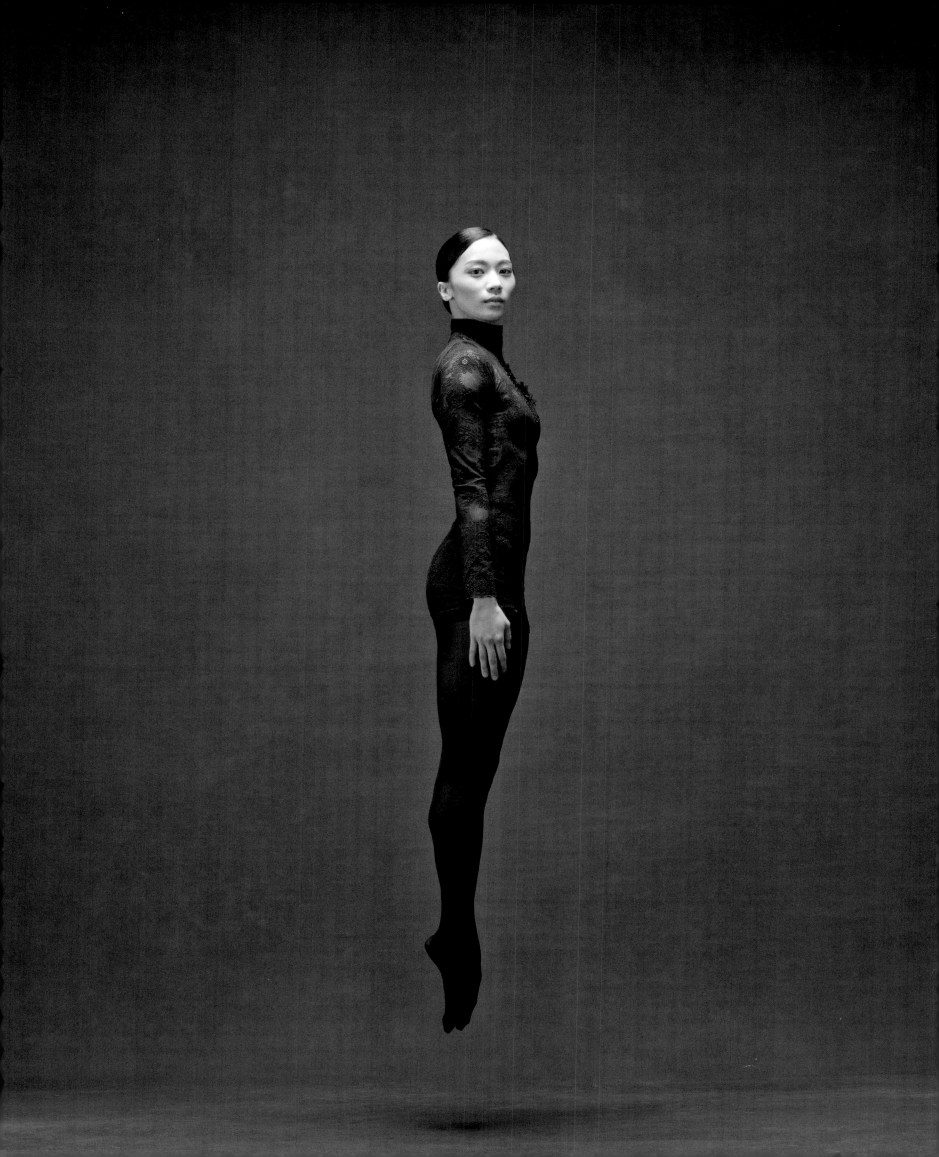

Christopher Wilson | Alvin Ailey American Dance Theater | *Clothing by Yohji Yamamoto*

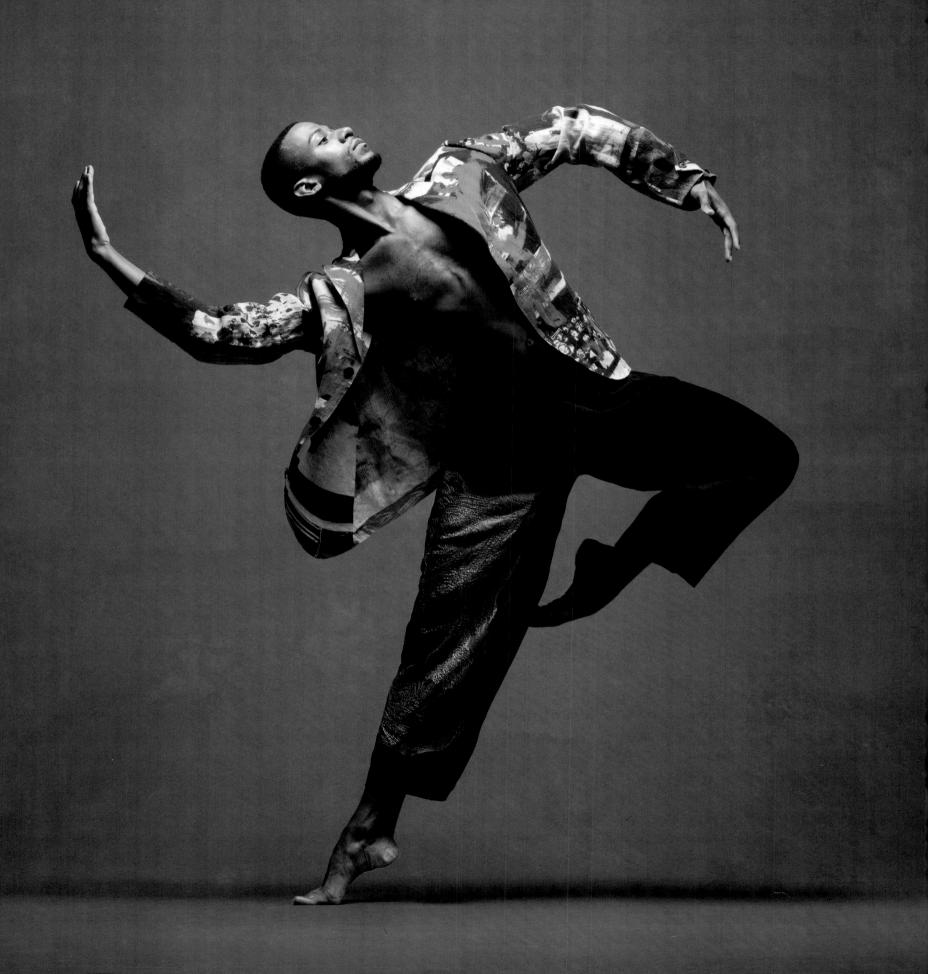

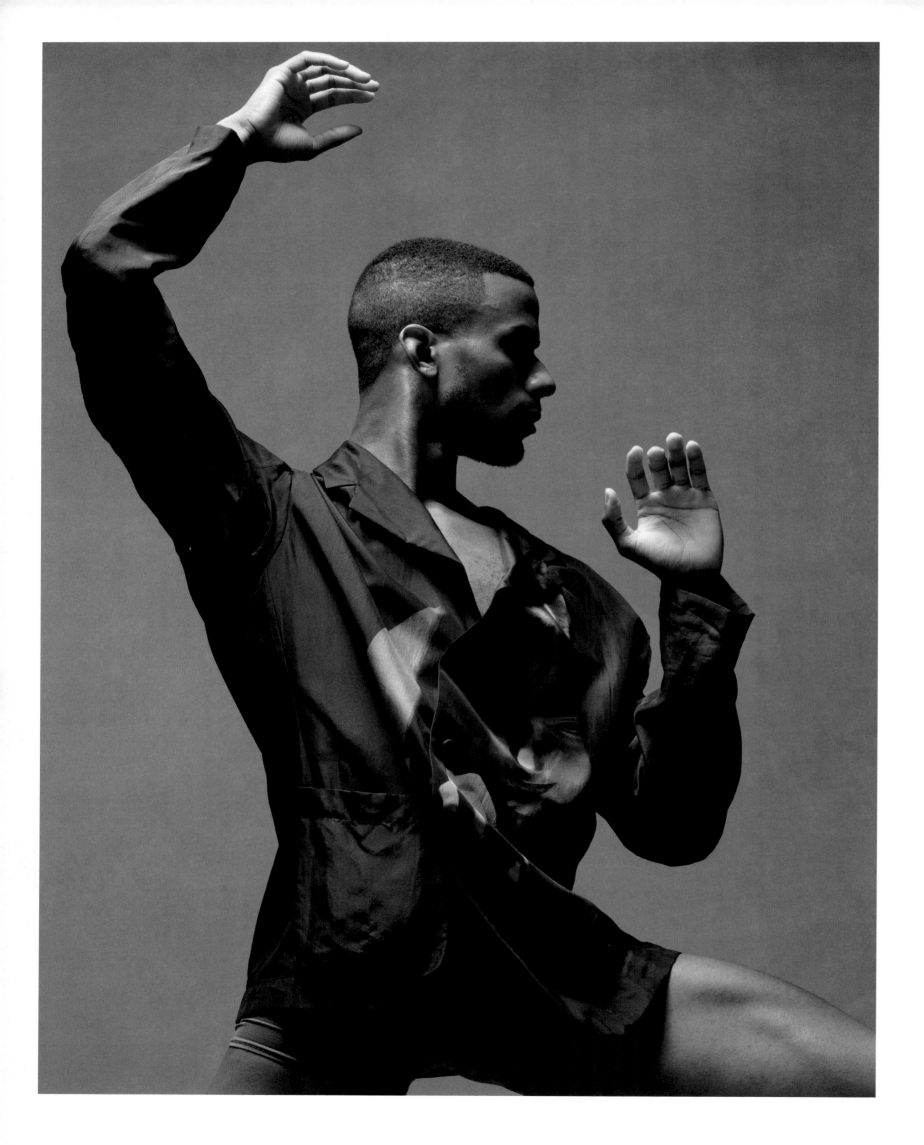

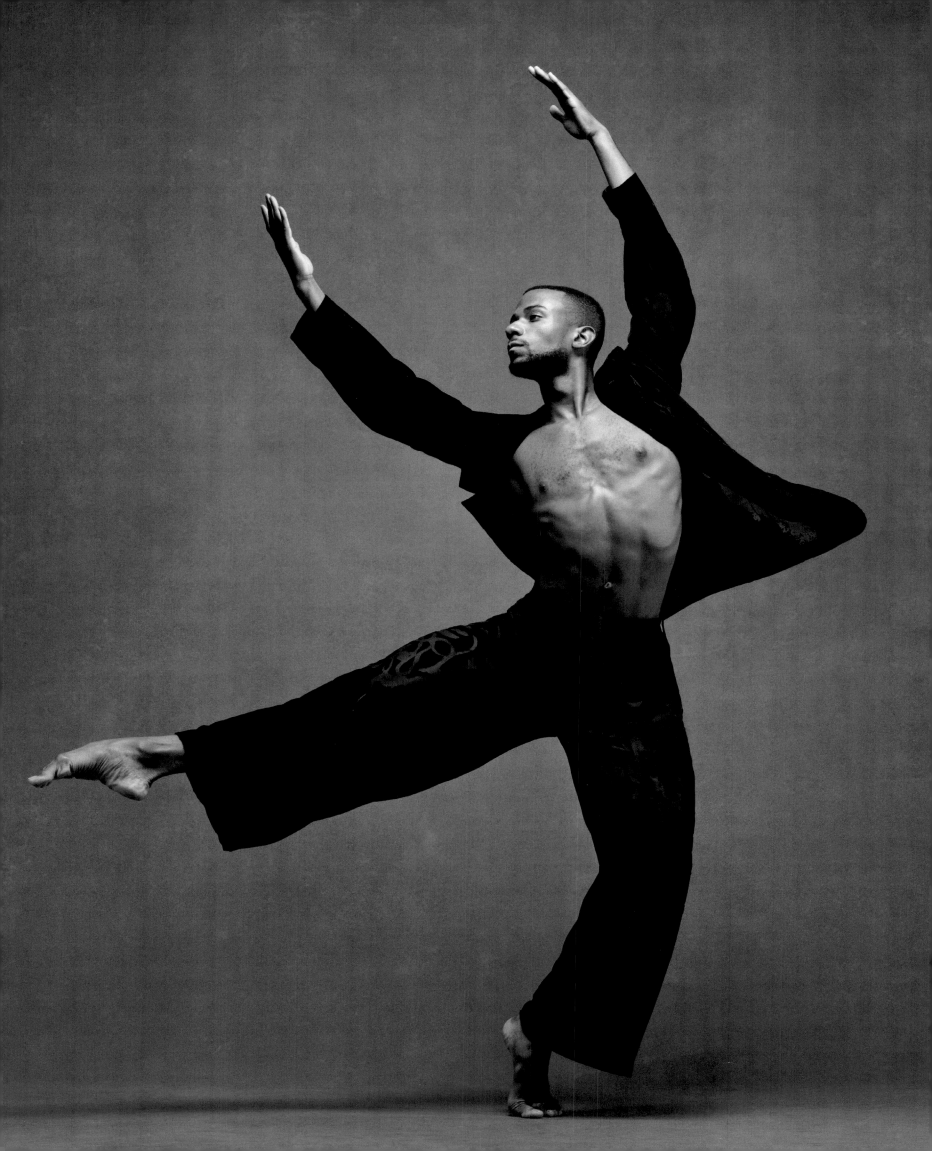

PeiJu-Chien Pott | Principal, Martha Graham Dance Company
Top by Comme des Garçons, c. 2008, skirt by Gianfranco Ferré. Courtesy New York Vintage

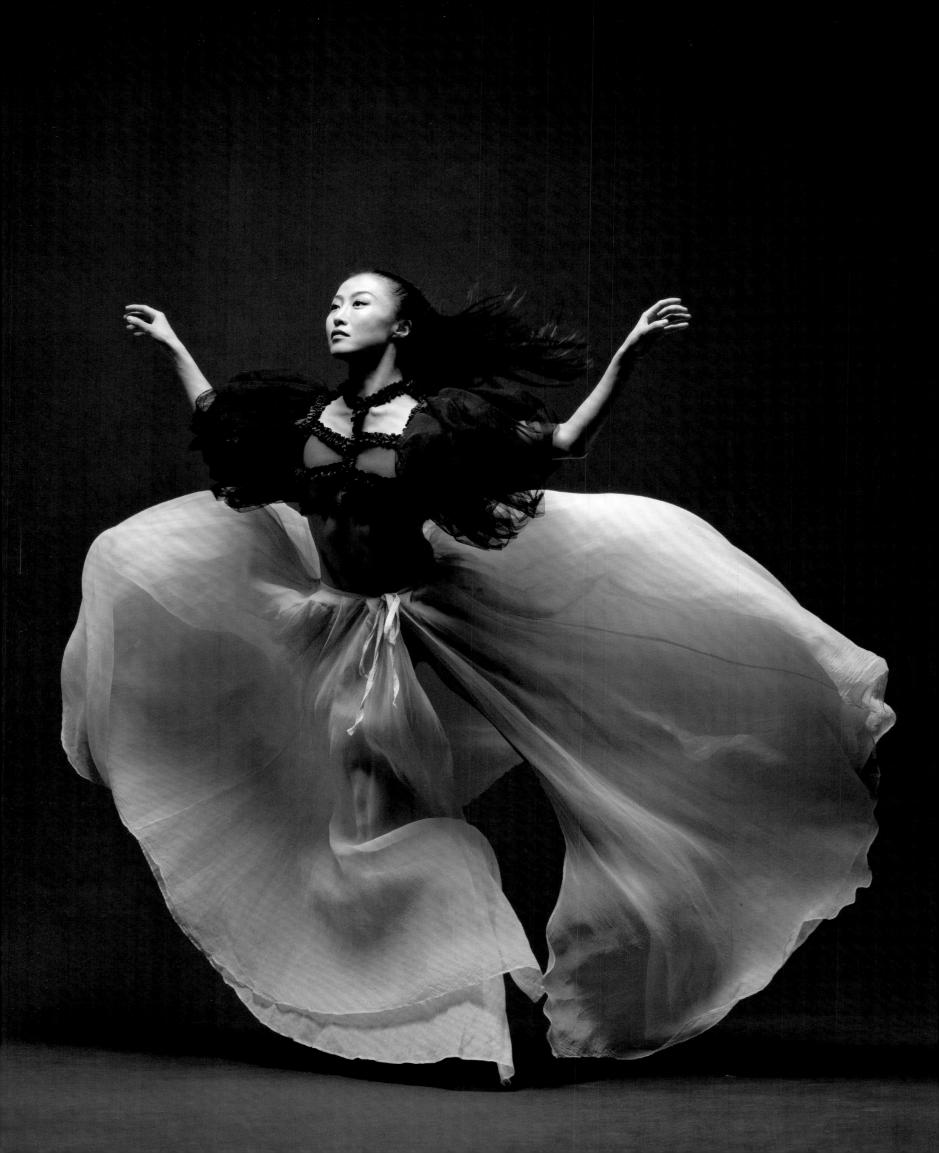

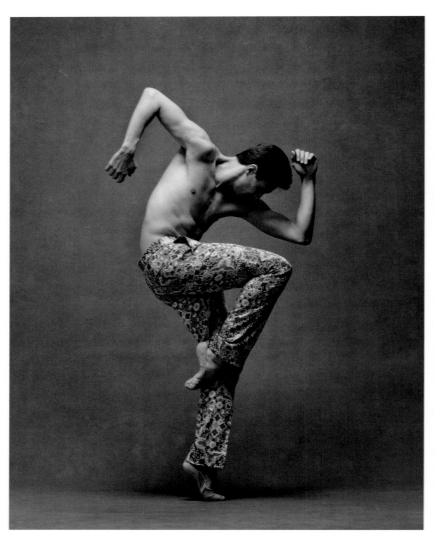 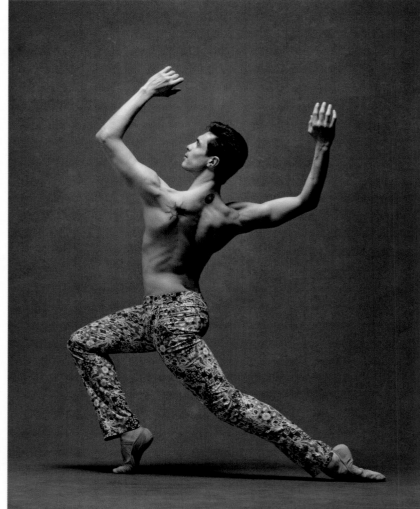

Alexandre Hammoudi | Soloist, American Ballet Theatre | *Clothing by Franco Lacosta*

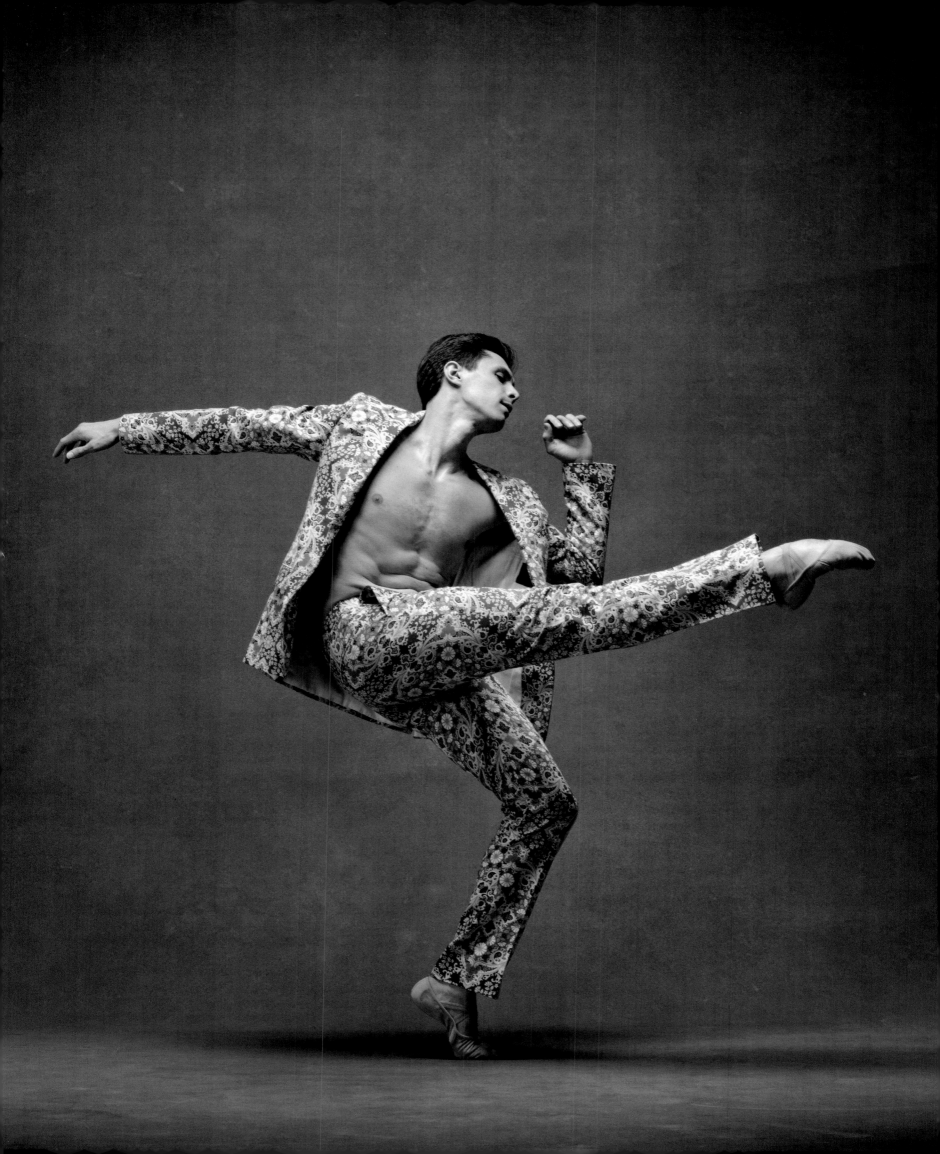

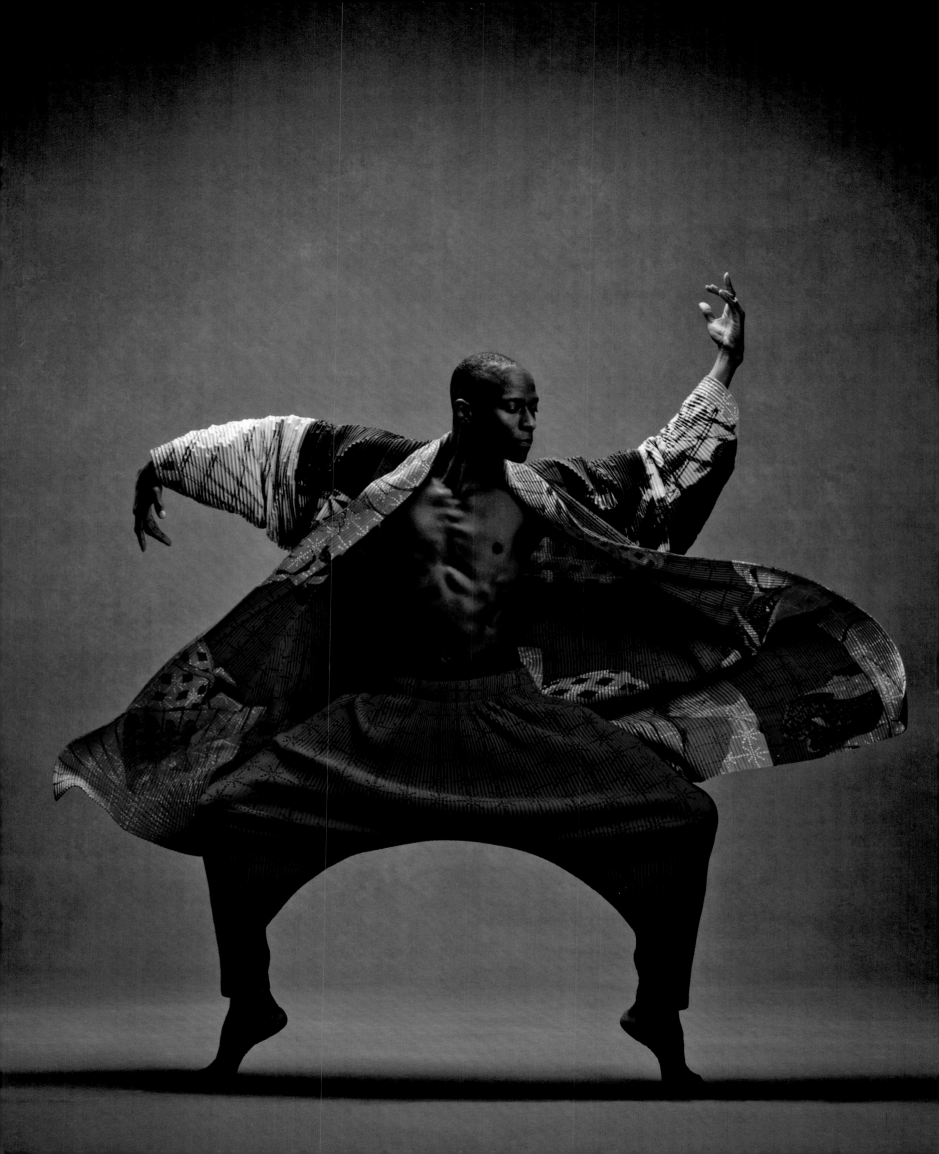

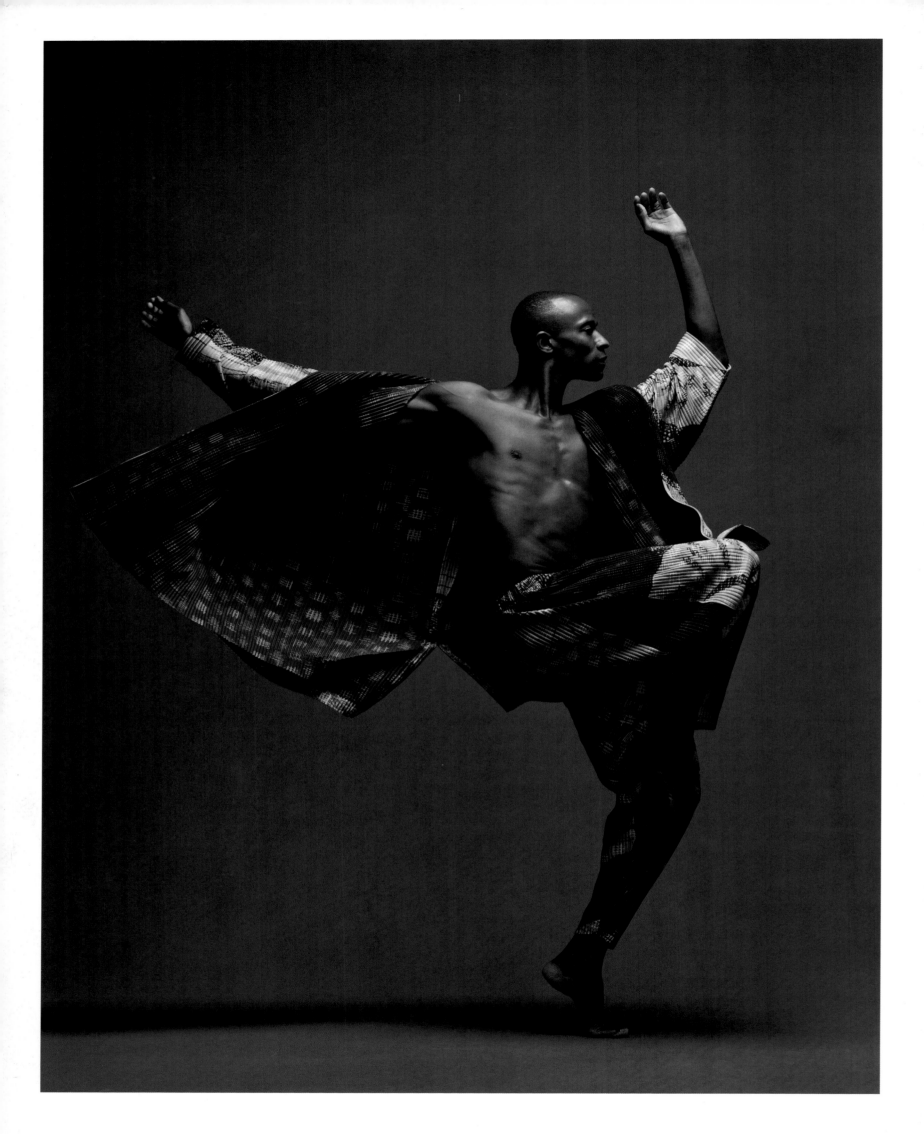

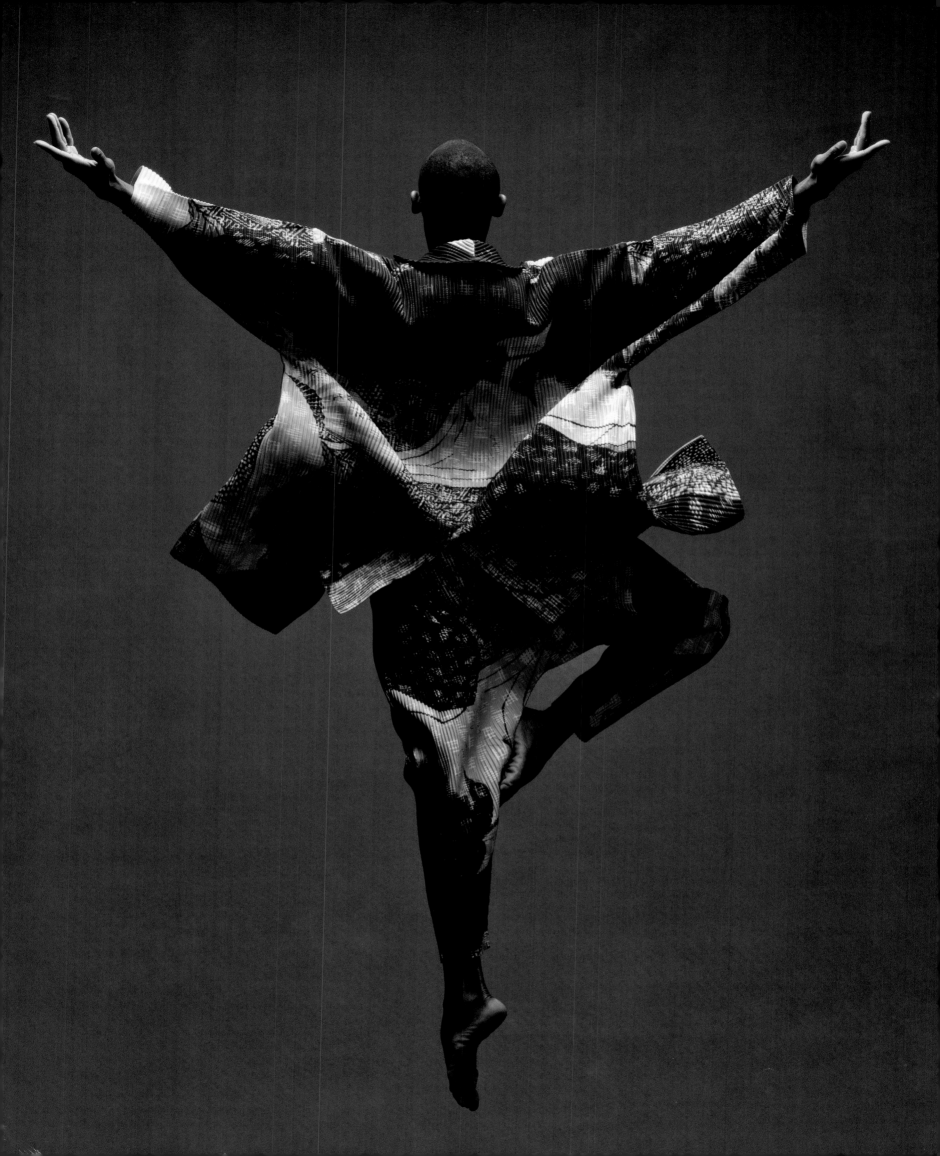

Anne Souder | Soloist, Martha Graham Dance Company | *Clothing by Issey Miyake*

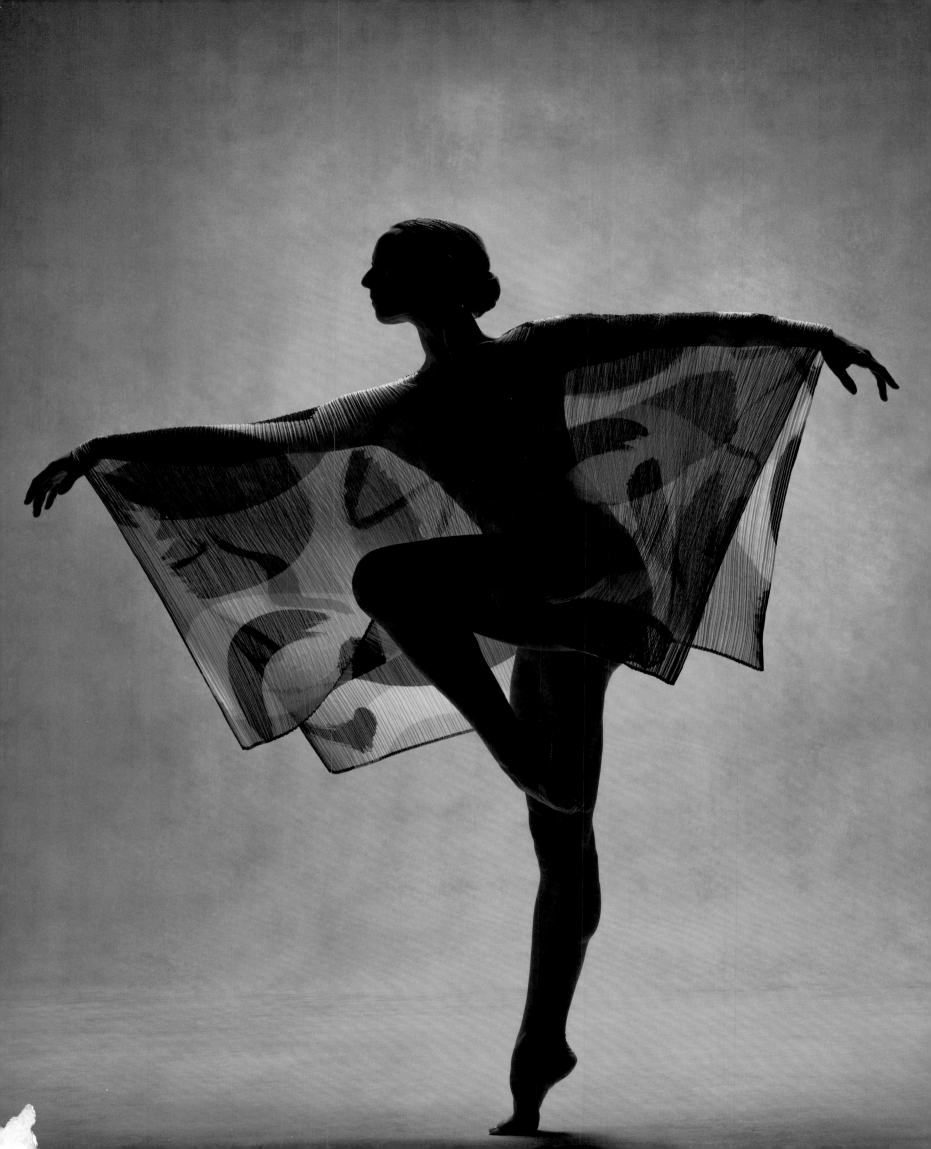

Photographers' Notes

It has always been a pleasure for us to collaborate with dancers, as we have found endless inspiration working with these artists. Dancers are able to express emotion through the movement of the body; their bodies become moving human sculptures. Even the simplest of gestures comes from a place of intention and expression. Ken and I have been photographing dancers for several years now and our love of working with dancers has only deepened.

This book is a sequel to our first book, *The Art of Movement*, which was published in 2016, and was the beginning of our exploration of fashion and dance. We began using costumes and clothing, which helped create a character for the dancer, introducing another element that gave the dancer something to work with, helping inspire movement. The clothing added the dimensions of color, shapes, and light that extended the dancer's movement. The fabric moved on its own as though it were a partner to dance with; other times it became a part of the dancer, as a fantastical extension of the lines of their bodies.

One of my very first jobs was at a fashion magazine called *Mirabella*, where I worked as a Photography Editor. I was situated right next to the fashion department and every day I watched as the stunning clothing from Valentino, Dior, and other designers went in and out of our offices. I watched the models try them on, turning around in circles to try to make the clothing move. Having grown up as a dancer myself, I always wanted the models to move more—I wanted to see the clothing come to life.

Combining several art forms—dance, fashion, and photography—has been an exciting exploration. The dancers arrive at our studio and try on the clothing. We discuss some ideas with them before the photography session and occasionally the dancer even brings along their favorite pieces. But more often than not, the clothing was a surprise for the dancer, a special piece I had selected that we thought would be inspiring for them and work well with the way they moved.

Writing this brings back so many memories from these sessions. Often a movement was so striking or vivid we knew immediately it would be the final image for the book. For example, Laura Halzack in the Elie Saab bodysuit with sleeves that look like wings. The image was our very first photograph of the session, as Laura lifted her arms, her wings expanded perfectly, like a bird in flight. Michael Trusnovec instantly felt a connection to Fred Astaire in the vintage tails. His movements took on a different feel and personality than when we had previously photographed him in a pair of tights. When PeiJu Chien-Pott danced in a Dior dress with rainbow colors, her movements created a kaleidoscope effect, I remember the gasps in the room. Sometimes the clothing took some time to understand—it was a partner with a mind of its own.

We styled every shoot ourselves, making sure we found the right clothing for each unique dancer. I was never a stylist, but I was always around fashion and loved couture, and, as a dancer, I knew how different styles of movement would work with different styles of clothing. I spent hours scouring the internet, looking for pieces that were sculptural, or evoked a feeling, anything I felt would inspire our dancers. We had clothing arrive from all corners of the world: France, Italy, England, Germany, Holland and other countries as far away as Australia, Lebanon, and Taiwan. Sometimes it took us years to actually reach a certain designer. Other times designers found us. After seeing our work, they also recognized the way dance could elevate fashion, and sent us pieces from their collections. It was always a miracle to me when I would see a piece by Iris Van Herpen or another favorite clothing designer in a photo online and later have dancers bringing it to life in our studio.

The inspiration to start our project was our daughters Sarah and Jenna. Both grew up loving and studying dance. Before they even took dance classes, dance was always a part of our lives together. Evenings at our house always included a dance performance where we would put on music, find some costumes and perform for each other. These early improvisations might include some text or singing, but most often they were just pure dance. Costumes were always an important part of the event and even the decision to simply use a leotard was intentional. Dance and fashion naturally go together. As Belinda Pieris states in her quote, "When a child puts on a dress, often the first thing she does is spin to feel how it moves with her."

—DEBORAH ORY, BROOKLYN, APRIL 2019

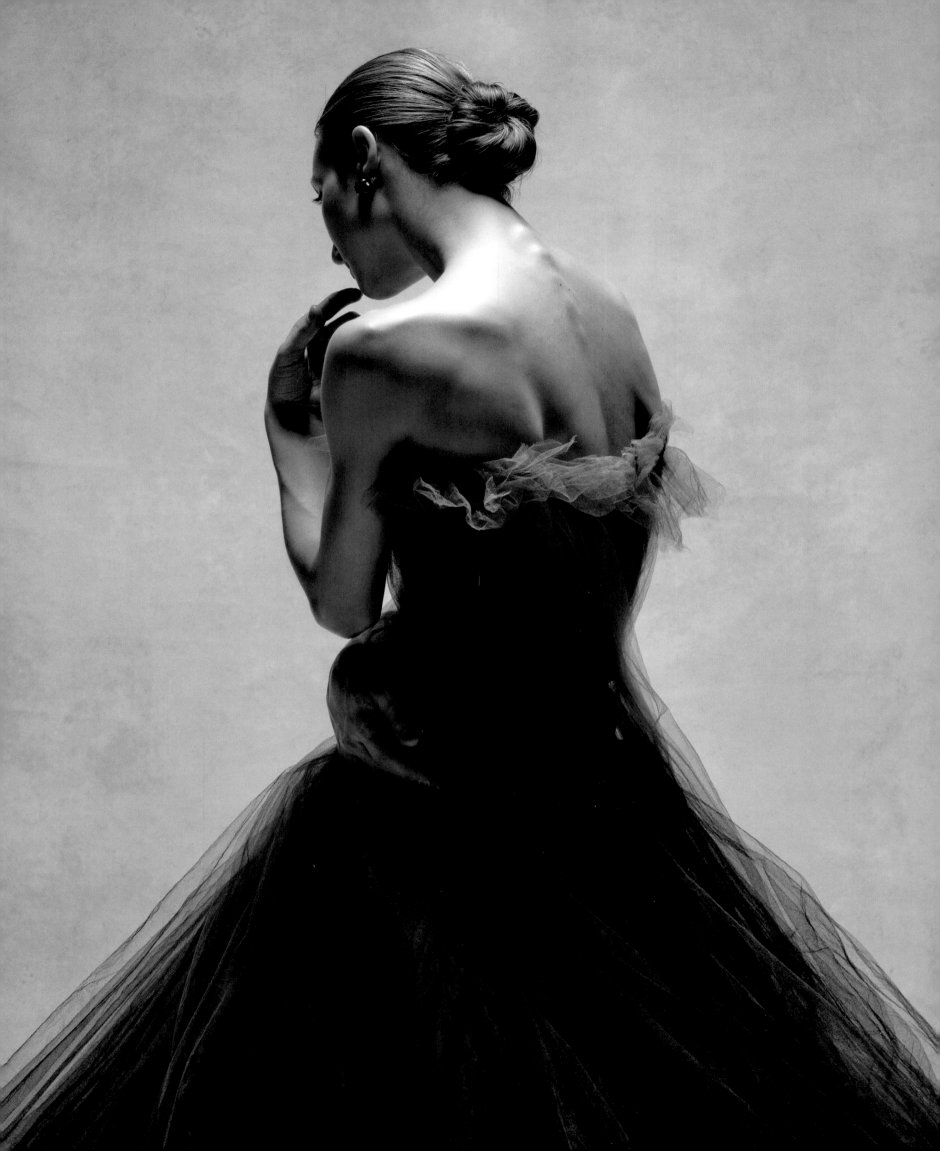

Acknowledgments

Many individuals deserve our gratitude for giving their time to this project. We'll start with Mr. Valentino, who hand picked the perfect dresses from his collection for Tiler Peck and wrote our foreword. Janet Eilber, Artistic Director of the Martha Graham Dance Company, has supported us since the beginning of our project. She has contributed her writing, costumes, and shared her beautiful dancers with us. Pamela Golbin shared her love of history and her knowledge of costumes and dance with us in her introduction.

We would like to thank all the dancers and designers who participated in the making of this book, and offer an extra special thanks to the following people who helped make this project a reality:

Veronica Bae
Tom Biondo
Joe Davidson and the staff at Rizzoli
Carol DiMaio
Jeff Dunas
Janet Eilber and the staff at the Martha Graham Company
Corey Field
Megan Fitzgerald
Maria Pia Gramaglia
George Greenfield
John and Jeri Heiden/Smog Design
Shannon Hoey and the staff at New York Vintage
Juliet Jane
Jeff Korchek
Hooman Majd
Charles Miers
Victoria Morris
Sarah Oliphant
Christopher Peregrin
The Royal Flower Group
Flavia Schepmans
Rachna Shah
Daniil Simkin
Nancy Knox Talcott
Alonso Teruel
Elise Weisbach

And a very special thanks to our daughters Sarah and Jenna who allowed us to make our home a photo studio by day, and who gave us countless hours of fashion and style advice.

Index

Lauren Lovette, Principal, New York City Ballet
Dress by Oscar de la Renta

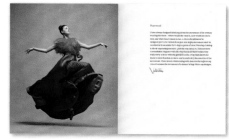

Hair by Jerome Cultrera / L'Atelier
Makeup by Claire Bayley / L'Atelier

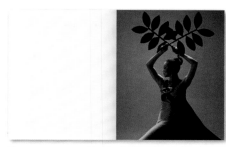

Costumes courtesy Martha Graham Dance Company

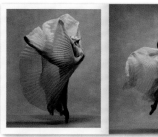

Hair and makeup by Juliet Jane

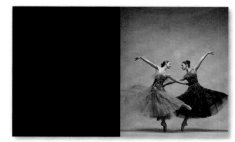

Hair and makeup by Juliet Jane

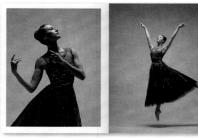

Hair and makeup by Juliet Jane

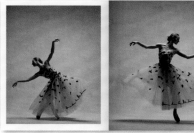

Hair and makeup by Juliet Jane

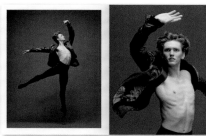

Jacket by Franco Lacosta. Tights by Yumiko

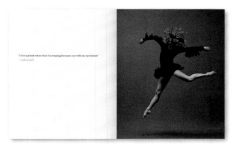

Hair and makeup by Juliet Jane

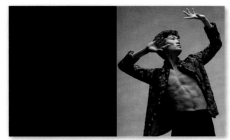

Jacket by Etro. Tights by Yumiko

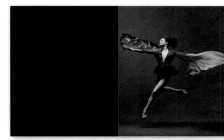

Hair and makeup by Juliet Jane

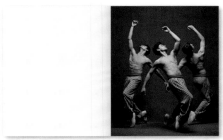

Costumes courtesy Miami City Ballet

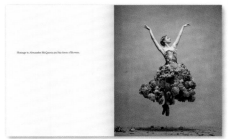

Flowers courtesy Royal Flower Group
Floral design by Olga Sahraoui / Sahola NYC

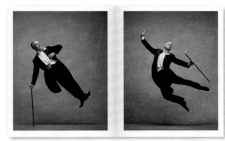

Tuxedo courtesy Hooman Majd

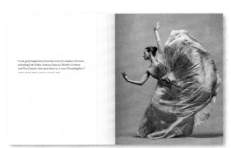

Hair by Jerome Cultrera / L'Atelier
Makeup by Claire Bayley / L'Atelier

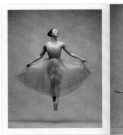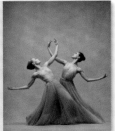

Hair by Jerome Cultrera / L'Atelier
Makeup by Claire Bayley / L'Atelier

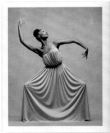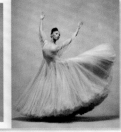

Makeup by Charlotte Willer / Home Agency

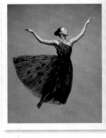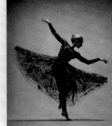

Hair by Jerome Cultrera / L'Atelier
Makeup by Claire Bayley / L'Atelier

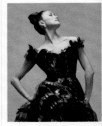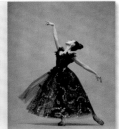

Hair by Jerome Cultrera / L'Atelier

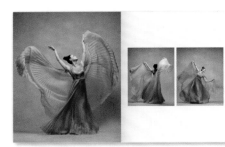

Hair by Jerome Cultrera / L'Atelier

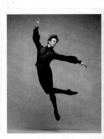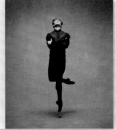

Costume courtesy National Ballet of Canada

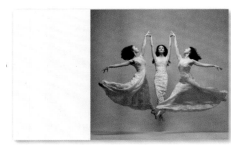

Hair and makeup by Brittany De Grofft

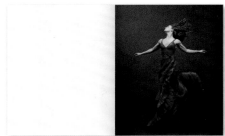

Hair and makeup by Juliet Jane

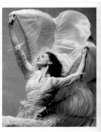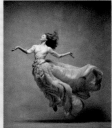

Hair and makeup by Juliet Jane

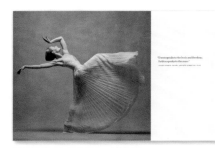

Hair by Jerome Cultrera / L'Atelier
Makeup by Claire Bayley / L'Atelier

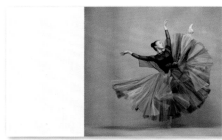

Makeup by Charlotte Willer / Home Agency

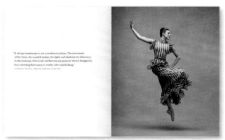

Hair and makeup by Angela Boswell

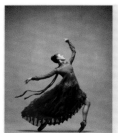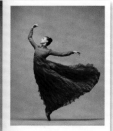

Hair and makeup by Angela Boswell

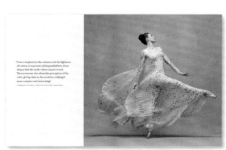

Hair and makeup by Angela Boswell

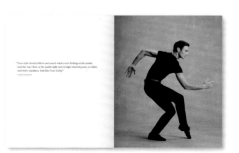

Costumes by Bob Crowley, dressed by Billy Hipkins
Costumes courtesy "An American in Paris" on Broadway

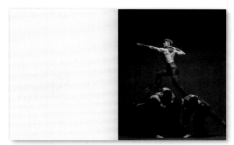

Costumes for Makers Dance Company

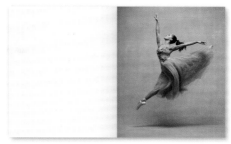

Hair by Deycke Heidorn. Makeup by Juliet Jane

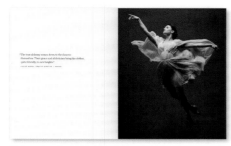

Hair and makeup by Juliet Jane

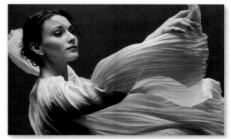

Hair and makeup by Juliet Jane

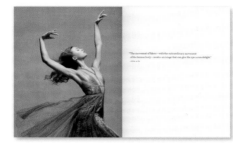

Hair and makeup by Juliet Jane

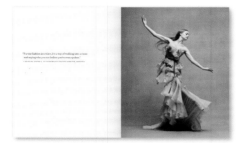

Hair and makeup by Brittany De Grofft

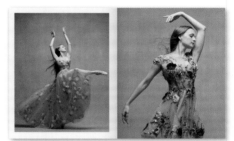

Hair and makeup by Brittany De Grofft

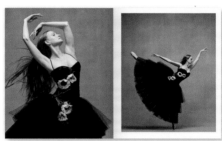

Hair and makeup by Brittany De Grofft

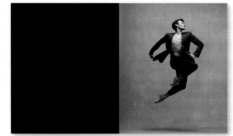

Jacket by Tom Ford. Tights by Yumiko

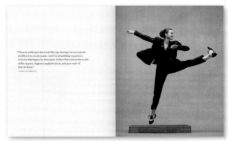

Hair and makeup by Juliet Jane

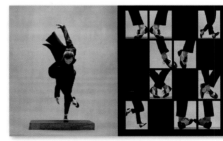

Hair and makeup by Juliet Jane

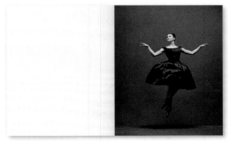

Hair and makeup by Juliet Jane

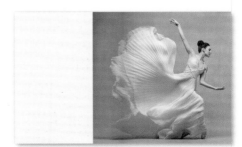

Hair by Jerome Cultrera / L'Atelier
Makeup by Claire Bayley / L'Atelier

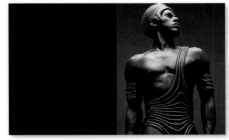

Costume by Halston for Martha Graham's
"Andromache's Lament", 1982, costume courtesy
Martha Graham Dance Company

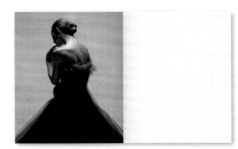

Christine Shevchenko, Principal, American Ballet
Theatre. Dress by Oscar de la Renta

First published in the United States of America in 2019 by
Rizzoli International Publications, Inc.
300 Park Avenue South
New York, NY 10010
www.rizzoliusa.com

Publisher: Charles Miers
Production Manager: Maria Pia Gramaglia
Managing Editor: Lynn Scrabis

Cover design: John Heiden, Smog Design, Inc.
Interior design: Flavia Schepmans
Additional text: Janet Eilber, Pamela Golbin, and Valentino

Printed in Italy
2019 2020 2021 2022 / 10 9 8 7 6 5 4 3 2 1

ISBN: 978-0-8478-6408-9
Library of Congress Control Number: 2019937412

Visit us online:
Facebook.com/RizzoliNewYork
Twitter: @Rizzoli_Books
Instagram.com/RizzoliBooks
Pinterest.com/RizzoliBooks
Youtube.com/user/RizzoliNY
Issuu.com/Rizzoli